The Literary Tourist

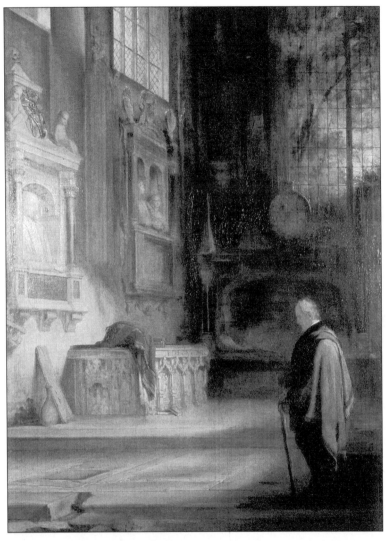

David Roberts (also variously attributed to Sir William Allan and to Benjamin Haydon), 'Sir Walter Scott on the occasion of his visit to Shakespeare's tomb in Holy Trinity Church, Stratford-upon-Avon on 8 April 1828.' Shakespeare Birthplace Trust.

The Literary Tourist

Nicola J. Watson

First published in hardback 2006
First published in paperback 2008 by
PALGRAVE MACMILLAN
Houndmills, Basingstoke, Hampshire RG21 6XS and
175 Fifth Avenue, New York, N.Y. 10010
Companies and representatives throughout the world

PALGRAVE MACMILLAN is the global academic imprint of the Palgrave Macmillan division of St. Martin's Press, LLC and of Palgrave Macmillan Ltd. Macmillan® is a registered trademark in the United States, United Kingdom and other countries. Palgrave is a registered trademark in the European Union and other countries.

ISBN-13: 978-1-4039-9992-4 hardback
ISBN-10: 1-4039-9992-9 hardback
ISBN-13: 978-0-230-21092-9 paperback
ISBN-10: 0-230-21092-9 paperback

This book is printed on paper suitable for recycling and made from fully managed and sustained forest sources.

A catalogue record for this book is available from the British Library.

Library of Congress Cataloging-in-Publication Data

Watson, Nicola J., 1958–
 The literary tourist : readers and places in romantic & Victorian Britain
/ Nicola J. Watson.
 p. cm.
 Includes bibliographical references and index.
 ISBN 1-4039-9992-9 (cloth) 0-230-21092-9 (pbk)
 1. Literary landmarks—England. 2. Authors, English—Homes and
haunts—England. 3. Tourism—England. I. Title.

PR109.W38 2006
914.2'0486—dc22 2006044635

10 9 8 7 6 5 4 3 2 1
17 16 15 14 13 12 11 10 09 08

Printed and bound in Great Britain by
CPI Antony Rowe, Chippenham and Eastbourne

Contents

List of Illustrations

Introduction

I Readers and places

This is a book about literary tourism as it develops over the course of the eighteenth and nineteenth centuries. It is about the ways in which reading, at least for a noticeable and mainstream category of literature's consumers, becomes progressively and differentially locked to place, over a period defined by the works of Thomas Gray and Jean-Jacques Rousseau at one end and those of Thomas Hardy at the other. This period saw the practice of visiting places associated with particular books in order to savour text, place and their interrelations grow into a commercially significant phenomenon, witnessing the rise of William Shakespeare's Stratford-upon-Avon, Sir Walter Scott's Abbotsford, Robert Burns's Alloway and the Brontë sisters' Haworth, amongst other flourishing sites of native literary pilgrimage.

After all these years of postcards from Anne Hathaway's Cottage and biscuit-tins from Haworth, this continuing desire to situate canonical literary texts in equally canonical landscapes may seem almost natural, but in other respects it remains a deeply counter-intuitive response to the pleasures and possibilities of imaginative reading. If I think back to my own sense of place when reading as a child, for example, I do not remember ever bothering to believe that places described were real in the way that my own domestic and school existence was real and physical. 'Real' was where I was when reading – in a window-seat, up the walnut-tree or under the bedclothes (and they were still bedclothes then). The book itself was, in Norton Juster's resonant phrase, 'a phantom tollbooth', or the 'wardrobe' that C.S. Lewis imagined as delivering you to Narnia, an entry-point or escape-hatch to a place altogether elsewhere.[1] Robert Louis Stevenson's formulation of 'The Land of Counterpane'

collapses exactly the experience of being relatively confined and yet imaginatively free, an experience of the dialectic of 'here' and 'there' that Charlotte Brontë dramatises at the opening of *Jane Eyre*, in which, seated in the curtained window-seat, neither quite inside nor outside, Jane is transported to the snowy reaches of the North Pole via the illustrations to *Bewick's Birds*, yet remains vividly aware of the situation in the room at the same time. John Masefield's 'box of delights' is not a box but a book – small on the outside, vast temporally and physically on the inside – and made available by the suspension of disbelief.[2]

Yet much of children's fiction – to consider only one of the legacies of the nineteenth-century realism with which literary tourism took its chief inception – is in fact set in verifiable places, although most children neither know nor care about this. For who cares when they are nine to discover from where, exactly, Swallow set sail on that memorable summer holiday? This was vividly demonstrated when I swept my two ten-year-old daughters one half-term up to the Lake District in search of the Swallows and the Amazons. On Lake Coniston, we took the 'Arthur Ransome' lake-steamer and circled in the prevailing drizzle around the original Wild Cat Island. There was the secret harbour, just as it is pictured in the book. The children were polite, but essentially unimpressed; as Elizabeth remarked, why did you need to visit the island, when you had the real thing, the book.

Why indeed. This visiting of places with literary associations is essentially an adult vice, obscure in its impulses. For Elizabeth, the 'origin' of place was the book itself, a truth to which I shall be returning. Elizabeth in this showed herself as more sophisticated than the majority of grown-up readers (especially grown-up writers of visitors' brochures), who are inclined to ascribe the origin of the book to place. In this they reiterate ideologically the founding gesture of Kipling's *Puck of Pook's Hill* (1906), by which Puck – accidentally called up by the chance recitation of part of Shakespeare's *A Midsummer Night's Dream* in an English field one Midsummer's Eve – obliges the children under his guidance to 'take seizin' of the earth as a condition of accessing its (his) stories; the gesture reiterates the romantic nationalist view of the text as latent in the soil of the homeland.[3] There is, accordingly, a thriving tourist industry presenting the place of the book for visitors, a sort of tourist anthology of the classics, canonical and popular, of English Literature, conveniently consumed not merely by the Briton but by the foreigner – whether American, Australian, Japanese or other. These days, you may visit a dazzling array of places where your favourite author was born, grew up, courted, lived or died, you may visit where your

favourite books were written, or places where they are set, and buy the postcard, too.[4] (The most illicit of such locations is probably the public loo in Hampstead associated with the amatory adventures of the playwright Joe Orton). You may set eyes upon the very table on which Austen's *Emma* was written at Chawton, the table on which Milton's *Paradise Regained* may have been written in Chalfont St Giles, the attic in Gough Square, London, in which Dr Johnson laboured at his *Dictionary*. You may prefer the out-and-out fiction offered by the museum at what purports to be 221b Baker Street (an address which in Sir Arthur Conan Doyle's time did not actually exist), with its fantasy of by-passing the author entirely by dropping in upon Sherlock Holmes and Dr Watson at a minute reconstruction of their rooms, or to tour 'Inspector Morse Country' and drop into the 'Morse Bar' at the Randolph Hotel in central Oxford. The experience is perhaps most powerfully compounded if the place of composition and fictional setting coincide. You may see the stone by the waterfall upon which Charlotte Brontë is said to have composed *Jane Eyre*, and on the same walk explore the path up the moorland valley to the place said to be the setting for her sister's *Wuthering Heights*. You may view the house in Castle Street, Edinburgh, where the young journalist Lockhart peered in through a window and witnessed the indefatigable movement across the pages of Walter Scott's hand, and then step down the street to stand on the plaque that marks 'The Heart of Midlothian'. Alongside the more extreme manifestations of the desire temporarily to occupy the same space as either the writer or the characters or both – such as the urge to visit King's Cross Station in the hopes of locating the point of departure for Hogwarts school in J.K. Rowling's Harry Potter books, now gratified in part by the provision of a sign reading 'Platform 9¾' garnished with half of a luggage-trolley apparently disappearing into the solid wall beneath it – visiting *Swallows and Amazons* country is almost sensible. The lakes really are there, and Arthur Ransome really did live and write there. You can, as I have just remarked, go and see Wild Cat Island (disappointingly small, as my children tried hard not to point out to me); you can see Ransome's desk, piled with books, sketches, a typewriter, a model of Swallow and even Swallow's flag; you can see the real 'Amazon' and the real 'Scarab', and even the real boat that was the model for Captain Flint's houseboat, 'the cabin set out with a feast of goodies for the 'pirates' and . . . Captain Nancy's 'black spot' on the table.'[5] So powerful is the impulse to identify Ransome's terrain within the topography of the lakes that there is a map available, identifying the sites of Beckfoot, Swallowdale, Holly Howe, Kanchenjunga, the Peak of Darien and Rio, the fruit of a lifetime's

work on the part of Roger Wardale, Ransome's illustrator. The Dog's Home really is there, as Wardale's photographs prove, and so is the 'North Pole'.

Visitors to the Lakes in search of the Swallows and Amazons perform a variety of experiments in imagination. They see the Lakes at once as Ransome's home, work-place and inspiration, and as a fictive landscape awaiting imaginative (re)possession and (re)discovery. Strikingly and crucially, this form of tourism recapitulates the controlling conceit of the series of Swallows and Amazons books: as *Secret Water* (1939) has it, 'You'll start with a blank map, that doesn't do more than show roughly what's water and what isn't. You'll have your tents, stores, everything we'd got ready. You'll be just a wee bit better off than Columbus. But you'll be marooned, fair and square.'6 The children set off to possess the land by re-naming it, an act of literary imagination comparable to those in which they have already been engaged in *Swallows and Amazons*, with the naming after Keats's *On First Looking into Chapman's Homer* of 'the Peak in Darien', and the children's pervasive determination to see the lake and its residents as a projection of their reading of R.L. Stevenson's *Treasure Island*. (Hence the initially hostile man on the houseboat becomes 'Captain Flint', and so on.) The best extended example of this is the episode in *Swallowdale* (1931) in which the Swallows and Amazons ascend Old Man Coniston, which they have named 'Kanchenjunga'. When they dig a little hole to bury a box containing a list of their names and the date, they find that their parents had done just the same, only they, apparently, had ascended the Matterhorn. In miniature this is a description of the emotional experience of the literary tourist. It is not simply that so and so was there, but rather that so and so imagined something there, and it was and was not the same thing, just as parents are and are not, ever, children, and just as children are and are not the same thing as their parents. It is a perfect description of the eruption of the uncanny, the familiar rendered strange. To tour Ransome country is not merely a recapitulation of the original act of possession-by-reading performed by Ransome's characters, but a repossession of that imaginative act, not because the map of the lakes corresponds in every detail with the world of Swallows and Amazons, but precisely because it does not. The names in the books are 'wrong' because they are child-generated names; but the topography, famously, does not quite work either, collapsing as it does Lake Coniston with Lake Windermere. Ransome's child characters, engaged in the process of imaginative transformation and possession of place, thus offer models for the adult reader-tourist. The text in fact models tourism, as do the

other texts around which the tourism develops with which I am occupied in this study.

As I have already remarked, nowadays literary tourism is so naturalised as a cultural phenomenon in the British Isles that one sees literary sites detailed in guidebooks and marked on the road map, and expects (and feels expected) to visit the museum shop and to buy the soap, the postcard and the bookmark. We hardly so much as hesitate, before paying over our entrance fees, to notice the oddity, indeed the sophistication, of a practice designed to link text to place by supplementing reading with travel. Nor do we pause to consider that as a cultural practice it is historically specific and of relatively recent inception. Eighteenth-century culture saw the rise of this new phenomenon, and the nineteenth and early twentieth centuries its heyday. For the first time travellers developed a taste for visiting a range of sites of purely literary interest: the well-established practice among the leisured and cultured of visiting living writers armed with letters of introduction was amplified by a new desire to visit the graves, the birthplaces and the carefully preserved homes of dead poets and men of letters. This fashion extended to the practice of visiting sites that writers had previously visited and written in or about. This appetite for seeking out the origins of the author and the locations of the author's writings led by the end of the nineteenth century to the habit of reinventing whole regions of the national map as 'Shakespeare country', 'Wordsworth's Lake District', 'Scott-land', 'Brontë country', 'Dickens's London', 'Hardy's Wessex' and so on, to which the rival literary Cornwalls of Daphne du Maurier and Winston Graham would soon be added.[7] The same period saw other writers colonize parts of Britain as literary regions that have subsequently vanished into thin air, dissolving like the baseless fabric of obsolete visions. Who now could pinpoint on the map 'Aylwin-land'? Yet you could have visited it, had you so wished, in 1904.[8]

The inception and development of modern literary tourism across the eighteenth and extended nineteenth centuries is the subject of this book, the first full-length scholarly study of its kind.[9] If nothing else, the previous near-invisibility to academic literary history of this topic and of the body of texts that makes it visible and recuperable suggests that the phenomenon warrants the serious critical attention that it has so markedly lacked to date. The embarrassment palpable among professional literary scholars over the practice of literary pilgrimage co-exists with a marked willingness to indulge in it as a private or even communal vice, or so conference programmes ranging from the annual Wordsworth Conference in Grasmere (providing Wordsworthian walks,

Wordsworthian readings *in situ*, and tours of Dove Cottage and Rydal Mount) to the Hardy summer conference in Dorchester (which comparably provides 'Hardy' walks) might suggest. Yet this co-existence of academic textual studies with tourism is thoroughly uneasy, not to say almost contraband, in a critical climate still inflected by New Criticism and its more heavily theorized successor, the version of post-structuralism (influenced by the work of Roland Barthes and Michel Foucault) which proclaims the death of the author and the nothingness outside the text. Purists and professionals should find the literary text in itself enough, it should not need supplementing or authenticating by reference to externals, especially to supposedly non-textual external realities, such as author or place. Only the amateur, only the naïve reader, could suppose that there was anything more, anything left, anything either originary or residual, let alone anything more legitimate or legitimating, to be found on the spot marked X. Yet although this modern embarrassment has rendered my subject rather disreputable, it has also suggested that this lingering desire to go on reading text in the light of place marks a threatening fissure in current academic theories of reading; and, as my language suggests, my own exploration of when and why the need arose to gloss the text by situating it in a landscape in fact owes a good deal to post-structuralist theory. Even Derrida's famous dictum that there is nothing outside the text, after all, occurs close to an equally striking assertion that there is nothing except the supplementary. As Barbara Johnson remarks, introducing deconstruction through her account of Derrida's reading of Rousseau's *Confessions*:

> It is clear that Derrida is not seeking the "meaning" of Rousseau's text in any traditional sense. He neither adds the text up into a final set of themes or affirmations nor looks for the reality of Rousseau's life outside the text. Indeed, says Derrida, there *is* no outside of the text:
>
>> *There is nothing outside of the text [il n'y a pas de hors-texte].* And that is neither because Jean-Jacques' life, or the existence of Mama or Thérèse *themselves*, is not of prime interest to us, nor because we have access to their so-called "real" existence only in the text and we have neither any means of alerting this, nor any right to neglect this limitation. All reasons of this type would already be sufficient, to be sure, but there are more radical reasons. What we have tried to show by following the guiding line of the "dangerous supplement," is that in what one calls the real life of these existences "of flesh and bone," beyond and behind what one

believes can be circumscribed as Rousseau's text, there has never been anything but writing; there have never been anything but supplements, substitutive significations which could only come forth in a chain of differential references, the "real" supervening, and being added only while taking on meaning from a trace and from an invocation of the supplement, etc. And thus to infinity, for we have read, *in the text*, that the absolute present, Nature, that which words like "real mother" name, have always already escaped, have never existed; that what opens meaning and language is writing as the disappearance of natural presence.

Far from being a simple warning against biographical or referential fallacy, *il n'y a pas de hors-texte* is a statement derived from Rousseau's autobiography itself. For what Rousseau's text tells us is that our very relation to "reality" already functions like a text. Rousseau's account of his life is not only itself a text, but it is a text that speaks only about the textuality of life. Rousseau's life does not *become* a text through his writing; it always already *was* one. Nothing, indeed, can be said to be *not* a text.[10]

The landscape sought by literary tourists, too, is a text, and a 'dangerously supplementary' one at that: to go to a place by the light of a book is at once to declare the place inadequately meaningful without the literary signification provided by the book, and to declare the book inadequate without this specific, anxiously located referent or paratext. Indeed to go somewhere in order to read or contemplate a particular book just there may be one of the most direct ways we have of unsettling our sense of the real and experiencing precisely Derrida's sense of the non-existence of 'natural presence'. It is more than coincidence that, as I shall be showing, two of the first books to inspire this particular species of supplementary reading – a practice inevitably doomed merely to focus and foreground the lack at the heart of the realist text – were Rousseau's pioneering essay in autobiographical verisimilitude, the *Confessions*, and his epistolary novel *La Nouvelle Héloïse*. Nor is this necessarily an undesired experience of a combination of plenitude and absence in which the real place and the realist text mutually undo and undercut one another. At one extreme of the practice, tourists actively seek out the anti-realist experience of being 'haunted', of forcefully realizing the presence of an absence, a form of tourist gothic powerfully characteristic of literary pilgrimage to sites such as Haworth Parsonage, discussed in chapter three.

It is important to recognize, at the same time, that the embarrassment often professed by contemporary academics about their own visits to the places described or implied by literature did not afflict even the most sophisticated readers from about the 1780s right through to the 1920s. Until really rather recently, texts have been just as much a matter of place as of print for many of their readers. Charmingly, for instance, Alfred, Lord Tennyson simply waved a dismissive poet laureate's hand at all the worthy guidebook information offered him on his visit to Lyme Regis in favour of the pleasures of literary tourism, setting aside the constitutional history of Britain in favour of the fiction of Jane Austen: 'Don't talk to me of the Duke of Monmouth . . . Show me the spot where Louisa Musgrove "fell down and was taken up lifeless".' (He was duly ushered out onto the Cobb).[11] Even so slight a piece of anecdotal evidence suggests that if we wish to understand how readers read texts in the long nineteenth century we would do well to attend to the remaining traces of literary pilgrimage, because they are, however imperfect, indicators and records of that otherwise most elusive of things to pin down, how readers experience and live out their reading. To attend to the literary pilgrimage is to begin to construct a materialist history of amateur reading pleasures that continue to be available to this day. This book, therefore, endeavours to contribute not simply to the history of travel and tourism but to the wider cultural history of reading, of how literature is consumed, experienced and projected within the individual reader's life, and within a readership more generally. To consider the history of the texts, practices and institutions of literary tourism is to get some limited access to the relations readers have set up over the last two hundred years with particular authors and texts, and how they have lived out and extended those relations through travel to certain places.

The chapters that follow not only provide the first history of literary tourism in Britain, but, *en route* and by implication, the beginnings of a literary history of those literary and sub-literary genres associated with the phenomenon of literary tourism. Indeed, although inevitably informed in part by stubbornly material history of tourism – its relations with increased leisure, mass literacy and the mass-availability of transport as horse and carriage gave way to the railway – this history remains focussed through the lenses of a succession of journalistic and literary texts. To write it, I have drawn together many and various types of texts, ranging widely across the fully literary out to the marginally and sub-literary and so to those 'texts' that would conventionally be considered non-literary. An interest in how place is written and how

writing is located in place has proved to involve far more than simply the consideration of the ways in which individual writers have been connected to place in the first instance via their own writings and then via subsequent works of criticism and biography, for both writings and biography are typically mediated extensively through other inter-texts.

In the late eighteenth century these inter-texts are most typically epitaph, elegy, obituary, tribute-poems and topographical poems; by the early nineteenth century a new crop of genres has sprung up. There are guidebooks like *Black's*, *Murray's*, and later *Baedeker's*, which typically excerpt literary loco-description, hybridizing gazetteer with anthology. There are published and unpublished travelogues and travel diaries designed by the traveller for the armchair traveller, such as Byron's *Childe Harold* III and IV (1816, 1818), Washington Irving's *Sketch Book* (1820) or Dorothy Wordsworth's *Recollections of a Tour Made in Scotland A.D. 1803* (which was not published until 1874). There are picture-books, cheap and comprehensive like Charles Mackenzie's *Interesting and Remarkable Places* (1832) which includes a large number of inaccurate wood-cuts of sites of literary interest, and extremely expensive volumes of steel-engravings, such as *The Land of Burns* (1840).

At mid-century there develops an important sub-genre, volumes of discrete essays devoted to localities of literary interest, of which the first and arguably most important are the volumes published by William Howitt, *Visits to Remarkable Places* (1840, 1842), and *Homes and Haunts of the Most Eminent British Poets* (1847). Howitt's admixture of biography and personal memoir of visiting some of the locations he described would become immensely influential, and a flood of such pilgrimage books was produced, bearing titles such as Mrs S.C. Hall's *Pilgrimages to English Shrines* (1850, 1853), Nathaniel Hawthorne's *Our Old Home* (1863), William Winter's *Old Shrines and Ivy* (1892), Elbert Hubbard's *Little Journeys to the Homes of Good Men and Great* (1895) and its many companion volumes, Marion Harland's *Where Ghosts Walk: The Haunts of Familiar Characters in History and Literature* (1898), Henry C. Shelley's *Literary Bypaths in Old England* (1909) and Christian Tearle's *Rambles with an American* (1910). As these titles would suggest, many of these are by Americans or interested in the American experience of Britain, intent upon redacting the experience of visiting the old country for their readers in the new, and especially alive to the act of coalescing familiar text with the ambiguously familiar and yet foreign landscape to which they were related so as to include some version of Britain as well as its literary canon within an amplified Anglophone heritage. As I shall be discussing at intervals throughout the rest of the book, the act of

superimposing the classic text upon the realities of a nonetheless dubiously real country produced certain habits of writing and memorialisation, habits of appropriation which involve constructing the British and their landscapes as themselves almost as fictitious as the text the tourist pursues. In this late Victorian transatlantic sub-genre, the natives, whether they appear to have stepped briefly out of the text or whether they are astoundingly ignorant of it (to leave it available for better-informed appropriation), appear as mere extensions of the located literary work the tourist is touring. Susan Coolidge's *What Katy Did Next* (1886), for example, offering teenaged American girls an account of how Katy visited 'Story-book England', includes a characteristic vignette of visiting Austen's tomb in Winchester Cathedral (which famously declines to mention her novels):

> They laid a few rain-washed flowers upon the tomb, and listened with edification to the verger, who inquired:
> 'Whatever was it, ma'am, that lady did which brought so many h'Americans to h'ask about her? Our h'English people don't seem to take the same h'interest.'
> 'She wrote such delightful stories,' explained Katy; but the old verger shook his head.
> 'I think h'it must be some other party, miss It stands to reason, miss, that we'd have heard of 'em h'over 'ere in England sooner than you would h'over there in h'America, if the books 'ad been h'anything so h'extraordinary.'[12]

That twenty-one-year old heroine, with her enthusiasm for London as a collection of 'places I know about in books' associated with Thackeray, Scott, Goldsmith, the Lambs, Dickens, Milton, Burney, Carlyle and George Eliot, is still very much alive today. Some years ago one of my students at Harvard wrote back from a semester spent in England in high indignation at how unlike it all was to 'Dickens's London.' (My reply, as I recall, neglected to commiserate with her on not having been confined in a blacking factory throughout her visit, though I could have directed her to the plaque which marks its site).

From the 1880s onwards appeared the first books that sought to lay out practical literary walking and cycling itineraries in detail, their titles betraying the dilettante joys of penetrating places where otherwise the tourist had no business – *Rambles 'en zig-zag' round London with Dickens* (1886), *Weekends in Dickens-Land: A Bijou Handbook for the Cyclist and Rambler, with Map* (1901), even the incongruously cheerful *A Spring-time*

Saunter Round and About Brontë-Land (1904). Finally, the turn of the century brought the development of full-blown 'literary geography' and the concomitant invention of the idea of the literary 'land' or 'country', in which author and characters from discrete works existed in magical and documentary simultaneity. Publishers began to bring out editions of novels elaborately illustrated with photographs of real locations, such as the 'Doone-Land' edition of R.D. Blackmore's *Lorna Doone* (1908), or the 'Wessex edition' of Hardy's novels (1912). They also commissioned shelves of books dedicated to searching out and illustrating, usually with large numbers of expensive photographs, the origins for the settings featured in novels. Examples of such books include Henry Snowden Ward and Katherine B. Ward's *The Real Dickens Land* (1904), remarkable for its scholarly and visual comprehensiveness. This habit of mind would continue to mature and become yet more ambitious, manifesting itself finally in the twinned forms of literary atlas and gazette, of David Daiches and John Flower's *Literary Landscapes of the British Isles: A Narrative Atlas* (1979) and *The Oxford Literary Guide to the British Isles* (1977), edited by Dorothy Eagle and Hilary Carnell.

If these are all texts that would be conventionally regarded as 'literary', they are supplemented and adumbrated in this study by the consideration of all manner of 'non-literary' 'texts', other forms of on-site quasi-biographical writing which bind writers and texts to place. There are the graves, tombs, cenotaphs, mausolea, memorials and monuments erected to writers (and sometimes to their relatives, their characters and even their pets – Maida the greyhound sits at Scott's feet in Edinburgh, Byron's Newfoundland sits at his feet in Hamilton Gardens, but Hodge, Johnson's cat, sits alone in bronze in Gough Square). Most elaborate of these non-literary 'texts' is the writer's house – whether realised as a plaque on the site (as is the case of Milton's birthplace, vaporised in the Great Fire) or on an existing house (like Daphne du Maurier's house in Readymoney, Fowey), whether collected as a curiosity (which is what happened to the wooden chalet in which Dickens wrote in the summer months) or opened as a full-blown commemorative museum, preserved and captioned. Such museums are stuffed with otherwise dangerously portable items that nonetheless are referred insistently to place and to authorial body – the desk of Scott, the pens of Hardy, the pewter ink-pot gouged with titles by Kipling, the couch of Emily Brontë, the slippers of Dorothy Wordsworth, the chair of Charles Dickens, and, especially privileged, those small 'relics' carefully identified with engraved brass plaques as cherished bits of the bedstead in which Burns died, or as locks of an author's hair (such as the fragment of that famous hair-fetishist

Milton's appropriately preserved at Chalfont St Giles). Such houses delight in presenting literary conundrums for the enthusiast – the little soldier in red in the nursery at Haworth that speaks to the initiate of the Brontë children's fantasy-lands of Angria and Gondal, or the letter-blocks that spell out 'blunder' at Chawton in reference to the covert message that passes between Jane Fairfax and Frank Churchill in *Emma*. Although the practice of preservation and conservation of writers' houses efficiently disguises the fact, most writers' houses as we view them nowadays are the product of a distinctively early twentieth-century aesthetic, typically taking the form in which they are familiar to us around the 1920s. Somewhere nearby will be the shop selling mass-produced souvenirs, prints, postcards, small gifts and novelty maps, but it would be a mistake to think of this aspect of the phenomenon as anything like as recent – in Stratford-upon-Avon, the first commercially produced literary souvenirs were available as early as the 1760s.

Although the provenance and pretensions of these genres produced for and by tourists are so various, considered together they provide a remarkably coherent account of the expanding emotional territory for which the nineteenth-century literary tourist took his or her ticket. These stories told about literary places in the aggregate reveal the assumptions, desires and emotions shared by their makers and their consumers. For this reason I have not been unduly anxious about allowing implied (even, in one instance, fictive) tourists to have equal status with my documented examples of actual tourists. As this conspectus of my sources indicates, it is a central premise of this book that literary place is produced by writing mediated by acts of readerly tourism, and in that sense literary place is itself a 'text'. It is the internal workings of an author's works, buttressed by a particularised series of inter-texts, which produce place, not the other way around. Further, it is one of the core hypotheses of this study that no author or text can be successfully located to place unless their writings model or cue tourism in one way or another. (The exception that spectacularly proves this rule is Shakespeare, as I shall be showing). I suggest that it is the text itself that invents and solicits tourism, that it is a historically specific kind of text which converts readers into tourists, and that tourism is, moreover, a historically specific kind of reading. This book therefore tries to re-construct the 'reader-tourist' or rather, 'reader-tourists', by which I mean the sensibilities implied by texts, be they literary, sub-literary or non-literary, which readers then endeavour to recapitulate through the protocols of tourism. As I show in the following chapters, a number of models or positions emerge for the reader-tourist: but whether recapitulating

authorial sentiment (as in the instance of Burns) or the emotions ascribed to characters (as in the case of Rousseau), whether actuated by a desire to slum it in the footsteps of Dickens, to see the ghosts of the Brontë girls, or to act as a topographical detective in defiance of Hardy's authorial smokescreen, it is a position typically defined and constructed by nostalgic belatedness, and by a constitutive disappointment which returns the reader-tourist back to the text, albeit now garnished (by the Victorians) with a bookmark made of the violets from Shelley's grave or (by the moderns) one that represents in full and tasteful colour a cluster of Wordsworthian daffodils.

In telling this story of how literary places came into being through texts, I have found myself considering, if not exactly resolving, three central questions. The first is the question of to what extent literary tourism was produced by anxieties on the part of both writers and readers about the erosion of the intimacy of the relationship between the two in an age of mass readership. The portability and multiplicity of the published book seems to have induced since the late eighteenth century a desire to authenticate the reading experience in a more 'personal' way, to reinforce an incompletely intimate and unsatisfactorily vicarious reading experience. This results in a desire to re-experience the text by interpolating the reader's body into an imperfect dialogue with the dead author. The reader goes to pay homage to the dead, or 'goes to see the author', or even, goes to be the author – to follow in their footsteps, to see with their eyes, to inhabit, however briefly, their homes and haunts. This typically takes the form of a fixation upon the author's body, which in turn leads to an emphasis upon locality. This desire is fuelled by the rise in the importance of a newly topographicised biography as an explanatory mechanism at the end of the eighteenth century (suitably exemplified by the copies of Boswell's *Life of Johnson* and *Journal of a Tour to the Hebrides* for sale in the gift shop at Gough Square) along with the new 'romantic' sense of the author's subject matter as primarily personal and strongly subjective. Is literary tourism 'romantic' (in that it apparently subscribes to the idea that the author is in excess of the text) or 'anti-romantic' (in the sense that it tests the supposed primacy of the imagination and of art)? The second question is whether one of the necessary effects of realist strategies in nineteenth-century narrative, be it biography, poetry or fiction, is tourism – whether once a text purports to describe a mundane and particularised social and physical world it immediately tempts its readers to go and check on its accuracy; or whether, indeed, the habit of literary tourism (and most of the major writers I deal with were inveterate literary tourists and

tour-guides themselves) actually produces realism, as writers begin to produce a kind of fiction which anticipates just this set of readerly and touristic strategies. The third is the question of how far literary tourism emerged as a side-effect of cultural nationalism, with the emerging national literary canon seized upon in order to effect a sort of interiorised national mapping, a national mapping eventually to be consumed both within and beyond the British Isles. Certainly the practice of literary pilgrimage has allowed travellers to make themselves imaginatively at home across the nation through the medium of literature: as the preface to the Doone-Land edition of *Lorna Doone* put it in 1908: 'The British Isles are a glorious heritage, to which Britons were strangers until Scott, Dickens, Blackmore, and others gave to certain parts a new and delightful population. The Southron penetrated the Highlands as a lonely wanderer until Rob Roy, Roderick Dhu, Dugald Dalgetty, and Ellen of the Isle were given him for companions . . .'[13] (As this remark would suggest, Walter Scott was the first British writer around whose works a national literary map was constructed, and he is hence of central importance in the study which follows). One of the prime effects of literary tourism was this expansion of personal intellectual property within a national landscape – having read the classics and visited the 'homes and haunts', a reader's grip upon national and Anglophone culture is extended, and so it is not surprising nowadays, for example, to find generic postcards of 'Scotland' or 'Great Britain' on sale at the respective souvenir shops at Abbotsford and at Stratford-upon-Avon. The sense of holding affective property in the nation via texts is still an important element in literary tourism: as Melvyn Bragg writes in his 'Foreword' to *Writers and Their Houses* (1993): 'Here the addresses are given; the rooms are prepared; the keys are handed over. They are all yours, these homes, as useful a part of our heritage as palaces and manor houses, and often much more interesting because of the presence of someone you already know.'[14] Another effect, however, which I have already touched upon, is the making of England and indeed Scotland as 'literary' and fictive – the consequence being for nineteenth-century American readers that it is debateable whether England and Scotland are the supplements which expose the incompleteness of English literature, or whether it is actually the other way round, so textualised are both.

The book which follows is organised into two inter-related halves. The first deals with touristic efforts to locate the author, and the second with efforts to locate the fictive text. Within these halves, the chapters are arranged in broadly chronological fashion, each organised as a case-study around the first emergence of a particular type of site of literary

pilgrimage. The spine of the whole lays out a story of how the eigh-teenth century's interest in poetic graves was extended in nineteenth-century culture to a fascination with, in turn, birthplaces, 'homes and haunts', and eventually the settings, real and fantastic, of fiction. The thrust of the argument is to identify on the one hand the ways in which texts solicit readers to locate and re-experience them within the speci-ficities of place, and, on the other, how place has come to be designed to accrete and secrete 'memories' of writer and of works. I begin with the story of the making of poets' graves from the centralised national pantheon of Poets' Corner to the romantically located loneliness of the graves of Gray, Keats and Shelley. From there, counter-intuitively, I move to the development of the concept and actuality of bardic 'birth-places', most especially at Stratford and at Alloway, considering them as expressions of the same urge to root the national bard in the land. Thereafter, I move to a consideration of writers' houses, newly displayed as workshops of genius. I discuss Abbotsford as the first ever writer's house to be consciously developed and opened to the public as the production-line of a national author, and then contrast its masculine triumphalism with the determined dysphoric regionalism of Haworth as a gothic description in bricks, mortar and landscape of Victorian female authorship. I consider both as determined by and determining the emergent genre of literary essays on the 'homes and haunts' of writ-ers. The second half of the book is concerned with a different form of tourist impulse – the desire, arising from realist narrative strategies, to disavow the author as the source of fiction, and to 'find' fictional char-acters naturalised within real landscape settings. I turn back in time to trace the development of English tourist interest in the environs of Lake Geneva as the setting for Rousseau's novel *La Nouvelle Helöise* (1761), identifying it as the precondition for the tourism of Loch Katrine inspired by Walter Scott's bestselling narrative poem, *The Lady of the Lake* (1810). The chapter concludes with some analysis of how R.D. Blackmore's romanticisation of Exmoor in *Lorna Doone* (1869) brought tourists to the region and yet disappointed them by accidentally forcing them to acknowledge the author's creatively irresponsible transcription of the region's actual topography into an unavailable landscape of romance. The final chapter moves from considering tourist terrains associated with single texts to consider the formation of literary coun-tries, taking as its core case-study the construction of 'Hardy's Wessex' because it is a terrain both unique and representative of the problem of literary geography in being at once almost entirely mappable onto real topography and yet, through being comprehensively re-named, so

resolutely and completely a 'dream-country'. My epilogue deals with an impulse that first manifests itself as early as the 1870s, an impulse to ground the dream-place within the real, to locate the rabbit-hole by which you could enter Wonderland, or the window in the air by which you could reach Lyra's Oxford. These then, are the last and most extreme instances of works and readerships dedicated to reifying marginal, exotic, perishable or downright lost landscapes. With them, I arrive at the limit-case of the desire to grapple place to text as a mode of reading.

None of these chapters, I should stress, is exhaustive – and nor for that matter is this study as a whole. The subject, so tempting in prospect as a picturesque byway, has turned out to lead into a vast uncharted terrain. I do not have enough space here to discuss, or even to mention, all the texts I have read in the course of researching this book, and nor, perhaps, would any of my readers want me to. A very large number of the books I have consulted in the Bodleian and elsewhere were virgin territory, their pages, pathetically, uncut and unread. Nor do I describe every feature of interest of those texts which I do consider, confining myself to some of what is new, telling and distinctive about them. Most glaringly, I do not attempt to deal comprehensively with the history of all writers' monuments, graves, birthplaces, houses or settings as they would appear in a literary gazette of the British Isles: such a task would not only be impossibly enormous but unhelpful, obscuring as it would do the story of the genesis of certain types of literary tourism. Instead, I have restricted myself to identifying emergent models of literary tourism, writing about those sites on which were inaugurated new forms of tourism and touristic emotion, forms that are then often back-dated, hybridised with other models, and read across to other sites. Where space has permitted I have occasionally indicated something of the subsequent history of these formations; thus the celebration of Scott's writing-desk and empty writing chair may be said to be the parent of the fetishisation of most if not all male writers' desks, governing the framing and presentation not only of Kipling's desk at his home in Bateman's in Sussex, Shaw's on show at Shaw's Corner, and Hardy's in the Dorset County Museum, but even the fictitious desk at which an effigy of Shakespeare is displayed writing busily that features in the Birthplace entry-display in Stratford. Nonetheless, despite the constraints of space, the book provides as broad and various a survey as it can of the particular modes of literary pilgrimage it discusses; and its value lies, I hope, in just this element of broad and symptomatic survey. In bringing what research has been

done around individual authors' posthumous relations with place into fruitful conjunction, and augmenting it with large-scale and methodical new research, this book aspires to offer the first connected narrative of the inception and development of a cultural phenomenon with which we are still living.

Finally, although in this book I take a dissecting scalpel to a whole category of literary emotions and practices, I should make it clear that I do not myself disavow these emotional investments. It has proved impossible and even undesirable to be entirely clinical and cold-hearted about the fluctuating and inadmissible thrills of literary tourism. Perhaps it is a measure of how uncharted and unexamined this investment is that it is hard to write analytically about it without sounding by turns either sentimental or sarcastic, credulous or incredulous. It is difficult to suppress a tremor of exasperated hauteur on reading Nathaniel Hawthorne's super-bland account of being shown the very pew in which Burns sat and saw the louse on the lady's hat that inspired 'To a Louse', but equally difficult not to be moved by Emily Brontë's writing-desk, or to be charmed by the idea of following the walking-route recently devised to trace the route followed in R.L. Stevenson's *Kidnapped* (1886: let us hope that present-day pedestrians are allowed to travel in a more leisurely fashion than were Stevenson's characters), and I could have cited any number of other examples. The jarring vibration of tone that I am conscious intermittently marks this book – as it does some of the nineteenth-century exercises in evoking literary pilgrimage that it explores – derives from and is native to the real-life, real-time, problematic intensity of the experience of literary pilgrimage from which this book derives its origins as well as its conclusions. For this reason I have allowed myself the occasional excursus in this book into reminiscence of my own exercises in pilgrimage, thereby deliberately breaking the decorums, rhetorical, scholarly and analytic, of academic prose. I do this to mark the borders of mutual embarrassment between the professional and amateur, the analytical and the sentimental, the textual and the autobiographical, the book and the body; the amateur, the sentimental, the autobiographical and the bodily are all normally excluded from academic discourse and yet they are the very origin, stuff and subject of this book. For this book springs from and is about the uncanny frisson that oscillated undecidably between absence and presence as my young daughters ran, clutching Philip Pullman's *The Amber Spyglass* open towards the end for its precious directions, through the side-arch into Oxford's Botanic Gardens to find Lyra's bench, empty except for a tiny posy of flowers left by an admirer. There, and not there,

full and yet vacant, strung between sentiment and scepticism, the elusive pungency of that reading experience in the garden is instigator, subject, and driver of this book.

* * * *

This book has been a lot of fun to research and write, and in retrospect, it has taken a long time to come to maturity, its seeds perhaps lying back many years ago when I acted as tourist guide to literary Oxford to avoid starving as a postgraduate student. I must thank first of all my current institution, the Open University (OU), who have not only allowed me to pursue my interest in literary locality to the extent of foisting it upon OU students in the shape of assorted print material and radio and television programmes made about Jane Austen's Bath, Bovary-land, George Eliot's Rome, the Lac Leman of Rousseau, Byron and Shelley, and du Maurier's 'Manderley', but have been very generous with leave to finish this book, and with money to pay for the pictures to illustrate it. Thanks are due too to the British Academy, who kindly funded most of my travel to literary locations across the British Isles. A number of librarians, custodians and curators have good-temperedly spent a good deal of time showing me their collections and answering questions – among them I should mention Anthony Burton, trustee of the Dickens House Museum, who spent a considerable amount of time guiding me among the collections; Jeanette McWhinnie, who talked to me extensively about the history of tourism to Abbotsford; Aidan Graham of the Shakespeare Birthplace Trust (who showed me, among much else, the Anne Hathaway's Cottage musical box that plays 'English Country Garden'); Rachel Clegg of the National Library of Scotland; Seamus Allan of the Bodleian; Diana Boston and her assistant at the Manor, Hemingford Grey; the custodian of Jane Austen's house in Chawton, and the landlady of the Globe Inn in Dumfries, who allowed me to sit in Burns's chair and proudly showed me the very bed on which he impregnated yet another unfortunate servant-maid. I am most grateful to Frank and Denise Cottrell Boyce for allowing me and my family to camp in their holiday-house while I 'did' Burns (may there be a blue plaque installed there in due course!), while it is hard to resist the vengeful impulse to execrate here the dreadful bed in a b & b on the outskirts of Callender that rendered part of my trip to the Trossachs so hallucinatory. I have been lucky enough to give parts of this work in progress to a series of friendly if slightly startled audiences, variously on Shakespeare at Wycliffe College, Oxford (2005); on Byron at Exeter

College, Oxford (2003); and on Keats at Rewley House, Oxford (2002); to talk in the St Giles' Lecture Series, Oxford, and in the Shakespeare Birthplace Trust education programme in Stratford, and to give early versions of the work on Rousseau and Scott at conferences on 'Tourism and Literature', Harrogate 2004 (where I had the pleasure of meeting and exchanging thoughts on the subject of literary tourism with another enthusiast, Alison Booth),[15] and at the British Association for Romantic Studies in Newcastle in 2005. I have been delighted to be invited not once but twice to be a part of the Shakespeare Birthday Procession, an event which, if any, should inspire meditation upon the nature of literary pilgrimage. Suman Gupta and Delia Da Sousa Correa read early drafts of the material and managed to be tactfully encouraging. Finally, I am much indebted to the anonymous reader for Palgrave Macmillan, whose lengthy, thoughtful, informed and generous critique was most helpful in the early stages of the writing-up of this project.

But my greatest debt is to the friends and family who have faithfully accompanied me both in spirit and in the flesh in the surprisingly arduous and intermittently comic business of dedicated literary tourism. My thanks go to Marilyn Butler for walking Jane Austen's Bath with me; to Cordelia Hall for bearing me company to Milton's cottage at Chalfont St Giles and drawing the fire of the well-meaning but inaccurate and inordinately inquisitive amateur guide; to Kathy Rowe and her enthusiastic family for insisting on being provided with a Philip Pullman tour of Oxford; to my parents Liz and Peter Watson for managing to be interested in Austen's house at Chawton, in Hardy's houses at Upper Bockhampton and Max Gate, and in every place associated with Wordsworth in the Lake District; and to my stoical father-in-law, Derek Dobson, who lent me his large collection of works on Hardy topography (he being an expert in this field) and who got wet through in a freak rain-storm while showing me the smuggler's path featured in *Moonfleet*. My dear children Elizabeth and Rosalind have regularly been obliged to give over part of their school holidays to literary tourism: they have accompanied me, largely uncomplaining and sometimes helpfully fascinated, to Dove Cottage, to Hill Top, to Wild Cat Island, to Abbotsford, to Melrose and Dryburgh Abbeys, to the Scott Monument and the Writers' Museum in Edinburgh, to Alloway, Dumfries, and all Burns plaques in between, to Haworth Parsonage and up to Top Withens in the snow on the shortest day of the year, to Alice's Treacle Well and Lyra's Bench, to 221b Baker Street, to Pope's birthplace on Lombard Street and Keats's at Moorgate, to Poets' Corner and to Platform 9¾, to Green Knowe and what can be found of Narnia, on adventures

to find both Pooh's and Puck's bridges, and to picnic on the beach below 'Manderley'. But my greatest debt, as ever, is to my colleague and husband Michael Dobson. However alienating literary tourism may constitutively be, I have never been alone as we walked in Coleridge's tracks on the Quantocks, visited Sterne's house in Coxwold and Goethe's and Schiller's *wohnhausen* in Weimar, Voltaire's house in Ferney and Byron's houses at Cologny and Newstead; traced John Ridd up the water-slide into the Doone Valley, and followed him over the shoulder of the hill and down to his wedding in Oare Church, verified the Mohun arms in Moonfleet Church, and experimented with the echoes in the defile of the Trossachs; were soaked to the skin finding Rob Roy's cave on Loch Lomond and identifying the cliff in Yorkshire down which Tom of *The Water Babies* climbed; explored the Keats–Shelley museum in Rome and the Keats house in Hampstead; and hunted out the Shakespeare and Chaucer plaques in deepest Southwark. Without his endless encouragement, our many long conversations over innumerable bottles of wine provided by him, his ruthlessly searching questions, and his sternly efficient editorial aid in preparing the manuscript for submission, this book would never have been finished on time. To him and to our daughters, therefore, this book is most lovingly dedicated, on the strict condition that they continue to agree to accompany me on these pleasantly enriching and deliciously futile investigations for some few years to come.

Nicola J. Watson
Upper Wolvercote
April 2006

Part I
Placing the Author

1
An Anthology of Corpses

I Poets cornered

Any literary tourist in Britain begins, in imagination at least, at Poets' Corner in Westminster Abbey. Deep in the heart of the metropolis, close beside the tombs of saints and kings, this is the national literary canon sculptured in stone for the benefit of posterity, an architecture of national literary consciousness, the first and still the most comprehensive attraction for the pilgrim with literary leanings. Although it is so famous it really is only an out-of-the-way corner cramped up on the outskirts of the vast royal, aristocratic and ecclesiastical grandeur of the Abbey, in which the individual monuments are so squashed together that you cannot help noticing that poets in death, as in life, are generally forced to travel economy class. There are some 120 writers, poets, actors, musicians and artists buried or memorialised here. The place is jammed with pale marbles like solidified ghosts, and with busts and plaques clinging and crowding like nesting seabirds twenty feet above. The assemblage gives the impression of some fantastic literary party worthy of the imagination of a Walter Savage Landor, in which you should be able to recognise everyone on sight, or at least to recognise the name when they are introduced, although nowadays few other than academics will know or even wish to know who were, say, William Mason, Thomas Campbell, or Matthew Prior (leaseholder of the biggest tomb in the place). But even the generally unrecognised are all clearly insiders, and that goes for even shameless gatecrashers like Longfellow, whose bust 'was placed amongst the memorials of the poets of England by the English admirers of an American poet' in 1884.

The guests at this literary salon boast very variable levels of personal presence as they jostle for the best position (nearest the statue of

Shakespeare, on the whole). Some, like Shakespeare, come full-length, life-size and well-captioned, others, like Tennyson, have been unkindly chopped off at the shoulders, still others, like Jonson, Keats and Shelley, come as flattened bas-relief profiles, while others still are reduced to meagre inscriptions in stone or in the glass of the windows. Some are still writing in defiance of death; Ernst Grabe, the seventeenth-century oriental scholar, is casually seated on his sarcophagus, dashing off a few notes as though he could not get into his coffin until he had met his last publisher's deadline. Shakespeare's statue suggests that he is showing off a favourite passage from *The Tempest* by giving a ponderous lecture about it, though the quotation at which he points has been grievously mis-transcribed. Some unexpectedly peer down from the memorial-encrusted walls above, like that consummate show-off David Garrick, flirtatiously sweeping aside his expensively tasselled stone curtains. There are writers urbane, upright and holding forth like Thomas Campbell, and writers seated in noble meditation like Wordsworth. Some are dressed with disconcerting realism in the costume of their day, some with picturesque historical inaccuracy, some (especially Poets Laureate) favour instead the severely ahistorical and chilly emblematic classicism of togas and laurel-wreaths. Milton is puritanically modern, Shakespeare anachronistically cavalier, Thomson grandly Roman. Sometimes the pervasive effect of inter-writer animation is deliberate, as in the way that Thomas Gray's P.A.-like Lyric Muse points up towards Milton, so connecting the two writers;[1] sometimes it has unintentionally comic side-effects, such as Sir Walter Scott's apparently sardonic benignity as he gazes at the voluptuous bottom of the personified 'History' who is for some reason shoving off the ignoble multitudes from clambering over the Duke of Argyll's immense tomb next door. Altogether less animated are those writers gift-wrapped in plain boxes like Chaucer and Spenser, or apparently potted up like Abraham Cowley into handsome urns swathed with sashes. Yet even those writers who do not appear highly realised in statue, bust or portrait medallion form often make personal and self-dramatising remarks to the visitor, in the shape of inscriptions. Gay's epitaph, composed by the author himself, 'Life is a jest; and all things show it: / I thought so once, but now I know it', is a worthy ancestor of the exit-lines (or are they posthumous chat-up lines?) littered across the more modern floor-stones. The severe discretion of Dickens's stone, marked by his wish only with his name and dates of birth and death, is not echoed in the stones that surround him, eagerly supplied by the writers' executors with posthumously selected quotations: 'Is all our life, then, but a dream?' (Carroll); 'Now I stretch

out my hand/and from the further shore I bid adieu to all who have cared to read any among the many words that I have written' (Trollope); 'My subject is war and the pity of war' (as the First World War poets chant in unison); 'Time held me green and dying/Though I sang in my chains like the sea' (Dylan Thomas). Isaak Walton gets in just as a cheeky monogram scratched with the date, 1658, on a handy tomb. Well might an early guidebook to the Abbey suggest that here both Unlearned and Learned might 'converse with the Monuments of the Dead,' though neither Unlearned nor Learned would be likely to get a word in edgeways.[2] Well might T. S. Eliot's slab remark that 'the communication of the dead is tongued with fire beyond the language of the living.' The total effort and effect of both statuary and inscription is to reanimate the dead and to make them speak to the living.

The disconcertingly miscellaneous, noisy, even incoherent effect of Poets' Corner that I have been evoking is only in part the result of historical changes in styles of funerary sculpture, from the Renaissance tombs of Chaucer and Spenser, to the early eighteenth-century classical bust of Milton which combines portraiture with emblems designed to epitomise poetic inspiration in general (an urn of divine fire) and *Paradise Lost* in particular (a lyre wreathed with a serpent), to the bourgeois realism of Scheemaker's full-length statue of Shakespeare (elbow propped on a pile of leather-bound books), to twentieth-century slate floor-stones which insist by contrast upon the author as pure textuality through inscription and appropriate incised emblems (D. H. Lawrence's is a phoenix, for example). And it is only in part the result of simply running out of space, which is the reason adduced by the current guidebook for the very recent appearance of the names of Pope, Wilde, Marlowe, Herrick, Housman, and Burney in the modern window-glass above Chaucer's tomb. It has much more to do with the ad hoc history of the place itself. Chaucer's tomb has been the heart of Poets' Corner since his remains were moved by admirers to a new tomb in 1556, some one hundred and fifty odd years after his death and original burial in the Abbey in 1400 as a good civil servant: appropriately, it is the presence of this creator of literary pilgrims which resulted in the Abbey becoming the destination of so many others over the ensuing centuries.[3] The location of this tomb was explicitly the reason for burying 'the prince of poets' Edmund Spenser nearby in early 1599, as his Latin epitaph points out. But two canonical dead English poets did not by themselves make a Poets' Corner, even bulked up with Francis Beaumont in 1616, and the laurelled bust of Michael Drayton in 1631, both pointedly squeezed in next to Chaucer, and Abraham Cowley,

John Denham and Sir William Davenant in the late 1660s. (Despite his subsequent memorial beside Spenser's, Ben Jonson's actual grave, captioned 'O Rare Ben Johnson', is located in the nave: it is curiously small, since Jonson managed to economise on space by arranging to have himself buried standing up). And considered as a national literary pantheon, a reference-guide, even an anthology, of the English (latterly Anglophone) classics in corpse form, Poets' Corner has always been full of notable absences and indeed, unwanted presences. Nathaniel Hawthorne wrote of his visit to Poets' Corner in 1855 that 'even their own special Corner contains some whom one does not care to meet',[4] referring presumably not merely to the mediocre or the downright unfamous, but also to the riff-raff of actors, artists and musicians that have mingled in the throng, and perhaps also to the undoubtedly respectable John Roberts, 'secretary to Henry Pelham under George II', who somehow snaffled the spot directly above Chaucer. Even among the *bona fide* writers buried in the Abbey, some have been felt to be beneath inclusion in the Corner and some above: the first major professional woman writer in English, Aphra Behn, is very nearby but still pointedly excluded, confined to the cloister outside, while her contemporary Margaret Cavendish, Duchess of Newcastle, is buried as an aristocrat rather than as a writer, keeping her husband company on the opposite side of the nave. Another Restoration literary figure is instead buried as an aristocrat's favourite: William Congreve also cut the company in Poets' Corner, lying elsewhere in the nave under a grandly expensive heap of marble masks paid for by his smitten patroness the Duchess of Marlborough in 1728.

In fact, Poets' Corner is something of a retrospective formulation, deriving from the newly nationalist impulses of early eighteenth-century culture which itself contributed to the growing popularity of the Abbey as a tourist attraction. Literary worthies were to be gathered here to represent British culture, and the site around Chaucer's grave now began to develop into a national compendium of the greats, an area of the building where writers could receive public honour as servants of the nation no less worthy in their way than soldiers or statesmen. One of the immediate and longstanding effects of this ambition to make the Corner represent the entire national canon was that, as Joseph Addison put it in 1711, the 'poetical quarter' was full of anomalies, featuring 'Poets who had no Monuments, and Monuments which had no Poets.' By this he not only meant the scatter of non-poets, but was referring to the beginnings of the Abbey's odd mix of graves without elaborate memorials, and elaborate memorials without corresponding graves.[5] The otherwise unprecedented practice of memorialising the poet *in*

absentia was inaugurated with the memorial put up in the early 1700s by the son of Thomas Shadwell, Poet Laureate in the reign of William and Mary, who was actually buried in Chelsea in 1692. This memorial, the product of an unstable combination of familial and literary piety, inaugurated a new establishment practice not merely of encouraging the burial of recently dead poets (such as Nicholas Rowe, Matthew Prior, John Gay and James Macpherson) in the Abbey, but the memorialisation of the recently and not-so-recently dead. Thus, John Philips is buried in Hereford Cathedral, but his monument, which records that he was 'second to Milton', was set up in Westminster in the early 1700s; similarly, James Thomson (d. 1748) is actually buried in Richmond, Gray (d. 1771), as we will see later in this chapter, in Stoke Poges, Goldsmith (d. 1774) in Temple Church, and William Mason (d. 1797) in Aston, but they are all provided with contemporary memorials in the Abbey. Thanks to the good offices of Alexander Pope, a bust of John Dryden was put up in 1720, twenty years after his death (replaced in 1731 with something grander), and the statue of Shakespeare, a belated rival to his actual tomb and portrait bust in Stratford, was commissioned in 1740.[6] Other benefactors included the Earl of Oxford, who put up a bas-relief of Jonson in 1723, William Benson, who prodded the authorities into providing space for a bust of Milton by Rysbrack in 1737 (despite the poet's radical dissenting beliefs and complicity in regicide), and John Barber, who organised and financed a monument to Samuel Butler in 1721. Spenser's monument was thoroughly restored in 1778, and Addison was commemorated only in 1808, just under a hundred years after his death.[7] Thanks to this flurry of activity, by 1733 Addison's 'poetical quarter' was now known as 'Poets' Corner' and was having grand claims made for it:

> Hail, sacred Reliques of the tuneful Train!
> Here ever honour'd, ever lov'd remain.
> No other Dust of the once Great or Wise,
> As each beneath the hallow'd Pavement lies,
> To this old Dome a juster Rev'rence brings . . .[8]

By the 1760s Oliver Goldsmith was referring to the aisles as 'Poets' Corner' in his *Citizen of the World*; his Chinese protagonist visits it as an established tourist attraction, not merely as one corner of a rather grand church, but as a site celebrating the national literature.[9]

Yet there remained many discomforts in melding the sacred and the secular within the same site, even in the service of the 'literary pilgrimage'

which, as the term suggests and as many scholars have demonstrated, took over many of the rituals and emotional investment of the practice of older Catholic pilgrimage.[10] A writer was likely to be insufficiently 'national' if Roman Catholic (although Dryden got in, Hopkins has only just managed to squeeze onto a window with him), atheist (Shelley and George Eliot), or downright scandalous (Byron's friends were refused permission to bury him in the Abbey because of his transgressive life and views, and after many representations his plaque in Westminster was only finally put up in that permissive year 1969; Wilkie Collins was similarly turned away on the grounds of irregularities in his private life, notably two mistresses and a scatter of illegitimate children). This practice of exclusion only accentuated the site's slightly unsettling mix of memorials with actual graves.

On the whole, however, eighteenth-century visitors seem to have been little troubled by the problem of what, exactly, they were remembering at the Abbey; it seemed to be immaterial (literally) whether what was being remembered was the body of the author or his books – the two corpuses were not apparently in a problematic relation with each other. The eighteenth-century visitor to the Abbey was above all engaged in a public act of grateful homage to the heroes – whether politicians, warriors or poets – who had made Albion great. This act was very much in the spirit (at the top end of the market) of the Temple of British Worthies at Stowe (erected in 1735, which itself included busts of Shakespeare, Milton and Pope, among other national heroes), or (a bit further down the social scale) the practice of buying reproduction busts with which to embellish private libraries.[11] The clumsy elision of the celebration of 'the name' of the poet, the location of his actual remains, and the memorial sculpture in John Dart's opening verses entitled 'Briton's Bards' to his antiquarian catalogue of the Abbey, *Westmonasterium* (1742), suggests as much:

> The Poet's Name can strike a Pale around,
> And where he rests he consecrates the Ground,
> Can from rude Hands the sculptur'd Marble save,
> And spread a sacred Influence round the Grave.[12]

In 1784 the Revd Thomas Maurice was able to write in his *Westminster Abbey: An Elegaic Poem* of his pleasure in falling prostrate upon 'the hallow'd ground / Where Britain's laurell'd progeny repose', also effectively suggesting that a few dead poets might stand (in the impoverished Jonson's case, literally) for all.[13] But this model would begin to

decay towards the end of the century. The anonymous poet who wrote in 1793 that 'Departed genius here exults to find / How little mortal he has left behind' was behind the times, for homage to the *idea* of the poets who together had made a national literature was to be superseded by a different model of tourism, one that would emphasise a personal, sentimental relation between the physical remains of the poet and the literary pilgrim.[14] Although the concept of marking public gratitude to a writer persisted within the Abbey, the culture became far more invested in founding statements of public gratitude upon actual corpses, both within the Abbey and outside it.

Papering-over the epistemological difference between memorial and remains was very much a nineteenth-century concern. The relation between authorial body, text, memorial and literary tourist would become highly charged from about the 1780s throughout the nineteenth century, and the question of where those mortal remains were left behind was to become altogether more pressing. By Victorian times, there was much more pressure to collect the real thing than there had been in the eighteenth century. In 1847 a writer on the 'literary and historical memorials of London' wrote deploring the potential sentimental charlatanism of Poets' Corner: 'That Poets' Corner should have been selected to hold the memorials of these celebrated men, is in a great degree to be regretted, inasmuch as we are apt to misplace our sentiment by imagining that we are standing on the dust of departed genius, whereas we are only gazing on their cenotaphs.'[15] The Dean of Westminster, Arthur Penrhyn Stanley, writing the history of the Abbey in 1868, also lamented 'how extremely unequal and uncertain is the commemoration, or absence of commemoration, of our famous men. It is this which . . . makes the Abbey, after all, but an imperfect monument of greatness.'[16] Symptomatically, he involves himself in speculation in order to recruit the embarrassingly absent Shakespeare, or if not Shakespeare, then at least, rather absurdly, his pen:

> [Spenser's] hearse was attended by poets, and mournful elegies and poems, with the pens that wrote them, were thrown into his tomb. What a funeral was that at which Beaumont, Fletcher, Jonson, and, in all probability, Shakespeare attended! – what a grave in which the pen of Shakespeare may be mouldering away![17]

If the absence of Shakespeare was thoroughly unsatisfactory, so too were the various absences of Gray, Wordsworth, Southey, Burns and Scott, though the Dean comforts himself with a conceit of the spiritual

extension across the national map of the idea of the Abbey: '[E]ven London is, or ought to be insignificant compared with England; Those quiet graves far away are the Poets' Corners of a yet vaster temple; or may we put it yet another way, and say that Stratford-upon-Avon and Dryburgh and Stoke Pogis and Grasmere, are chapels-of-ease united by invisible cloisters with Westminster Abbey itself?'[18] In this formulation, Shakespeare's grave, Thomas Gray's grave, William Wordsworth's grave and, more surprisingly, Sir Walter Scott's grave are especially 'English' *because* of their physical distance from the national pantheon. (The Dean, however, does not include Burns in this list of far-flung 'English' sites; indeed, the memorial to Burns must be the least convincing of all in Poets' Corner, and that is because, as my next chapter shows, he is so explicitly the national poet of Scotland.) I shall be dealing with the way the localised 'Englishness' of these sites – together with that of the yet further-flung graves of Keats and Shelley in Rome – undid the centrality of the Abbey as the site upon which writers were commemorated in the second part of this chapter and in Chapter 3. In line with the impulse behind the Dean's cleverly inclusive conceit, as Samantha Matthews has shown, late Victorian writers were disproportionately represented amongst the Abbey's interments because there was great insistence, often in express contradiction of the wishes of the late writer and of his relatives, on shipping adequately respectable poetic corpses up from the provinces to the national literary mausoleum, in a process of more or less compulsory annexation of the bodies of the great for the nation.[19] The Victorian and Edwardian establishment laboured mightily to make a corner in the commodity that was poets. Thomas Hardy became the victim of the most darkly comic version of this passion for authenticating memorial with actual remains; his heart eventually remained in Stinsford Churchyard in deference to his known wishes, and consonant with his status as a regional novelist; but his ashes were compulsorily installed in the Abbey. He has the dubious honour of being one of the only two poets who are buried in two places (the other is Shelley, whose ashes are buried in the Protestant Cemetery at Rome, and whose heart was returned to his grieving widow, and is now buried in Percy Florence's grave in Bournemouth alongside her), and the only one whose dismemberment was a matter of national pride. His double burial was necessitated by the Abbey's increasingly coercive claims to be a site upon which acts of official cultural remembrance were staged as well as a site upon which individual readers could repeat this act of remembrance.

Such coercion was rendered necessary by the increasing tendency of nineteenth-century culture to turn away from the very idea of a

pantheon realised within the Abbey. For, despite the official grandeur of the Abbey and its aggressive policy of securing poetical remains, the nineteenth-century literary tourist increasingly found the experience of visiting Poets' Corner sentimentally inadequate, indeed, not entirely 'poetic'. This sense of inauthenticity was variously compounded of a sense that Westminster's official grandeur was overblown or inappropriate to individual writers; of a feeling that the site was too public, too crowded, too comprehensive to foster the reverent intimacies of sentimental pilgrimage; and, above all, of a growing desire to locate the author within a place or places conceived of as organically connected both to the physical person and to the literary corpus. It is possible to calibrate something of this shift in sentiment by comparing Ben Jonson's remarks in his dedicatory poem to the First Folio (1623) on Shakespeare's burial far from Westminster Abbey with Washington Irving's remarks two hundred years later, in his best-selling travel memoir, *The Sketch Book* (1820). Elsewhere in the Folio, William Basse's elegy 'On the Death of William Shakespeare' developed the conceit of fitting Shakespeare into the Abbey's poetic pantheon, at least in imagination: 'Renownèd Spenser, lie a thought more nigh / To learnèd Chaucer; and rare Beaumont, lie / A little nearer Spenser, to make room / For Shakespeare in your threefold, fourfold tomb.'[20] Replying, Jonson excuses Shakespeare's absence from the Abbey by regarding a 'tomb' as an inappropriate memorial – Shakespeare's real memorial is his work:

> My Shakespeare, rise. I will not lodge thee by
> Chaucer or Spenser, or bid Beaumont lie
> A little further to make thee a room.
> Thou art a monument without a tomb,
> And art alive still while thy book doth live[21]

By contrast Washington Irving is fixated upon Shakespeare's tomb, but considers it more appropriately located in Stratford-upon-Avon than it ever could have been in Westminster. Writing of his visit to Shakespeare's grave in Holy Trinity Church in 1820 he remarked:

> What honour could his name have derived from being mingled in dusty companionship with the epitaphs and escutcheons, and venal eulogiums of a titled multitude? What would a crowded corner in Westminster Abbey have been, compared with this reverend pile, which seems to stand in beautiful loneliness as his sole mausoleum![22]

The appropriateness of a provincial church as the location of the grave for the national poet seems to reside in its relative lack of snobbery and competition. An early guidebook to Stratford had concurred, noting that Shakespeare's fate was happier than either Milton's or Spenser's, buried in the 'bustle and roar of London', adding that 'No poet, perhaps, rests so happily as Shakspere. This is better than being buried at Westminster Abbey or St Paul's, to lie at peace among your own.'[23] Although it must be admitted that a guidebook to Stratford is hardly disinterested in advocating the superior charms of Holy Trinity over Westminster Abbey, this claim marks the inauguration of a distinctively nineteenth-century sensibility in that it no longer considers Shakespeare's 'own' to be principally his forebears, colleagues and descendants in the national canon, but, rather, his family, friends and neighbours. This is the sensibility that would underlie Hardy's double burial too; for Hardy's body was not merely divided between the rival claims of nation and of dead wife, but was bisected to dramatise his paradoxical nature as a writer – a writer of national and hence metropolitan importance whose work was considered fundamentally provincial. His oeuvre was felt to be rooted so strongly in the metaphorical heart of Wessex that that was where his literal heart should be buried too, even if the rest of his remains demanded inclusion in the pantheon at Poets' Corner. The pursuit of a supposed organic connection between writer and place would lead nineteenth-century literary tourists to make pilgrimages to graves well beyond Poets' Corner – in fact, the further beyond the better. In so doing, they aimed to refer the writer to a unique authenticity of physical location, to construct a sentimental experience unique to themselves, and to plot writing across the map of the nation.

II Grave matters

> The object of our pilgrimage is to persuade the reader to accompany us to the depositories of the distinguished dead . . . (T. P. Grinsted, 1867)[24]

The practice of visiting poets' graves dates from classical antiquity; Virgil's tomb in Posillipo just outside Naples was reputedly a tourist draw from his death in 19 BC – St Paul was supposed to have wept over his grave. As we have seen, Chaucer's tomb in Westminster Abbey was from at least the 1550s onwards a place charged with meaning. Beyond the Abbey, however, there is little evidence for any widespread practice

in Britain of visiting poets' graves and associated monuments before the mid-eighteenth century. It is conventional to explain this historically specific upsurge of interest in writers' graves by locating it as a practice within a general increase of interest in the mid-eighteenth century in so-called 'necro-tourism' (the practice of visiting graves and graveyards), and by arguing that literary pilgrimage is modelled upon religious pilgrimage, and that with the decline of religious sensibility in the Enlightenment came the secularisation of pilgrimage and the consequent replacement of the saint and his or her holy and healing places with the author and his or her native haunts.[25] It is certainly true that the literary pilgrimage takes over much of the language, protocols and emotional structures of the religious pilgrimage, as Péter Dávidházi has shown.[26] Yet this observation does not in itself explain the desire to visit the physical remains of a writer as a substitute for those of a saint. What miracle, after all, were the mortal remains of a writer supposed to perform that their living books had not?

Jonson's lines to Shakespeare, quoted above – 'Thou art a monument, without a tomb, / And art alive still, while thy book doth live . . .' – suggest that the fetishisation of the poet's body was not yet a cultural commonplace in the seventeenth century, although they point to an already established mental habit of revivifying the poet by directly addressing him. It was the development of the biography of writers as an explanatory supplemental inter-text that began to connect authorial body and text more intimately. Although this can be said to have become classic with Dr Johnson's *Lives of the English Poets* (1779–81), it was operative earlier in the century; certainly it seems to have been Nicholas Rowe's life of Shakespeare, published as part of his edition of the complete plays in 1709, combined with a growing sense of a national literary canon, that stimulated general interest in Shakespeare's grave in Stratford-upon-Avon.[27] Although by 1656 the local antiquarian Sir William Dugdale had thought the stiff, old-fashioned monument of sufficient interest to include an engraving of it in his book *Antiquities of Warwickshire*, and although there are records of a few seventeenth-century travellers directing their inquisitive steps to the chancel of Holy Trinity Church, tourist pressure did not build up until about the 1730s, coinciding neatly with the upsurge of national commemoration at Westminster Abbey that I have already noted.[28] In 1737, for example, the artist and antiquary George Vertue made a visit in the company of the Earl of Oxford, and, in addition to sketching the monument, commissioned a local sculptor to make him a cast to display at home, the first ever souvenir reproduction.[29] He was by no means alone in his

desire to appropriate the piece, for by that time the monument was already in a poor state of repair, thanks to the vandalism of a growing number of relic-hunting tourists, necessitating the first restoration of 1748. Tellingly, that restoration was overtaken in 1793 when Edmond Malone, the age's most influential Shakespeare editor, notoriously persuaded the vicar to paint the coloured bust stone-colour, so as to render it, as he thought, more as it must have been originally.[30] The effect would also, of course, have been to make it more uniform with the eighteenth-century poetic memorials in Westminster Abbey.

The touristic impulse to take relics – whether pieces chipped off the monument, artefacts made from the mulberry tree that Shakespeare was supposed to have planted with his own hands or from the crab-apple tree under which he was supposed to have slept off a drinking-binge, bits of 'Shakespeare's chair', or, a Victorian preference, sprigs of ivy from the churchyard and elsewhere – marks the emergence of a new model of tourism driven by a desire on the part of the tourist to construct a more intimate and exclusive relationship with the writer than is supposed to be available through mere reading. As succinctly visualised in William Allan's 'Sir Walter Scott on the occasion of his visit to Shakespeare's tomb in Holy Trinity Church, Stratford-upon-Avon on 8 April 1828' (cover illustration), a visit to the tomb was the occasion for a dialogue with the dead, a dialogue literalised at its simplest in the practice of scrawling a signature upon the bust, first recorded in 1824 and presumably facilitated by Malone's whitewash, although Isaak Walton's graffito in the Abbey suggests that this practice may have begun much earlier.[31] At its extreme, instituting this dialogue could involve plundering the grave for physical relics; although Shakespeare's grave has remained intact (at least in modern times – scholars have speculated about the odd shortness of the gravestone in the church floor), the same is not true of, for example, the graves of Milton, Sterne and Burns. When Milton's body was exhumed at St Giles's, Cripplegate preparatory to being moved in 1790, there was a disgraceful scramble for teeth, bones and hair, which the verger sold ('Ill fare the hands that heaved the stones, where Milton's ashes lay! / That trembled not to grasp his bones, and steal his dust away!', wrote a horrified William Cowper in 'On the late indecent liberties taken with the remains of Milton'). Many of these relics were bought back to be returned to the grave, but some may well have wound up on display in the cottage dedicated to Milton's memory in Chalfont St Giles, and a lock of the hair dispersed on this sacrilegious occasion may very well have later inspired Keats's sonnet on the subject. As is well-known,

Laurence Sterne's body was stolen after burial in 1768, and only escaped dissection at the last minute through being recognised on the slab by the surgeon; it is unclear, however, whether his body was stolen to order as a literary curiosity of interest to the medical profession. Certainly Burns's body, which has been dug up no fewer than three times, on two of which the skull was removed for some days to the local doctor's house, has been intensively interrogated on the slimmest of pretexts.[32]

It is possible to date this desire to converse with dead poets and writers with some precision. Although, as the fame of Thomas Gray's *Elegy Written in a Country Churchyard* shows, the culture as a whole was hospitable to the idea of meditating upon the tombs of the dead from at least the second half of the eighteenth century, the conceit of actually holding converse with the dead seems to date only from around 1800. It is expressed forcefully by William Godwin in his *Essay on Sepulchres* (1809), in which he proposes 'Erecting Some Memorial of the Illustrious Dead in all Ages on the Spot where their Remains have been interred.' Godwin remarks that he was inspired by a visit to Westminster, not only by a sense of unwarranted absences and presences, but by the universal neglect of its monuments, and by his meditations upon the prevalent practice of erasing memorials in country churchyards. His rationale for marking the graves of the great is to encourage the practice of visiting them, arguing that such memorial practice will enlarge the general national psyche, releasing it from everyday materialism into a more progressive spirituality and 'strong imagination':

Inestimable benefit will . . . flow, from the habit of seeing with the intellectual eye things not visible to the eye of sense, and our attaining the craft and mystery, by which we may, spiritually, each in his several sphere,

Compel the earth and ocean to give up
Their dead alive.[33]

Godwin argues that the material worthlessness of the dead body, viewed rationally, is over-ridden by two considerations – a sense of mourning like that felt by one friend for another, which demands that the dead be located, and a sense that at these graves the historical event is, uniquely, still acting, still contemporary: 'the dust that is covered by his tomb, is simply and literally *the great man himself*.'[34] Indeed, the grave is not merely a grave, it is a home, indeed, more

than that, it is a place to which all comers are invited to the poet's 'at home':

> Let us visit their tombs; let us indulge all the reality we can now have, of a sort of conference with these men, by repairing to the scene which, as far as they are at all on earth, *they still inhabit*.[35]

Dropping in upon the dead, compelling them to have a quick chat, these are desires that drive Godwin's prose: imagining visiting Milton's grave (or rather, the place 'where *he now dwells*') he all but literalises the euphemism of 'the last home' or 'last resting-place' or 'last dwelling-place' – the bonus is that 'Some spirit shall escape his ashes, and whisper to me things unfelt before', that it will be possible to 'call his ghost from the tomb to commune with me, and to satisfy the ardour of my love.'[36]

The Essay on Sepulchres had a lukewarm, even a bemused reception; amongst the reasons for this was the *outré* quality of the proposal, which even the sympathetic *Monthly Review* considered overly 'sentimental' and 'romantic'.[37] They might also have echoed Hotspur's sardonic comment on Glendower's professed practice of calling spirits 'from the vasty deep', 'But will they come when you do call for them?' (*1 Henry IV*, 3.1.53). Yet Godwin's essay was to prove prophetic; it recommends the compilation of both an 'atlas' and a 'catalogue' of important graves as a form of security against catastrophes of war (very pertinent at a time of anxiety over Napoleonic invasion), noting also that such would be 'precious' to the man of sentiment, 'and prove to be a Traveller's Guide, of a very different measure of utility, from the 'Catalogue of Gentlemen's Seats,' which is now appended to the 'Book of Post-Roads through Every Part of Great Britain.'' It would be around 150 years before *The Oxford Literary Guide to the British Isles*, combining maps and gazette, and indexing authors to place, would precisely fulfil Godwin's ambition.[38]

Godwin's insistence upon the idea of converse with the dead writer as friend, too, was prescient. Only ten years later, this impulse towards grounding the experience of reading within an unmediated one-to-one spiritual telephone-call with the dead poet was most famously described by Washington Irving, whose meditations on the subject were to become commonplaces for the rest of the nineteenth century. Writing about his visit to Poets' Corner in his *Sketch Book* (1820), for example, Irving considered its superior attractions to other tombs in the Abbey, noting that visitors were actuated by a sense of personal intimacy with

the writer rendered possible by reading, akin to the rituals of private mourning:

> Notwithstanding the simplicity of these memorials, I have always observed that the visitors to the abbey remain longest about them. A kinder and fonder feeling takes place of that cold curiosity or vague admiration with which they gaze on the splendid monuments of the great and the heroic. They linger about these as about the tombs of friends and companions; for indeed there is something of companionship between the author and reader. Other men are known to posterity only through the medium of history, which is constantly growing faint and obscure: but the intercourse between the author and his fellow-men is ever new, active, and immediate.[39]

The necro-touristic impulse is to set up not merely a personal relationship but a physical relationship, as Irving's remarks on visiting Shakespeare's tomb suggest: 'I trod the sounding pavement, there was something intense and thrilling in the idea, that, in very truth, the remains of Shakespeare were mouldering beneath my feet. It was a long time before I could prevail upon myself to leave the place . . .'[40] Although, as I show below, the sentimental protocols of grave-visiting change over time, this impulse towards a physical, exclusive relationship remains a constant.

Almost entirely missing from the accounts of grave-visiting provided by both Godwin and Irving, however, are the texts through which they as readers came to be intimate with the author in the first place. Godwin mentions only briefly that the effect of immortality in the case of writers depends upon writing and reading: 'They are not dead. They are still with us in their stories, in their words, in their writings.'[41] Irving vanishes the act of reading into 'intercourse', far closer to their joint ideal of 'converse.' Indeed, this elision is symptomatic and constitutive of the practice of grave-visiting. To visit the grave is to supplement and secure print-culture – as Godwin remarks: 'I regard the place of [the poet's] burial as one part of his biography, without which all other records and remains are left in a maimed and imperfect state.'[42] Indeed, one might say that the practice of grave-visiting arises precisely at the moment of general anxiety around print-culture, an anxiety which has been to date largely discussed in terms of the romantic author's anxiety over the alienation and degradation of his mass-audience, but which also, by contagion, infected the romantic reader, who similarly became anxious over the alienation of the author, and the promiscuity of the

text.[43] With the rise of romantic poetics the body of the author became newly charged as a site of both origin and excess to the text; conversely the portability and multiplicity of the published book seems to have induced a desire to authenticate the reading experience in a more 'personal' way, to reinforce an incompletely intimate reading experience. Grave-visiting is imagined as a way of by-passing the text in favour of a more perfect dialogue with the dead author. The grave, therefore, secures the personal relation between romantic author and romantic reader, otherwise threatened by mass-literacy and mass-readership, and this is why books – as such – are rarely mentioned in these early evocations of grave-visiting.

At first glance, indeed, the grave of an author could be considered anti-book in the extreme. Whereas a book is by definition mass-produced for mass-circulation (if the author is lucky), the grave by definition is unique and non-portable. (This non-portability does not extend to the body itself, or indeed to the monument, as we will see below, yet ideologically the grave is supposed to be located rather than mobile.) While the text of a book is printed, the text of a tomb is inscribed and engraven. One is impersonal and promiscuous, the other personalised and faithfully authorised. The writing on a tomb is thus more definitely 'voiced' than even the most autobiographically voiced piece of print. I consider grave-visiting practices at more length below, but it is perhaps worth noting here that the educational habit of memorisation combined with the desire for 'converse' to develop a practice of reciting aloud or internally from the author's works upon the spot, so ventriloquising 'whispers' from the ashes, or so Hardy's strangely autobiographical-sounding account of the visit of Ethelberta reciting *Paradise Lost* over Milton's tomb in St Giles's, Cripplegate would suggest.[44] Yet although the grave appears antithetical to print, and sometimes even claims to be so via its inscription (as we will see, Keats's epitaph remarks despairingly that his name has been 'writ on water'), it has been the printed text that has typically determined the meaning of poets' graves, sometimes even before the headstone has been purchased.

That said, not all graves 'mean' the same, or as much. This is because in the mythos of many poets death is essentially incidental, while in others it is constitutive. The death of, say, William Blake is not critical to the popular apprehension of him as a poet, and so his grave in Bunhill Fields is not a particular draw. On the other hand, the deaths of Keats and Shelley found the idea of the romantic poet dying young and unrecognised, in exile, and so their graves are shrines. The deaths – and therefore graves – of the three Brontë sisters, and more recently of Sylvia

Plath, have become iconic of the fate of the woman writer. In yet other cases it is the siting of the grave and its mode as memorial which is powerfully iconographical of the poet as locked into a national landscape – writers whose final resting places have hereby become emblematic include Thomas Gray, Walter Scott and William Wordsworth. Two sites in particular usefully dramatise the transformation from the mid-eighteenth century through the mid-nineteenth century of the understanding of the relation of mortal remains to poetical remains: the grave of Thomas Gray at Stoke Poges, and the graves of Keats and Shelley in the Protestant cemetery at Rome.

In a country churchyard

Ev'n in our ashes live their wonted fires

At a little distance from Stoke Poges lies the church which boasts probably the most famous churchyard in Britain. This is 'the country churchyard' which Thomas Gray made famous in 1751 on the publication of his *Elegy Written in a Country Churchyard* and where he is himself buried. Here, bypassing a large yew, you come to the wall of the church, where there is a brick table-tomb, inscribed 'Dorothy Gray, widow; the tender careful mother of many children, One of whom alone had the misfortune to survive her'. On the wall of the church is a small plaque, dated 1799, which reads: 'Opposite to this stone in the same tomb upon which he has so feelingly recorded his grief at the loss of a beloved parent, are deposited the remains of Thomas Gray, the author of the Elegy Written in a Country Churchyard, etc. He was buried August 6, 1771.' Beyond the churchyard is a little path marked with a National Trust sign. If you follow it round though the scrubby bushes and spindly trees, upon you bursts an enormous, late eighteenth-century monument, a squared-off column some twenty feet high, upon which rests a large neo-classical sarcophagus enclosed in cast-iron railings. Each of its four sides carries an inscription. One side quotes from *Ode on a Distant Prospect of Eton College*, two more sides carry lengthy quotations from *Elegy Written in a Country Churchyard*, and the fourth announces:

> This Monument, in honour of
> THOMAS GRAY,
> was erected A.D. 1799,
> Among the scenery
> Celebrated by that great lyric and Elegaic Poet.
> He died in 1771,

> And lies unnoted in the adjoining church-yard,
> Under the Tomb-stone on which he piously
> And pathetically recorded the interment
> Of his Aunt and lamented Mother.

It was erected in 1799 by John Penn, descendant of the William Penn who founded Pennsylvania, as part of a general renovation of his property which included re-organising the church, demolishing the old manor house and building a new and imposing domed residence. The vista from Stoke Park was designedly ornamented by the handsome monument set in a sheep-dotted parkland and balanced by a view of the church. The engraving reproduced here, dating from the 1830s, shows not so much what it must actually have looked like then as the general idea of what it looked like in the popular imagination: the cenotaph is set in an ideal pastoral English landscape, flanked with the church to the left and the old manor-house in which Gray sometimes stayed to the right (Figure 1.1).

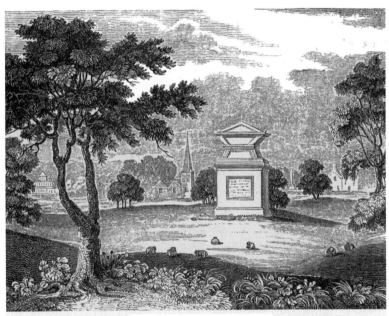

GRAY'S MONUMENT, STOKE PARK.

Figure 1.1 Gray's monument, Stoke Poges, from Charles Mackenzie, *Interesting and Remarkable Places* (London, 1832). Writers' Resources, Oxford.
John Penn's 1799 monument to the poet Gray, ornamenting parkland flanked with the church and the manor house in which Gray was frequently resident.

What this site presents to the visitor, and has done ever since 1799, is the family grave of a poet otherwise professionally memorialised in Westminster Abbey made over into a 'Poet's Grave'. At the turn of the century, the generalised, neo-classical and non-localised 'Poet' of the Enlightenment was converted into a specific biographicised persona, a proto-Romantic Poet more appropriately memorialised at Stoke Poges than at the Abbey. The material reality of Gray's grave was progressively redesigned to correspond with 'the grave of the author of the *Elegy in a Country Churchyard*.' Eventually, it would be converted into a sort of proto-Grasmere churchyard – a place where readers could confidently come to find an English poet at one with the English soil. The story of how this happens exemplifies both the cultural shift from a model of literary tourism as public homage to a sentimental exchange, and the ways in which a text, in this case the *Elegy*, could be made to script such tourism.

At the time of its publication in 1751, Gray's *Elegy* was a latish example of the then fashion for so-called 'graveyard poetry', which included, for example, Edward Young's *The Complaint, or Night-Thoughts on Life, Death, and Immortality* (1742–5) and Blair's *The Grave* (1743). Sentimental, melancholic and proto-Gothic, this school of poetry specialised in personal meditations over tombs usually in otherwise unspecified, indeed generalised, locations and usually in the twilight of evening or oncoming night. The *Elegy* meditates upon the graves of 'the rude forefathers of the hamlet', validating their lack of fame marked by the absence of 'trophies' typical of grand religious edifices such as the Abbey 'Where through the long-drawn aisle and fretted vault / The pealing anthem swells the note of praise.' It specifically dismisses the desirability of 'storied urn or animated bust' while registering the pathos of 'uncouth rhymes and shapeless sculpture', the simplicity of names, ages and holy texts in place of full-blown 'elegy'. If the poem celebrates the 'neglected spot' over official grandeur, it also personalises the solitary poet from the opening as speaker/owner of the poetic meditation – 'The curfew tolls the knell of parting day, / The lowing herd wind slowly o'er the lea, / The ploughman homeward plods his weary way, / And leaves the world to darkness and to me.' More startlingly, the final stanzas produce the poet as the object of some future 'kindred spirit' poet-tourist's 'contemplation' and inquiry:

> For thee, who, mindful of th' unhonoured dead,
> Dost in these lines their artless tale relate;
> If chance, by lonely Contemplation led,
> Some kindred spirit shall inquire thy fate . . .

The poem imagines such a graveyard tourist engaged in chat about the fate of the Poet with a local 'hoary-headed swain', a standard trope, one might remark, of travel literature. Thus prompted, the 'swain' tells the story of the Poet's death, and acts as tour-guide to his grave, upon which is engraved an 'epitaph' which marks the youthful Poet as anonymous and unsuccessful.[45]

The *Elegy* was celebrated from the moment of its publication, indeed, rather before it, as it was circulated around Gray's friends and admirers. It potentially scripts all future visits to poets' graves; it certainly scripted all subsequent visits to Gray's grave. It was, understandably, common-place to identify Gray with the speaker of the poem even in his lifetime: Thomas Warton, the Younger addressed his *Sonnet to Mr Gray* imagining him in the throes of composition in the churchyard, a fancifully senti-mental vignette which strategically echoes those famous lines from the *Elegy* – 'The curfew tolls the knell of passing day' and 'Beneath those rugged elms, that yew-tree's shade':

> While slowly-pacing thro' the churchyard dew,
> At curfeu-time [sic], beneath the dark-green yew,
> Thy pensive genius strikes the moral strings . . .[46]

At the time of Gray's death in 1771, twenty years later, the *Elegy* was well on the way to becoming a documentary part of the poet's biogra-phy, or so the anonymous *An Irregular Ode, occasioned by the Death of Mr Gray* (1772) would suggest. This obituary tribute notes especially the power of the *Elegy*, identifying Gray unproblematically with the speak-er of the poem:

> But most the music of thy plaintive moan
> With lengthen'd note detains the list'ning ear,
> As lost in thought thou wanders't all alone
> Where spirits hover round their mansions drear.
> By contemplation's eye serenely view'd
> Each lowly object wears an awful mien:
> 'Tis our own blindness veils the latent good:
> The works of Nature need but to be seen.
> Thou saw'st her beaming from the hamlet-sires
> *Beneath those rugged elms, that yew tree's shade;*
> *Where now still faithful to their *wonted fires*
> Thy own dear ashes are *for ever laid*.[47]

The writer embeds quotation from the *Elegy* within his own verse the better to embed Gray within the scene of the churchyard, and the asterisk leads to an unambiguously biographical footnote: 'Gray was buried at Stoke, the scene of the Elegy.' From being the generalised place characteristic of enlightenment graveyard poetry, the 'country church-yard' at a stroke becomes a realistic, mappable location, Stoke Poges.

Although this poem thus conflated and located the churchyard and the poet, it would still be another twenty-odd years before John Penn would decide to beautify his grounds, Stowe-fashion, by celebrating the fortuitous presence of the poet's grave with his grand cenotaph by Wyatt, the style of which is redolent of the last gasp of neo-classical funerary grandeur. What sets it apart from the memorials in the Abbey is its location; although the style and size of the monument might seem tactless as a memorial to the poet of the *Elegy*, its location bespeaks the importance of memorialising the poet's body as lying 'far from the madding crowd'. The first inscription from the *Elegy* (stanzas 4 and 5) directs the visitor to the churchyard to view the graves of 'the rude fore-fathers of the hamlet' (l.16), the second (stanzas 27 and 28) quotes the swain's account of the disappearance of the poet – 'nor yet beside the rill, / Nor up the lawn, nor at the wood was he' (ll. 111–2). The dual effect is once again to identify Gray with the fictive figure of the Poet, both buried in the real, adjoining churchyard. Consonant with this effect, by 1815 Thomas Mathias was noting that the churchyard had become the site of more than mere imaginary wandering with the poet:

> Lord of the various lyre! devout we turn
> Our pilgrim step to thy supreme abode,
> And tread with awe the solitary road
> To deck with votive wreaths thy hallow'd urn![48]

Although the conceit of the 'votive wreaths' and 'hallow'd urn' is old-fashioned for 1815, the sentiment is not – it is as romantic as the third canto of *Childe Harold's Pilgrimage* published the following year. By mid-century, many had followed in Mathias's footsteps: William Howitt in his *Homes and Haunts of the Most Eminent British Poets* (1847) commented that it was unnecessary to illustrate the church as it had been so often engraved, and Mrs S. C. Hall, writing in 1850, recorded her guide telling her that the site was much visited, and that visitors scratched their names on the walls, and 'took away bits of the yew and wild flowers'.[49]

As this anecdotal evidence might suggest, subsequent travellers were less taken with the grandeur of Penn's monument: as one traveller remarked acidly nearly a hundred years later, quoting another anonymous writer: 'it "resembles nothing so much as a huge tea-caddy," and its inscription celebrates the builder more than the bard.'[50] They were more likely to regard the romantic anonymity of Gray's tomb, combined with the rural peace of the churchyard, as the emotional centre of gravity to the experience. This anonymity, apparently accidental since Gray's will makes no such specification, nevertheless appears congruent with, not to say overdetermined by, the *Elegy*, dissolving Gray not merely into the speaker of the poem, but also into the anonymous dead poet with whose epitaph the poem closes. By the late 1830s the process of making over Stoke Poges and Thomas Gray into the 'country churchyard' and the 'Poet' of the *Elegy* was all but complete; it was possible to imagine Gray both in the throes of composing the *Elegy* and as its own dead subject. The effect was to constitute Gray as his own tour-guide. Robert Montgomery's poem *At the Tomb of Gray* (1836) suggests that it was already possible for visitors to the churchyard to do more than merely visit the tomb in homage to the dead. In language reminiscent of Godwin's, Montgomery's verse claims firmly both that 'the poetry of dreams that spot surrounds / Where Genius ponder'd' and that 'memories bright and deep pervade / The quiet scene where once a Bard has been,' fudging the distinction between the reader's and the writer's dreaming and memories. More, he claims that it is not the body but the mind of the poet that 'consecrates' the ground. With the help of the accuracy of Gray's topographical description conveyed by strategic quotation, strengthened by visiting the grave at twilight, the adequately sentimental reader can reanimate Gray:

> How many a foot, where pensive Gray hath rov'd,
> Will love to linger! 'Tis the spell of Mind
> That consecrates the ground a poet trod;
> The air is eloquent with living thoughts,
> And fine impressions of his favour'd muse;
> While Inspiration, like a god of Song,
> Wakes the deep echoes of his deathless lyre!
> But lo! – the churchyard! – Mark those 'rugged elms,'
> That 'Yew-tree shade,' – 'yon ivy-mantled tower,'
> And thread the path where heaves the mouldering heap;
> Then, stranger, thou art soulless earth indeed,
> If the lone bard beside thee does not stand,
> Formed into life by Fancy's moulding spell.[51]

Some ten years later, William Howitt noted with satisfaction not merely that Gray's description of the place was 'quite literal' but that the place conflated composition and biography – it was here that the poems 'were not only written, but were mingled with the circumstances, and all the tenderest feelings of his own life.'[52] The hack-writer T. P. Grinsted rehashed and expanded the trope in 1867:

> We wander into the churchyard, which possesses much poetical interest. The minstrel whose grave we seek has frequently stood in the shadow of this dark tree, contemplating the scattered mounds. It was here that, in all probability, he conceived his universally admired 'Elegy', and thought of the unrecognised dead:
>
> 'Perhaps in this neglected spot is laid
> Some heart once pregnant with celestial fire;
> Hands that the rod of empire might have sway'd,
> Or wak'd to ecstasy the living lyre.'
> If such, the poet has himself laid down by their side,
> for this is the grave of
> THOMAS GRAY.[53]

Gray's poem has become his own epitaph and monument. He is at a stroke converted into 'a mute inglorious Milton' over whose grave the tourist broods, thereby both reiterating and trumping the poet.

By 1895, Stoke Poges churchyard was effectively a palimpsest. For the visitor, it was at one and the same time the place of originating poetic reverie, the site of actual composition, the setting described literally in the *Elegy*, and the location of the poet's grave. It conflated the bodily, the biographical and the textual, and it could do this by virtue of Gray's topographical literalism. At the end of the century, Theodore Wolfe carefully detailed 'the absolute fidelity' of the *Elegy*, its exact reproduction of the scene past and present: 'Above us rises the square tower, mantled with ivy . . .; here are the rugged elms with their foliage swaying in the summer breeze above the lowly graves; yonder by the church porch is the dark yew whose opaque shade covers the site of the poet's accustomed seat on the needle-carpeted sward; around us are scattered the mouldering heaps beneath which, "each in his narrow cell forever laid," sleep the rustic dead.'[54] And so on, for some pages. This literalist and realist aesthetic would culminate in the unintentional comedy of the early twentieth-century guidebook which makes Gray over into a pedantic naturalist: 'His eye, keen for all things rural, discerned

the rugged forms of *Ulmus Campestris*, and the graceful drooping of a *Taxus Baccata*.'[55] So far have we come from the graceful neo-classical generalisation of 'a' country churchyard. But this realist aesthetic underpins the possibility of fusing with the poet, being animated by him:

> While our hearts are thrilling with the associations of the place and the hour, while the ashes of the tender poet rest at our feet and the objects that inspired the matchless poem surround us, we may hope to share in some measure the tenderer emotions to which the contemplation of this scene stirred his soul. As we ponder these objects, upon which his loving vision lingered, they seem strangely familiar; we feel that we have known them long and will love them always.[56]

As we have already noted, Dean Stanley's lament over absences from the Abbey precincts in 1868 encompassed that of Gray, which he put down, with Wordsworth's, to 'patriarchal feeling' which 'drew them away from the neighbourhood of the great, with whom they consorted in the tumult of life, to the graves of father and mother, or beloved child, far away to the country churchyards where they severally repose.'[57] Stanley's language echoes that of the *Elegy* – with its sense of the 'forefathers of the hamlet' lying 'far from the madding crowd' and mourned not generally but privately by 'some fond breast'. Stanley's sense of these country churchyards as outlying chapels of the national pantheon of the Abbey also derives from the *Elegy*, from its invocation of Whig heroes, Hampden, Milton and Crowell, however 'mute and inglorious' their local rustic analogues. Stanley's sense of the consummate Englishness of Gray's grave guaranteed by the rhetoric and sentiments of the *Elegy* found full expression some thirty years later in Henry C. Shelley's *Literary Bypaths in Old England* (1906), in which Shelley identified the churchyard as 'The birthplace of Gray's Elegy'. Looking ahead, it is a measure of how by the turn of the twentieth century the idea of pilgrimage to the author's grave has been displaced by pilgrimage to the source of the text that Shelley remarks that 'the visitor hither has the *added* sad pleasure of pausing by the tomb of the poet whose verse has been the motive of his pilgrimage'[58] (italics added). His pleasure that 'each picture in the poem has its faithful counterpart' derives from his sense that the churchyard and its environs adequately realise the poem as a whole. This realism is essential to guaranteeing the poem's truth, desirable because for Shelley the poem secures not merely 'Englishness' but centres Anglophone culture. 'Gray's "Elegy" is *the* Elegy of the English-speaking race. All its most outstanding qualities are native

to the sea-girt isle in which that race had its origin.'[59] A visit to the churchyard by this American writer thus is the necessary supplement to a reading of the poem for 'Many words and phrases in the poem only convey the full power of their emotion to the mind which can interpret them in the light and knowledge of English history and English rural life.'[60]

Over the course of 150 years, the churchyard at Stoke Poges thus converted Gray's preference for family over institutional associations, into, successively, poetic 'associations' suitable for beautifying a country-house landscape, romantic anonymity and obscurity, a rural, progressive 'Englishness', and a founding-point for Anglophone culture, all constructions pre-scripted by the *Elegy* itself. The centrality of the *Elegy* to what we can discover about the experience of the 'myriad tourists' who visited Stoke Poges over the century may stand as a preliminary statement in miniature of one of the central hypotheses of this study; that although tourists typically anticipate and construct a relationship with the dead author that is essentially physical and anti-textual, designed to ground the virtuality and alienation of the reading experience within person, place and occasion, this is for the most part only made possible by the text itself. Although the literary pilgrim's desire to bypass or supplement the author's incarnation in mass print culture necessarily denies this, literary tourist sites do not in any sense precede print culture but, rather, are created by it. Texts – or rather, readings of texts – make places in their own image.

In a city cemetery

If in the case of Stoke Poges the material reality of the poet's grave is subsequently supplemented so as to correspond to the *Elegy*, the graves of Keats and Shelley in the Protestant cemetery outside Rome were from the start designed so as to correspond with Shelley's elegy for Keats, *Adonais* (1821). Like Gray's grave, they would nonetheless attract supplementary memorial too, designed to make them correspond more nearly to later Victorian readings of the poem. As in the case of Gray's grave, the story of the making of these sites of literary pilgrimage strongly evidences the ways in which nineteenth-century culture supplemented the official triumphalism of the Abbey with a desire to celebrate and identify with the marginality of the romantic poet. Unlike Stoke Poges, however, these graves do not come to represent an Englishness exhaled by the landscape – but tell a story of Englishness exiled, a story therefore particularly attractive to women writers, and to Americans. If the story of how eighteenth- and nineteenth-century

tourism refashioned Gray's tomb provides one exemplary narrative of how English poets' mortal remains were ever more thoroughly embedded in the national landscape from the Enlightenment through the early twentieth century, the story of how nineteenth-century literary tourism memorialised Keats and Shelley provides the one striking exception. Here the emphasis is on the manner and place of death rather than on the place of burial, and the poet's body is imagined not as resting in earthy peace at home but as being dispersed, dissolved, even atomised.

We fast-forward some seventy years from the publication of the *Elegy*, and some fifty years from Gray's funeral, to attend one of the most famous death-beds in literary history, going on to eavesdrop at one of its most famous funerary scenes. English countryside gives way to Italian city, churchyard to cemetery, respectable melancholy to impassioned homoerotic mourning, Anglican rites to semi-pagan rituals, 'home' to 'exile'. The history of the interlinked making and reading of the tombs of Keats and Shelley in Rome's Protestant Cemetery, and the genesis of the Keats–Shelley Museum in the centre of the city, illustrates how essential the dramatisation and location, not merely of the romantic poet's body, but of his death, became to subsequent literary history, and consequently, to subsequent literary tourism. For the English literary tourist, the map of Rome is skewed out towards its margins – towards the Cemetery beyond the city walls of Catholic Rome where throughout the nineteenth century Protestants and foreigners were buried at night to avoid offending native sensibilities. There, after an arduous bus-ride, near the squat Pyramid of Cestius you will find the tomb of Keats, side-by-side with the devoted friend who nursed him on his death-bed, Joseph Severn, and a little way away, the grave of Shelley, also side-by-side with a friend who assisted at his obsequies, Edward Trelawney. Yet Keats and Shelley are not entirely banished outside the walls of Rome; by the side of the Piazza di Spagna, in what was the foreigners' quarter, next to the famous steps on which Charles Dickens found crowds of artists' models and where nowadays flocks of teenagers giggle and ogle one another, up a narrow distempered staircase, you will find the Keats–Shelley Museum. This set of rooms is where in 1821 Keats finally succumbed to the consumption which brought him to Italy in a doomed quest for health, and is the only literary site in the world devoted exclusively to the place where an author died; by force of a long-standing affinity between the poets as young English contemporaries, the museum also commemorates the death of Shelley, who in death has become the spiritual room-mate of his brother-poet. Although the death of poets, and sometimes its physical situation, had

occasionally meant much before – one thinks here of the great interest in Thomas Chatterton's suicide, the relics in circulation of the bedstead on which Robert Burns died in 1784, and, much later, the interest in the room in which Friedrich Schiller died in Weimar – this was the first time that poetic death was so extensively commemorated by narration on-site.

The unusual interest in the deaths of Keats and Shelley is indicated by the sheer number of nineteenth-century writings concerned with their graves – as Matthews notes, there are more nineteenth-century poems concerned with the graves of Keats and Shelley than with the graves of all other poets combined.[61] Their graves effectively became topographical essays, condensed tropes of romantic alienation, sites that dramatised the fate of the poetic imagination blighted and forced into exile by public indifference and yet freed into the classically pagan Italian ether, and sites that, visited, dramatised retrospective poetic vindication. So Emma Blyton's tribute poem *To the Memory of Keats* imagines the literary visit as a form of compensatory monumentalisation and memorialisation:

> What, though no proud, eulogious pyramid
> Graces the spot where thy young corse is hid?
> Still o'er that fragrant mound the tear is shed –
> The tear of sympathy . . .[62]

Erasure and exile are at once celebrated and reinscribed by such visits as the condition of the romantic poet; yet they are also atoned for, mitigated, and empathised with.

It is easy to overstate the interest in actually visiting the graves themselves, partly because Keats's friends set themselves energetically to promote Keats's posthumous reputation, which included insisting on the increasing number of visitors. English-speaking tourists to Rome, even though they were often preoccupied themselves with nursing invalids, typically set themselves an enormous itinerary to accomplish that precluded such a far-flung visit. That said, *What Katy Did Next* (1886), essentially the Grand Tour redacted for American teenagers, lists among the sights Katy does at Rome 'the English cemetery to see the grave of Keats.'[63] There is some evidence that literary pilgrimage was initially hampered not merely by the relative obscurity of the poets in the early Victorian era but by Keats's insistence on his grave-stone remaining anonymous, as it did until in 1867 a wall-plaque was put up indicating the identity of the grave's occupant.[64] Anna Jameson, for example, in her partially fictive *Diary of an Ennuyée* (1826), pays a thoroughly romantic visit to the cemetery noting its 'wild, desolate, and poetical

grandeur' and the graves of those who died tragically young and far from home, but mentions neither the tombs of Keats nor of Shelley, surely a missed opportunity; in 1842 Frances Trollope paid a visit to the grave of Shelley, but seems to have missed that of Keats; the first traveller's account that I have been able to locate of visiting the graves is that of Dickens in 1844, and his brief description is surprisingly vague:

> . . . to an English traveller, [the Pyramid] serves to mark the grave of Shelley too, whose ashes lie beneath a little garden near it. Nearer still, almost within its shadow, lie the bones of Keats, 'whose name is writ in water,' that shines brightly in the landscape of a calm Italian night.[65]

Indeed, subsequent descriptions of the graves betray how much this was an imaginary literary landscape, for they are often markedly inaccurate. The evocative title vignette to William Howitt's 1847 essay on Keats, which carries in the 'illustrations' list the title 'The Tombs of Keats and Shelley at Rome' (Figure 1.2) nicely exemplifies a founding Victorian

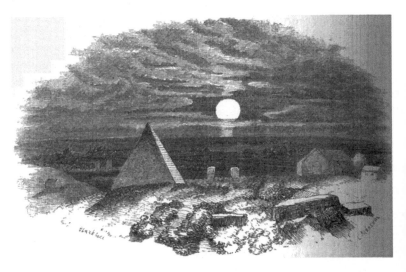

Figure 1.2 The graves of Keats and Shelley in the Protestant cemetery in Rome, from William Howitt, *Homes and Haunts of the Most Eminent British Poets* (1847: 3rd edn, London, 1858). Writers' Resources, Oxford.

Howitt's romantic but inaccurate depiction of the moonlit graves of Keats and Shelley side by side beneath the Pyramid of Cestius in the Protestant Cemetery at Rome describes Victorian expectations of the relation between the two poets.

misconception about the graves, which was that they lay side by side, under the Pyramid of Cestius. As I have already remarked, Keats's grave lies beside that of his friend Joseph Severn, and Shelley lies beside his friend Trelawney, but in other respects this pairing of Keats and Shelley is imaginatively true, because the poets' graves from the very beginning both as sites and as sights were determined by Shelley's elegy on Keats, *Adonais*, published the year after Keats's death, in July 1821.[66] The landscape Howitt pictures is in fact the landscape of *Adonais*.

It seems downright ironical that a poem so peculiarly invested in the transcendent ethereality of the abstract noun should have anything to do with the literalist exercise of locating the poet's body, yet so it was. Although Shelley's poem climaxes with the installation of 'the soul of Adonais, like a star' in 'the abode where the Eternal are', it was also instrumental in designing the understanding of the location of Keats's body. In the best poetic tradition, Keats had composed his own epitaph – 'Here lies one whose name was writ on water' – requesting before his death that Severn visit the cemetery to pick out a spot and tell him all about it, and stipulating that otherwise the headstone should remain anonymous. In practice, some months after Keats's death Severn, desiring to carry out his friend's wishes without entirely acceding to his self-erasure, consulted Trelawney, who suggested an epitaph which quoted *Adonais*: 'Here lies the spoils / of a / young English poet / "Whose master's hand is cold, whose silver lyre unstrung" / And by whose desire is inscribed / "Whose name was writ in water."' In the event Severn asserted the primacy and strength of the poet's act of self-epitaph over Shelleyan elegy by embedding it within something more strongly novelistic, not to say verging on the maudlin, in temper and mode:

> *This Grave*
> *Contains all that was Mortal,*
> *Of a*
> YOUNG ENGLISH POET
> *Who*
> *On his Death Bed*
> *In the Bitterness of his Heart*
> *At the malicious Power of his Enemies*
> *Desired*
> *The words to be engraven on his Tomb Stone*
> "Here Lies One
> Whose Name was Writ in Water"
> Feb 24th 1821

As Matthews points out, this inscription, although in the event it does not actually quote *Adonais*, was nevertheless strongly influenced by the language of the 'preface' to the poem, and, furthermore, translated the 'silver lyre' into the emblem of the broken lyre carved above the epitaph.[67] The grave would be planted with daisies – actualising the pastoral version of the cemetery shared between Severn and Keats before his death and the description that Shelley gave of the location of the grave:

> Go thou to Rome . . .
> . . . the Spirit of the spot shall lead
> Thy footsteps to a slope of green access
> Where, like an infant's smile, over the dead,
> A light of laughing flowers along the grass is spread. (ll. 433–441)

Shelley's memorial landscape is pagan, ruined, lonely, and yet surprisingly specific – guidebook specific for anyone in the know – noting the surrounding collapsing walls, the weed-grown ruins and the Pyramid of Cestius, although the poem shies away from the actual grave as too raw with recent emotion. Subsequent accounts of the site would typically refer implicitly or explicitly to *Adonais*: in 1898, Marion Harland in her essay on Keats in Rome simply quoted the lines from *Adonais* that locate the grave.[68]

If *Adonais* had an immediate impact upon the memorialisation of Keats, by sheer historical accident it also came to script Shelley's own death. Lost the year after the publication of his elegy in a sailing accident in a storm, Shelley had seemingly foreshadowed his own death in detail in the final stanza of *Adonais*:

> . . . my spirit's bark is driven,
> Far from the shore, far from the trembling throng
> Whose sails were never to the tempest given;
> The massy earth and spheréd skies are riven!
> I am borne darkly, fearfully, afar;
> Whilst burning through the inmost veil of Heaven,
> The soul of Adonais, like a star,
> Beacons from the abode where the Eternal are.

Adonais would, consequently, come also to script the memorialisation of Shelley himself, acting as the poet's own epitaph – 'Who in another's fate now wept his own' (l. 300). Howitt commented: 'Who but will

regard as prophecy the last stanza of "Adonais"?'[69] As his grieving widow herself wrote, 'Adonais is not Keats's it is his own elegy – he bids you there go to Rome.'[70] As this would suggest, the argument between Trelawney and Mary Shelley over the multiple re-location of Shelley's body (from the first burial on the beach at Viareggio, after cremation on the beach to the Protestant cemetery at Rome, and then relocated again within the cemetery) was not merely between the claims of the pagan and the Christian, or between the homosocial and the familial (their infant son William was also buried in Rome), it was also in some sense scripted by readings of *Adonais* as a description of poetic death, memorial and apotheosis. In the event, Trelawney's practice was romantically pagan; not only was he involved in the exhumation and cremation of Shelley's body on the beach at Viareggio and the subsequent funeral in Rome, at a later date he relocated the body again, planting it around with poetic laurels and mourning cypress. Mary Shelley's approach was altogether more text-book Victorian; eventually winning possession of the heart (snatched from the fire) from Leigh Hunt, she wrapped it in a leaf from *Adonais* and stored it in her writing desk. (Although the slab over Shelley's ashes in Rome reads 'Cor Cordium', producing the widely-held Victorian misconception that therefore his heart rested there, Shelley's heart is actually interred in unromantic Bournemouth.) She also commissioned a memorial marble installed in Christchurch Priory, chiefly remarkable for featuring a version of herself cradling the dead body of the poet backed by the bow of a boat presumably drawn up upon the beach which she herself never visited; with this memorial, the cremated and exiled body of her husband is reconstituted and relocated at home in England.

Adonais would continue to function as self-elegiac right through until the end of the century. In 1892 it was proposed to erect a magnificent marble monument by Edward Onslow Ford in place of Trelawney's plain slab, a marble designed to dramatise late-Victorian ideas of Shelley. In the event, this proved impossible because space was too restricted, and the piece ended up at University College, Oxford. In gleaming white marble, it realises the poet naked, recumbent and life-size, if one can use such a term of a sculpture that aspires to show the poet beautifully dead. Above this chilly, drowned figure rises a smallish domed hall, railed off from the irreverent pranks of undergraduates, and roofed in by stained glass. Around the mausoleum are inscribed the lines from *Adonais* it literalises – 'Life, like a dome of many-coloured glass, / Stains the white radiance of Eternity' (ll. 462–3). The Ford sculpture is by no means the first representation of the dead Shelley – the head-piece to Howitt's

essay, for example, illustrates Shelley's body neatly swathed before cremation on the beach; and it is, as we have already noted, depicted in the Christchurch Priory memorial. Yet, with the single exception of the medieval effigy of John Gower in Southwark cathedral, Shelley is the only writer who has ever been commemorated by a depiction of his dead body designed to mark the site of the grave, and the sheer extravagance of this *fin de siècle* gesture points to a specialness in the cultural investment in his death – and by association, in that of Keats, whose volume of verse was burnt with the corpse, for ever mingling the writing of one with the body of the other. It is not accidental that at roughly the same time a tablet 'telling who died here, and when' was put up on the lodgings at the Piazza di Spagna, and that by the 1890s it had become a standard practice to visit the lodgings in the Piazza di Spagna to view the room in which Keats was slowly etherealised into *Adonais*-like immortality: as the American Marion Harland wrote of her visit in 1898, 'We pause for a last look at the corner in which Keats's bed used to stand, then go silently down the stairs that gave back the slow echoes of the bearers' tread when the pitifully light weight of his mortal remains was removed for their long rest.'[71] Retailing the story that unread letters from England were laid in the coffin, Harland allows herself a fantastic reanimation through the fantasy of posthumous correspondence: 'We can imagine that the pulseless heart would quicken with one last painful throb as the unread letters were laid upon it.'[72] The Anglophone literary visitor is like the unread letter from home, endeavouring reanimation; the Keats–Shelley museum, opened on the site in 1906, a careful reconstruction of the lodgings that the Italian authorities had torn apart after Keats's death in an effort to rid them of supposed contagion, is living testimony to this turn-of-the century desire. Its displays remain thanatocentric to an extraordinary degree, animated (if that is the word) by the death-mask of Keats, by casts of his hand and foot, and by the loving display of locks of Shelley's hair and other relics.

The violets and daisies pressed into pocket-volumes of Keats and Shelley as 'souvenirs' remember Englishness disseminated and etherealised in a foreign place. The far-awayness of Keats and Shelley acts eventually not only as a statement of romantic alienation and subsequent apotheosis, but also as a romantic version of the alienation and etherealisation of print-culture. That interest in poetic death, in the moment when the poet 'transcends' or escapes the mortal, is already scripted by romantic poetics as an escape from the commercial tiresomeness of publication, and from the neglect and scorn of critics and readers. The poet's 'ashes', literal or metaphoric, are the mere residue of

escape into immortality, but this is an escape, characteristically for the period, which is not imagined in terms of the print-culture which alone confers such immortality. Yet visitors still come to reunite poetic body and poetic corpus, imaginatively melding, over and over again, Keats's book with Shelley's ashes, Shelley's ashes with Shelley's book.

More comforting, perhaps, and indeed more economical, to celebrate these writers when their work was still pure romantic potential; by visiting not Rome but, respectively, Moorgate in London and Warnham in Sussex. For as my next chapter will show, eighteenth- and nineteenth-century literary tourism had by now invented another mode of pilgrimage specifically to mark the imagined harmony between author and native soil, concerned not with graves but with birthplaces. Even the most alienated and doomed young geniuses, it transpires, can hereby be reclaimed for the domestic. Once a year, tourists can admire the gardens of the aristocratic house, Field Place, where Shelley was born, and, rewinding him from atheism and exile into untroubled Anglicanism, they can call at the picturesque country church nearby to inspect his certificate of baptism. And in London, they can remember his cockney colleague all the year round at 85 Moorgate by visiting the establishment that now flourishes beneath the blue plaque that marks his birthplace, Keats's Bar. Less grand than Westminster Abbey, and less glamorous than Rome, it is more English than both. A pint of the true, the blushful Hippocrene, anyone?

2
Cradles of Genius

O the flummery of a birthplace!

John Keats[1]

In 1769 the greatest Shakespearean actor of the day, David Garrick, staged the first major public celebration of Shakespeare's 200th birthday, the Shakespeare Jubilee, five years and five months late, at Stratford-upon-Avon. Stratford would never again be the sleepy, backward, muddy little coaching-town in economic decline that the carriages full of aristocratic bardolaters arriving in their hundreds from London would find. Garrick's extravaganza put Stratford on the national map for the generality of tourists, beginning the process of making it a must-see location in itself, rather than merely a coaching town in which the traveller might idle away the hours waiting for his dinner by visiting places of local interest, including Shakespeare's tomb. The Jubilee would consolidate what has proved an enduring tradition of celebrating not just Shakespeare's birthday (already being marked by some enthusiasts as early as the 1750s)[2] but the birthdays of other poets as well, a tradition thriving today in the shape of the Birthday Procession held in Stratford on the Saturday nearest to 23 April and in that of the 25 January annual celebration of 'Burns Night', to cite what remain the two most prominent anniversaries in the literary calendar. The celebration of a poet's Birthday is the precondition for the invention of the idea of a birthplace, and by extension, the conservation and display of a house as a Birthplace, and not the least important innovation of the Jubilee was Garrick's initial identification and subsequent display and celebration of Shakespeare's place of birth. From 1769 onwards, tourists to Stratford would consequently amplify their original itinerary from merely peeping at Shakespeare's grave in Holy Trinity Church, to visiting the 'birthroom'

in the house in Henley Street as well. Thus, although the modern Birthday Procession, with due pomp and biographical decorum, starts from the Birthplace on its way to lay flowers on Shakespeare's grave, historically speaking this itinerary was actually covered in reverse.

Garrick's seminal amplification of emotional investment to include not merely the grave but the cradle of genius was, in part, dictated by convenience. His initial intention had been to celebrate the Jubilee in London, as would seem more appropriate given Shakespeare's career as a metropolitan playwright. His choice of Stratford had in part been forced, but was rendered possible and exploitable by the fact that Shakespeare had conveniently managed to be born in the same place in which he had died. This widening of focus from grave to cradle seems to be at first glance elegant and inevitable, suggesting simply an extension of the search for the origins of text from the author's dead body to the moment when he or she became flesh. The Biblical language here is not accidental; just as pilgrimage to the relics of writers is based on a Protestant memory of Catholic pilgrimage to adore the relics of saints, so too a pilgrimage to a writer's birthplace must contain memories of the core Christian pilgrimage to see Bethlehem in the Holy Land. But, on closer inspection, this transference of interest is a complicated transaction, both in emotional and in practical terms. It is one thing to pay your respects to the bodily remains of a poet, filed away explicitly for viewing by posterity in the organised system of memorial represented by church, churchyard or cemetery. It is altogether another thing to make pilgrimage to the place where he or she was born. The grave was already the sort of site upon which memorial was conventional, and which provided physical evidence of the bodily existence of the author outside of the text; but to make a birthplace into a memorial of the author's physical existence requires a substantial effort of the collective imagination. Although both grave and cradle may be said to speak of 'origins', they are clearly different concepts of origin. The grave speaks of textual origin simply as the site of the body that existed beyond or in addition to the composition, dissemination and reading of the text; the cradle speaks of the origin of the body itself, and then, by implication, of the importance of environment in the making of the child who will become the writer. In no other way can interest in the place 'Where his first infant lays sweet SHAKSPEARE sung . . .' be generated.[3] As I show below, the process of inventing birthplaces involves producing a dynamic narrative to supplement the finality and stasis of epitaph. This narrative is necessarily biographical and located, or, to put it another way, realist and spatialised, and it tells the story of the childhood

origins of literary genius in a specific place – as such, it is typical of late eighteenth-century stories of the genesis of identity, best exemplified by a text to which I shall be returning later in this study, Jean-Jacques Rousseau's autobiographical *Confessions* (1781–8). A birthplace is then made by superimposing this narrative upon a surviving house by way of plaque, caption and visitor protocols, including graffiti and relic-acquisition on-site, and by the dissemination of the likeness of the house in print-culture.

Surprisingly, considering that as surely as a writer dies, he or she has been born, this shift or extension of emotional investment from grave to birthplace only holds for comparatively few authors. Again, it appears at first glance that this is principally a matter of practicalities: graves may be dedicated to the dead more or less in perpetuity, 'birthplaces' are actually houses, and even if they do not actually disappear, as did Milton's birthplace in Bread Street, engulfed by the Great Fire of London, they are too expensive not to be adapted and updated for re-use. But not all birthplaces are born equal, anyway. Many writers' places of birth are not marked at all, even in London, which has had a positively aggressive policy of setting up blue plaques for well over a century. The majority of those writers whose place of birth is memorialised only merit a plaque – in London, for instance, where so many poets' first houses had already been redeveloped before the poets could possibly achieve sufficient fame to warrant a preservation order, the birth of Alexander Pope is commemorated only by a tablet at the entrance of Plough Court, Lombard Street, and that of Byron only by a medallion affixed to the branch of John Lewis's on Oxford Street. Only a very few such births are celebrated by the expensive preservation of a birthplace organised as monument and museum. Such include Shakespeare's birthplace in Stratford-upon-Avon, Samuel Johnson's in Lichfield, Burns's in Alloway, Wordsworth's in Cockermouth, Dickens's in Portsmouth, J.M. Barrie's in Kirriemuir, the Carlyles' in Ecclefechan and Haddington, and Hardy's in Higher Bockhampton. Even amongst these, however, there proves to be a differential in their hold over the sentimental tourist's imagination, and this derives from how important the circumstances of their birth are to the individual writer's mythos. Hence, the provincial births of Johnson, Dickens, Barrie and Carlyle are overshadowed by their careers within glittering circles of London writers and intellectuals, careers that were deliberately designed to supersede provincial origins. The figure of Peter Pan apparently climbing into the window of the byre at Kirriemuir does not undermine our sense that the statue of Peter Pan erected in Kensington Gardens is a more appropriately sited monument,

a sense founded on the fictional knowledge that it was a London window into which he climbed that night when the parents were out and the dog locked up. Although Boswell's great biography of Johnson identified the birthplace at Lichfield, and although the house was being illustrated as early as an 1835 edition of the *Life*, it was and is still the attic in London in which the lexicographer laboured at such length that captured the common imagination. Wordsworth's birthplace at Cockermouth, although it has recently undergone a revamp to make it less peripheral, still seems unimportant beside Dove Cottage and Grasmere, the places central to and originating of Wordsworthian landscape. In fact, the general practice of celebrating the writer's birthplace dates only from about the turn of the twentieth century – the Dr Johnson museum in Lichfield was opened in 1901, for example. By contrast, the birthplaces of Shakespeare and Burns are central to the nineteenth-century popular understanding of these writers, and very largely for the same reasons, for they celebrate these writers' humble origins at the same time as extensively anchoring their youths within national rural landscapes. The making of these two sites is bound up together, for, while the making of Burns's birthplace is made possible by the making of Shakespeare's birthplace, it is also true that the making of Alloway conditions the subsequent making of Stratford. Both insist above all on the connections between national poet and national soil.

These two sites between them may be said to set up a model of 'textless tourism' to balance that which I have described as associated with necro-tourism. By this I mean, not that such tourism is not produced by many and various texts, but that it aspires to being a text-free experience, indeed, to being an experience that pre-empts the necessity for texts. In this sense birthplace and grave might be conceived of as a pair of book-ends, organising and yet 'outside' the book. What follows is the story of how – and why – Shakespeare's Stratford is produced in spite of the near-total absence of Stratford and its environs from Shakespeare's works, and how Burns's Alloway is produced as a place where poetry grows from place in a manner miraculously unmediated by print.

I Shakespeare's Birthplace

Upon entering the town of Stratford, a feeling, I trust, something more elevated than that of mere curiosity, naturally directs the steps of every admirer of our divine Poet towards that spot which gave birth to the most extraordinary genius this or any other country has ever produced . . .[4]

Shakespeare's Birthplace today is the product of two centuries of development, and its emotional affect is recognisably derived from that offered to and described by the nineteenth-century visitor. 'Doing' Stratford today, the neophyte is most likely to start here.[5] Entry at present is through a cunningly designed portal exhibition, redesigned in April 2000, through which the visitor is acclimatised to a provincial Tudor past which provides a backdrop for what local biographical detail we have about Shakespeare. The whole dramatises Stratford as both epitomising and embosomed in 'Shakespeare's countryside', and as energising the plays in general and in particular: 'his plays and poems abound with references to rural characters, country customs, wild flowers, animals and birds.' In keeping with this pastoral aesthetic, the visitor enters the Birthplace proper through a garden, planted up with flowers and herbs mentioned in the works. The Birthplace itself is displayed principally as a house, rather than as a museum, conspicuously free for the most part of print information, which is confined to a room containing displays telling the history of the Birthplace itself. Here can be seen details of the visit of John Adams and Thomas Jefferson in 1786, the first visitors' book from 1812, the collection of *Extemporary Verses, written at the Birthplace of Shakespeare at Stratford-upon-Avon by People of Genius . . .* (1818) made up by the then owner of the Birthplace, Mary Hornby, visitor statistics then and now, and the famous window from the 'birthroom' (so-called from the early nineteenth century, though the term seems nowadays more redolent of obstetrics than of belles-lettres), which preserves what remains of the sanctioned practice of graffiti indulged in by some of the earliest visitors, including Sir Walter Scott. Even this room is principally designed less as a museum than as a warm-up act, demonstrating the importance past celebrities have accorded to their visits. Old depictions of the birthroom emphasise this as well, though apparently in contradictory ways: a photograph taken in 1882 is included largely to illustrate previous visitors' practice of scrawling their signatures upon the whitewashed walls, whereas the Victorian painting *In Shakespeare's House, Stratford-upon-Avon* by Edwin Landseer and Henry Wallis emphasises the romantic emptiness of the room, instinct with future genius signified by the casual litter of a shield, a skull, a spade, a rat, a glove, a dog and a Bible. The room itself ('please turn off your mobile phones!') is consciously empty and blandly domestic, down to the cradle standing by the bed. To visit the Birthplace nowadays is thus explicitly to recapitulate two and a half centuries of previous pilgrimage and yet to come to an empty silent space, potential, secretive and blank, signifying the space or time before

'Shakespeare', before there was anything to remember. It thus celebrates source and potential within fertile rurality rather than Shakespeare's achievement of London fame and status.

As I have already noted, the beginnings of that celebration of source and potential lie back in August 1769, when Garrick's publicity machine brought a large crowd drawn from high society out from London to Stratford, to celebrate Shakespeare's 200th birthday with a heady cocktail of miscellaneous entertainments – a breakfast, an oratorio, a concert, a ball, a horse race, a procession of 170 Shakespearean characters, a set of songs sung round the streets, an ambitious 'Ode' celebrating Shakespeare's achievements composed and recited by Garrick himself, a masquerade, an Assembly and fireworks. Garrick was unlucky in the weather (a persistent downpour meant that the procession had to be cancelled, and the performance of the 'Ode' was almost flooded by the rising Avon), and acid comments were passed about the nature of the entertainments. Most eyewitness accounts felt that the event was an expensive fiasco. However, contemporary condemnation was not visited on Garrick for excluding from these many and various entertainments, scripted in their entirety by Garrick, any performance of Shakespeare's actual works. Although modern commentary has frequently commented on this as an instance of Garrick's vaingloriousness or the philistinism of his audience, this is to miss the point; what Garrick's multi-media spectacular did was to invent an off-stage, off-page Shakespeare, a Shakespeare ripe for apotheosis as 'National Bard'. The Shakespeare Garrick's Jubilee delineated was located not in the Complete Works but at the centre of an as-yet imperfectly biographicised narrative set in an as-yet imperfectly localised Stratford.[6]

The persons who attended the Jubilee at Stratford in 1769 were not exactly tourists as we would understand the term, and nor was the Jubilee exactly a tourist event in that it was essentially occasional. Yet Garrick's extravaganza contributed notable elements to the Stratford tourist industry as it had already developed around Shakespeare's grave. Indeed, Garrick's scripting of Stratford was to compensate for the demolition of Shakespeare's house at New Place ten years before by the vindictive Rev. Francis Gastrell as a way of avoiding at a stroke the annoyances of both tourists and taxes. The script of the Jubilee established Stratford, together with the surrounding countryside of Warwickshire, as a plausible, indeed the 'natural' (rather than arbitrary) location of a Shakespeare cult, partly by general invocation of the Bard as a local ('the Will of all Wills was a Warwickshire Will,' as the hit-song of the festival chorused),[7] and partly by theatricalising real locations

within the town. Places were effectively made into scenery for the drama of Shakespeare's birth, and they were reciprocally dramatised, gaining added meaning and value.

The prime example of this dramatisation was the Birthplace, which the Jubilee made into the centrepiece of the Shakespeare tourist cult for the first time; reports of the Jubilee were illustrated by the first public print of the Birthplace in the *Gentleman's Magazine*. The rained-off procession of Shakespeare characters had planned to stop at the Birthplace, hung with an allegorical banner representing the sun bursting out from behind clouds to enlighten the world, which was to be draped from the window of the room that Garrick had decided (arbitrarily, and without any actual scholarly evidence, although the attribution has stuck) had been the Birthroom. Here the actors were to sing:

> Here Nature nurs'd her darling boy, . . .
> Now, now, we tread inchanted ground,
> Here Shakespeare walked and sung![8]

Individually dramatised locations were linked into a narrative by the moving of the procession along an imaginary biographical trajectory from spot to numinous spot – from the Birthplace to the monument in the church, where Shakespeare's tomb was ritually heaped with flowers. So fundamental did this narrative of location become to the cult of Shakespeare that it remains the underlying itinerary of the Shakespeare Birthday Procession to this day.

The Jubilee did more than invent a prototype tourist itinerary of Stratford based loosely upon Shakespearean biography. It invented a prototype tourist sensibility and protocols to animate it. The lines above, for example, suggest an essentially touristic audience for the Birthplace. Rather than merely viewing the house as an interesting 'antiquity', the audience is solicited to a theatrical experience lived in the moment and fundamentally sentimental in its effort to put the tourist into the same place and thus, by an effort of time-defying imagination, almost into the physical presence of the Poet. The Birthplace from henceforth was the privileged location for Shakespeare pilgrims, and its lucky tenant, Mrs Hart, profited accordingly: as she said to that indefatigable traveller the Hon. John Byng in 1781, while showing him 'Shakespeare's old chair': 'It has been carefully handed down by our family, but people never thought so much of it till after the Jubilee, and now see what pieces they have cut from it, as well as from the old flooring in the bedroom!'[9] Taking the hint, Byng seized his opportunity

while he could, and acquired the bottom strut of the chair, probably at an extortionate price. The anecdote suggests that this sort of visiting combined with relic-acquisition is an extension of the practice of scribbling on the tomb; if such graffiti is a sign of having briefly occupied the same space as the dead poet, Byng's relic is a more portable version of having briefly occupied the same space as the living poet, to have trodden 'inchanted ground'.

The first stirrings of a nineteenth-century tourist aesthetic are thus visible at the peripheries of Garrick's Jubilee, which might in this fashion lay claim to being the founding festival of romanticism. But, though the Jubilee hints at, it does not fully model Victorian literary pilgrimage. The need to hang an allegorical banner from the Birthplace window at all points out that this particular place had yet to become recognisable, let alone iconic, and let alone a locus promising a supremely authentic physical tourist experience. (That authenticity and uniqueness, paradoxically, was only achieved through the reproduction and dissemination of its likeness. In this sense the engraving in the *Gentleman's Magazine* did what ecstatically pausing the procession outside the Birthplace could not do fully; it linked the Birthplace and the Shakespeare you might read at home together within print culture.) The presence of the allegorical banner further suggests the impossibility of making any birthplace, as it were, stand for itself – it needs marking. It suggests also how novel it was to mark such a place and how non-biographical its view of the Birthplace was as the place where genius burst forth. The Jubilee did not, principally, locate Shakespeare in the Birthplace or indeed in Stratford more generally, according to a realist aesthetic derived from the biographical.

It would take time after the Jubilee to complete the transfer from the allegorical to the biographical suggested by Garrick's words for the song at the end of his performance of the *Ode*, in which Ben Jonson's largely figurative 'sweet swan of Avon' was transformed into an unintentionally comic vignette of Shakespeare catching his death of cold from endlessly lying about on the damp banks of the river:

> Thou soft-flowing Avon, by thy silver stream,
> Of things more than mortal, sweet Shakespeare would dream,
> The fairies by moonlight dance round his green bed
> For hallow'd the turf is which pillow'd his head.[10]

One of the effects of developing allegory into biography was to begin the invention of 'Shakespeare country'. Once the Birthplace was no

longer simply an allegory of 'the birth of genius' but seen in more realist terms as the actual location in which William Shakespeare was born, it followed that tourists became much more interested in the general environment within which Shakespeare's boyhood and youth were spent, too. Allegory was overtaken by narrative designed to connect a set of mostly spurious anecdotes and slightly less spurious locations. Although Shakespeare's earlier biographers, notably Rowe, had connected anecdotes about the Bard with Stratford's environs, the man who first elaborated Shakespearean biography with visually realised locations by way of illustration, and who modelled appropriate tourist sentiment in a romantically enthusiastic first-person narrative of his pilgrimage, was Samuel Ireland, now best remembered as the father of the forger of Shakespeare's letters and additional manuscripts, William Henry Ireland. *Picturesque Views on the Upper, or Warwickshire Avon* (1795) successfully joined up long-familiar Shakespearean oral traditions into an itinerary for an extended excursion into the country centred upon the Birthplace, which could then be readily repeated by readers fired with the sort of enthusiasm that one traveller was already expressing in 1793: 'STRATFORD! *All hail to thee!* When I tread thy hallowed walks; when I pass over the same mould that has been pressed by the feet of SHAKESPEARE, I feel inclined to kiss the earth itself.'[11]

The frontispiece to *Picturesque Views* in many ways exemplifies the late eighteenth century's emergent sense of locating the living author within a specific landscape (Figure 2.1). It combines, rather uneasily, the allegorical and the realistic. On the one hand, the aesthetic appears to be neoclassical allegory: the Bard is accessorised festooned with harp, scrolls and masks of comedy and tragedy, identified by a rather pointed swan, and solicited by a variety of classically undressed females including 'Nature' to what, if we were to go by the strategically placed net and fishing-rod, seems to be an impromptu fishing-trip on the Avon. This Shakespeare is recognisably the generalized and gentlemanly Bard in the mode of the statues by Scheemakers and Roubiliac, more lifelike to eighteenth-century taste than the bust that ornaments the tomb, but lifelike in appearance rather than in behaviour, pictured here perpetually and improbably picnicking on the inspirational but generic river-bank sward. This is the late eighteenth-century poetic traveller's Shakespeare; as William Dodd had it in 1767, apostrophizing the Avon, 'gentle Shakespeare's youthful feet, / Beside thee frolic rov'd.'[12] On the other hand, this picture essays certain effects of precise verisimilitude: the background to this classical montage is dominated by a thoroughly realistic view of the church spire at Stratford-upon-Avon (albeit an anachronistic one – Holy Trinity's tower

Here. NATURE *listining stood,whilst Shakespear play'd*
And wonder'd at the Work herself had made .! *Churchill*

London Pub. for Sam! Ireland Feb 2? 1795 .

Figure 2.1 Frontispiece to Samuel Ireland, *Picturesque Views on the Upper, or Warwickshire Avon* (London, 1795). Writers' Resources, Oxford.
An uneasy mix of allegory and realism, Ireland's depiction of an inspired Shakespeare on the banks of the Avon marks the gradual emergence of a sense of 'Shakespeare's Stratford.'

boasted no spire until the eighteenth century). The documentary detail of the church unavoidably suggests the chilliness of those river nymphs, and inadvertently solicits all sorts of explanatory narrative as to the nature and occasion of this ill-conceived outing.

The rest of Ireland's *Picturesque Views* could be seen as dedicated to providing the explanatory narrative and the documentary detail that

transforms this preliminary scene from the allegorical to the realistic. Ireland models for his reader a must-do itinerary, a useful guide to appropriate sentiments, and appropriate activities, including the acquisition of relics and souvenirs, making 'Shakespeare' into the founding principle for a new aesthetic or sensibility of travel. Though Ireland's publication is not what we would understand as a guidebook, being more a cross between travel narrative, coffee-table book and antiquarian notes, it does bring together for the first time biography, pictures and a first-person account of visiting the place, describing and delineating a visit which readers are effectively urged to repeat for themselves. And it is demonstrably invested in that sense of the local, particular and topographically accurate that is peculiar to the nineteenth century. Accordingly, the text is lavishly illustrated with detailed engravings of locales associated with the biography of Shakespeare: Charlecote House (where Shakespeare was alleged to have been caught stealing deer by Sir Thomas Lucy), Fulbrook Lodge (the alternative scene of the deer-stealing episode, according to local guide and poet John Jordan), 'the kitchen of Shakespeare's House' (including 'Shakespeare's Chair'), the monument in the church, Anne Hathaway's cottage (the first ever representation) and an artist's impression of the temporary rotunda in which Garrick had recited his Ode at the Jubilee nearly thirty years earlier. Of especial interest is an implausible reconstruction of New Place complete with Tudor figures. It looks nothing like what we know New Place to have looked like in Tudor times, but it does look like what contemporaries felt the Tudor should have looked like. Here, Ireland previews the Victorian desire to make Stratford adequately Tudor and so Shakespearean, going to the lengths of putting Shakespeare's crest above the Adam-style neo-classical doorway. These illustrations are carefully documentary, unlike the frontispiece. In this they find their origin not only in Garrick's Jubilee (as the illustration of the rotunda tacitly admits) but also in some of the scenery used for Garrick's smash-hit play *The Jubilee* staged in London the following season, which represented the White Hart so realistically that one of the audience, John Byng, had no trouble recognising it when he did visit Stratford himself. In this Ireland's book would preview the sensibility that informed the realistic painted backdrops for Charles Kemble's 1829 production of the first English play to boast the young Shakespeare as its hero, Charles Somerset's biographical *Shakspeare's Early Days*. As the playbill for a performance in 1830 at the Theatre, Doncaster, remarks, this 'Historical and Legendary National Drama' featured 'new scenery' which included the 'Outside of the HOUSE in which SHAKSPEARE WAS BORN, in

Henley-Street, Stratford', and a 'DIORAMIC VIEW of Stratford-upon-Avon, the River, Church, etc.'[13]

Shakspeare's Early Days, although largely biographical in content, being concerned with Shakespeare's expulsion from Stratford in the wake of the Sir Thomas Lucy affair, is remarkable for an inset pageant which, while consciously reiterating Garrick's procession of Shakespearean characters, located Shakespeare's inspiration once again beside the miraculous river: it showed

> SHAKSPEARE'S DRAMATIC VISION upon the Banks of the 'SOFT-FLOWING AVON,' In which will be exhibited, in *Peristrephic Progression, and Aereal Grouping*, the principal Characters of Shakspeare's POPULAR PLAYS.

Such a 'vision' realises Garrick's suggestion that Shakespeare simply dreamt his material, asleep on the green turf, surrounded by fairies – it is not a coincidence that the cast-list for this inset pageant also includes Oberon and Titania. What is striking about this is not simply that the form hybridises biography, documentary realism and pageant in a way still reminiscent of Garrick and Ireland, but that it expands within a biographical frame the suggestion that Shakespeare was inspired not simply by 'Nature' but 'Nature' on the banks of the Avon. This is a fiction of the origins of writing that entirely by-passes the arduous and commercially grubby business of writing and publishing, ascribing the origins of the writing to the landscape with a little help from the fairies. One effect of this conceit is to strengthen the suggestion that Shakespeare was not merely a natural but a national genius, the embodiment of the genius loci, thereby strengthening touristic desire to visit this hyper-English location.

Indeed, visiting Stratford and the surrounding countryside was to become an experience of Shakespeare that would trump reading altogether; perhaps the most striking cameo of this effect is provided in Christian Tearle's *Rambles with an American* (1910), in which Tearle's semi-fictional American tourist, Mr Fairchild, disappointed by the Birthplace, is forced out into Shakespeare's countryside to 'bathe in Shakespeare's river' in order to get a proper sense of Shakespeare. He flings away his modern souvenir plaque into the Avon because it was adorned with an inaccurate transcription of Shakespeare's lines, and plucks instead a few leaves of ivy from the 'Birthhouse'.[14] In this he is entirely in the spirit of nineteenth-century literary pilgrimage to birthplaces; although brought to Stratford by the power of print-culture, he

tries to discard print in favour of something non-commercial and natural, an immediate physical organic experience rather than a representation or reproduction.

Before considering the later nineteenth-century development of Stratford and its environs, however, I want to turn to consider the parallel development of Alloway, the birthplace of Burns, Scotland's rival natural genius and national Bard. Whereas, as the meanderings of my story above would suggest, it was really rather hard to meld Shakespeare and Stratford to produce a natural and national romantic genius, Burns was almost immediately made over into the original national genius, sprung from the soil and singing Scotland.

II Burns's Birthplace

> *All ask the cottage of his birth,*
> *Gaze on the scenes he loved and sung . . .*[15]

The story of the slow development of Shakespeare's Birthplace and its environs is remarkable in many ways because it is so unlikely. A London playwright was metamorphosed into a Warwickshire child of nature with virtually no help from the man himself; almost nil mention of the locality in his works, combined with, by modern standards, a scanty biographical record. The same conditions did not hold in the case of Robert Burns, born ten years before Garrick's Jubilee in a poverty-stricken thatched cottage in Alloway on the main road leading out of the town of Ayr in the Scottish Lowlands, and dead at thirty-seven and a half in 1796. By contrast to Stratford, Burns's birthplace and its environs were developed with astonishing speed, a speed that suggests not merely that the pre-existence of the Shakespearean template was enabling, but the relative hospitability of Burns's life as mediated by his own *oeuvre* and subsequent biographical writing to this form of commemoration. Although, like Shakespeare, Burns would inspire a form of text-less tourism, this was invented directly and speedily out of a set of identifiable publications of his own and others.

Within a mere three years of Burns's death, there is evidence that the Cottage, by then being used as an alehouse, was already being visited, in the shape of a poem by a twenty-three year old Richard Gall entitled *Verses written on visiting the house in which the celebrated Robert Burns was Born, and the Surrounding Scenery, in Autumn 1799*, verses which suggestively culminate in apostrophising Burns as 'Scotia's Shakespeare'.[16] Within eight years, a Burns club had had the bright idea of celebrating

Burns's birthday there.[17] A year later, in 1805, an engraving of the Cottage had appeared in the *Scots Magazine*, the first of many such representations. By 1805 there was a board affixed to the outside of the Cottage reading 'Halt, passenger, and read: / This is the humble cottage / That gave birth to the cele / brated poet Robert Burns.' By 1818, the year in which John Keats visited, the Cottage, still operating as an alehouse, was showing a crude portrait of Burns on wood, and was known as the 'Burns Head Inn'.[18] The built-in bed in which Burns had been born, still on show, was available for viewing from an early date. As in Stratford, visitors typically carved their names into the furniture, or scribbled on walls and fixtures.[19] By September 1838 there was a regular visitors' 'album' and visitors that month alone ran to some three hundred and fifty.[20] By 1847, the year in which Stratford set up the Birthplace Trust, a large hall had already been built behind the Cottage to house a small museum.[21] By 1857 it was possible to buy engravings of the locality on the spot, and by 1876, the Cottage was retailing 'a choice collection of photographs, fancy boxes, needle cases, caups, trays and other souvenirs . . . warranted made out of wood which grew on the banks of Doon,' souvenirs that thus spoke of land, locality and the poet's own haunts, reminiscent of those that had increasingly been available since 1756 in Stratford when William Sharp had begun to make such a good thing out of manufacturing knick-knacks out of the felled mulberry tree said to have been planted by Shakespeare himself.[22] Such speed suggests on the one hand that the concept of 'the birthplace' was already available, thanks to Garrick and Ireland; but it also suggests that Burns was a subject peculiarly suited to this form of processing by admiring readers.

Perhaps the principal reason for the early and rapid glorification of Burns's birthplace, oddly enough, was the unsatisfactoriness of his grave in Dumfries, over which a plain stone was only set some years after the poet's death with the aid of subscription. Subsequently, in 1815, Burns's body was exhumed and moved to another site within the churchyard where there was enough space to erect a mausoleum. This mausoleum, opened with much ceremonial procession and pompous speech-making on 6 June 1815, is a grand affair enough: neo-classical in inspiration, domed and pillared in whitewashed stone, it gleams out as deliberately exceptional among the upright red sandstone monuments that universally surround it. Within the dome, an allegorical bas-relief shows the poet at the plough being accosted by a brazen and dismayingly solid Muse of Coila who brandishes the mantle of inspiration threateningly over the Poet's head, in reference to Burns's own dedication to the second edition of his *Poems, Chiefly in the Scottish Dialect* (1797): 'The

poetic genius of my country found me as the prophetic bard Elijah did Elisha – at the plough; and threw her inspiring mantle over me. She bade me sing the *loves*, the *joys*, the *rural scenes* and *rural pleasures* of my native soil, in my native tongue.' Still piled high when we saw it in February rain with birthday celebration flowers, the mausoleum is a lavish monument to high poetic celebrity, and it was certainly designed with the literary pilgrim in mind. As the address at the official dinner had it, clumsily but tellingly mis-quoting Gray's *Elegy*:

> Full many a pious pilgrim shall repair
> To drink fresh draughts of inspiration there:
> For still thy grave poetic warmth inspires,
> 'Still, in thine ashes live their wonted fires!'[23]

This drinking-fountain-cum-bonfire has never been to everybody's taste – not to Keats's for example, and even less to William Howitt's, who felt, as most mid-Victorians must have felt, that allegory was inappropriate to the earthy realism of Burns: 'The allegorical figure of the Muse seems too much, and the absence of the horses too little. Burns would have looked quite as well standing at the plough, and looking up inspired by the muse without her being visible.'[24] Yet it was not so much the rhetorical mode of the mausoleum that was problematic, outdated although it certainly was in 1815, as the supposed manner of Burns's death.[25] Throughout the nineteenth century, Burns was thought to have died of alcoholism (rather than, as later theories have had it, of heart failure associated with early rheumatic fever, or as is currently speculated, of brucellosis). This, even more than his marital irregularities and his compromising radical politics, caused the dignitary charged with the job of giving the dedication speech at the opening of the mausoleum positively to writhe with delicacy as he endeavoured to avoid censuring the dead while being obliged to admit that there were grounds for such censure. Burns's conjectured fate, in the age of the temperance movement, informs Wordsworth's terse elegy for Burns with Chatterton as 'mighty poets dead in their misery' and his sister's verdict on the Dumfries graveyard as early as 1802 that it was 'unpoetic ground'.[26] It remained a problem throughout the century, as the contortions of Thomas Campbell's verse suggest:

> Farewell! And ne'er may envy dare
> To wring one baleful poison drop
> From the unshed laurels of thy bust!

> But while the lark sings sweet in air,
> Still may the grateful pilgrim stop
> To bless the spot that holds thy dust.[27]

The grave at Dumfries spoke of folly and self-inflicted harm, and the nearby civil servant's house lived in by Burns in his capacity as excise officer was not much better: as Nathaniel Hawthorne remarked sourly but pertinently in 1857, 'Altogether it is a very poor and unsuitable place for a pastoral and rural poet to live or die in,' a sentiment re-echoed by Theodore Wolfe at the end of the century: 'An environment more repulsive and depressing, a spot more unworthy to be the home of a poet of nature, can scarcely be imagined.'[28] The Cottage, on the other hand, provided such a rural setting for genius. The importance of the Cottage to contemporaries' sense of Burns is underscored by the treatment given to it in Dr William Currie's biographical memoir attached to his important and much reprinted edition of the *Works of Robert Burns* (1800) is remarkably specific about the location of the Cottage: he notes that Burns was born 'in a small house about two miles from the town of Ayr, and within a few hundred yards of Alloway church', adding for good measure a footnote with further details for the curious traveller: 'this house is on the right hand side of the road from Ayr to Maybole It is now a country ale-house.'[29] Keats wrote enthusiastically of his projected visit in July 1818 that 'I am approaching Burns's cottage very fast One of the pleasantest means of annulling self is approaching such a shrine as the Cottage of Burns – we need not think of his misery – that is all gone – bad luck to it – I shall look upon it [the Cottage] hereafter with unmixed pleasure as I do upon my Straford [sic] on Avon day . . .'[30] Such pain that the sentimental tourist might experience was quite different in type to that inspired by the mausoleum. In Richard Gall's words,

> O but it makes my heart fu' sair,
> The lowly blast-worn bower to see,
> Where infant Genius wont to smile,
> Whare brightened first the Poet's e'e!
>
> **Burns**, heavenly Bard! 'twas here thy mind
> Traced ilka object wildly grand;
> Here first thou caught dame Nature's fire,
> An' snatched the pencil from her hand.[31]

Gall's heart may be sore, but it is sore with a form of pride, pride in the 'ploughman poet' who was felt to have been a natural genius,

nursed as an infant, not by his mere mother Agnes Broun, but by Nature, like Garrick's Shakespeare, until he snatches 'the pencil from her hand.' The Cottage in Alloway spoke inspiritingly of genius awakening within an idealised rural setting in something of the same way as Stratford was supposed to do.

The Cottage and its environs spoke of humble origins transcended by natural genius courtesy in part of Currie's remarks on the Cottage which anchored it to the opening of Burns's 'A Vision'. The opening of 'A Vision' locates the poet in 'an auld clay biggin' just before he is interviewed for the job of National Bard by the Muse of Coila, and the poem 'There was a lad' in which he dramatises the story of his birth, complete with fortune-telling gypsy and the collapse of the Cottage's gable-end in a winter storm: ''Twas then a blast of Janwar win' / Blew Hansel in on Robin.' (The literal-minded will point out here that this storm damage actually happened when the infant Robert was some eight or nine days old.) Currie further claimed that 'The Cotter's Saturday Night', the poem that probably received most contemporary approbation as serious and dignified, had provided a true and faithful description of the Burns's family life in the Cottage during the poet's youth, a representation endorsed by the interpolated memoir by John Murdoch, the school-master who lodged there, and which would become canonical in all future accounts of the 'auld clay biggin'.[32] Prints illustrating this poem were rapidly produced, one of which was owned by Burns himself, and which finally acted as a frame for one contemporary print of Burns himself at home in the Cottage.[33] The profoundly nationalistic inflection of this poem's ideal of virtuous domesticity would therefore come to colour the presence of the Cottage in popular culture.

Describing Burns thus as both natural and national genius, Alloway also produced Burns as a bit of a lad, rather in the spirit of Garrick's evocation of 'The Will of all Wills', who was, needless to say, 'a Warwickshire Will.' The third text associated with Alloway was *Tam o' Shanter*, set, as Currie noted, in Alloway church. The poem tells the story of how a drunken farmer leaves Ayr one stormy night, and, riding past Alloway Kirk on his way home, pauses to spy on a party of witches and warlocks dancing to the pipes of the devil. Foolishly betraying himself by calling out approbation for the dancing of the youngest witch in her 'cutty sark', he only escapes pursuit by reaching the safety of the keystone on the Brig o' Doon, baffling the witches who are unable to cross the running water. The circumstances in which Burns tossed off this piece go far to explain why it has become such an integral part of the Burns tourist experience: making the acquaintance of Captain Francis Grose,

then compiling his *Antiquities of Scotland*, Burns requested that he include a plate of the ruined Alloway Kirk in the second volume of 1791, probably because of its family connections – Burns's father was buried there, and he intended himself to be buried there. Grose agreed, on condition that Burns supply him with a poetic rendition of the traditions associated with the ruined church which had been the subject of their conversation; the result was published in an extended footnote. Alloway Kirk, therefore, was visually famous fourteen years before the Cottage itself. Its enduring place in the Burns itinerary, however, is perhaps not because it is regarded as masterpiece but because the story of the drunken Tam, embedded within the birthplace site, functions as a repressed and comic version of Burns's amatory and alcoholic delinquencies which were supposed to have hastened his death.

This prevalence of the story of *Tam o' Shanter* within the experience of visiting the Cottage is illustrated in one of the earliest extant accounts of a visit. Keats lists the sights: 'we came down upon everything suddenly – there were in our way the 'bonny Doon', with the Brig that Tam o' Shanter crossed – Kirk Alloway, Burns's Cottage and then the Brigs of Ayr.' The companions took in the view from the bridge (where they took a pinch of snuff on the famous key-stone), and then visited the kirk (taking in also the spots where 'Mungo's mither hang'd hersel' and 'drunken Charlie brak's neck-bane' before repairing to the Cottage, which Keats records as sporting a sign as the Birthplace, for whisky and the obligatory stream of anecdotes from the elderly charlatan of a host, Miller Goudie, who claimed, with very slender foundation, to have known Burns, and entirely mendaciously, to be the Miller mentioned in *Tam*.[34] Keats was profoundly depressed by his experience of visiting the inn, and was unable to write what he regarded as a decent sonnet to mark the occasion and the spot. He put this down in part to his renascent sense of Burns's subsequent career, which he had hoped to leave behind in Dumfries with the mausoleum: 'His misery is a dead weight upon the nimbleness of one's quill.'[35] Other travellers, though equally annoyed by Miller Goudie, maintained the light-heartedness of Keats's snuff-taking on the brig as the ethos of their visit. The poet Hew Ainslie's published account of a similar all-male tour undertaken by himself and two friends just a year later in the summer of 1820, *A Pilgrimage to the Land of Burns; containing Anecdotes of the Bard, and of the Characters he Immortalized, with numerous pieces of poetry, original and collected* (1822), makes it clear that the Tam o' Shanter experience was as important, if not more so, than visiting the birthplace. Having visited the house of Tam's drinking companion 'Souter Johnny' in Ayr, they

took Tam's road to Alloway, dropping in at the birthplace for whisky and to see 'the apartment containing the portrait of the Bard' – a visit enlivened by Miller Goudie's well-rehearsed patter ('there he sits in paint and timmer, that I hae often seen sit in flesh and blood').[36] One of the threesome achieves a consonant vision of Burns 'under the roof where our favourite Bard was born, and where his mighty soul first began to burn and boil out of its earthly tabernacle.'[37] In the place in which the modern tourist is now treated to the waxwork spectacle of father, mother and the young Robert engaged in reading from the Bible, a scene derived from 'The Cotter's Saturday Night', this nineteenth-century tourist saw the more disreputable hard-drinking satirist and lover of low-life: the portrait comes alive and Burns is seen 'seated in rather an obscure corner of the room, and evidently employed in both musing and remarking' in the company of many of those real-life characters immortalized in his poetry under the names of 'Holy Willy', 'Dr Hornbook' and 'Davie Sillers'.[38] However, even this experience pales into insignificance beside their visit to Kirk Alloway, described as 'the very core of their pilgrimage,' where they picnicked in the grand style, and made speeches and verses to Burns's memory that run to many pages.

Ainslie and his friends were by no means alone in making Alloway Kirk, rather than the birthplace itself, the focus of their interest. Hoping to acquire a souvenir of his visit 'Edie' asked after some wood from the ruins of the Kirk 'just as muckle o't as wou'd made a heft to a kail gully, or a shank to a punch spoon', only to be informed that all the wooden rafters had long gone and been transformed into souvenir snuff-boxes (many of which can be seen nowadays in the various Burns museums).[39] Some of those rafters eventually wound up roofing a 'Shell Palace' in the grounds of Doonbrae Cottage. Encrusted with shells on the outside, and mirror on the inside, favoured visitors of a certain class were asked in to admire the rafters in their startling new setting.[40] By the 1840s, not content with souvenirs from the site of the Kirk, which, incidentally, included two whole tombstones originally erected on the grave of Burns's father which were carried away piecemeal (the present tombstone is the third erected on the site), it had become fashionable amongst the aristocracy to acquire plots of land within the derelict precincts of Alloway Kirk, and there they were buried, gruesomely jostling for position as literary celebs by association, which accounts for the surprising crowdedness of the site both outside and inside the walls. The extraordinariness of this fashion is a peculiar, not to say perverse, witness to the canonicity of *Tam o' Shanter* as a version of Burns himself.

The unstable combination of humbleness, respectability and disreputability that I have been describing as articulated for the nineteenth-century tourist by Alloway is played out in the history of the conservation and monumentalisation of the site. In 1813 the old Brig o' Doon was reprieved from demolition by enthusiasts for *Tam o' Shanter*, who subsequently banded together to lay the foundations of a monument to Burns's birth, erected just above the old Brig o' Doon in 1820 (Figure 2.2). Opened in 1823, the sheer incongruity of this monument (this 'fane', as it was poetically called) with the concept of Burns as rustic bard embodied by the Cottage was just the point. It takes part of its meaning from the humbleness of the Cottage (by the side of which it was originally

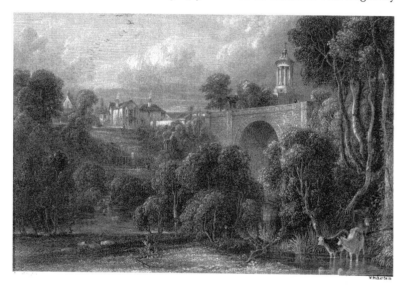

NEW BRIG OF DOON

WITH BURNS' MONUMENT

Published by Blackie & Son Glasgow.

Figure 2.2 New Brig of Doon, with Burns' monument, from *The Land of Burns: A Series of Landscapes and Portraits, illustrative of the Life and Writings of the Scottish Poet. The Landscapes from paintings made expressly for the work by D.O. Hill esq. R.S.A. The Literary Department by Professor Wilson . . . and Robert Chambers esq.* (Glasgow, Edinburgh, and London, 1840). Bodleian Library.

Alloway, Burns's birthplace, showing the uneasy proximity of Alloway Kirk (setting for '*Tam O'Shanter*'), the Banks of Doon, and the immense neo-classical monument erected posthumously by Burns's admirers.

hoped to erect it).[41] Seventy foot high, a circular temple perched on massive triangular foundations representing the three districts of Ayrshire, boasting nine columns representing the nine muses and topped off with golden dolphins symbolizing Apollo the god of song, and a tripod of divine fire, it was so designed that you could (and can) climb up inside it and view the surrounding countryside. It memorialises Burns, who confessedly did not have a classical education, as nonetheless a classical national and international poet in the tradition of Homer and Virgil. (The essentially abstract conception of the Monument did not prevent Victorians from covertly biographicising and sentimentalising it: within it at various points different relics have been displayed, including a lock of Highland Mary's hair and the Bible Burns is said to have given her on their parting, the wedding ring of Burns's wife Jean Armour and Burns's ring set with her hair). Yet even this designedly austere grandeur found itself paying a tribute to the vernacular disreputability of *Tam* in the Burns festival of 1844. After processing from Ayr to the birthplace in a manner thoroughly reminiscent of contemporaneous celebrations of Shakespeare's birthday, the local dignitaries and enthusiasts were treated to the usual musical entertainments, a banquet, speeches and the ceremonial festooning of the monument with flowers. But then the ten thousand strong crowd were treated to a delightful dramatic surprise – 'the sudden appearance of Tam o' Shanter "well-mounted on his gray mare Meg" and a flight of witches in full pursuit of her, till he reached and passed the keystone of the arch of the Auld Brig.'[42] The current audiovisual 'Tam o' Shanter Experience' (not to be missed) running nearby at the Burns Heritage Centre thus has a very long history.

By 1844, therefore, Keats's and Ainslie's improvised experiences had been formalised within a succession of festivals which largely imitated the various Shakespeare jubilees that had followed in the wake of Garrick's first effort. And in many ways, the construction and experience of the Cottage as a tourist-site over the course of the nineteenth century closely shadowed the protocols and fashions established by Stratford-upon-Avon. Visitors left their signatures on the site, although here they did not confine themselves to signing the walls, but carved their initials on all the furniture as well until eventually supplied with a visitors' book; they purchased souvenirs made of wood that grew 'on the banks o' Doon'; extensions were erected to cope with the growing number of visitors; and by 1897 there were the inevitable accusations of commercialism – Henry Shelley, for example, complained that the Cottage, no longer a pub, had 'rather too much the air of a commercial show-place, with its conventional turnstile and persistent charge of

twopence admission somehow the air seems stifling to the literary pilgrim.'[43] In 1902, therefore, it was decided to make the experience more 'authentic' by stripping away all extensions and restoring the interior to kitchen, living-space, barn and cow-byre, very much as it is displayed nowadays, though without the life-size models of family, cows, chickens, cat and the introductory video that enliven it at the present.[44] The Cottage is due soon to undergo another of these phases of re-authentication under the auspices of the National Trust of Scotland, and it seems likely that this will involve a further stripping-out, rather as in Stratford, to produce a space of empty potential.

III The 'Land of Burns' & 'Shakespeare's Stratford'

> *Land of the Bard! To nature not alone,*
> *All beauty dost thou owe:*
> *Thy poet lives, thy scenes among,*
> *Breathing the music of his song,*
> *O'er earth below . . .*[45]

Although the development of Burns's cottage as a place of pilgrimage over the nineteenth century may be seen to follow upon developments in Stratford, this is not true of the parallel developments in the 'Land of Burns' and 'Shakespeare country'. Despite the pioneering work of Ireland's *Picturesque Views* in developing 'Shakespeare country', 'The Land of Burns' developed more rapidly, comprehensively, and convincingly than Shakespeare country, arguably setting the model for how to make a landscape originate and express a 'national' poet. This was, in large part, because the work of Burns was generically more suited to the attempt to root it within a landscape than Shakespeare's plays were. Gall's little poem of 1799, composed a mere four years after W.H. Ireland's *Picturesque Views*, adumbrates even at this very early stage, the fundamental emotional and rhetorical structures that would be developed over the course of the nineteenth century and which still inform Burns tourism today.

Expanding from a consideration of the Cottage to its close environs, Gall apostrophises the river Doon that runs close by, writing:

> O Doon! Aft wad he tent thy stream,
> Whan roaming near thy flowery thorn,
> An' sweetly sing 'departed joys,
> 'Departed never to return!'

> An' near thy bonny crystal wave,
> Reft o' its rose we find the brier,
> Beneath whase shade he wont to lean,
> An' press the cheek o' **Jeanie** dear.
>
> O'er yonder heights, in simmer tide,
> His canty whistle aften rang;
> An' this the bank, an' this the brae,
> That echoed back the Ploughman's sang.

Gall describes a poetic genius rooted organically in the specificities of place through personal sentiment and biographical incident. In defiance of the facts as laid out in the first biography of Burns, Robert Heron's memoir published in the *Monthly Magazine* for 1797, Gall imagines Burns on the banks of the Doon courting Jean Armour, a strategy which already qualifies as a new mode of tourist sentiment. He does so in near-quotation from Burns's songs, serially citing 'Ye banks and braes o' bonny Doon' ('Ye'll brak my heart, ye warbling birds, that wanton through the flowery thorn, / Ye mind me o' departed joys, departed, never to return' and 'But my fause lover stole the rose, and left and left the thorn to me'), 'My luve is like a red, red rose', and 'I dream of Jeanie wi' the light brown hair'. Poet is imagined as at one with the 'Ploughman's sang', and crucially, his experience can be 'found' and so repeated: 'Reft o' its rose we find the brier, / Beneath whase shade he wont to lean, / An' press the cheek o' Jeanie dear'. The landscape exhales the poet's song.

This sense of the poet as principally a song-maker in dialect is peculiarly partial viewed as a description of Burns's *oeuvre*, even as it was known in 1799, but it does point up the relative freedom of Burns from the weight of the idea of text and print-culture.[46] Song can be felt to flow naturally, spontaneously, organically and solely, from the poet's body inspired by and within the landscape, the more so when it is closely related to traditional song. From very early on, with Currie's important and much reprinted edition of the *Works* and the biographical and critical notices attached to it, this made it possible paradoxically to regard Burns as at once an entirely autobiographical poet and as an entirely national Bard. On the one hand, his poetry, according to Currie, is never 'fictitious' – the man and the poet are one and the same:

> The subjects on which he has written, are seldom, if ever, imaginary; his poems, as well as his letters, may be considered as the effusions

of his sensibility, and the transcript of his own musings on the real incidents of his humble life.. . . His writings may therefore be regarded as affording a great part of the data on which our account of his personal character has been founded; and most of the observations we have applied to the man, are applicable, with little variation, to the poet.[47]

On the other hand, his poetry included the 'most happy delineations of the characters, manners, and scenery that presented themselves to his observation' and so 'displays, and as it were embalms, the peculiar manners of his country; and . . . may be considered as a monument not to his name only, but to the expiring genius of an ancient and once independent nation.'[48] Thus a poet of sensibility can also be a national poet, enlarging 'the poetical scenery of his country' through a set of new ballads added to the traditional repertoire:

Many of her rivers and mountains, formerly unknown to the Muse, are now consecrated by his immortal verse. The Doon, the Lugar, the Ayr, the Nith, and the Cluden – will in future, like the Yarrow, the Tweed, and the Tay, be considered as classic streams, and their borders will be trod with new and superior emotions.[49]

Currie's prose is, like Gall's verses, already mandating the idea of walking these locations in a state of emotional recognition. He suggests the possibility, indeed the desirability, of retracing the poet's steps. In so doing, the walker will experience 'new and superior' emotions, which are imagined as at once originating with the poet and yet as thus becoming collective. Currie specifies the reality of locations referred to in 'The Lea Rig', 'Highland Mary', 'The Soldier's Return', and 'Logan Water', noting that the walk along the banks of the Nith and Cluden to Lincluden Abbey (still sign-posted as the Burns Walk to this day) is associated with the composition of 'Ca' the yowes to the knowes' and 'A Vision'.[50] Here, the experience is utterly divergent from subsequently formulated tourist experiences which might seem at first glance to be similar. Walking with Wordsworth, for example, is to walk with the sage of Grasmere; the tone may be lofty, at any rate on his side, but the experience is essentially a dialogue. With Burns, however, the utterance is not simply personalised to Burns but operates as a set of inhabitable all-purpose but fundamental human emotions, varying from the amatory – 'My luve is like a red, red rose' – to the political – 'A man's a man for a' that'. These emotions become general (though focused through 'Burns')

because of the strongly traditional nature of the form and of the address of the songs. With Burns we have at once the lyric poet who is personalised to the landscape because of the biographical force and occasionalism of the poetry, and yet also an impersonal poet, who gives voice to the songs of the country, and so to its very soil and to its people: a channel for the entire tradition of the folk.

Ainslie's *A Pilgrimage* (1820) portrays autobiographically just these habits of tourist sentiment and travel. This pilgrimage, made as a last celebration of their friendship before two of the three emigrated to America, aimed to extend their reading of the works and the biography to a sense of 'the living material, out of which he built so imperishable a fame', a material that is composite of traditional song, local characters, the 'walls that kept him warm', and, above all, scenery: 'we long to see the land that gave him birth, the rivers by which he roamed, the woods in which he sang.'[51] Actually, what these young poets *really* want to do is sing the songs themselves in the same place as Burns was supposed to have done. And they do. They sing 'Scots Wha Hae wi' Wallace Bled' on Carthen Crags, they sing 'Ayrshire Lasses' on their entry into Ayrshire, they recite 'Mauchline Belles' on Galston Moor, they sing 'Ye Banks and Braes' by the banks of the Doon, and 'Highland Mary' by the river Ayr. When they are not singing or reciting Burns, they are collecting traditional songs like Burns's, making up their own sub-Burnsian poetry apostrophising places or girls, collecting the tombstones of those persons immortalized by Burns under the names of 'Nanse Tinnock', 'Holy Willie' and 'Racer Jess', visiting Burns's pubs (in one instance to view the chair made out of the 'cutty stool' on which he had been obliged to endure the censure of the elders of the kirk at Mauchline for his irregular relationship with Jean Armour), or investigating the possibility of souvenirs. They display, in short, a remarkable versatility and range as literary tourists walking in the steps of Burns, especially considering the early date of this expedition.

Ainslie's thoughtful remarks on the way in which merely biographical interest in a birthplace can be extended to the development of 'the land of Burns' cannot be bettered as a description of the way in which certain sorts of lyric poetry can infuse the poet into the landscape, dissolving the inconvenient mediation of print into mere metaphor:

> In visiting the birth-place of the most of those mighty men who have made the world their debtors, we are generally occupied with the reflection, that the man, whose 'immortal essence' either instructed, amused, or enraptured us, opened his young eye, tottered his first

step, and lisped his first word amid such scenes. But here these are only inconsiderable items in the sum of our feelings. All around – the mountains, rivers, forests, and floods – cry loudly of him, for he spoke of them. *There* lies the living library that stored his mind, and the pages from which he so faithfully copied. His soul gushed forth in the brawl of the Bonny Doon; melted into melody at the song of these leafy woods – or mounted into Heaven with the wing of the morning lark – Nature, in a word, was his nurse, and while she lives, will be his monument.[52]

Burns's poems are thus stored within the scenery. More than twenty years later, William Howitt would write similarly of his experience of standing on the Brig of Ayr and remembering his reading of 'The Auld and the New Brig': 'There is a peculiar pleasure in standing on this old Brig, so exactly has Burns enabled you to place yourself in the very scene that he contemplated at the moment of conceiving his poem.'[53] This idea of short-circuiting print-culture by reconstituting the moment and vantage-point of poetic conception within the tourist-reader also founds the extraordinarily lavish picture book *The Land of Burns*, published in 1840, which out-does any similar production associated with Shakespeare, and is second in elaborateness among feats of literary topography only to a few subsequent illustrated editions of Scott's Waverley novels. In two large volumes, boasting numerous landscapes and portraits engraved from especially commissioned paintings by David Oliver Hill, R.S.A., and with text supplied by none other than Professor John Wilson and Robert Chambers on the basis of visits expressly made for the purpose, this aimed to provide comprehensive illustration of the life and writings of Burns. Most strikingly, these volumes feel no need to explain or recommend themselves to the reader; they take the reader's topographical interest for granted, even extending illustration to locations not associated with Burns 'on a cumulative principle . . . as characteristic features of that land identified with his genius.'[54] These sentiments also inform the handsome prints that began to appear in the 1850s to celebrate the centenary of his birth, which typically show a portrait of Burns at centre, surrounded by vignettes of locations associated with him and his writings.[55] Both *The Land of Burns* and these prints were capitalising upon well-established touristic habits. Travelling north, the Wordsworths were shown Ellisland Farm, where the poet wrote *Tam o' Shanter*, as early as 1803; in 1833, passing by Mossgiel Farm (the interior of which was already being illustrated in 1832 in *Interesting and Remarkable Places*), where Burns composed 'To a

Mouse' and 'To a Daisy,' they, like many thereafter, were shown the very field in which Burns turned up the mouse's nest, and the next-door field in which he ploughed up the mountain daisy.[56] In 1857, Hawthorne saw this field (in which he 'plucked a whole handful of these flowers, which will be precious to many friends in our own country as coming from Burns's farm') and by the exercise of some rudeness also viewed Burns's bedroom.[57] By the 1890s Mossgiel had a regular visitors' book.[58] The years to come would add more sites further off the beaten track up to the Highlands. In the 1830s it was customary to visit the grave of the original for Tam o' Shanter, one Douglas Graham of Shanter Farm; so picturesque was this thought to be that Hill included a painting of 'Tam's grave' in *The Land of Burns*, replacing the actual inscription with 'the fictitious appellation'.[59] In the early 1840s, Howitt insisted on being allowed to visit the thorn-tree under which Burns was supposed to have said goodbye to his Highland Mary, and found it broken and battered by souvenir-hunters,[60] and consonant with this interest in 1842, the original grave of Highland Mary was embellished by a grand carving representing 'the parting of the lovers, who are overshadowed by a figure of 'Grief''; while beneath it is the word 'Mary', and the lines – 'Oh, Mary! Dear departed shade! / Where is thy place of blissful rest?'[61] In 1857, Hawthorne was being shown the very pew in St Michael's church at Dumfries in which the young lady sat on whom Burns saw the louse immortalised in 'To a Louse'.[62] By the 1880s, admirers would be visiting the Ballochmyle Woods, setting for 'The Bonny Lass of Ballochmyle'; for their better pleasure the owner had placed viewing benches, had marked one 'the poet's own chair', and had built a grotto called the 'Fog House' on the spot where the poet met Miss Alexander, the addressee of the poem. At the back of it was a 'tablet' which contained 'a facsimile of two of the verses of the poem . . . as they appear in [the] original manuscript.'[63]

Today 'Burns Country' is covered with memorial plaques and inscriptions to an almost inconceivable extent. It bears witness to a habit of memorial that outdoes the memorialisation of any other writer dead or alive. There are grand official memorials, there are municipal memorials, there are opportunistically commercial memorials, there are memorials put up by individuals and by corporations; and they all apparently co-exist happily, in strong contradistinction to the slight hauteur with which the official Shakespeare properties regard less 'authentic' sites. There are memorials to events in Burns's life, memorials to places where he wrote poems, and memorials to the places about which he wrote poems. The nineteenth-century admirer merely visited

these places, plucked a few leaves of ivy, and subscribed where appropriate for another plaque; the twentieth-century visitor has been provided with a stunning array of postcards of sacred places, which are themselves designed to act as memorial of place.[64] Without even attempting to be in any way comprehensive, and bracketing the problems of Glasgow and Edinburgh altogether, one might list a sample of some of these plaques and signage: in Ayr the Tam o' Shanter Inn (with the very chair in which Tam sat, and the 'caup' from which he drank); in Dumfries the Ho in the Wa' Inn, the Globe Inn (littered with plaques engraved with his verses), the Burns House, the Burns Café, the Burns Hairdresser, the statue of Burns, the statue of Jean Armour, the map in the churchyard showing not just the location of Burns's grave but those of all his contemporaries; in Mauchline another statue of Jean Armour (put up in 2004 – surely the first time the wife of a poet has ever been so honoured) and Burns's own pew in St Michael's church, another Burns house, Nanse Tinnock's, the churchyard, Poosie Nansie's pub (credited as the scene of 'The Jolly Beggars' and still authentically squalid, as I can vouch from personal experience – my shoes actually stuck to the floor, so filthy was it); elsewhere, Ellisland Farm and Mossgiel Farm. There is a cairn in Leglen Woods where Burns was supposedly inspired to write 'Scots Wha Hae wi' Wallace Bled'. There is a plaque to mark a favourite walk at Drukken Steps. There is a column (some fifteen or twenty feet high) at the place where Burns said goodbye to Highland Mary; there is a plaque at Brow Well where he came to take the waters as he was dying (which sighs with more than a touch of imperfectly veiled commercial regret that 'The inn was destroyed in 1863, no one at that time thinking it of any great importance'), there is a plaque on the fish-and-chip shop in Annan where he apparently wrote 'The Deil's Awa' wi' the Excise-Man'; there is a mural on the gable of the pub in New Cumnock where he drank. There are, seemingly in every direction, panes of glass upon which he scratched a few lines of verse. There were panes in the hermitage at Friars' Carse where Burns met Grose (William Howitt tried to find them in 1847 but found only ruins),[65] at Ellisland, at the Black Bull Inn in Moffat, at Loudoun Manse, at the Cross Keys Inn in Falkirk, and at his favourite pub, The Globe Inn in Dumfries.

Perhaps these panes of glass, above all, seem the most perfect emblem of the way that with Burns the act of composition is supposed to be all but indistinguishable from the biographical occasion – they epitomise the way in which all these plaques and memorials taken together are curiously indiscriminate about the difference between 'life' and 'work' – it is all made of the same stuff. As with the 'tablet' on the grotto at

Ballochmyle, the alienations and inauthenticities of print do not enter here, nor the portability even of manuscript; this is poetry simultaneously derived from and engraved upon place. This habit of mind also manifested itself, paradoxically, in print forms, the spectrum of which may be indicated by a souvenir publication held at the Writers' Museum in Edinburgh – *The Scottish Keepsake: A set of poems by Burns bound in wood, warranted part of the barn roof of Mossgiel Farm* (no date) – and by the industrious Henry Shelley's late *The Ayrshire Homes and Haunts of Burns* (1897), which simply juxtaposes photographs captioned with the poems. However, this engraving of poet and poetry upon place was already epitomised as early as 1840 by one of Hill's 'fancy pictures' which acts as a frontispiece to the second volume of *The Land of Burns*. Entitled 'The Poet's Dream', it shows Burns asleep in Lincluden Abbey, 'which I need not remind a devotee of Burns was one of his most favourite haunts' (Figure 2.3).[66] It comes supplied with an elaborate description by the artist:

> I have supposed that the Bard has visited this beautiful seclusion, late on a summer night; that he has lain down on one of the verdant knolls before the ruin . . . [and] falls asleep, and immediately supposes his head to be pillowed on the lap of Coila. . . . In this situation he is found by the king and queen of the fairies, who with their train of elves, spunkies, brownies, kelpies, mermaids, etc, come to hold a night of high revelry They immediately recognize him as the child of song, who had celebrated their race, and resolve to gratify him with a vision of some subjects worthy of being by him immortalised. As on another 'mid-summer night,' a difference of opinion arises between the royal pair, in regard to the nature of the vision to be presented. The voice of the king is still for war, and he wishes to inspire the poet to sing of high and noble deeds. The queen gives her voice for gentler and humbler themes . . .'[67]

This poet's dream is highly reminiscent of the way in which *Shakspeare's Early Days* locates Shakespeare's 'vision' on the banks of the Avon superintended by the King and Queen of Fairies. As in the play, Burns's fictional and semi-fictional characters from *Tam o' Shanter*, 'The Jolly Beggars', 'To Captain Grose', and 'Death and Dr Hornbook' appear in the same register as locations depicted with documentary accuracy, not merely Lincluden Abbey itself, but the Monument at Alloway, included to dramatise the artist's sense that 'through poverty, neglect and detraction, the vision of his future fame never forsook him;' 'accordingly his

Figure 2.3 'The Poet's Dream', from *The Land of Burns: A Series of Landscapes and Portraits, illustrative of the Life and Writings of the Scottish Poet. The Landscapes from paintings made expressly for the work by D.O. Hill esq. R.S.A. The Literary Department by Professor Wilson . . . and Robert Chambers esq.* (Glasgow, Edinburgh, and London, 1840). Bodleian Library.
The poet naturalised within a landscape both regional and national.

monument is seen in the bright, though far distance'.[68] Characters are thus given the same epistemological status as location. The conceit of the poet 'dreaming' his characters cuts out everything that must intervene before the poet's 'dreams' can be transferred whole and entire to the reader so that they can 'dream' it in their turn, retracing Burns's

steps to Lincluden. Intentionality, the physical act of writing on a desk, and the whole business of printing, retailing and reviewing books, simply vanishes. This version of the poet Burns is not merely idiosyncratic to this picture; although a desk on which Burns wrote is nowadays shown in the house at Dumfries and one is also on display at the Writers' Museum in Edinburgh they do not command the same reverential awe that, for example, Sir Walter Scott's multiple desks command. The desk is, by comparison, an irrelevant side-show.

The fairies, derived according to the description from 'Ca' the yowes to the knowes', are, however, associated with Titania and Oberon from Shakespeare's *A Midsummer Night's Dream*. As in the case of *Shakspeare's Early Days*, the fairies are of such interest because they are a critical marker of the Victorian desire to root 'The Poet' into a rural landscape conceived of as national. 'The Poet's Dream' is explicitly full of *'national expression'*; the king of the Fairies conjures up the national flag and the figures of Wallace, Bruce, Douglas and Randolph, 'characters, it may be presumed, in the intended drama, founded on a portion in the history of the great restorer of Scottish liberty, which Burns long nourished the idea of writing, and which Sir Walter Scott regretted, and his countrymen may ever regret, he did not live to write.'[69] The Bardic figure at the apex of the picture is 'the stern and stalwart ghaist of liberty' which appeared to Burns on this site. By contrast, *Shakspeare's Early Days* is obliged to remove Shakespeare to London to nationalise him successfully by making Queen Elizabeth give him the prize as National Poet.[70] 'The Poet's Dream' successfully makes over Burns as a national poet, compounded in about equal parts of national epic, love-ballads (hence the 'rustic beauties'), and satiric whisky-flavoured raunchiness: 'The whole phantasma is lighted up from the fire of a fairy distillery, which may be at once taken as allusive to the professional occupation of the exciseman, and as showing the nature of that spell of power which has conjured up the vision; namely, the very potent "but very natural necromancy of the punch-bowl".'[71]

The similarities between 'The Poet's Dream' and *Shakspeare's Early Days* take us back to the Victorian problem of inventing a 'Shakespeare country' around the birthplace. The play had already produced the deer-stealing rambunctious Shakespeare as a parallel version of Burns's attractive irregularities (though here given a cast of Saxon respectability by a Robin Hood-like pretext of feeding the distressed poor); it remained to invent Shakespeare as a lover worthy of the landscape of 'merrie England'. The problem was solved by inventing 'Anne Hathaway's Cottage' in ways reminiscent of the insertion of Burns as ploughman,

poet and lover into the landscape. If Burns's amatory irregularities were rather an embarrassment to Victorians, far more so were the troubling facts of Shakespeare's marriage at eighteen to a woman some eight years his senior, and already heavily pregnant, the provision in his will pointedly leaving only the 'second-best bed' to his wife, and the general awkwardness of the Sonnets, which, whether addressed to man or woman, were clearly not addressed to Mrs Anne Shakespeare *née* Hathaway. As a result, this outlying cottage, visited first by Ireland in a purely antiquarian spirit, was pressed into service as the locus of a sentimental idyll. Purporting to narrate the love-affair of Shakespeare and Anne, Emma Severn's truly execrable novel *Anne Hathaway, or Shakespeare in Love* (1845) expends a great deal of time and effort upon presenting the Cottage as a virtuous rural retreat, not unlike that bought by Celia and Rosalind in *As You Like It*. It is symptomatically surrounded by a magical and botanically simultaneous countryside infested with fairies, escapees from *Midsummer Night's Dream*, jealous of the marital happiness of the two lovers:

> The sprites drooped mournfully, and wept till the harebells and violets of Stratford Wood and Shottery lawn were brimmed to overflowing with fairy tears of grief, envy, and despair.[72]

Regrettable though Severn's prose is, her fairies certify Shakespeare's organic relation with the English countryside via his love for Anne within this pastoral. By 1839, when William Howitt made his visit to Stratford, recorded in his *Visits to Remarkable Places*, he consciously diverted his footsteps away from the Birthplace towards neglected Shottery, which he found to be 'authentic and unchanged'. To Americans especially the setting of the Cottage would sum up all that was English: a guide of the 1890s wrote it up as a 'perfectly representative and thoroughly characteristic bit of genuine English rustic scenery.'[73] In 1886 William Winter, perhaps the most influential American writer on Stratford after his countrymen Washington Irving and Nathaniel Hawthorne, was much taken with this 'rustic retreat' as 'the shrine of Shakespeare's love'.[74] Typically for his time, he traces Shakespeare's supposed love of flowers and of pastoral landscape to his happy memories of the scenes of his wooing, and reverently carries away a 'farewell gift of woodbine and roses from the porch'.[75] Though this portrait of the poet in love smacks as much of Fotherington–Thomas as of Burns, it demonstrates the way in which by the 1880s Shottery had evolved into a satisfactory location for the heady mix of rustic chivalry,

merrie Englandism, botany and romantic domesticity overseen by fairies that 'Shakespeare's England' was supposed to have been. (By 1910, courtesy of this enthusiasm, the whole set-up had become a good deal less 'rustic' than advertised; Christian Tearle in his *Rambles with an American* noted rather sourly that 'The meadow paths are not nearly as sylvan as the guide-books would lead one to expect. The endless stream of excursionists, which has flowed along them throughout spring, summer and autumn for so many years, has left its mark.'[76])

Both Shakespeare and Burns are made into National Bards by being naturalised to a landscape and locality at once actual and representative. This is achieved through a series of texts which coalesce the allegorical and the realist within a specified place. The notion that the Poet is simply the medium through which the land – whether embodied as Enlightenment 'Nature' or as Victorian fairies – dreams its own national literature is common to the formation of both Shakespeare Country and the Land of Burns, and demands a cultural forgetting of the mediation of print. This erasure is rendered the more possible because the genres with which each poet is primarily associated – drama and song – are already both rather ambiguously related to print culture. The apparent dematerialization of print-culture encouraged and mandated tourism to the place which had at once originated the poet and the poets' visions, the more so since these places were envisaged as the destination for consciously patriotic pilgrimage, whether on the part of natives or on the part of the wider English-speaking cultures that regarded such places as in some sense original to their own nation. Both these places, paradoxically, only bulked so large in the American imagination by virtue of the wide dissemination of publications about Stratford and Alloway, combined with visual representations ranging from prints to pop-up models to ceramics; as William Winter observed in 1886: 'Every pilgrim to Stratford knows beforehand, in a general way, what he will there behold. Copious and frequent description of its Shakespearean associations have made the place familiar to all the world.'[77] By the end of the century, as a result, American travel-writers were regularly expressing disappointment with the confined physical actuality of these national locations: Hawthorne complained in 1857 that Burns's cottage was dirty and smelt, and that Alloway kirk was 'inconceivably small, considering how large a space it fills in our imagination before we see it'.[78] In 1863 he was complaining in almost the same words that the Birthplace in Stratford was 'a smaller and humbler house than any description can prepare the visitor to expect', that indeed, there had been too much description – the visitor had 'heard, read, thought, and dreamed' too

much about the place for it to live up to expectations.[79] Christian Tearle's fictional American tourist, Mr Fairchild, complained in 1910 of the failure of reality to live up to the imagination, carping both that the tidied-up Birthplace was 'offensively modern', and yet that it was dismayingly archaic: 'so mean and so dark that you can't think of any civilised person living in it, without a sort of pity.' Mr Fairchild traces his own disappointment to his sense of Shakespeare 'as some great natural wonder, something in the open air – something like the sea itself, or a mountain'.[80] As Mr Fairchild's remark suggests, the successful national mystifications of 'Shakespeare Country' and 'The Land of Burns' may depend upon the centrality of the birthplaces, but depend equally upon the absence of any house that could plausibly be described as a professional writer's workshop. In the next chapter, I turn to a different type of destination for the literary tourist, looking at two writers' houses that display two very different models of workshops of creation and solicit two very different types of tourism, namely Abbotsford, home of Sir Walter Scott, and Haworth, home of the Brontë sisters.

3
Homes and Haunts

A birthplace is of course in some sense a 'writer's house', but it is almost never the house in which the writing has actually been done, the workshop of genius, the apogee of literary tourist sites. One of the very few exceptions to this rule – and marking a transitional state between the Poets' Birthplaces of my last chapter and the Writers' Houses that dominate this – is the cottage in Upper Bockhampton in which Thomas Hardy was not only born and brought up but wrote some early poetry and the first two of his novels to meet with success and define him as a novelist of rural life. Hardy's birthplace was celebrated as early as 1902 by one Wilkinson Sherren, some twenty years before his death, when the cottage was still in the ownership of the family and its privacy was jealously guarded by Hardy himself. Sherren was interested especially in its perceived suitability as the source of Hardy's *oeuvre*:

> Embosomed in this solitude is the picturesque house where Mr Thomas Hardy was born, and where his childhood days were saturated with rural peace and glamour . . . A more favourable environment for one who was to win reputation chiefly on account of his studies of rustic life, cannot be imagined.[1]

Sherren here, in accordance with convention, describes the birthplace as pre-existing the labour of writing. The craft and work of composition is replaced by a story of formative environment. In Burns's case the inconvenient fact that the poet was only seven years old when the family removed from Alloway to Mount Oliphant is actually an advantage. The current video presentation at the 'Auld Clay Biggin' almost makes a virtue of the fact that the cottage has nothing to do with conscious literary artistry, concluding that 'the flame of [Burns's] poetic genius had

already been kindled here'. Nothing more remained to be done, clearly. In Upper Bockhampton the situation is slightly more complicated, for it was here, as a notice announces, in a window-seat upstairs, that Hardy wrote *Under the Greenwood Tree* (1872) and *Far From the Madding Crowd* (1874), gazing out in the throes of composition upon the confined view. Here (and there is some foundation for this contention in the work itself) Hardy wrote naturally and unselfconsciously, in a way that precedes the hard grind of the professional writer, in the same way that Burns was supposed to have done. The window-seat is the equivalent of Burns's panes of glass in its assertion of the writer's direct transcription of reality. This sense of the unity of experience with the writing is amplified in the mythology of both houses by the fact that both were family-built – Alloway by Burns's father, Upper Bockhampton by Hardy's great-grandfather – and by the poets' own evocations of the houses, in Hardy's instance, in the early poem *Domicilium*. The buildings are thus physically and genetically connected to the writers, and in this respect their celebrity can be seen as the antithesis of that promulgated within the 'workshop' type of the writer's house, epitomised by the writer's desk. The cottage only speaks of Hardy as poet of the rustic because it does *not* contain Hardy's desk; that desk, ramparted with pens and books that speak the hard, professional labour of the prolific novelist, is safely quarantined behind glass in the Dorset County Museum down the road in Dorchester.

Two houses that do speak of the writer's creative labour – albeit in very different ways – are my subject in this chapter: Abbotsford, the most famous of Sir Walter Scott's many homes, and Haworth, home of Charlotte Brontë and her sisters. Abbotsford is of critical importance in the development of the writer's house as a place to visit because it is the first house in Britain to have been shown as the site of the writer's work; indeed, it was the first house consciously designed by a writer to display the income and status derived from authorship, to exemplify and epitomise his writing, to act as a fitting frame for the personae and literary achievements of both the Minstrel of the North and the Author of Waverley, and to be visited by admirers from the outset. As such, it is the model for many subsequent displays of 'writers' houses', most particularly those houses initially organised as display-cases by the living writer; examples that spring to mind include not only Victor Hugo's house in Guernsey, extraordinary as a collection of curiosities dramatising Hugo as a historical novelist in the mould of Scott, but Wordsworth's house in Rydal Mount, which was not only designed by the poet to provide a suitable setting for the Sage of Grasmere, but

which by 1832 was attracting general tourist interest of a sort reminiscent of that generated much earlier by Abbotsford.[2]

Haworth can claim an equal grip on the nineteenth-century imagination, and yet it forms an instructive contrast to Abbotsford in almost every way. Haworth, unlike Abbotsford, was a 'back-formation'. Whereas Abbotsford was made by the author in the likeness of the author, Haworth was made into the likeness of the Brontës subsequently, and so betrays more explicitly what the culture wished to make of the sisters. Whereas Abbotsford dramatises the extraordinary success, both cultural and commercial, of an author, Haworth dramatises female authorship as unsuccessful to the point of invisibility. If Abbotsford provides a largely euphoric narrative of the self-made genius, Haworth provides a dysphoric, not to say Gothic, narrative of female repression, suffering, and death. Abbotsford is designed as a monument to the powers of the 'Wizard of the North' and the 'Author of Waverley', Haworth is designed principally as a memorial to dead young women. Accordingly, while the centre of Abbotsford is conceived of as Scott's desk and chair, Haworth presents a diffusion, a portability, a perishability of sites of writing both within the house and out on the moors.

Although Abbotsford was and is still a castle of fantasy, and Haworth is merely a poverty-stricken Victorian parsonage, Haworth has proved to have more staying power as a tourist site. In the summer, it is hardly possible to move in the village streets for the throngs of local and foreign tourists 'doing' Haworth. In part this is because the Yorkshire Tourist Board has been aggressively and successfully embedding the Parsonage within a generalised 'heritage' landscape compounded of the sublime discomfort of the moors, obsolete industrialism, and a shopping experience of rugs and fudge, whereas Abbotsford stands alone in an unfashionable landscape, and on an unfashionable route north; in part it is because Haworth has been made to stand for nineteenth-century Victorian Yorkshire, providing a tourist experience which might be summed up as 'Glad I wasn't there', whereas Abbotsford is so idiosyncratic that, unlike Haworth (or unlike Stratford which purveys merrie Tudorishness, or Alloway which displays eighteenth-century peasant life) it cannot be made to stand as exemplary of a period. Abbotsford is so invested in historical kitsch as not to be amenable to a makeover as 'history'; it remains resolutely 'literary'. But above all, the relative quietness of the coach-park at Abbotsford may be explained by the fall from favour of Scott's novels, while *Jane Eyre* and *Wuthering Heights* have continued to exert wide appeal.

The model of tourism that is currently associated with both houses was, as I shall be showing, generated within the authors' lifetimes and

was retailed by accounts of visits supplied by two important texts in par-
ticular – Washington Irving's *Abbotsford* (1832) and Elizabeth Gaskell's
Life of Charlotte Brontë (1857). The visit to Abbotsford is organised
(despite the long-standing practice of obliging visitors to enter via the
basement) as a visit to the living adult author armed with a letter of
introduction, with the prospect of having Scott as host, companion,
and tour guide to the grand reception rooms of his home and to his
favourite 'haunts' in the locality. The visit to Haworth, by contrast, is
organised essentially as an act of impertinent prying upon a retiring
lady, peeping in at the parlour windows and tip-toeing up to her very
bedroom. Yet these tourist acts have this in common; in both instances
the act of viewing the house is an imaginative effort to bring the dead
author once more to life, to meet the writer as posthumous host or
friend.

I Abbotsford

It was in the vale of the Tweed just north of the Northumbrian borders
that Scott at the age of forty chose to build his second home, the place
where he would spend his time when he was not required by his duties
on the Court of Session to be in residence in Castle Street, Edinburgh.
Over a period of some thirteen years between 1811 and 1824, he trans-
formed an old farmhouse with the inauspicious name of Clartyhole
(i.e. muddy place) into 'Abbotsford', an architectural fantasy which inau-
gurated the Victorian Scottish baronial style, and which was to embody
Scott's own sense of his family's ancient prestige in the shape of a laird's
estate surrounding a miniature baronial-cum-monastic pile. Scott poured
his very considerable earnings from his poetry and the Waverley novels
into extravagant pseudo-medieval architecture, into acquiring a large
miscellany of historical curiosities, and into buying parcels of land locally,
especially land with literary or historical associations, so expanding the
estate from one hundred acres on purchase to a thousand by 1818. The
end-result was 'a sort of a romance of a house . . . built in imitation of
an old Scottish manor house', as Scott put it, surrounded by 500 acres of
mixed woodland planted by its new proprietor – oak, poplar, filbert,
laburnum, horse-chestnut, sweet-briar, hollies and birch.

Of all writers' houses, Abbotsford is the most exemplary, for in mak-
ing it and its environs Scott invented the genre of the writer's house in
Britain.[3] The building and its locality were already conceived and organ-
ised by Scott in his lifetime to be visited by the literary tourist eager to
see the Minstrel of the North within the Border landscapes and settings

that he had sold to a romance-smitten public as the backdrops for *The Minstrelsy of the Scottish Border* (1802–3), *The Lay of the Last Minstrel* (1805) and *Marmion* (1808). From early on, Scott had colluded with the invention of the locality as a tourist-draw, providing the notes, for example, to John C. Schetky's *Illustrations of Walter Scott's Lay of the Last Minstrel: consisting of twelve views on the rivers Bothwick, Ettrick, Yarrow, Tiviot, and Tweed . . .* (1808). (The book's title belies its ambition, for it also illustrated locations mentioned in the *Minstrelsy* and *Marmion*.) Scott's notes had specifically solicited tourism of Melrose: 'The precise site of [the tomb of Michael Scott, the wizard in *The Lay of the Last Minstrel* with whom Scott would himself be identified] is now unknown; but the inquisitive stranger may still see the stone on which the monk was seated when he communicated to Walter of Deloraine the tale of the enchanter's death.'[4] (As we will see, plenty of 'inquisitive strangers' took up the offer.) Built during the full flush of his financial and critical success, in the centre of what Scott already regarded as 'classic ground', the Borderlands featured in the traditional ballads which Scott had collected, edited and made wildly popular in *The Minstrelsy*, Abbotsford served as the epicentre in his and others' imagination of a 'storied vicinity', stories variously historical, traditional and derived from Scott's own verse narratives, melded together in one heady recipe for romance.[5] The exterior and interiors of the house Scott once affectionately called his 'Conundrum Castle' were designed as a literary puzzle, explicitly alluding to the settings of the poems that had made Scott's fortune – hence the copies of details from Melrose Abbey (featured in the *Lay*) and Rosslyn Chapel (which appears in *Marmion*) – and covertly performing Scott's secret identity as 'The Author of Waverley'. It was 'literary' in this sense to the extent that it was not quite respectable; Scott's many visitors were often rendered uneasy by Abbotsford's performative and deliberately whimsical character. As early as 1819 Scott's future son-in-law J.G. Lockhart, publishing his account of a visit in the previous year, called it 'a strange fantastic structure' with an interior 'in character' with the exterior.[6] Lady Frances Shelley (the poet Shelley's aunt by marriage and model for Di Vernon in *Rob Roy*), visiting Abbotsford in 1819, remarked with faint disdain that it had 'the appearance of a castle built of pastry – something like those we see on a supper table. But one must not quiz the castle or criticise the whims of such a genius.'[7]

One of Scott's visitors was the young Washington Irving, who turned up with a letter of introduction in 1816. He would publish an account of that visit in 1832, just after Scott's death, an account which, given the imprimatur of the author of the *Sketch Book*, would arguably set a

large part of the itinerary and sensibility of all future literary tourists to Abbotsford and the country round about. As an account of a visit to the living author published after his death, it is neither precisely memoir nor memorial, but rather, an exercise in reanimating the dead author in terms of a personal visit to meet the author and be guided by him around his house and his favourite places. As such, it modelled a form of already impossible tourism. Irving had travelled down from Edinburgh as a self-confessed literary tourist, hoping 'chiefly to get a sight of the "mighty minstrel of the North"'.[8] Scott offered to guide him around the delights of the locality, pressing him to stay for a few days on the grounds that time and information were necessary to get the best out of the landscape. 'You must not think our neighbourhood is to be read in a morning, like a newspaper,' said Scott; 'it takes several days of study for an observant traveller, that has a relish for auld-world trumpery.'[9] The young Irving duly discovers that the landscape does indeed refuse to open its secrets to the uninitiated armed only with the standardised sensibilities of the picturesque tourist; it is available only to those who look with the eyes of Scott, who are lucky enough to be guided by him whether in person or in imagination. From the top of the Eildon hills, Scott shows Irving an extensive view which serves at once as anthologisation, topographical index and map of the Border ballads and of his own verse romances:

> Yonder is Lammermuir, and Smailholme; and there you have Galashiels, and Torwoodlees, and Gala Water; and in that direction you see Teviotdale and the Braes of Yarrow, and Ettrick Stream winding along like a silver thread, to throw itself into the Tweed.
> He went on to call over many names celebrated in Scottish song, and most of which had recently received a romantic interest from his own pen. In fact, I saw a great part of the border country spread out before me, and could trace the scenes of those poems and romances which had in a manner bewitched the world.[10]

Irving's response, however, is not what either he or Scott expected:

> I gazed about me with mute surprise, I may almost say, with disappointment. I beheld a mere succession of grey waving hills, line beyond line, as far as my eye could reach, monotonous in their aspect, and so destitute of trees, that one could almost see a stout fly walking along their profile; and the far-famed Tweed appeared a naked stream, flowing between bare hills, without a tree or a thicket

on its banks; and yet, such had been the magic web of poetry and romance thrown over the whole, that it had a greater charm for me than the richest scenery I had beheld in England.[11]

This sense of viewing a visually uninteresting landscape made romantic purely by superimposed literary association, was thoroughly new, although it was not confined to Irving; Frances Shelley also recorded both her surprise at the boringness of the landscape and at the power of Scott's narratives to glamorise the touristic experience of it:

> There is not a spot mentioned by this romantic poet which does not owe its renown for beauty and charm to the exquisite description of it, as seen through his magic glass. As in a highly finished miniature, every blemish of complexion vanishes without destroying the likeness, so it is with Scott's descriptions. Although they are accurate, the poet heightens every beauty and conceals every defect.[12]

Irving's account of how he accompanied Scott to the 'fairy ground' of the Eildon Stone and Huntley Bank, the site of the encounter between Thomas the Rhymer and the Fairy Queen, further demonstrates the way in which Scott had a well-developed sense of himself as a literary tourist and made of his guests literary tourists as well. Scott, however, did not on this occasion act as tour-guide to his own literary landscape; Irving was convoyed by Scott's son Charles to Melrose Abbey, made over for the rest of the nineteenth century as the setting of *The Lay of the Last Minstrel*.

Irving's account of his visit to Melrose is classic in that it identifies one of the pleasures of literary tourism as the act of discriminating between the actual setting and the romance naturalised there. Irving does so by gently laughing at the zealous credulity of Johnnie Bower the then custodian, who pointed out 'every thing in the Abbey that had been described by Scott in his "Lay of the Last Minstrel",' and documented the accuracy of his account by repeating, 'with broad Scotch accent, the passage which corroborated it.'[13] 'Every thing' included 'the identical stone on which stout William of Deloraine and the monk took their seat on that memorable night when the wizard's book was to be removed from the grave.'[14] Indeed, the generic demands of constructing a tour of the ruins in relation to the poem had led Bower to elaborate further on Scott's realism of setting, or in Irving's words, to go 'beyond Scott in the minuteness of his antiquarian research',

> for he had discovered the very tomb of the wizard, the position of which had been left in doubt by the poet. This he boasted to have

ascertained by the position of the oriel window, and the direction in which the moonbeams fell at night, through the stained glass casting the shadow of the red cross on the spot, as had all been specified in the poem.[15]

Bower had also found his own ingenious solution to the regular disappointment awaiting the many visitors who turned up hoping, as a result of the minute tourist-guide type instructions given by Scott in the famous lines 'If thou wouldst view fair Melrose aright, / Go, visit it by the pale moonlight', to see the ruins by the light of the moon. As the moon was inconveniently irregular, and liable to be obscured by cloud, Bower had devised a more reliable substitute: 'This was a great double tallow candle stuck upon the end of a pole, with which he would conduct his visitors about the ruins on a dark night; so much to their satisfaction, that at length he began to think it even preferable to the moon itself. 'It does na' light up a'at once, to be sure,' he would say, "but then you can shift it about, and show the auld Abbey, bit by bit, whilst the moon only shines on one side."'[16] These anecdotes of Bower serve two purposes for Irving: the first is to distinguish the sophistication of his own tourist desire to see the Abbey as the setting for the *Lay* from Bower's desire to see and to show him the Abbey as the place where the events of the *Lay* took place – the distinction is fine but critical. Irving verges upon presenting Bower as a parody of Scott himself in his willingness and ability to reinvent Melrose to suit romance, drawing back subsequently to insist that Bower is Scott's creature – that 'Scott used to amuse himself with the simplicity of the old man, and his zeal in verifying every passage of the poem, as though it had been authentic history' so that 'he always acquiesced in his deductions', and that Bower had become so identified with the *Lay* that his identity had become mixed up with its personages, becoming thus, even before Scott wrote his obituary, one of Scott's characters.[17] For Irving, Scott remains thus in control of the fantasy of Melrose rather than, like Bower, controlled by it; the figure of Scott, rather than the locality itself, is thus secured as the origin of romance.

In sum, Irving's essay on his visit to Scott insisted that the charms of the locality were invisible to those who did not have the benefit of Scott as a guide, in actuality and through his poems; its pleasures were associative, literary and antiquarian rather than visual and picturesque. Irving's various walks and drives with Scott, including down the Yarrow and to Dryburgh Abbey, effectively delineated the favourite haunts of the poet for all future visitors, and equally set up a desire to have the

urbane, informed company of Scott on such visits, even if only in imagination. Irving's double vision of Scott's borderland, a potent confluence of disappointment and admiration, would echo in personal accounts and tourist's handbooks down the century: 'That sense of something wanted, of a discrepancy between what was expected and what is seen, will weigh on whomsoever comes to this part of the land of Scott without being prepared to read *his* poetry, and the poetry of the past, into the view before him' wrote David Hannay in 1888.[18] Tourists after Irving would continue to aspire to see the country as Scott saw it, and to imagine Scott in the act of seeing it: 'As you go through this haunted country, now so peaceful, where the gaunt outline of the peel towers rises up from field or wood, you may see in imagination a solitary horseman, the presiding genius of this Borderland, reining in his horse to gaze round him with eyes which see more of Scotland than any man has ever seen – Walter Scott.'[19]

In 1816, however, Abbotsford was not simply the house of the celebrated Minstrel of the North; it was also, secretly, the home of 'the Author of Waverley,' and Irving and Scott's other guests amused themselves very much by engaging in efforts to solve the open riddle and identify Scott with the anonymous novelist. Seeing through Scott's eyes could also include seeing what Scott had seen and represented but had not admitted to seeing or representing; Irving thoroughly enjoyed himself sourcing *The Antiquary*, just published, on site, commenting that 'many of the antiquarian humours of Monkbarns were taken from [Scott's] own richly-compounded character', remarking of their walk to the local Roman camp that it was evident that 'some of the scenes and personages of that admirable novel were furnished by his immediate neighbourhood', and noting further in the course of a boat-trip on the Lake of Cauldshiel that a bench in the boat provided by Lord Somerville was marked 'Search No. 1', which suggested that it was either the source of or a joking allusion to *The Antiquary*.[20] Nor did his detective work cease there, extending to a careful perusal of Scott's collections of antiquities in Abbotsford itself. He noted 'above all, a gun which had belonged to Rob Roy, and bore his initials, R.M.G., an object of peculiar interest to me at the time, as it was understood Scott was actually engaged in printing a novel founded on the story of that famous outlaw.'[21] This habit of 'reading' Scott's curiosities as the origin or reference to Scott's fiction was not peculiar to Irving; it was also indulged in by Frances Shelley, who noted Scott's acquisition not merely of the door to the Edinburgh jail known as the Tolbooth, but with it its key, which, she remarks, alluding to one of the heroines of *The Heart of Midlothian*

(1818), 'had turned the lock on Effie Deans'.[22] Abbotsford was in this respect congruent with the storied vicinity of its environs, for it was itself 'storied' for those who had eyes to see and wit to puzzle out the conundrum or parlour game that Scott set them in his displays of curiosities set into Abbotsford's walls and laid out in the library and his armoury. Most of these pertained to his novels, with the exception of James VI's hunting-bottle, which drops straight out of *The Lady of the Lake* (1810). Scott typically acquired these items before he wrote the novels to which they seem related – this is true of the keys and door of 'the heart of Midlothian' or the old Tolbooth of Edinburgh; of Montrose's sword, the pocket-book worked by Flora Macdonald, Helen MacGregor's brooch, the lock of Prince Charlie's hair; of Rob Roy's broadsword, dirk, gun, and sporran purse, the oak panelling in part taken from Holyrood palace, and the hunting-knife that belonged to Charles Edward Stewart, the bullet from Culloden and the crucifix 'reported to have been carried by Mary Queen of Scots at execution' and the piece of her gown.

Irving's essay thus began to imagine how tourists might both find and find out not just the Minstrel but Scott the novelist by visiting Abbotsford with the eye of a detective. If the landscape operated as a spatialised anthology of the poetry, by contrast Abbotsford's collections certified authorial labour; they were at once the source, the aides-memoires and the debris of such imaginative work. Abbotsford itself was essentially novelistic in conception, a meta-narrative derived from and referencing material things. As William Howitt would write in 1847,

> No one could have seen Abbotsford itself without being at once convinced of [Scott's authorship of the Waverley Novels], if he had never been so before. Without, the very stones of the old gateway of the Tolbooth of Edinburgh started the fact in his face; within, it was a perfect collection of testimonies to the fact. The gun of Rob Roy; the pistols of Claverhouse; the thumbikins which had tortured the covenanters; nay, a whole host of things cried out – 'We belong to the author of Waverley.'[23]

And if Abbotsford was essentially novelistic, so too was Scott's grave, which organised his body to inhabit in perpetuity an architectural equivalent of his romances. Scott's grave remade Dryburgh Abbey for the nineteenth century. From being a ruin enhancing the Duke of Buchan's late eighteenth-century picturesque garden, it was transformed by Scott's insistence on being buried there into a vast poet's

mausoleum, outdoing any other poet's grave. As William Howitt would write in 1847, a sentiment echoed by Hawthorne: 'It is a mausoleum well befitting the author of the Lay of the Last Minstrel and . . . we must say that it would be difficult to select a spot more in keeping with Scott's character, genius, and feelings.'[24]

After Scott's death, Abbotsford was thrown open to the paying public in February 1833, receiving, according to the current chatelaine, some 1500 visitors that year alone. It seems that some entry-charge was made, although unfortunately no record survives detailing the amount. Five years later, in 1838, one impressed visitor recorded that on the 7 November the visitors' book boasted nineteen signatures since the first of the month.[25] As the home of Scotland's other national author, the man who had produced a new and comprehensive edition of Scottish national literature and history, Abbotsford became a national shrine where it was possible to pay homage to that prodigy of production. In the light of Scott's death, the whole assemblage very soon seemed to partake of the aesthetic of Scott's own collected edition, the Magnum Opus; a postscript that was in some respects a preface, to borrow a phrase from *Waverley*, filled with a collection of things that were like material footnotes to the novels. It was read as another romance by the Author of Waverley, a place in which the visitor could get closer to the writer's inspiration and modus operandi. Visiting in 1856, Hawthorne disliked Abbotsford, which he found suffocating, 'a plaything' rather than a real house,[26] but conceded that he understood 'the romances the better for having seen [Scott's] house; and his house the better, for having read his romances'.[27] John Marius Wilson, writing the first dedicated guidebook to Scott country in 1858, felt that the house's extravagance could only be excused if viewed as a novelistic exercise: it is, he observes,

> nearly as much a museum as an edifice. The house is truly 'a romance in stone and lime.' Yet the amount of elaboration in it, in proportion to its size, requires all the associations of Sir Walter's name and genius, and would, in any ordinary case, have required a bulk of building five or ten times larger, to prevent it from being ridiculous.[28]

The equally dubious Theodore Fontane wrote two years later in 1860 that Abbotsford was at once an epitome of Scott's novelistic genius, and a poor example of it:

> Willy-nilly, the whole building proves that what suits one set of circumstances does not suit all, and that the revival of the past, the

embellishment of a modern creation with the rich poetic details from the Middle Ages, may bewitch and enchant us in one context while in another it can become something little better than an oddity and a joke . . . There has been no flash of inspiration sufficiently strong to weld the hostile elements into a unity[29]

For Fontane, Abbotsford was a failed novel because its writer was no longer alive and it was consequently insufficiently textual; it was reduced to at best a writer's notebook or an inanimate fairground sideshow:

While the writer was himself still alive for whom these things had real significance . . . they were endowed with life under the influence of the living word which proceeded from him – Now, however, when these notes can no longer be heard, the stones are stone again, and even one who is familiar with Scottish history and song walks through these rooms as though they were a waxwork show.[30]

Despite his intermittent discomfort and distaste, Fontane still concluded that he had experienced 'a full pure satisfaction at having wandered through that strange house . . . that house which was also the creation of his poetic genius.'[31] What Abbotsford embodied, wrote H.V. Morton as late as 1927, was 'the rough material of the romantic novel'. The house as a whole was 'like nothing so much as a studio', the accumulated curiosities were 'the lay figures from which he drew his inspiration', and the whole was in another form 'one of his greatest historical novels'.[32]

If Scott's energies when living had made of the house both the workshop of magically inexhaustible genius and the architectural equivalent of a Waverley novel, his death rendered the house a national fiction with a tragic ending. Indeed, one of the reasons Abbotsford became the first writer's house open to the public, rather than what Scott had intended it to become, a private home to a dynasty of lairds, was because it featured in what was to become one of the great heroic stories of Victorian culture, the story of how Scott first built a castle and then redeemed it from his creditors against all probability and at the cost of his health with the fairy gold of the great stream of the Waverley novels. J.G. Lockhart's monumental biography of his father-in-law, *Memoirs of the Life of Sir Walter Scott* (1837–8), together with Scott's own famous *Journal* that detailed the struggles of his last years to retain Abbotsford with honour, essentially made Abbotsford over to the nation, at any rate imaginatively. By his death, even though it did

indeed eventually pass to his eldest son as he had so fervently wished, it had come to embody not Scott's feudal fantasy but the Victorian virtues of entrepreneurship, duty, hard graft and sheer brutal commercial productivity. Not every Victorian was entirely seduced by this narrative, of course: Elizabeth Grant called Abbotsford 'that monument of vanity, human absurdity, or madness', and the actor Macready, a fervent admirer of Scott's works, commented in his diary of his visit to Abbotsford in 1846 that it was 'the most disagreeable exhibition I have almost ever seen, itself the suicidal instrument of his fate, and monument of his vanity and indiscretion.'[33] (Interestingly, Macready was also horrified by the display of Abbotsford as frozen at the moment of Scott's death, and especially at the display of Scott's clothes, which he regarded as in 'the worst possible taste'.[34] His distaste calibrates the difference between the high Victorian culture of mourning that came to fruition some twenty years later, and which Abbotsford seems prophetically to embody.) Nonetheless, for later Victorian culture, Abbotsford was at once a record of a triumph and a poignant disaster; it had its own narrative as brilliant, varied and desperate as any of the novels which it echoed stylistically.

The earliest description of 'doing' Abbotsford and its environs after Scott's death is provided by Thomas Dibdin, in 1838, in his monumental *A Bibliographical, Antiquarian, and Picturesque Tour in the Northern Counties of England and in Scotland.* Dibdin does Scott as Minstrel, reiterating the itinerary and the sensibility sketched out by Irving: he remarks severely that the Border landscape has been touched up by Scott ('the wand of the poet only has here created a fairy land'), visits Melrose (noting that 'it would indeed require the keeping-down tint of 'pale moonlight' to absorb all these vulgarities in a sort of poetical mist,' being especially annoyed by washing-lines hung with linen), and visits Dryburgh Abbey to see 'the GRAVE OF SCOTT', remarking with disapproval on the lack as yet of a monument and tellingly comparing, even at this early date, Dryburgh with Stratford:

> Pilgrims, without end or number, [will] hie hither What Garrick has said of the shrine of Shakespeare, will doubtless be said of that of Scott . . .
>> The fairies by moonlight dance round his green bed,
>> And hallow'd the turf be which pillows his head!'[35]

As the Garrick (mis)quotation here suggests, Dibdin is already organising Scott into the tradition of the Poet embedded in the landscape.

Dibdin elaborates this cliché with a vision of Scott as simultaneously Poet and tourist-guide of Melrose; on entering the Abbey, he writes,

> [I] fancied I saw the embodied spirit of the GREAT POET sitting upon the *identical spot* which it used to occupy in its more substantial form of flesh and blood . . . 'There, sir,' said the living genius of the place – (a Mr Bower – who has made every nook and recess of the ruin his own) 'there, Sir Walter Scott used to sit and look about him.' Of course, I was bound to sit and do the same . . .[36]

Indeed, Dibdin bought (and reproduced in his book) the postcard of Scott sitting in Melrose that Bower flogged him. Irving's suggestion that Bower was Scott's double is here realised – Bower appears as the 'living genius' of the place, Scott the dead one.

If Dibdin finds the poet at one with the landscape at Melrose and Dryburgh, he finds the novelist at Abbotsford. For Dibdin, the heart of the display that is Abbotsford was Scott's little, self-enclosed study in which (as it happened) he wrote comparatively few of his novels but which has nonetheless served as a focus for the myth of Scott's prodigious output:

> You walk into Sir Walter's study, sit in his chair, gaze upon the motley furniture; and hard by, in a boudoir, behold his straw hat, jacket, waistcoat, trousers, high shoes, and walking-stick – in all which he was wont to be arrayed – hanging upon a couple of nails. You cannot fail to be sensibly affected. I own that I felt more than when I was standing by his graveside . . .[37]

Dibdin's brief description of the study focuses upon the desk and chair as the place of creation, and upon the other traces of the authorial body provided by the clothes. Others also experienced this as a work-place: Hawthorne too saw Scott's clothes and walking-sticks, sat, like Dibdin, in Scott's chair, and, with relief, noted the workmanlike quality of the study itself at the centre of the Abbotsford fantasy: 'made to work in, and without any fantastic adaptation of old forms to modern uses.'[38] He also noted that part of the experience of visiting the house was to be shown where Scott died and that 'it seemed to me that we spoke with a sort of hush in our voices, as if he was still dying here, or but just departed.'[39] Dibdin similarly downplays the importance of the grave in favour of the place of the fatal work of creation.

William Howitt's essay on Scott of 1847 is the first full expression of how to tour Scott country so as to experience the romance and

melancholy of Abbotsford, which is the subject of the vignette with which it is illustrated (Figure 3.1). Howitt's view is vastly romanticised, to the point of actual inaccuracy, because this is a description of how Scott's novels looked, and how of Abbotsford *was* a Scott romance, 'a fairy castle': 'Quaint and beautiful as one of his descriptions it arose.'[40] The fictionality of Abbotsford was proven for Howitt by its fate—'But, as the fabric of this glorious estate had risen as by the spell of a necromancer, so it fell'—and by the way that it is not as large in actuality as in the imagination.[41] The persistent note of Howitt's account is how the fascination of Abbotsford has vanished with the Great Enchanter himself – of how, unlike earlier, luckier guests, a walk through the grounds in Scott's favourite walks supplies not romance but 'fresh evidence of the vanished romance of Abbotsford. How long was it since Miss Edgeworth sate by the little waterfall in the Rhymer's glen, and gave her name to the stone on which she was seated? The darkness that had

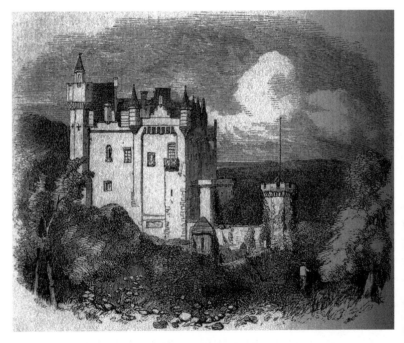

Figure 3.1 Abbotsford, from William Howitt, *Homes and Haunts of the Most Eminent British Poets* (1847: 3rd edn, London, 1858). Writers' Resources, Oxford.
 Abbotsford not as it looked or looks but as the Victorians felt it was supposed to look, as a Waverley novel constructed in stone.

now closed so thickly on my way, seemed to my excited imagination to have fallen on the world.'[42]

Howitt's sense of the sadness of Abbotsford holds true even more powerfully today. Visiting Abbotsford has been a melancholy experience at least since 1847 – these days on a wet October afternoon at the end of the season it seems especially so. The house retains its embarrassing Victorian fossilised quality; laid out much more explicitly than we are nowadays accustomed to as a shrine to its builder, it is still studded with rather dismaying relics which he himself would have mightily relished – a lock of hair, a walking-stick, the sofa on which he died, and worst of all, embalmed in a glass case, 'the last suit of clothes Sir Walter Scott wore' complete with shoes, gloves, hat, chain, stick and gaiters. Indeed the whole house is displayed pretty much as it has been since the death of Sir Walter Scott, so as to speak of the novelist dead in the service of the national literature. The study today, shown very much as it was to Hawthorne and Dibdin, is animated by representation and relic of Scott; the first in the shape of a bronze cast of Scott's head taken after his death placed in the small turret room which he called his 'Speak-a-bit', the second a lock of Scott's hair. Personal items are used to give physical scale and temporal narrative to the idea of the author; the beginning of the narrative is indicated by Scott's baby cutlery, the end by his spectacles lying on the desk. Although, as we have seen, relics of authors had been treasured before the 1830s they had not been displayed as part of a domestic and thanatocentric montage before, nor indeed in such numbers; in such an assemblage they are no longer individual relics, near-souvenirs, but make up a shadowy outline of the author's domestic and physical life. At the centre of the room are the pieces of furniture that dramatise the writer's labour: the 'Sheraton writing table and chair used by Sir Walter Scott when writing his novels, in 39 Castle Street, Edinburgh' and the very desk and chair in which Scott, Dibdin and Hawthorne sat. Effectively both a physical memorial to the imagination and a miniature essay on the relation between the imagination, industry, the commercial and the physical, Sir Walter Scott's writing desk, complete with cheque book, spectacles, paper knife and seals is captioned 'at which the later Novels were written and where he laboured to pay off the Debt, incurred 1826, through the firms of Messrs Constable and Ballantyne'.

Yet this old Victorian melancholy is redoubled for the modern admirer of Scott and his novels. With the recent death of Joan Hope-Scott, the property has passed out of the hands of Scott's immediate family and into the hands of a Trust, and seems to be holding its breath, hovering

between two states of being, between a family house and a museum. Moreover, Abbotsford is a place which over the last fifty years or so has fallen from a pre-eminent place in national consciousness, along with Scott's novels and his poetry, so that now even the house only half remembers why it was ever important. Captain Basil Hall, Scott's neighbour and friend, seems to have been accidentally prophetic when he fantasized as early in 1841 of seeing Abbotsford itself fallen into the romantic ruined state of the other Abbeys lining the Tweed;[43] only, it is not so much a ruin as a fossil, a space in negative of the vanished labour of the Author of Waverley and of his country's almost vanished passion for his ability to bring the landscapes of Scotland to life:

> At the touch of this bold necromancer, sprung up living forms of the most fascinating grace. The whole public opened eyes of wonder, and in breathless amazement and delight saw this active and unweariable agent call round him, from the brooks and mountains of his native land, troop after troop of kings, queens, warriors, women of regal forms and more regal spirits; visions of purity and loveliness; and lowly creatures of no less glorious virtues. The whole land seemed astir with armies, insurrections, pageantries of love, and passages of sorrow, that for twenty years kept the enraptured public in a trance, as it were, of ever-accumulating marvel and joy.[44]

II Haworth

To turn from the phenomenon that was and is Abbotsford to the contemplation of Haworth Parsonage is imaginatively to take a view right across the spectrum of the nineteenth century's sense of the writer's house. Abbotsford is conceived and born in the early years of the century, and petrified into sanctity as the young Victoria ascends the throne; Haworth is born much more slowly between 1857 and the end of the century when the first Brontë museum was set up, but is born recognisably out of a distinctively late Victorian sensibility, almost at the last gasp of the dying queen. The two houses have this much in common: they are arguably the two most important and exemplary writers' houses of the period, and they epitomise and dramatise the fictional genres associated with their tenants, the one historical romance, the other Gothic fiction in the tradition of Ann Radcliffe. But otherwise, as these (egregiously over-simplified) generic affiliations would suggest, they stand in marked contrast to one another. As we have seen, Abbotsford is romantic, national, public, self-dramatising; its

prime narratives are the accumulation of property, especially land, and a prodigious fertility of imagination and wealth, supplemented with a narrative of heroic male devotion to duty – a success-story terminated by tragedy. Crammed with artefacts alluding to a multiplicity of fictional and historical characters, Abbotsford flows out into its landscape and possesses it. The trophied workshop of a conscious genius, Abbotsford's heart is the writer's desk, scene of the 'necromancer's' labour, which reanimates the history of his nation. The visitor to Abbotsford is solicited in parallel to fantasise the euphoric reanimation of the 'eidolon' of his host and tourist-guide Scott, whether at home, striding up to take in the view of his romantic terrain from the Eildon Hills or from 'Scott's View' (still marked as such on the Ordnance Survey map), or musing in Melrose and Dryburgh Abbeys. In strong contrast, Haworth is regional and marginal to the nation, domestic and pathologically, genteelly secretive, informed by privation and desolation, standing in fragile and constricted domestic contradistinction to the wildness of the surrounding moors lowering at its back and to the stony expanse of gravestones spread ominously before it. Populated rather than animated by ghosts who are given measure by a pathetic litter of clothes, boots and other relics, Haworth provides a story of appropriately womanly failure. The experience of the visitor to Haworth is markedly dysphoric, almost masochistic, as the tourist-reader finds herself enmeshed in an actualised Gothic novel, imaginatively immured with the unhappy ghosts of the sisters. Where Abbotsford is positively boastful about the bookish professionalism of writing, celebrating its sorcerously transformative power upon place, whether that manifests itself in the building of Abbotsford itself or merely in the imaginative remaking of Melrose, Haworth Parsonage insists that writing is always autobiographical and that it transforms nothing. It makes the labour of writing all but invisible, naturalising it into the sisters' diseased bodies and tragic biographies. Strange though it may seem, Haworth is thus both an exemplary writer's house and not a writer's house at all, actualising the impossibility of the Victorian woman writer.

I visited Haworth twice – once on a rain-blackened day in July, and once on the shortest day of the year in the snow – and thoroughly dreary it looked on both occasions, in spite of the cheerful souvenir shops selling everything from Brontë Original Unique Yorkshire Liqueur to Brontë fudge, and the choice of refreshments at the comfortable if incongruously named Heathcliff café or the *Villette* tea-shop. The Parsonage looks satisfyingly like a setting for a Gothic novel, pressed behind by the wild high flat-backed moors and fronted by a churchyard

heaving uncomfortably with blackened streaked gravestones – some flat, some upright, some broken and tilting as though the dead were forcing themselves up uneasily through the sodden strips of grass – pressing hard up against the wall that divides the churchyard from the tiny front garden. The dead eventually claimed the famous tenants of the Parsonage: 'This was the site / Of the gate leading / To the church, used by / The Brontë Family, / And through which they / Were carried to / Their final resting place' remarks a tablet on the graveyard wall opposite the front door. The church sports a plaque entitled 'The Brontë Graves' which provides a map of how to find the Brontë servants' graves in the churchyard, and helpfully points out that 'the Brontë family are not buried in the churchyard, but in a vault beneath the church itself'. In the church hangs the nineteenth-century memorial plaque that recites a litany of deaths culminating in that of Patrick Brontë. If the Parsonage is thus defined as Gothic by the wildness of the moors and the grimness of the graveyard, it is also recognisably Gothic in being set in such a confined and palimpsestic space. The proximity to the parsonage of the church in which six of the family are buried, the churchyard in which their servants are interred, the school at which Charlotte taught, the Black Bull at which Branwell Brontë used to get his drink and the apothecary's shop at which he purchased his opium, make Haworth an unusually compact literary site.[45]

The Parsonage itself is presented as a confined and super-feminine domesticity. The visitor is invited by the occasional caption to imagine Emily peeling potatoes in the kitchen, or practising the piano in the front room, the girls playing with toys in the children's 'office' and later walking round and round the parlour table, Charlotte dressing for her wedding and picking up her bonnet to go to church. The Parsonage derives its power over the visitor from the way in which it is emotionally and historically compacted as a biographical palimpsest within this domestic frame: the nursery in which the children played is the room in which the adult Emily slept and may have died, and where Emily was supposed to have rescued Branwell from his burning bed, and where he died; next to it is that in which Patrick Brontë struggled with his alcoholic son Branwell in the throes of *delirium tremens*; the dining-room in which Charlotte, Emily and Anne walked round the table, discussing their plans, is also the room that contains the hard, slippery-looking sofa on which Emily is traditionally supposed to have died, and where the grieving Charlotte paced alone late at night after the deaths of her sisters; the gate through which Charlotte passed to her wedding is the gate through which her coffin was carried on the day of her funeral.[46]

As this description suggests, this palimpsestic quality is classically Gothic in its imbrication of these family tableaux of the innocence and happiness of childhood and youth with adult vice, shame, crime and violent death; Haworth Parsonage presents as simply a set of deleted scenes from *Jane Eyre*, so like is its affect to the episode in which Jane goes to bed the night before her wedding to Rochester only to be woken by the 'ghost' of the insane Bertha Mason, the disavowed first wife of her husband-to-be.

The house is set up as a drama of childhood hopes rendered melancholy in retrospect by early death, eliding the women's writing between the make-believe of the nursery and the sufferings of terminal illness. Although many of the displays point towards writing for those who know their Brontë biography – the solitary toy soldier in the nursery speaks to the aficionado of the childhood fictional worlds of Gondal and Angria, a diary-paper and a book lies on the kitchen table, the table in the parlour is the 'scene of writing' around which the young women wrote and discussed their novels – the house itself as shown does not dramatise professional published writing except as something done in miniature, and almost entirely secretly and invisibly. There is nothing that Charlotte wrote displayed in the house itself except her letters about her projected marriage to Nicholls; even her portable writing-desk, and that belonging to Emily, are postponed to the museum-annexe which visitors can only reach after passing through the house itself. The suffocating domesticity of the set-up is itself a narrative; the visitor is invited to astonishment that full-scale novels could be imagined and realised in such a narrow space and in such a short time; the dead girls outside the walls press in upon the imagined living girls inside.

Beyond the house nowadays is the exhibition room, housing the Brontë Society's collection of relics. In keeping with the house's privileging of the domestic over the writerly, it presents a curious jumble of the writerly and the domestic, giving equal value to a litter of sewing-boxes, paint-boxes, children's toys and mugs and to the writer's tools – Charlotte's writing desk, flanked by her spectacles, her seal, blotting paper, ink-bottle, nibs, quill, a miniature handmade book and the slender volume of *Poems by Currer, Ellis, and Acton Bell* (1846), Emily's writing-desk. The tortuously autobiographical relation between the private female body and public print-culture, between the Brontë sisters and the Bell brothers, is emphasised and dramatised by this jumble. The most startling example of this autobiographicisation of writing is perhaps the 'actual trunk bought by Charlotte Brontë in Brussels', bearing

a brass plaque to this effect, and acting therefore as an allusion to Lucy Snowe's trunk in *Villette*.

In keeping with this emphasis upon the domestic and autobiographical origins of writing the gift-shop sells small domestic artefacts by way of souvenirs, more plausible than those on sale in, say, Stratford-upon-Avon, because more clearly appropriate; needlework kits that evoke the hours spent by the sisters in sewing, a brooch showing Emily that embodies a faint folk-memory of mourning brooches, notepaper backed with one of Charlotte's sketches, calligraphy sets bearing a representation of Charlotte, a reproduction of Charlotte's wedding-ring, and three little figurines called 'storymakers'. Finally, you slip out of the door, raise your umbrella against the wind and the rain, and, if you are still feeling energetic, escape in the well-signposted footsteps of the Brontë sisters and Catherine Earnshaw, up to the moors, towards 'the Brontë waterfall' where you will find the stone called 'the Brontë chair' and so on to Top Withens, supposed site for Wuthering Heights, some three miles away.[47] If you have done all of that, then you have 'done' Haworth as it is currently presented, though a true Brontë pilgrim will also seek out other local places associated with the Brontës – the birthplace of the three surviving Brontë sisters at Thornton, for example, or the original of *Jane Eyre*'s Lowood School at Cowan Bridge. A real enthusiast might even go all the way to Brussels, where a plaque set up as recently as 1980 now marks the site of the 'allée défendue' where Lucy Snowe and her creator before her lingered in *Villette*, and where in 1993 a couple of pilgrims set up their own home-made plaque, now gone.[48]

'Authentic' though the parsonage museum purports to be, meticulously restored and decorated in original colours and wallpapers, and filled with items that either did once belong to the Brontës or are of their period, it is, unlike Abbotsford, entirely a 'back-formation'. It has been made to look like the house that a century and a half of visitors have desired and expected to see, the originating space of the sisters' novels. In fact, the house we see nowadays is in part an *effect* of their novels. The extent to which this is true can be gauged by one instance where the house and its environs have signally failed to match expectations produced by the fiction, the location of the sisters' graves. As I have already noted, there is a plaque on the exterior of the church indicating that Emily and Charlotte are buried not in the graveyard but in the crypt, a plaque which tacitly acknowledges the fruitless hunt that many have made amongst the gravestones before discovering the memorial inside the church. This misconception is of very early date; the death of Charlotte Brontë in 1855 was sufficiently high-profile to

prompt an obituary in the same year by Harriet Martineau, an acquaintance and admirer, in which she claimed that Charlotte had looked directly out of the window of the parsonage onto her sisters' graves in the churchyard.[49] Martineau's elision of the inconvenient facts that Emily was buried in the church and Anne in Scarborough is echoed by Matthew Arnold in his elegy, entitled 'Haworth Churchyard' in which he, the first of many, imagined Charlotte as buried in the open graveyard.[50] Emily Dickinson likewise imagined the grave some five years after Charlotte's death as 'All overgrown with cunning moss,' suggesting an exterior location.[51] W.H. Charlton's tribute-poem of 1855 compounded these errors to include all three sisters: 'Beside her sisters lay her down to rest, / By the lone church that stands amid the moors; / And let her grave be wet with moorland showers; / Let moorland larks sing o'er her mouldering breast!'[52] The mistake, however, is entirely understandable – the sisters *ought* to have been buried outside. Such expectations have in large part been derived from the fate of Catherine Earnshaw who is, at her own request, buried in the open at the very extremity of the churchyard in *Wuthering Heights* (1847) rather than inside the church:

> The place of Catherine's interment, to the surprise of the villagers, was neither in the chapel, under the carved monument of the Lintons, nor yet by the tombs of her own relations, outside. It was dug on a green slope, in a corner of the kirkyard, where the wall is so low that heath and bilberry plants have climbed over it from the moor; and peat mould almost buries it.[53]

The actuality of the Brontës' respectable middle-class female family life, which mandated family burial in the church crypt, is over-written for tourist-readers by the romantic location Emily invented for her heroine's grave.

If the fiction of the Brontës supplied both detail and genre to inflect readers' expectations of Haworth, it was one of their readers, and another novelist, Elizabeth Gaskell, who largely invented Haworth as a tourist destination through her *Life of Charlotte Brontë* (1857), together with its founding biographical inter-texts, Charlotte's own 'Preface to *Wuthering Heights*', her 'Biographical Notice of Ellis and Acton Bell' and her posthumous edition of Emily and Anne's poetry (all 1850). Arguably never superseded, the *Life* remained authoritative throughout the nineteenth and twentieth centuries, and to this day determines the presentation of the Parsonage, laid out now to exemplify its state the year

Gaskell came to visit her new friend Charlotte, 1853. Gaskell's presentation of her visit to the parsonage in the *Life* is of the first importance to understanding why and in what form Haworth became central to the Brontë literary pilgrimage.

Although Miss Brontë of Haworth had attracted the interest of the inquisitive with literary pretensions when she abandoned her male pseudonym, Currer Bell, with the publication of *Shirley* in 1849, interest in the Parsonage itself was relatively muted and incidental by comparison to what was to come after the publication of Gaskell's *Life*. Previously, it seems that some were seized with a desire to attend Sunday eucharist at Haworth church, travelling from places as far distant as Halifax in order to gawp at the famous authoress from the church's galleries.[54] It was said that strangers had come from beyond Burnley to see her, and that the sexton was well-tipped for pointing her out.[55] Charlotte Brontë was also said to have shifted her customary position on the family pew so as to screen herself from such unwelcome attentions.[56] Early visitors to the parsonage included Mr Francis Rennock, a self-styled 'Patron of the Arts' who had managed to force an introduction to Patrick Brontë, but whom neither Charlotte Brontë nor her newly-arrived visitor Mrs Gaskell would see,[57] and the young John Stores Smith, who in 1850, spurred on by literary ambition, took, in his own self-congratulatory words, 'the hot blood and rollicking high spirits of one-and-twenty into this silent and sombre catacomb'.[58]

On the publication of Gaskell's *Life* in 1857 this early trickle of visitors increased dramatically, becoming the subject of comment both public – in the local papers – and private – in the letters of the two men still resident in the Parsonage. Patrick Brontë wrote to Gaskell in August 1857 with a mixture of pride and exasperation that such visitors 'would, if we let them, pay a gossiping visit to us, in our proper persons'.[59] In 1858, *Black's Picturesque Guide to Yorkshire* devoted no fewer than five pages to Haworth and the Brontës, well-padded with excerpts from the *Life* and providing extracts from poems which located the women strongly in Haworth, providing vignettes of them in the churchyard, either as corpses or as mourners. The same year, Walter White published an account of a walking tour in Yorkshire which had included a visit to Haworth, conducted very much on the lines suggested by *Black's*, noting that the village already seemed to be used to visitors.[60] By 1858, the sexton already seems to have developed an established routine for showing visitors around the church, displaying not merely Charlotte's memorial tablet, but the Brontë family pew, and the page in the marriage register in which Charlotte had written her maiden name for the last time.

(So attractive was this peculiarly intimate and feminine example of Charlotte's writing that the register had to be protected from fingering by 1914.)[61] The sexton seems also to have been prepared to chisel an introduction to the parsonage for anyone of gentlemanly pretensions and of sufficient hardihood, and to have had a lucrative sideline in souvenir photographs into the bargain.[62] The landlord of the Black Bull, too, had a good stock of family anecdotes, principally of Branwell, and by the 1860s was offering visitors the chance to sit in 'his' chair, which, incidentally, you can still see, tucked away up a few steps muddled up with the pub vacuum cleaner.[63] There were souvenirs on public sale, too, as early as 1858: shops displayed photographs of the church, of the parsonage, of Patrick Brontë and the Rev. Nicholls, though none of Charlotte herself because Nicholls refused to release any likenesses.[64] One surviving photograph of the parsonage (dated c. 1856 by the Brontë Society) shows the parsonage viewed across a graveyard apparently thronged with gentlemanly sightseers.[65] On commissioning a new memorial which would have enough room for his own name to be added to the bottom, Patrick Brontë felt impelled to order that the old tablet – featured extensively in the opening chapter of Gaskell's *Life* – be broken into pieces and buried in the churchyard to foil souvenir hunters.

One of the principal effects of Gaskell's *Life* was that the Parsonage itself became, as far as its tenants were concerned, inconveniently interesting. The Rev. Ward, the incoming incumbent on Patrick's death, is said to have offered it for sale to literary enthusiasts; receiving no offers of hard cash, he resorted to planting the front of the parsonage garden with trees to discourage the many gapers, and resolutely refused entrance to the inquisitive, so earning himself thoroughgoing unpopularity amongst contemporary Brontë enthusiasts.[66] He only amplified this odium by enlarging and modernising the parsonage in the 1860s. His replacement of the old windows with large panes of plate glass came in for especial condemnation by one visitor, W.H. Cooke, who argued that they were not 'in unison with the wierd [sic] desolate scene which surrounds the parsonage.'[67] Cooke also commented indignantly that

> we were not allowed to enter [the parsonage] – the present incumbent sternly refusing to admit a single visitor, or to permit one, even for an instant, to peer into that family sitting-room of the Brontës, wherein were written works which have conferred immortal lustre upon this incumbent's present residence, and which will live long after he himself has mouldered down to dust, and his bran-new window-frames have rotted to decay.[68]

(The principal beneficiary of this modernisation, apart from the rector's family of course, was the American visitor, Charles Hale, who in 1861 managed to carry away a fair amount of the house by way of souvenir, including 'the whole lower sash of the window of the bedroom of Charlotte Brontë'.)[69] Nor did Ward improve his relations with literary posterity by demolishing the body of the church in 1879, a move supported by his congregation but regarded by literary pilgrims as 'a sad act of vandalism'.[70] This demolition was reputed to have discouraged the great majority of visitors; Erskine Stuart noted in 1888 that 'Since the day when the old church, redolent with memories of . . . the Brontës, was swept away, Haworth has been nearly deserted by visitors.'[71] The hostility roused by Ward's entirely rational modernisations suggests the extent to which Gaskell's biography had not only identified a minutely realised physical setting with the Brontës' writing, but had suggested that a visit to Haworth and its church would yield an enriched understanding of the writers.

Despite the loss of the original church, the setting-up of the Brontë museum in the former Yorkshire Penny Bank in 1895 with the aim of halting the dispersal of Brontë relics, along with the new availability of the novels in Britain in cheap editions due to the lapse in copyright, initiated a fresh boom in Brontë tourism.[72] By the end of 1900, it has been estimated that there were some 3000 paying visitors per annum to the museum alone, suggesting a yet larger number of visitors to Haworth itself.[73] Although the possibility of acquiring the Parsonage to house the museum was once again mooted in 1898, the project fell by the wayside, and was only realised in 1927, when a local benefactor purchased the house from the Church and presented it to the Society. The Parsonage opened in 1928 as a museum rather than a restored house, showing relics in glass-cases.[74] It only took the 'authentic' form in which it is familiar today in the 1950s when the house was redecorated to the period, the windows reglazed with small original-style panes, and the ever-increasing collection of relics and books relegated to an annexe, with the express intention of transforming the building 'from a museum into a home'.[75] The history of the Parsonage museum over the first half of the twentieth century could be described as rescuing things from being entombed in glass cases and reanimating them; it took something like a century for Haworth Parsonage to be born again as Gaskell had seen it in September 1853 and evoked it in print in 1857.[76] Yet despite this time-lag, the *Life* had made the parsonage central to readers' sense of the Brontë sisters sixty years before the paying public was admitted, and a hundred-odd before this loving restoration. Not only had Gaskell

provided a detailed description of it inside and out, including a frontispiece engraving, she had both implicitly and explicitly given her readers to understand that the Parsonage, and the village of Haworth itself, was of the first importance to understanding Charlotte Brontë.

As befitted a mid-Victorian realist novelist rather than a professional biographer, Gaskell began her study of Brontë's life with neither her birth nor her family background but with an entire chapter devoted to 'Description of Keighley and its neighbourhood – Haworth Parsonage and Church – Tablets of the Brontë family.' With this rhetorical gesture she at a stroke rooted Charlotte Brontë in an intensively realised physical and social context, ensuring that the Brontës' family lineage and birthplace would remain of relatively little interest to Brontë enthusiasts in comparison to the parsonage and church. Remarkably enough, she combined novelistic technique with the language and protocols of the mid-Victorian guidebook to such good effect that all subsequent personal and guidebook accounts of the pilgrimage to Haworth were in the event pre-empted, reduced to mere quotation or stealthy reiteration. In her opening pages, she conducts her reader through Keighley, along the road towards Haworth, as though arriving alone for a visit:

> Right before the traveller on this road rises Haworth village; he can see it for two miles before he arrives, for it is situated on the side of a pretty steep hill, with a background of dun and purple moors, rising and sweeping away yet higher than the church All around the horizon there is this same line of sinuous wave-like hills; the scoops into which they fall only revealing other hills beyond, of similar colour and shape, crowned with wild, bleak moors – grand, from the ideas of solitude and loneliness which they suggest, or oppressive from the feeling they give of being pent-up by some monotonous and illimitable barrier, according to the mood of mind in which the spectator may be.[77]

This passage neatly combines topographical accuracy with a delineation of the possible 'mood' of the place – grand or oppressive, which will turn out to prefigure one of Gaskell's central figures – a genius pent-up in solitude, but which also suggests an emotional spectrum of ways for the tourist to respond to the locality. Gaskell then takes her reader with her up the hill into Haworth, dramatising its steepness with the sense that the horses 'seem to be in constant danger of slipping backwards' and bringing reader and author into a dramatic if lightly touched-in physical immediacy as together they arrive at the top of the slope: 'But this surmounted,

the church lies a little off the main road on the left; a hundred yards, or so, and the driver relaxes his care, and the horse breathes more easily, as they pass into the quiet little by-street that leads to Haworth Parsonage.'[78]

Having in this way modelled the visitor's arrival at Haworth, Gaskell then orientates him as an outsider (he stands outside, with his back to the church) with a documentary scrupulousness belonging, again, to the practical genre of the guidebook. But this guidebookiness is intercut with a delicate intimation of personal knowledge of the house's past (the flower-beds were once carefully tended) that belongs much more to the omniscient narrator typical of Gaskell's own novelistic practice:

> The parsonage stands at right angles to the road, facing down upon the church; so that, in fact, parsonage, church, and belfried school-house, form three sides of an irregular oblong, of which the fourth is open to the fields and moors that lie beyond. The area of the oblong is filled up by a crowded churchyard, and a small garden or court in front of the clergyman's house. As the entrance to this from the road is at the side, the path goes round the corner into the little plot of ground. Underneath the windows is a narrow flower-border, carefully tended in days of yore, although only the most hardy plants could be made to grow there. Within the stone wall, which keeps out the surrounding churchyard, are bushes of elder and lilac; the rest of the ground is occupied by a square grass-plot and gravel-walk. The house is of grey stone, two stories high, heavily roofed with flags, in order to resist the winds that might strip off a lighter covering. It appears to have been built about a hundred years ago, and to consist of four rooms on each story; the two windows on the right (as the visitor stands with his back to the church, ready to enter in at the front door) belonging to Mr Brontë's study, the two on the left to the family sitting-room.[79]

The effect is a gentle oscillation between the perspective of the outsider and the insider, a promise of inside information for the reader 'ready to enter in at the front door'. This language is suffused with a potentially Gothic narrative; the house and garden are imagined as resisting the animosity of both the weather and the ominously encroaching churchyard. The accompanying engraving amplifies this Gothic suggestion (Figure 3.2). Gaskell's final remark on the house's appearance, that 'Everything about the place tells of the most dainty order, the most exquisite cleanliness' is at once documentary and metaphorical – this time of ladylikeness: 'Inside and outside of that house cleanliness goes up into its essence, purity.'[80] Gaskell's description

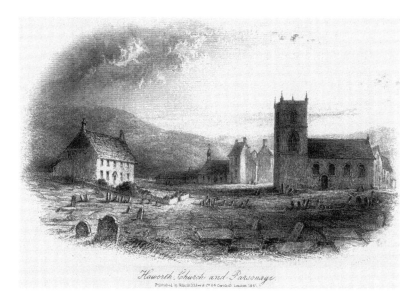

Haworth Church and Parsonage.

Figure 3.2 Haworth Parsonage, from Elizabeth Gaskell, *The Life of Charlotte Brontë* (London, 1857). Bodleian Library.
Haworth as romanticised and death-ridden desolation, with the moors rising up behind.

of the house prefigures her version of Charlotte Brontë, ladylike, retiring (so far there has been no mention of her whatsoever except on the title-page), reared in a hostile environment. Just how hostile, the imagined visitor is about to find out; baulked of entering in at the front door for the present, he is conducted into the church which is dismissed as commonplace except for 'a mural-tablet on the right-hand side of the communion-table, bearing the following inscription . . .'[81] Gaskell quotes the original tablet, and finally, the tablet to Charlotte herself:

ADJOINING LIE THE REMAINS OF
CHARLOTTE, WIFE
OF THE
REV. ARTHUR BELL NICHOLLS, A.B.
AND DAUGHTER OF THE REV. P. BRONTË, A.B., INCUMBENT.
SHE DIED MARCH 31ST, 1855, IN THE 39TH
YEAR OF HER AGE.

With this the literary pilgrim arrives at the memorial inscription which the biography – and the house – will set itself to amplify.

The centrality of the Parsonage and the church to Gaskell's biography was perhaps inevitable, given that the house and church were already institutionally as well as physically contiguous, and given that the Brontë sisters spent so much of their lives there, but it was the first time that a biography was so pervaded by the centrality of a house. Even Abbotsford does not loom so large in Lockhart's biography. It is indicative of the power of Haworth in the Brontë mythos that the mistake has been regularly made of believing that the children were born there – they certainly should have been. Gaskell's narrative tells of repeated returns to the house after ambitious excursions – out to school, out to become governesses or tutors, out even to Brussels to be educated and to become teachers – excursions which in the main were disappointed or aborted or ill-fated. Maria and Elizabeth left the house for school only to die; Emily left the house only to become ill with home-sickness, Branwell to involve himself foolishly with his employer's wife, Anne leaves joyfully but too late for Scarborough, and dies there. The house is uniquely impacted as a biographical site in Gaskell's biography. She dramatises the small children, 'still, noiseless' in the family parlour as their mother died slowly in the room above.[82] Into the same space, she conjures the three remaining adult sisters, reading out their reviews to each other, Emily scornful and contemptuous of all criticism, while Patrick Brontë takes his meals alone as was his invariable custom. And finally, she provides heart-wrenching vignettes of the bereaved Charlotte pacing the night away around the same parlour table. Above all, the house is an essential mechanism in compacting Charlotte Brontë, clergyman's daughter, eldest sister and lady, confined within a household routine detailed at every juncture, with Currer Bell, celebrated author of 'wild', 'romantic' and shocking tales. No wonder that the total effect of the biography is to convince the reader, as it did the young Virginia Woolf, that 'Haworth and the Brontës are somehow inextricably mixed. It expresses the Brontës; the Brontës express it; they fit like a snail its shell.'[83] Woolf's metaphor testifies to the sense produced by Gaskell's biography that the empty shell of the house is itself animal and organic, a physical cast of the shape of absent bodies and minds. In the event, on her visit in 1904 Woolf found Haworth rather deficient in Gothic gloominess, though sufficiently 'dingy and commonplace.'[84] Her expectations, like those of other visitors, were formed by 'print and picture', specifically, the frontispiece to the *Life*.[85] This depiction – and its power to interpellate the armchair tourist – was still powerful in 1904, Woolf noting that it 'struck the key-note of the book' for 'it seemed to be all graves – gravestones stood all round; you walked on

a pavement littered with dead names; the graves had solemnly invaded the garden of the parsonage itself, which was a little oasis of life in the midst of the dead.'[86] Formally bracketed by death, opening with the memorial tablet in the church and closing with Charlotte's funeral, the *Life* is like Haworth Parsonage itself, built over graves.

Gaskell's depiction of Haworth after the deaths of Branwell, Emily and Anne also owes a great deal to her use of the novels of the Brontë sisters, most especially *Shirley* and *Wuthering Heights*, as a form of biographical 'information'. Her description of Charlotte alone in the parsonage late at night clearly derives from the haunting of Heathcliff by Catharine Earnshaw in the last pages of *Wuthering Heights*:

> All the grim superstitions of the North had been implanted in her during her childhood by the servants who believed in them. They recurred to her now, – with no shrinking from the spirits of the Dead, but with such an intense longing once more to stand face to face with the souls of her sisters, as no one but she could have felt. It seemed as if the very strength of her yearning should have compelled them to appear. On windy nights, cries, and sobs, and wailings seemed to go round the house, as of the dearly-beloved vainly striving to force their way to her.[87]

This profoundly Gothic scene requires the reader 'who has even faintly pictured to himself her life at this time, – the solitary days, – the waking, watching nights' to 'imagine to what a sensitive pitch her nerves were strung, and how such a state was sure to affect her health.'[88] Such a reader would have been equipped for such an act of sympathy by familiarity with *Shirley*, and most especially with the scenes in *Shirley* dealing with the wasting away nearly to death of Caroline Helstone from loneliness. Written during the period over which Branwell, Emily and Anne successively died, as Gaskell carefully pointed out, *Shirley* expresses very poignantly the sense of being entombed in the solitude of a parsonage, and the horror of the approaching death of a sister. Gaskell quotes from *Shirley* at length to dramatise Charlotte's own feelings at this juncture, using one of the passages that characteristically threatens to break the frame of the narrative with autobiographical feeling (though Caroline Helstone wakes, and is actually on the mend, the description of this waking is so full of other wakings to near-death that for a moment it is difficult to register the negatives):

> No piteous, unconscious moaning sound – which so wastes our strength that, even if we have sworn to be firm, a rush of unconquerable tears

sweeps away the oath – preceded her waking. No space of deaf apathy
followed. The first words were not those of one becoming estranged
from this world, and already permitted to stray at times into realms
foreign to the living.[89]

Gaskell's use of *Shirley* as a source extends to Gaskell's treatment of
the death of a young friend Martha Yorke, 'Jessy' in *Shirley*, and leads
her again to quote another of those moments which break the frame of
the narrative to provide an apparent vignette of the author seated at the
window of a house. Remarkably, Gaskell breaks into the quotation to
identify the house by implication as Haworth Parsonage itself, writing:

'But, Jessy, I will write about you no more. This is an autumn
evening, wet and wild. There is only one cloud in the sky; but it cur-
tains it from pole to pole. The wind cannot rest: it hurries sobbing
over hills of sullen outline, colourless with twilight and mist. Rain
has beat all day on that church tower' (Haworth): 'it rises dark from
the stony enclosure of its graveyard: the nettles, the long grass, and
the tombs all drip with wet.'[90]

Gaskell's use of the text of *Shirley* to flesh out her biography was
certainly licensed by Brontë's use of local personages as models for her
characters and real localities as models for her settings, albeit renamed
and relocated. Yet the total effect is to make *Shirley* inter-textual with
Haworth, making it possible to 'read' Haworth as the Rectory in *Shirley*,
described as 'a windowed grave', built 'very near the churchyard: the back
part of the house is extremely ancient, and it is said that the out-kitchens
there were once enclosed in the churchyard, and that there are graves
under them.'[91] Gaskell also reads Haworth across onto *Jane Eyre*, quoting
a friend's anecdote which identifies Jane's dream of 'carrying a little wail-
ing child, and being unable to still it' as one of Charlotte's recurrent
dreams, which was located to Haworth: 'She described herself as having
the most painful sense of pity for the little thing, lying *inert*, as sick chil-
dren do, while she walked about in some gloomy place with it, such as
the aisle of Haworth Church.'[92] She suggests that Rochester's ghostly
voice on the wind was perhaps first heard in Haworth Parsonage.[93] She
quotes another account of a visit which identifies Charlotte Brontë with
Jane Eyre and locates subject and heroine together in the Parsonage:

Miss Bronte put me so in mind of her own 'Jane Eyre'. She looked
smaller than ever, and moved about so quietly, and noiselessly, just

like a little bird, as Rochester called her Now there is something touching in the sight of that little creature entombed in such a place, and moving about herself like a spirit, especially when you think that the slight still frame encloses a force of strong fiery life, which nothing has been able to freeze or extinguish.[94]

Such a practice – and these are only a few exemplary instances – efficiently flattens out the distinction between fictional and biographical material. Gaskell's vivid depictions of the Parsonage as congruent with the novels, amplified by laying over Charlotte's own depictions of similar interiors onto the Parsonage, begin to make the Parsonage into the ur-text of the Brontës. This effect is redoubled by Gaskell's use of Charlotte's letters.

Extended quotation of intimate letters was unprecedented and indeed shocking in a biography; it made this biography of an uneventful life into a series of cataclysmic personal events in the inner life. Charlotte's letters animate the text with first-person 'voice' in a way that is congruent with and extends Gaskell's use of first-person narrative moments from the novels. This effect in relation to the house is perhaps most powerful in the letters which Gaskell includes on Charlotte's grief on returning to Haworth from Scarborough after Anne's death:

All was clean and bright, waiting for me. Papa and the servants were well; and all received me with an affection which should have consoled. The dogs seemed in strange ecstasy. I am certain they regarded me as harbinger of others. The dumb creatures thought that as I was returned, those who had been so long absent were not far behind.

I left Papa soon, and went into the dining-room: I shut the door – I tried to be glad that I was come home. I have always been glad before – except once – even then I was cheered. But this time joy was not to be the sensation. I felt that the house was all silent – the rooms were all empty. I remembered where the three were laid – in what narrow dark dwellings – never more to reappear on earth. So the sense of desolation and bitterness took possession of me.[95]

Gaskell's deployment of this letter provides the subsequent tourist-reader with what amounts to a sound-track of a dead voice to animate the experience of visiting the parlour. Moreover, Gaskell's vision of the haunted Charlotte, pacing the parlour, 'left desolate, to listen for echoing steps that never came, – and to hear the wind sobbing at the

windows, with an almost articulate sound'[96] which expands this letter models the subsequent experience, real or imagined, of visiting the Parsonage, for it expresses the sense of absence, mourning, and haunt-edness that, as we will see, comes to inhere at the core of any Brontë pilgrimage.

By intercutting real letters with strategic quotation from the fiction and framing the whole with dramatic appeals to readers' sympathies, Gaskell made of the physical reality of the Parsonage a super-illustration and objective correlative to the gripping novel that Gaskell writes in conjunction with her co-author, Charlotte Brontë. Not that the process was complete on the first publication of the *Life*. It would take extensive reiteration of these techniques, in guidebooks, fictionalised biographies and pilgrimage memoirs, to fully produce Haworth. One lengthy evo-cation of the Parsonage may serve to exemplify the end-point of the process which Gaskell set in motion: here the travel-writer Theodore Wolfe combines the novels, letters and biography in a way foreshad-owed by Gaskell but further amplified and compacted with an easy bril-liance that suggests that this is essentially a commonplace in 1895:

> The arrangement of the apartments is unchanged. Most interesting of these, is the Brontë parlor [sic], at the left of the entrance; here the three curates of 'Shirley' used to take tea with Mr Brontë and were upbraided by Charlotte for their intolerance; here the sisters discussed their plots and read each other's MSS; here they transmuted the sor-rows of their lives into the stories which made the name of Brontë immortal; here Emily, 'her imagination occupied with Wuthering Heights,' watched in the darkness to admit Branwell coming late and drunken from the Black Bull; here Charlotte, the survivor of all, paced the night-watches in solitary anguish, haunted by the vanished faces, the voices for ever stilled, the echoing footsteps that come no more. Here, too, she lay in her coffin The kitchen where the sis-ters read with their books propped on the table before them while they worked, and where Emily (prototype of 'Shirley'), bitten by a dog at the gate of the lane, took one of Tabby's glowing irons from the fire and cauterized the wound, telling no one till the danger was past. Above the parlor is the chamber in which Charlotte and Emily died . . . the adjoining children's study was later Branwell's apartment and the theatre of the most terrible tragedies of this stricken family . . . here Emily rescued him – stricken with drunken stupor – from his burning couch, as 'Jane Eyre' saved Rochester; here he breathed out his blighted life erect upon his feet, his pockets filled with love-letters from the

perfidious woman who wrought his ruin Visitors are rarely admitted to the vicarage.[97]

This bravura flattening out of the distinction between the biographical and fictional effectively locates the sisters in the same physical space and on the same imaginative plane as their characters. By doubling them indiscriminately with their fictional characters, smoothing out the epistemological difference between them so that they become simply textual memories, Wolfe amplifies Gaskell's sense of Haworth as the location of a meta-Gothic-novel.

The remainder of Wolfe's account in *A Literary Pilgrimage* (1895) of his tourism of Brontë sites points to the way that it comes to be associated around the 1890s with a model of the literary tourist as both of haunted and haunter – haunted by the ghosts of the Brontës and their characters, haunting the reconstructed territory of their lives as a sort of ghostly afterthought who passes through leaving no damage. By 1897, for example, the poetess Harriet Spofford was imagining the parsonage haunted by the ghosts of the three sisters: 'There are three ghosts upon the stair!'[98] Such a model of haunting is endemic in the case of the Brontë sisters partly because Gothic doubling is characteristic of many of the most striking structures of their novels – not merely Cathy and Heathcliff, but the haunting of Lucy Snowe by her ghostly double the nun. So powerful was this model of the haunted tourist that it proved transferable beyond the confines of Haworth; for Wolfe and another American, Marion Harland, one of the most thrilling ways of experiencing the effect of being haunted by the Brontës was to explore Brussels on the trail of *Villette*, newly animated with biographical significance with the recent revelation of Charlotte's unrequited passion for the master of the Pensionnat Heger, Monsieur Heger, during her stay there.

Harland, author of *Where Ghosts Walk: The Haunts of Familiar Characters in History and Literature* (1898), set off 'to see, with bodily vision, a locality familiar to the mind's eye',[99] trusting herself and friend 'recklessly' 'to the chart furnished by Charlotte herself'. Thanks to the documentary faithfulness of *Villette* to its setting – 'the fidelity of a photograph, taken by an artist and developed by an adept' – Harland succeeded in viewing, with a happy lack of discrimination between the fictional and the biographical, the book closet in which Lucy Snowe locked up Catalonia Dolores, the attic where Charlotte and Emily's beds used to stand, 'the ledge on which [Lucy Snowe] sat through the thunderstorm', and the 'allée défendue'.[100] Harland experiments with seeing double – not just 'seeing' the sisters in the same space as

fictional characters, but 'seeing' a fictional site, familiar from the novel, laid over upon a previously unseen reality. This thrill of superimposing the imagined figures of Charlotte, Emily and Lucy Snowe upon the ver-ifiable documentary reality of place, of animating place with *Villette* read simultaneously as fiction and biography is even more explicit in Theodore Wolfe's pages. His account also equalises the status of the top-ographical, the biographical and the fictional; the reader-tourist popu-lates place with 'associations' and 'memories' derived from reading. He describes his walk down the allée défendue thus:

> The throng of vivid associations which filled the place tempted us to linger. The garden was not a spacious nor even a pretty one, and yet it seemed to us singularly pleasing and familiar, as if we were revisit-ing it after an absence. Seated upon a rustic bench close at hand, pos-sibly the very one which Lucy had 'reclaimed from fungi and mould,' how the memories came surging up in our minds! How often in the summer twilight poor Charlotte had lingered here in solitude after the day's burdens and trials with 'stupid and impertinent pupils'! How often, with weary feet and a dreary heart, she had paced this secluded walk and thought with longing, of the dear ones in far away Haworth parsonage! In this sheltered corner her other self, Lucy, sat and listened to the distant chimes and thought forbidden thoughts and cherished impossible hopes . . .'[101]

On arriving in the school-room at the Pensionnat Heger ('how quickly our fancy peopled the place!') he experiences the ultimate double seeing of the master's desk, as at once fictional site and documented reality, as at once pseudo-memory and real personal memory in the making:

> Upon this desk were heaped his bouquets that morning; from its smooth surface poor Lucy dislodged and fractured his spectacles; and here, seated in Paul's chair, at Paul's desk, we saw and were presented to Paul Emanuel himself, – M. Heger.[102]

The sense of both these writers that they were visiting sites that they 'remembered' derives in part from the narrative mode of *Villette* which is in the form of first-person retrospective narration and suffused with a rhetoric of memory, nostalgia and regret. In part it also derives from Gaskell's sense that *Villette* was built of Charlotte Brontë's personal memories rooted in the pensionnat, a sense well-founded on her field-trip to Brussels to meet Monsieur Heger. This effect of topographical

memory was further reinforced by another set of inter-texts, the illustrations to the collected edition published in the early 1870s.

These illustrations, rather in the mode of the topographical illustrations that accompanied Scott's poetry and novels, realised and reinforced the commonplace claim made since Gaskell's *Life* that the settings of the Brontë novels, especially Charlotte's, were 'photographically correct', an extension of the argument that the sisters' lives were so confined that fiction and life were as one: 'her life is transcribed into her novels. The one is a daguerreotype of the other'.[103] The illustrator for Smith and Elder for the 1870s collected edition took advice from Mrs Gaskell as to where to find the originals for Thrushcross Grange, Wuthering Heights, Lowood School, Thornfield Hall, Fieldhead and so on, and engraved them captioned with their fictional names and mildly fictionalised by being peopled in little with figures suggestive of the Brontë sisters' heroines. His illustrations included the garden of the Pensionnat Heger, shown populated by a few female figures, flooded in early evening moonlight. In the aggregate, these illustrations bear witness to the enterprise of realist texts (however mixed with Gothic) to 'remember' places; more, they encourage the readers of realist texts to 'remember' places. But though their ambition is apparently to flesh out or realise the text in the reader's memory more fully, their effect is paradoxical. Installing a slight hiatus or hesitation between text and illustration, a tectonic shift between inter-texts, they amplify the imperfect fit between fiction and biographical and topographical fact. Out of this is born an individual and collective urge for verification, the *desire* to remember and anchor the text *in situ*, whether by official plaque or personal pilgrimage.

The Smith Elder illustrated edition began the hunt for the originals of the Brontë's settings in good earnest, which reached climaxed at the end of the century, beginning with J.A. Erskine Stuart's *The Brontë Country: Its Topography, Antiquities, and History* (1888), which included detailed itineraries for a number of walks around localities associated with the sisters, and culminating in the publication of Herbert Wroot's monumental *Sources of Charlotte Brontë's Novels: Persons and Places* (1902, revised 1906 and 1935). With the formation of the Brontë society, which, it is to be remembered, was intended to preserve the physical traces of the Brontës *in situ*, came the institution of the annual literary ramble – the very first one being to Cowan Bridge, the school the five Brontë girls attended, where the two older sisters died, and the original for Lowood School in *Jane Eyre*. Over the succeeding years, this ramble to varied destinations would fix ever more firmly the locations and boundaries of 'Brontë country', until in 1905 the Haworth edition

provided large photographs of settings from different elevations as a form of verification. By 1914 the first evidence that 'Brontë country' was a popular rather than a merely academic formulation appears with the publication of Mrs Ellis H. Chadwick's *In the Footsteps of the Brontës*, packed with photographs of locations both biographical and fictional, and with the advertisement of Mr James Bradley's 'popular lantern lecture on the Brontë country', boasting no fewer than one hundred slides.[104]

'Brontë country' as it thus emerges at the end of the century is an amalgam of biographical and ambiguously real and fictive locations. It is populated indiscriminately by the sisters themselves, by their fictional characters, and by houses and places which are at once fictive (since they have usually been transposed and have always been re-named) and yet which are sufficiently real to be documented, mapped, marked and viewed. Although the transformation and translocation of these places – most signally, perhaps, Wuthering Heights, a fusion of Law Hill with the location of Top Withens – might speak to the imaginative power of the sisters, it is not usually taken to do so; rather, 'Brontë country' effectively amplifies Haworth Parsonage as a narrative space which compacts together inextricably the Gothic of the sisters' lives and of their novels. It offers itself to the reader-tourist as itself a historico-Gothic novel, a meta-text capacious enough to comprehend both the lives and works of the Brontës. They become the narrated rather than the narrators, as much characters as their own creations. Such, it seems, is the condition of female authorship; to be successful as a woman writer is only to be co-opted as a figure subjected to her own fictive landscapes.

It is a testimony to the extent to which Haworth was being presented as domestic Gothic by the 1890s that the American writer Elbert Hubbard felt obliged in 1897 to protest vehemently against this as a construction. After a minute description of his visit to the Parsonage during which he is shown Charlotte's desk, her letters and the 'footstool she made and covered herself . . . filled with heather blossoms – just as she left it', he refuses impatiently to see her as a victim immured in a gothic house penned in by moorland desolation; rather, he argues, she achieved financial success, friends, praise and fame from her loving portrayal of the moors:

> Charlotte loved the great stretch of the purple moors . . . the wild winds that sighed and moaned at casements or raged in sullen wrath, tugging at the roof, were her friends . . . they were her properties, and no writer who ever lived has made such splendid use of winds and storm-clouds and driving rain.

And he concluded that 'people who point to the chasing angry clouds and the swish of dripping rose bushes blown against the cottage windows as proof of Charlotte Brontë's depression' were essentially missing the point.[105] Hubbard's bracing dose of good sense was not, however, typical of most tourist-responses, which were more consonant with John Stores Smith's comment in 1868 (Gaskellian in its sensibility) that 'Of all the sad, heart-broken looking buildings I had passed through, this looked the saddest Here was the most original living Englishwoman, who had broken out into the full glory of an achieved success, whose pen was wealth to her, whose name was on every cultivated tongue, and whose creations were in every cultivated mind, and this – this was her home!'[106]

Founded as it is on a fusion of the biographical with the fictional, 'Brontë country' is only one among many authorial 'countries' precipitated in the 1890s and flourishing through to the 1920s, geographies that had already come to include 'Scott country'. It is, however, one of the most extreme and exemplary formations. Like Abbotsford, Haworth presented and presents itself as a conundrum of authorship; only, while the mystery of the identity of the 'Author of Waverley' resolved itself with Scott's admission of authorship after the financial disaster in the mid-1820s, the mystery of the Brontë sisters' authorship was not resolved by Charlotte's admission that Currer, Ellis and Acton Bell were in plain fact Charlotte, Emily and Anne Brontë. The problem of how three supposedly sheltered and ill-educated young ladies could have produced a string of scandalous novels continues to agitate and animate the scholarly displays at Haworth. If the invention of 'Scott country' was in large part a way of delineating nation, the invention of Brontë country has been arguably a way of coping with authors otherwise dangerously diffused throughout print-culture under pseudonymity; it has been a way of confining them within geography.

With Brontë country, I come to the furthest extreme of the desire to locate the author within the landscape, whether as corpse, infant, wizard or ghost. But there are other forms of literary geography that are, at best, only vestigially secured by authorial biography. Indeed, there are forms of literary geography which do their level best to deny the author's agency in inventing the landscape that the tourist comes to see. In what follows, I trace literary tourists' desire to travel to places where only the fictitious have trod, and where only fictitious events have (or have not) happened, considering the ways in which these locations have existed in a dialectic with authorial biography and, indeed, with documentary reality.

Part II
Locating the Fictive

4
Ladies and Lakes

The land which has been imprinted by the footstep of genius, or by the beings of its creation, can never fail to produce a deep and enthusiastic interest. The anxious eye searches for the haunts of those whom history has chronicled, and the fancy feels charmed to revel with the creatures of another's imagination. It is the genius of Rousseau, Voltaire, Gibbon, de Stael, and Byron, that gives such a magic to the scenery of Lac Leman; and the Trossachs, Loch-Ard, and Loch Lomond, would be bereft of half their charms, were they not associated with the magical creations of Sir Walter Scott.[1]

So wrote an anonymous guidebook writer in 1838, describing a set of rationales for the 'deep and enthusiastic interest' of the literary tourist. He variously secretes within the landscape associations deriving from the biographical ('the anxious eye searches for the haunts of those whom history has chronicled'), and the more purely fictive ('the creatures of another's imagination'). Most literary tourism is indeed a mongrel compound of both, as my discussion of Brontë country amply illustrates, but in this half of the book I am interested in tracing the origin of the practice of visiting sites associated principally with the fictive, sites where nothing historically verifiable happened, sites where, as this writer endearingly puts it, 'the fancy feels charmed to revel with the creatures of another's imagination'. If the governing genre of the first half of this book is therefore biography, the genre that governs this second part is fictional narrative organised within realist settings. My examples coincide in part with those of the guidebook writer – the Lac Leman or Lake Geneva of Jean Jacques Rousseau and George Gordon, Lord Byron, and the Trossachs and Loch Katrine of Sir Walter Scott – although I supplement his list with a book published some thirty years

after his remarks, R.D. Blackmore's best-selling novel *Lorna Doone* (1869). Although as it happens in all these instances the author had actually either travelled to or lived in the area (not always the case with the settings for fiction, as Ann Radcliffe's use of an Italy she never visited may attest), the fact that the land had 'been imprinted by the footstep of genius' was not in itself the tourist draw. Indeed, the tourism associated with these sites is marked by a tendency to disavow or bracket the author altogether.

This interest in places populated by purely fictional characters and where purely fictional events had taken place emerged at the end of the eighteenth century, with the tourist excitement especially on the part of English travellers sparked specifically by Jean Jacques Rousseau's revolutionary novel of sentiment, *Julie: ou, La Nouvelle Héloïse* (1761). It would become a dominant way of looking at literary landscapes throughout the nineteenth and twentieth centuries. It develops out of and supplements the well-established eighteenth-century practice of embarking on tours to admire the picturesque, and later, the sublime in landscape; with *La Nouvelle Héloïse*, spectacular landscapes first became invested with fictive figures and sentimental narrative. Not only was a new way of looking at landscape thus born, so, too, was a new way of living with reading. Clasping the text in one hand, tourists would travel to Lake Geneva, and subsequently to other romantic landscapes, in search of spots infused with sentiment and invariably associated with an unavailable woman who embodies all that is romantic and desired within the landscape. Hoping to re-experience all the force of the sentiment described in the text on the exact site described there, tourists were almost always disappointed; but then, that disappointment was part of the experience too, whether it was simply a failure to find the sentimental spot at all outside the confines of the text because it had either been obliterated or had never existed in the first place, or whether the tourist experienced a failure of sentiment, a failure which functioned as an efficient reiteration of the protagonist's poignant experience of not being able to possess or control the woman. With the publication of *Julie*, a new tourist experience was born; to go to a place one has read about with passion is to be guaranteed an emotional experience, even if it is a negative one.

Although the development of sentimental tourism associated with the fictive was probably an accident waiting to happen (Laurence Sterne's *A Sentimental Journey* was published in 1767, after all, and would itself eventually stimulate a small class of tourists to retrace Parson Yorick's itinerary), as I have already remarked, it was Rousseau's writings and

Rousseau's readers that invented this new way of looking at landscape through literature; more specifically, it was *La Nouvelle Héloïse* which delineated the shape of sentimental landscape tourism. The story of the development – and the decay – of tourism associated with this novel illuminates the rhetorical conditions a literary text has to fulfil before it will elicit this type of impulse on the part of its readers, and is the subject of the first part of this chapter. The subsequent story of how this model of sentimental tourism is transposed into historical romance by Walter Scott, R.D. Blackmore, and subsequently by their tourist-readers so as to operate within Scottish and English landscapes occupies the rest.

I *La Nouvelle Héloïse* (1761)

> *Here would I dwell, forgetting and forgot;*
> *And oft, methinks (of such strange potency*
> *The spells that Genius scatters where he will)*
> *Oft should I wander forth like one in search,*
> *And say, half-dreaming, 'Here St Preux has stood!'*
> *Then turn and gaze on Clarens.*

> Samuel Rogers, *Italy* (1822–8).

Although now largely forgotten by everyone except scholars, *Julie: ou, La Nouvelle Héloïse* was one of the most widely read novels of the late eighteenth century both in the original and in translation. It would not be an exaggeration to say that if you had pretensions to being well-read at the time, you would certainly have had to have been familiar with it. Its situation hovers at the edge of emotional pornography as it reworks the old story of Héloïse and her tutor Abelard in modern terms. Two young lovers, Julie, the daughter of a local grandee, the other St Preux, a poor man retained as her tutor, gradually fall passionately in love with each other. The story is told entirely in letters from these two to their intimate friends Lord Edward Bomston and Claire, letters which Rousseau claims merely to have 'edited'. Julie's father, the Baron d'Etange, forbids their marriage, and insists that she marries his friend, the virtuous M. Wolmar. The rest of the novel details (again in frequently impassioned letters) both lovers' efforts to overcome their emotions. Julie seems successfully to have redirected her affections towards her husband and young family until it becomes clear to her that she is still in love with St Preux; the resulting desperate struggle between love and virtue is cut short by her tragic death, brought about by her rescue of her son from drowning in the lake.

The well-documented immediate sentimental and scandalous appeal of *La Nouvelle Hélöise* will not alone account for the novel's ability to generate tourism by the end of the century.[2] On publication *La Nouvelle Hélöise*, like Samuel Richardson's *Clarissa* (1747–8), from which Rousseau's novel derives certain characteristics, prompted a stream of letters from admirers to Rousseau. Such letters were not concerned to congratulate Rousseau as a writer but to ask for more information about Julie, begging for more letters, and even for her portrait, or asking (on the part of female readers) for an introduction to St Preux.[3] Rousseau remarked that women readers especially had been convinced 'that I had written my own story, and that I was myself the hero of my own novel.'[4] So insistent was this demand that Rousseau replied to it in a preface printed separately, translated into English as *A Dialogue between a Man of Letters and Mr J.J. Rousseau, on the Subject of Romances. Published since his ELOISA, and intended as a PREFACE to that Work.* 'N' quizzes 'R' on whether Julie and her confidante Claire actually exist or existed. He is baffled by the sphinx-like reply, 'what signifies it whether they ever existed or not? They are nowhere to be found: they are no more.' On insisting rather plaintively 'however, you are acquainted with the scene of action . . . Vevai, in the Pays de Vaud', 'N' receives the disappointing and teasing reply:

> I declare that I never heard of Baron d'Etange, or his daughter. The name of Wolmar is entirely unknown in that country. I have been at Clarens, but never saw any house like that which is described in these letters. I passed through it, in my return from Italy, in the very year when the sad catastrophe happened, and I found no one in tears for the death of Eloisa Wolmar. In short, as much as I can recollect of the country, there are, in these letters, several transpositions of places, and topographical errors, proceeding either from ignorance in the author, or from a design to mislead the reader.[5]

Such a reply, despite its professed insistence on privileging the novelist's creativity over the mere representation of real places, was practically an invitation to readers to 'check' the accuracy of the fiction against the real setting. Rousseau virtually casts himself as a tourist here, who has travelled the ground to verify – or otherwise – the novel. Arguably, the *Dialogue* marks the moment when Lake Geneva could first be plotted onto the literary tourist's map as the country of Julie.

Consequently, admirers did not confine themselves to letters; the first recorded tourist brought to the locality by *La Nouvelle Hélöise* was

arguably the young James Boswell, on his way down to Italy in 1764, intent upon meeting Rousseau himself. (Boswell was not only a confirmed literary lion-hunter, but would become a gazetted literary tourist; only five years later he would be involved in pioneering Shakespeare tourism as a participant in Garrick's Jubilee in Stratford). In preparation for this piece of spectacular effrontery, he crammed *La Nouvelle Héloïse*, and arrived on the fifty-two year-old Rousseau's doorstep at Motiers with a letter of self-introduction in which he dramatised himself as a romantic genius, another St Preux, in a very passable pastiche of Rousseau's style (never over-modest, he described it as a masterpiece and preserved it 'as a proof that my soul can be sublime'):

> I present myself, Sir, as a man of singular merit, as a man with a feeling heart, a sensitive and melancholy spirit. Ah! If all that I have suffered does not give me singular merit in the eyes of M. Rousseau, why was I made as I am? Why did he write as he has written? . . . Your books, Sir, have melted my heart, have elevated my soul, have fired my imagination . . .

A few lines further on, he makes his self-insertion into the structures of Rousseau's novel fully explicit; in language reminiscent of the to-and-fro of counsel and sympathy characteristic of the letters between Rousseau's lovers and their confidantes, he writes: 'I am in a serious and delicate situation concerning which I ardently desire the counsel of the author of the *Nouvelle Héloïse*. If you are the charitable being I believe you to be, you cannot hesitate to grant it.'[6] Boswell succeeded in extorting a series of interviews out of Rousseau, partly by providing a written 'sketch' of his life to date, remarkable for a style of ingenuous self-revelation calculated to appeal to the man who had authored *La Nouvelle Héloïse* and who would later produce an equally revolutionary autobiography, the *Confessions* (composed 1770, published posthumously in 1782).

Boswell's account of his visit is instructive as much for what he does not do, as for what he does. He visits the author of *Julie* at home, rather than visiting the settings associated with the novel. He performs St Preux to the originator and the supposed original of St Preux, rather than performing St Preux *in situ* around Clarens. Nor do these touristic possibilities, which were probably well-established by the 1780s, seem to have occurred either to him or to Rousseau at this early stage; given Boswell's sheer cheek, he would otherwise surely have asked and probably succeeded in getting Rousseau to guide him round the locations

associated with the novel. Nevertheless, in between recording these interviews, Boswell provides us with a tantalising vignette of himself and an inn-keeper's daughter singing together a popular ballad (presumably from sheet-music) versifying the plot of *La Nouvelle Hélöise*, of which he remarked 'Though the song is written in a ludicrous style, the recollection of the events made me cry.'[7] Although hard evidence is difficult to come by to support Simon Schama's assertion that 'by the time the complete oeuvre, including the *Confessions*, had been published in 1783, the countryside around Geneva had become a site of pilgrimage,'[8] Boswell's anecdote certainly suggests that the local bed and breakfasts were already in 1764 garnishing their hospitality with a *soupçon* of local literary interest.

This tourist phenomenon of the 1780s almost certainly received a substantial boost from the publication of Rousseau's autobiography. Of particular interest in the context of this enquiry is the way in which the *Confessions* realises the locality of Lake Geneva in so much detail, rooting Rousseau physically within this region. Rousseau discusses his choice of setting for his novel; as in the *Dialogue*, in the very same breath that he identifies the novel's locations, he withdraws his fictional characters from the reader's eager grasp. They are mere 'chimeras' of the imagination:

> In order to place my characters in a suitable setting, I passed the loveliest places I had seen in my travels one after another in review. But I found no woodland fresh enough, no countryside moving enough to suit me . . . My imagination was tired of inventing, and wanted some real locality to serve as a basis, and to create for the inhabitants I intended to place there the illusion of real existence . . . Finally I chose that lake around which my heart has never ceased to wander. I fixed on that part of its shores, which my wishes long ago chose as my dwelling-place in that imaginary state of bliss which is all that fate has allowed me. My poor Mamma's birthplace had still a special attraction for me. Its contrasting features, the richness and variety of its landscape, the magnificence and majesty of the whole, which charms the senses, moves the heart, and elevates the soul, finally determined me, and I established my young pupils at Vevey.[9]

Rooting the novel within his long-term relationship with an older woman, Mme. Warens (nicknamed 'Mamma'), Rousseau reiterates that the setting of *La Nouvelle Hélöise* really exists, though in practically the same breath he offers discouraging advice to would-be tourists: 'Go to

Vevay – visit the countryside, examine the sites, walk by the lake, and see for yourself if Nature hasn't made this beautiful place for a Julie, a Claire, and for a St Preux; but don't search for them there.'[10]

Although Rousseau's international celebrity meant that by 1814 Geneva had sprouted a plaque marking the birthplace, and by 1816 an obelisk on the Planpalais, neither Geneva itself nor Rousseau's other homes attracted literary tourists. The romantic tourist to Lake Geneva was not primarily in search of sites associated with the writer, but was, rather, in search of vantage-points at which to have sentimental experiences which echoed those rapturously detailed in Rousseau's novel. In this, he was not unlike the tourist of the picturesque or sublime landscape who preceded him. Just as the landscape tourist sought out the best vantage-points, often listed in guidebooks, so as to get the most 'classic' view of the country, so too the Rousseau tourist sought out the best 'stations' around the lake so as to get the classic Rousseauistic sentimental experience. *La Nouvelle Héloïse* effectively served both as sourcebook and subsequently as guidebook to these 'classic' sentimental places and poses. It could produce tourism in this way because its own structures efficiently modelled tourism. In brief, it provided in its hero St Preux a model of the reader-tourist as a belated, impotent interloper; it modelled an unavailable object of touristic desire in Julie; it scripted a tourist experience of attempted and partially failing emotional reiteration conducted within finely particularised, mappable and photographically realistic landscape settings, which themselves, according to the novel, serve as perpetual reservoirs of externalised passion and emotion; and, finally, it developed even as it draws upon the epistolary discourse of the tourist's letters home.

Throughout the novel, Rousseau's young hero, St Preux, is set up as an interloper lucky enough to have been admitted to a privileged position within the d'Etange household at Vevay. He analyses and admires the household as an outsider, reporting on it and analysing it in letters for the benefit of his English friend, Lord B–. Expelled from this household mid-way through the novel, he nonetheless returns to the married Julie's home to perform the same reporting function, intensified by his sense that the Wolmars have built at Clarens a philosophical and marital idyll. In respect to both households, his letters are marked with the desire to belong, combined with the recognition that he can never do so. In this way, St Preux vividly delineates a mentality common to the reader-tourist, who typically suffers from a desire to be included within or to experience first-hand the fiction, but, invisible, unnecessary, and secondary to the fiction, he or she is forever doomed to frustration.

If St Preux occupies the position of tourist-as-interloper in this fashion, he also models the tourist in his impotence and his belatedness. Unlike the original Abelard who is castrated for his presumptive love, St Preux is only figuratively castrated, made into a spectator of the triumph of his rival and forced to learn to like it. As a result he is forced into melancholy emotional tourism once Julie is married to Wolmar. He leaves on his travels to mend his broken heart, but four years later, passing through the area once more on the way to Italy, he is unable to resist seeing Julie again. The novel dramatises two subsequent visits to sites associated with emotional scenes of the past, visits designed either to exorcise or recreate past emotions. The first, to the Bosquet de Julie, scene of the first kiss and declaration of love between Julie and St Preux, is orchestrated by Wolmar, with the express intention of cauterizing any lingering passion by repeating the forbidden kiss in strictly platonic mode in public.[11] The second visit is initiated by St Preux, who drags the unwilling Julie along to a spot suffused for him with memories of passion to see whether he can rekindle the past emotions which Julie has now virtuously suppressed in obedience to her father and husband. Hard upon their escape from the storm that emblematically hits them at the deepest spot in the lake, they land on the rocks at Meillerie. St Preux persuades Julie to take a walk with him to the place from which he wrote her love-letters after his banishment from the d'Etange household.[12] He writes an extended account of the visit to a place full of 'old memorials' of his passion to his English confidante Lord B–:

> In the midst of these noble and superb objects [the Alps], the little spot where we were displayed all the charms of an agreeable and rural retreat; small floods of water filtered through the rocks, and flowed along the verdure in crystal streams. Some wild fruit-trees leant their heads over ours; the cool and moist earth was covered in grass and flowers. Comparing this agreeable retreat with the objects which surrounded us, one would have thought that this desert spot was designed as an asylum for two lovers, who alone had escaped the general wreck of nature
>
> 'Now (said I to Eloisa, looking at her with eyes swimming in tears) is your heart perfectly still in this place, and do you feel no secret emotion at the sight of a spot which is full of you?' Immediately, without waiting for her answer, I led her towards the rock, and showed her where her cipher was engraved in a thousand places On seeing them again at such a distance of time, I found how powerfully the review of these objects renewed my former violent

sensations 'Here is the stone where I used to sit, to reflect on your happy abode at a distance; on this I penned that letter which moved your heart; these sharp flints served me as graving tools to cut out your name; here I crossed that frozen torrent to regain one of your letters which the wind had carried off' 'Let us be gone, my friend, (said she, with a tone of emotion) the air of this place is not good for me.' I went with her sighing . . . and I quitted that melancholy spot for ever, with as much regret as I would have taken leave of Eloisa herself.[13]

As here, this tourism of past emotions is throughout the novel strongly associated with finely detailed and particularised landscape settings. The landscape is at once realistic and sentimental; the style of description suggests that this is a real place, but also that place serves as a reservoir of externalised passion and emotion, to which a sensitive soul, a new St Preux, could return again and again, drawing upon its emotional energies.

Repeatedly, however, as Rousseau's hero revisits sites of former happiness, he invents a landscape full of heartache, a landscape with an essential absence at its heart. 'I began with recollecting a walk of the same kind which we took together, during the rapture of our early loves A crowd of objects, which recalled the image of my past happiness, all pressed upon me, and rushed into my memory, to increase my present wretchedness. It is past, said I to myself; those times, those happy times, will be no more; they are gone for ever!'[14] Once the landscape is characterised in this way by the inaccessibility of Julie, the way is clear for the tourist to see with St Preux's eyes; to visit these places is not to have Julie, but to repeat St Preux's experience of *not* having Julie. Paradoxically, the absence of Julie makes her presence in the landscape all the more felt, and St Preux's experience of tormented passion all the more available to the tourist-reader.

No literal touristic revisiting would be possible, however, were it not that Rousseau had chosen real landscape settings for his fiction, a revolutionary decision. Although there had been novels before that had taken real-life settings, none of them had been anything like so particularised to a landscape, a landscape, moreover, already long established as a tourist attraction both because of its 'beauties' and because it was readily viewable from one of the main routes for travellers on their way to Italy on the Grand Tour. Rousseau combined elaborate landscape description, which readers at the time valued for its force, beauty and detailed accuracy, with real places in which his fictional events took

place. Contemporary readers could, and did, plot the novel on a map of the eastern end of the lake: Vevay, Julie's first home and scene of her awakening love for St Preux; Clarens, the location of the 'Bosquet de Julie' and the Wolmar household; the rocks of Meillerie, upon which St Preux carved Julie's name; Chillon, off which Julie dived to rescue her son; and the eastern end of the lake itself, which the lovers continually traverse and which becomes stormy or calm in response to their fluctuating passions. From plotting the fiction on the map it was a shortish step for the affluent to go and see these settings for themselves. The vivid and verifiable topographical realism of this typical editorial footnote is a postcard in itself: 'These mountains are so high, that half an hour after sunset its rays still gild the tops of them, and the reflection of red on those white summits forms a beautiful roseate colour, which may be perceived at a great distance.'[15] Its photographic realism founds a corresponding expectation on the part of the reader that somewhere Julie's name must indeed be carved upon the rocks of Meillerie.

The relationship between a touristic St Preux and a realistic landscape setting must have been underscored for contemporary readers by the form of the text. St Preux's letters to England are so reminiscent of exactly the sort of letters a traveller at the time might well have written home, describing manners and customs, as well as amorous adventures and landscapes, that they provoke imitation and emulation. Rousseau's pretence that he is editing real letters reinforces topographical verisimilitude with documentary realism. Finally, from the first edition onwards, the text was often accompanied by expensive engravings by Moreau the younger illustrating dramatic moments in the text. These included the first kiss of Julie and St Preux in the Bosquet de Julie, the storm that nearly oversets their boat and drowns them, Julie and St Preux at Meillerie, and Julie's death-bed. Of these, all but the last set the lovers in such a detailed environment that the reader could be forgiven for seeking out the real place.

If *La Nouvelle Hélöise* functioned as a sentimental source-book, it is not simply fanciful or metaphorical to note that it also acted as a guidebook – the evidence suggests that from the beginning tourists carried the many volumes of this very fat novel with them in their carriages, and they appear to have been familiar enough with it to riffle to the relevant pages and read the right sections out, reverently and expressively, to their travelling companions. Our next documented glimpse of Rousseau tourism is afforded in the mid 1790s, when the celebrated British radical poet, historian, travel-writer and novelist, Helen Maria Williams, visited Geneva. She both commented upon the practice of carrying the

novel as a guide, and remarked that further description of the place on her part was unnecessary given both Rousseau's own evocation and that of subsequent literary enthusiasts:

> The country around Vevay, where Rousseau has placed the scene of his charming romance, is become classic ground It would be hopeless to attempt a new sketch of these enchanting regions after the glowing description of Rousseau, which has already been so often detailed by the hundred sentimental pilgrims, who with Heloise in hand, run over the rocks and mountains to catch the lover's inspiration. All in nature is still romantic, wild, and graceful, as Rousseau has painted it[16]

Despite, or perhaps even stimulated by, Rousseau's warning of 'transpositions of places, and topographical errors', the Julie itinerary was well-mapped by the time the poet Samuel Rogers took his trip in 1814 and jotted down in his journal:

> Meillerie – its grey rocks, like enormous battlements, a thousand fairy glades running here and there up among them – St Preux – Clarens in sight Clarens. Climbed up thro a vineyard to the Maison Rousseau now a heap of stones, supposed to be the scite [sic] of Julia's house – the lake heavenly – the rocks of Meillerie in deep shadow . . . A house in which Rousseau is said to have lived with Mme de Warens by the roadside between Clarens and La Tour. Vevay.[17]

It was said that the Empress Marie Louise, Napoleon's second wife, had slept at Meillerie in wretched accommodation, purely 'in remembrance of St Preux'.[18] As Byron and Shelley's accounts four years later indicate, the established tourist itinerary included trips to the rocks of Meillerie, to Clarens, to Vevai, to the Bosquet de Julie and to the Castle of Chillon.

Having set up house in the Villa Diodati in Cologny, just outside Geneva and overlooking Lac Leman, Byron toured the eastern end of the lake in a small open sailing boat twice, once in late June 1816, with his new poet acquaintance, Shelley, and once that September with an old college friend out from England, John Cam Hobhouse, with whom he revisited Vevey, Clarens and Chillon. The principal object of both of these tours was to view 'all the scenes most celebrated by Rousseau in his "Hélöise"'.[19] These tours themselves repeated Rousseau's own tour of the lake undertaken sixty-two years previously – anti-clockwise around

the lake from Geneva to Meillerie, Vevey, Lausanne, and back to Geneva – a tour made in preparation for the writing of his novel. Caught in one of the vicious and sudden storms for which the lake is notorious, Byron and Shelley were nearly wrecked. Byron seems to have been delighted, at least in retrospect, for their accident had repeated one of the most famous episodes of Rousseau's fiction, and so had authenticated and endorsed his reading experience.[20]

The poets' reactions, recorded variously in jottings, poems, letters and journals, and a travelogue, vary from the naïve to the highly sophisticated. Shelley, busy rereading *La Nouvelle Hélöise*, was, so his manuscript jottings suggest, hugely enthusiastic about seeing the 'scenes which [Rousseau's genius] has so wonderfully peopled'.[21] He displays a tendency to compare the actual present with an entirely fictional past, without noticing the oddity of so doing; he looks at the landscape as a souvenir of fictional events, with a naïve delight in being able to insert himself in that landscape in the footsteps of Julie; he shows an unsophisticated keenness to locate the 'precise spot' for a fictional happening:

> We proceeded with a contrary wind to Clarens, against a heavy swell. I never felt more strongly than on landing at Clarens that the spirit of old times had deserted a retreat it once embellished. A thousand times have Julie and St Preux walked on this terrassed road looking towards these mountains which I now behold, nay treading on the ground where now I tread. From the window of our lodging our landlady pointed out the 'bosquet de Julie.' . . . The road which conducted to it wound up the steep ascent thro woods of walnut and chestnut We went again to the bosquet de Julie, and found that the precise spot was now utterly obliterated . . .[22]

The published version, co-authored with his wife Mary Shelley, *History of a Six Weeks' Tour* (1817), is at once more elaborately sentimental and rather more nuanced. He repeats the remark quoted above, and adds for good measure a dash of St Preux-style emotion rather in the style of Boswell doing Rousseau:

> We walked forward among the vineyards, whose narrow terraces overlook this affecting scene. Why did the cold maxims of the world compel me at this moment to repress the tears of melancholy transport which it would have been so sweet to indulge, immeasurably, even until the darkness of the night had swallowed up the objects which excited them?[23]

In a fit of sentiment, they gathered roses on the terrace in the (necessarily implausible) 'feeling that they might be the posterity of some planted by Julia's hand.'[24] However, his general position on the pleasures of literary tourism is rather more complicated than this suggests. Commenting on 'the divine beauty of Rousseau's imagination, as it exhibits itself in Julie,' he remarks further 'It is inconceivable what an enchantment the scene itself lends to these delineations, from which its own most touching charm arises.'[25] Here Shelley postulates a thoroughly sophisticated relation of reader to landscape. The reader begins by appreciating the landscape as supplemental to the experience of reading the novel, and only thereafter revises his sense of the novel as itself derived from the landscape. Of Meillerie itself he similarly remarks 'Meillerie is the well known scene of St Preux's visionary exile; but Meillerie is indeed inchanted ground, were Rousseau no magician.'[26] He meditates upon the ways on which the landscape is changed by reading *Julie*, and the experience of reading *Julie* changed by seeing the landscape:

> I read Julie all day [on the voyage from St Gingolph to Clarens]; an overflowing, as it now seems, surrounded by the scenes which it has so wonderfully peopled, of sublimest genius, and more than human sensibility. Meillerie, the Castle of Chillon, Clarens, the mountains of La Valais and Savoy, present themselves to the imagination as monuments of things that were once familiar, and of beings that were once dear to it. They were created indeed by one mind, but a mind so powerfully bright as to cast a shade of falsehood on the records that are called reality.[27]

Shelley describes very clearly the way in which the landscape becomes a monument or memorial to the reader of his own memories, even if these 'memories' are simply of reading about imaginary experiences and characters. So strong is this effect that it can obliterate the merely 'real' aspect of the landscape.

At first glance, the much older sightseer Byron seems also to have his naïve side, as revealed in a letter to his friend Murray: 'Tomorrow we go to Meillerie – & Clarens – & Vevey – with Rousseau in hand – to see his scenery – according to his delineation in his Heloise now before me.'(Byron to John Murray, 27 June 1816).[28] He displays, for example, something of the same tendency I have already noted to check the accuracy of Rousseau's descriptions: 'I have traversed all Rousseau's ground – with the Heloise before me – & am struck to a degree with the force and

accuracy of his descriptions – & the beauty of their reality.'[29] However, his considered response, laid out in the stanzas and the footnotes to his best-selling travelogue poem *Childe Harold's Pilgrimage, Canto III*, is considerably more subtle. The long footnote to his stanzas on Clarens and Rousseau begins by quoting both *La Nouvelle Hélöise* and the *Confessions* as authority for his own descriptions of the landscape, and by remarking on 'its peculiar adaptation to the persons and events with which it has been peopled', which seems something of an unconscious back-formation. However, he goes on to suggest, echoing Shelley's remark about Meillerie as intrinsically 'inchanted ground,' that the landscape would still have the same power without the associations provided by Rousseau: 'If Rousseau had never written, nor lived, the same associations would not less have belonged to such scenes.' His next paragraph, delighting in the coincidence of the literary and the personal, underscores this desire to cut out the author as middle-man:

> I had the fortune (good or evil as it might be) to sail from Meillerie (where we landed for some time), to St Gingo during a lake storm, which added to the magnificence of all around, although occasionally accompanied by danger to the boat, which was small and overloaded. It was over this very part of the lake that Rousseau has driven the boat of St Preux and Madame Wolmar to Meillerie for shelter during a tempest.

Finally, commenting upon the destruction of the 'Bosquet de Julie' and the rocks of Meillerie, he remarks 'Rousseau has not been particularly fortunate in the preservation of the "local habitations" he has given to "airy nothings".'[30] He is surprisingly critical of this destruction of the landscape, given his position, reasonable enough, that the places he seeks out are not really memorials to anything. Byron thus oscillates between denying Rousseau primacy over the meanings of the landscape, and allowing him it: fittingly, after the publication of the immensely successful *Childe Harold's Pilgrimage III*, the environs of Geneva would remain the country of Julie and Rousseau, but it would be seen largely through the lens of Byron's famous celebration:

> Clarens! Sweet Clarens, birth-place of deep Love!
> Thine air is the young breath of passionate thought;
> The trees take root in Love; the snows above
> The very Glaciers have his colours caught
> And sun-set into rose-hues sees them wrought

By rays which sleep there lovingly: the rocks,
In permanent crags, tell here of Love, who sought
In them a refuge from the worldly shocks,
Which stir and sting the soul with hope that woos, then mocks.[31]

Not all visitors were as much in sympathy with what Mary Shelley called in 1817 'classic ground, peopled with tender and glorious imaginations of the present and the past.'[32] Thomas Raffles, a well-connected Evangelical clergyman who set out from Liverpool on his travels in 1817, hard on Byron's heels, arrived in Geneva clutching a copy of *Childe Harold III* as his tour guide. Raffles's view of Rousseau's connections with the landscape could not have been more vehemently different from Byron's and the Shelleys', though he was equally convinced of the impossibility of divorcing the landscape from such literary association. Of Meillerie, 'famous,' he inaccurately asserts, 'as the residence of Rousseau', he remarks:

This name [of Rousseau], which I am well aware, would excite the eulogies of many a pen, and impart to the surrounding scenes, a charm more powerful than any their own romantic beauties could create, has, I must acknowledge, a far different influence on me. I cannot but connect it with the pestilential principles – the blasphemous productions – and the deep sensuality, of the infidel that owned it. Who, that has any respect for the honour of revelation, or the happiness of mankind, but must regret . . . that such lovely scenes should have been polluted by the breath of such depraved and prostituted genius.[33]

For most subsequent English visitors – and they were many, far outnumbering other nationalities – the doubling of Rousseau and Byron, helped along by the congruence between the Byronic sensibility of *Childe Harold's Pilgrimage*, St Preux, and the Rousseau of the *Confessions*, infused the already spectacular landscapes with additional power and pathos. So efficiently had these texts done so that in 1824 the young Charles Tennant, not generally at a loss for words in his lively travelogue, wrote: 'So much has been so often said about the beauties of this lake, that the language of description is exhausted.' Despite this slight sense of satiety, he sets off for 'the most beautiful and romantic village of Meillerie.'[34] His experience did, and did not, mirror Byron's at Clarens. Where Byron had commented with satisfaction that there he had seen 'a young *paysanne* – beautiful as Julie herself' (Byron to

Augusta Leigh, 18 September 1816),[35] the equally hopeful Tennant wrote ruefully of Meillerie: 'Here seemed the very spot to seek for Julie; but alas! I saw only a few ragged children, who came running up into the road to beg from the stranger a few *batz*. There was, I will confess, something in this reality of life which produced upon my feelings an effect which might . . . be compared to that produced upon the ear by discordant sounds after sweetest harmony.'[36] He scattered some coppers, set his heels to his horse, and left Meillerie for ever. Although Tennant's search for Julie may be said to be the canonical form of local literary tourism, it was not the only one. In the 1820s, Anna Jameson dramatised the reactions of her partially fictive woman tourist to the area, reactions that owe something of their formulation to Byron, but which suggest that women tourists may have adopted the posture of the desiring Julie rather than St Preux:

> La Meillerie – Vevai! What magic in those names! And o what a power has genius to hallow with its lovely creations, scenes already so lavishly adorned by nature! It was not, however, of St Preux I thought as I passed under the rock of the Meillerie . . .[37]

Jameson's protagonist is full of erotic disappointment over her own lost lover; in this her experience of absence and disappointment is emotionally analogous to Tennant's.

Yet even though Tennant is signally disappointed in his search for Julie, he can still make a story out of it. The experience is one of repeating previous baffled searches for Julie – and the more people visited and wrote about their visits, the more the touristic experience consisted in repeating those visits. Consequently, a visit to Meillerie itself could never authentically disappoint, because it simply took its place upon the spectrum of possible already recorded experiences, all of which, anyway, were primarily of disappointment. In general, this principle of repetition reinforced tourism: Tennant, visiting the dungeons of Chillon primarily because Byron had done so, contemplated carving his name below that of Byron on one of the pillars. Comically, this little anecdote illustrates the constitutive inauthenticity of such repetition; Byron's name had not in fact been chipped by Byron himself, but by an earlier retracer of his footsteps anxious to supply this wished-for memorial graffito on Byron's behalf.

If Byron's travelogue facilitated subsequent tourists' ability to access a codified 'Julie' experience, so too did the evolution of the guidebook which exploited and reinforced the practice of following in the footsteps

of previous characters and previous sentimental travellers. By the late 1830s, the resourceful publishing entrepreneur John Murray III (grandson of Byron's correspondent) was producing revolutionary, and handy, guidebooks. *A Handbook for Travellers in Switzerland, and the alps of Savoy and Piedmont*, published in 1838, contained not only practical information, but the essential Rousseau helpfully excerpted in company with useful gobbets of Byron. Since Murray held the copyright of *Childe Harold III* and *The Prisoner of Chillon*, this was excellent business practice; embellishing the skeleton of the road-book familiar to the eighteenth-century traveller with excursions into moral, political and literary information for the educated reader, travelling light was likely to increase sales also of Byron's poetry. With Murray in hand, it was no longer necessary to carry or even to have read the whole of the *Confessions*, *La Nouvelle Héloïse*, or *Childe Harold's Pilgrimage III*; nor was it necessary to have studied the other local literary giants, Voltaire or Gibbon, or either of Madame de Staël's hefty sentimental novels, *Corinne* and *Delphine*. Instead, you slipped into your pocket a compendium of 'deathless associations' efficiently indexed to the 'immortalised localities of the lake'.[38] Murray's handbook, though more practical, was a similar enterprise to *Childe Harold III* and indeed derived from it; both saturated scenery with layers of historico-literary meanings.

Murray's practice of extraction makes Byron's poem, and with it *La Nouvelle Héloïse*, into captions for virtual postcards: he re-titles two major excerpts from *Childe Harold*, for example, under counterpoised headings: 'Lake Leman, in a calm' and 'Lake Leman in a storm'.[39] It would be only a few years, given advances in cheap printing techniques, before this verbal postcard would be realised in books of 'views', mapping the text onto the lake: by 1850 *The Continental Tourist* adorns its selection of views with Byronic epigrams: 'Rousseau, Voltaire, our Gibbon, and de Stael / Leman! These names are worthy of thy shore.'[40] Murray's suggested 'Route 56' for travellers, from Geneva to Martigny via Lausanne, Vevay, Chillon and Meillerie, takes in, besides other literary sites, the country of *Julie*, or rather, takes in *Julie* as 'done' by Byron. Although Murray does quote from Rousseau's *Confessions* in the section on Vevay, noting that Rousseau's celebrity made it famous, he only quotes those sections already cited by Byron in *Childe Harold*. Murray's uncomplicated approval of Vevay as 'the scenery of the Nouvelle Heloise'[41] contrasts with his remarks on the disappointments of Clarens, which exemplify the crucial importance of repetition to the touristic experience: '*Clarens*, so sentimentally described by Rousseau in the Nouvelle Heloise . . . is a

poor, dirty village, far less attractive than many of its neighbours.' He continues:

> . . . it probably owes its celebrity to a well-sounding name, which fitted it for the pages of a romance. Rousseau's admirers have puzzled themselves with endeavouring to identify the localities, though he himself stated that they are 'grossièrement altérées.' The spot on which the beautiful 'bosquet de Julie' is sought for is now a potato-field. Byron . . . has forgotten to ask whether the bosquet really ever had any existence except in Rousseau's imagination.[42]

This scepticism about Rousseau's realism, swiftly muted by enthusiasm for the undoubtedly real beauties of the surrounding scenery, 'which has been accurately described by Rousseau,[43] foreshadows the sentiments of writers later in the century.

The success of Murray's handbook was vast – it sold 50,000 copies over the next seventy years.[44] Combined with the enormous popularity of *Childe Harold* over the century, this meant that it was almost impossible not to see the environs of Lake Geneva through the eyes and sentiments of Byron. John Torr, writing to his beloved Maria Jackson from Geneva in 1840, noted that he had been rowing on the lake, and that 'I read Childe Harold there, and as I anticipated, found Byron's description of the spot correct even to a word.'[45] Ruskin, who spent many childhood summers there from 1833 onwards, partly because of his father's sentimental enthusiasm for *La Nouvelle Héloïse*, remarked in his autobiography that it was Byron (rather than Rousseau) who had 'animated' the scenery of Chillon and Meillerie 'with the sense of real human nobleness and grief'.[46] Meillerie, then, was no longer exclusively Rousseau's literary territory, but Byron's. Ruskin makes an unflattering comparison between Byron and Samuel Rogers, whom he calls 'a mere dilettante' for not making a distinction in his best-selling poem *Italy* (first published in 1822, revised and illustrated in 1830) between the thrill of standing 'where Tell leapt ashore' and standing where 'St Preux has stood',[47] between visiting the location of a verifiable historical happening and the site of a purely imaginary event. While Ruskin's reading of Rogers does not take into account the deliberate uncertainty of 'half-dreaming' (see epigraph above), his strictures do suggest that by the end of the century when Ruskin was writing his autobiographical *Praeterita* (drafted 1885–9), Rousseau's novelistic realism, which had produced Rogers's tourist ecstasy in the first place, had come to seem inadequate or even faintly fraudulent.

To consider this proposition in more detail, we might jump-cut to William Sharp's account of touring Lake Geneva in his *Literary Geography* (1904). By the turn of the century it is possible for Sharp to dismiss with cutting sarcasm the Byronic and Rousseauistic 'exhausted associations' and 'paralysing quotations' littered across the lake scenery,[48] and to be especially sardonic about the effect of guidebooks upon the tourist:

> Rousseau is the prey of the guidebooker. 'La Nouvelle Heloise' is exploited by Baedeker, Joanne and Company with . . . methodical monotony. . . . From Lausanne to Vevey, from Vevey to Montreux, and above all at Clarens, the unwary tourist is caught in a Rousseau net, wanders in a Helöisian maze. He hears (generally for the first time) of Saint Preux and Milord Edouard, of the heart-adventures of Claire and Julie, and he makes pathetically arduous efforts to visit the scenes 'immortalised' by these person of whom he may never have heard, in whom he takes no interest, and of whom he hopes in his soul never to hear again.[49]

We are a world away from the experience of Rogers here. Where he was inspired to St Preux-like reverie by his reading of the novel, seeing the landscape vividly colourised through the lens of Rousseau's prose, the early twentieth-century tourist dutifully sees a landscape created by the guidebook instead. Or rather, he can barely see the landscape for the literary detritus of *La Nouvelle Héloïse*. The realism of Rousseau's novel, which led to tourism in the first place, has resulted finally in the discarding and disembowelling of the novel – a guidebook map, studded with amputated quotation and pallid anecdote, will do. Although Sharp then provides a few suggestions for 'rambles' designed for anyone who really has read the *Confessions* and *La Nouvelle Héloïse*, his real feeling is that it is time that *La Nouvelle Héloïse* be erased from the literary map to which it had itself once given meaning, time that the real displaced this early essay in realism. He recommends that, rather than visiting Clarens in memory of Julie, the tourist pays homage instead at the tomb of an under-rated but, at any rate, a real person, Henri-Frédéric Amiel, the diarist of the posthumously published *Fragments d'un Journal Intime* (1883).[50]

Thus although it had inaugurated the great age of realistic and regional fiction Rousseau's novel was, a century and a half after its publication, at last overtaken by its own success. So well-known that there was no need to read it, the text lost its power to seduce readers into becoming

tourists. Hence the visitors most likely to be seen with copies of Rousseau around Lake Geneva nowadays are merely academics such as myself, archaeologists of these layers of past emotional investment. Yet although *Julie* tourism all but disappeared by the end of the century in its native habitat, it had already conditioned the transference of such habits of sentiment onto other romantic landscapes in nineteenth-century Britain, in the first instance a landscape exploited by Sir Walter Scott in his best-selling poem *The Lady of the Lake* (1810). What *La Nouvelle Héloïse* had done for the beauties of Lac Leman, *The Lady of the Lake* did for the picturesque of Loch Katrine. Scott's Highlands would become a must-see sentimental destination for the landscape tourist, supplementing the beauties of Rousseau's Alps, as the agreeably prolix title of a little book published anonymously in 1836 makes clear: *Notes of a ramble through France, Italy, Switzerland, Germany, Holland, and Belgium; and of a visit to the scenes of 'The Lady of the Lake.' By a lover of the picturesque.*

II *The Lady of the Lake* (1810)

Arguably the publishing event of 1810, *The Lady of the Lake* marked the height of Scott's fame and sales as a poet; his next poem, *Rokeby*, was a flop, and *The Lord of the Isles* was, comparatively, a non-event. So successful was *The Lady of the Lake* that the publisher Ballantyne was caught out with too small an initial print-run; the total sales for 1810 were 17,250.[51] Publications and derivatives associated with the poem also reached record levels: every wealthy person's library, it seems, could boast of the two rival sets of plates commissioned from Westall and Cook to illustrate the poem and designed to be bound up with it; drawing-rooms and officers' messes alike were littered pelisse-deep in sheet-music of the inset songs; crowds in London and Dublin flocked to see stage adaptations enlivened with the latest special effects. The unparalleled success of *The Lady of the Lake* marked the beginning of tourist interest in locations associated with Scott's works, an interest which would extend rapidly thereafter, as we have seen, to the poetic environs of Abbotsford. Within the year, the area of the Trossachs and Loch Katrine was descended upon by unprecedented numbers of genteel tourists, and the numbers of tourists would go on expanding throughout the century, carried thither first by horse and carriage but subsequently by railway, steamer and charabanc. To this day, the little town of Callander, gateway to the Trossachs, boasts a Waverley Hotel, an Abbotsford Lodge and so on, in homage to the writer who brought it so much profit.

Today, not very much survives of that great Victorian enthusiasm. The steamer named the 'Sir Walter Scott', built in the 1890s, still chugs across Loch Katrine in the summer carrying tourists from the Trossachs up to Stronachlar. Oddly hapless rags of quotation from the poem's set-piece landscape descriptions adorn the helpful plaques otherwise retailing snippets of history which have been installed in front of all the best views by what is now the presiding genius of the place, the Glasgow Waterworks (which rather compromised Loch Katrine's status as a region of romance after Scott's time by taking it over as a water reservoir), and the heroic concrete stag couched as the foreground of the magnificent view from the turreted Trossachs Hotel is captioned with Scott's famous opening lines, 'The stag at eve had drunk his fill / Where danced the moon on Monan's rill'. In every direction, including Victoria's Royal Cottage, are outcrops of hunting lodges and holiday villas built of the fabric of Abbotsfordian fantasy, towered, turreted and gabled so as to stretch all structural credulity. It is just possible to catch the sound of the faint whisk of phantom crinolines along the winding paths criss-crossed with trickling water and upholstered with moss, ferns, and rhododendrons in between the whizzing of today's mountain-bike wheels, but on the whole Victorian romance has faded along with *The Lady of the Lake* itself, and both seem past all but antiquarian last rites. The narrative that entranced the vast majority of Victorian readers has silently expired. Ungratefully, the gift-shop on the pier, though well-stocked with other books, sells no Scott whatsoever; although for no very good reason its stock includes a postcard of Robert Burns, the Minstrel of the North goes quite unrepresented. Visitors and proprietor alike appear unaware that even the names of Loch Katrine and its presiding mountain Ben A'an owe their form to Scott's metrical necessities, and that the English place-names blandly recorded on the Ordnance Survey map to this day – Ellen's Isle, the Silver Strand – derive from Scott's poem rather than ancient usage. Like Rousseau's landscape, the Trossachs has lapsed back into mere picturesqueness.

In choosing the Trossachs as the setting for *The Lady of the Lake*, Scott had in fact pitched upon an area already sufficiently famous for the type of sublime and picturesque scenery beloved of hunters after landscape thrills.[52] The intrepid Sarah (Aust) Murray, for example, published her account of her travels in the area in *A Companion, and Useful Guide to the Beauties of Scotland . . . To which is added, a more particular description of Scotland, especially that part of it, called the Highlands* in 1799.[53] Her tour of 2000 miles in the summer of 1796 included a full-day excursion to

'the wonders around Loch Catheine'. She describes the road from Callander to Loch Katrine, the necessity of taking food for horses, self and servants in the absence of any other provision in such a remote place, advises caution at the deep ford at Glen Finglas, warns of the dangers of the bog at the opening to the loch (in which her own horses foundered over their backs), and suggests procuring a boat, if possible, to go to view 'the Den of Ghosts', a perpendicular rock formation rising steeply from the depths of the lake.[54] Her romantic expectations of the wild scenery were fully satisfied – the Loch was 'beyond, far beyond description, either of pen or pencil. Nothing but the eye can convey to the mind such scenery' (149). Despite torrential rain, she enthusiastically toured the loch in a boat, viewed the 'Den', admired 'the beautiful wooded island' at the foot of the lake (151), and, wet through, walked back through the pass of the Trossachs, picking up pebbles in an undamped spirit of geological inquiry. Her account does not include much anecdote of local history or local superstitions – her landscape comes without people or stories, although it is clear that those that she was told she has transcribed faithfully. Briskly practical and enjoyably down-to-earth in her earnest interest in how to do the sights 'in safety and comfort', she identifies the location principally in terms of its appeal to the eye eager for picturesque sensation, and to the sensibility curious after the sublime shudder.

Murray's account of her visit may be amplified by that of the anonymous author of *The Traveller's Guide; or, a Topographical Description of Scotland, and of the Islands belonging to it . . .* (1798), which describes exactly what contemporary travellers found so delightful about the scenery of the Trossachs; it was, unlike the Highlands for the most part, visually and aurally eventful. *The Traveller's Guide* describes the experience of walking or sailing along the lake:

> Sometimes the view of the lake is lost; then it bursts suddenly on the eye; and a cluster of islands and capes appear, at different distances, which give them an apparent motion of different degrees of velocity, as the spectator rides along the opposite beach: at other times, his road is at the foot of rugged and stupendous cliffs; and trees are growing where no earth is to be seen. Every rock has its echo; every grove is vocal . . . In a word, by both land and water, there are so many turnings and windings, so many heights and hollows, so many glens, and capes, and bays, that one cannot advance 20 yards without having his prospect changed, by the continual appearance of new objects, while others are constantly retiring out of sight.[55]

Other contemporary accounts of the area emphasize this taste for a landscape that seemed to dramatize itself as the traveller moved through it. It is evident, for example, in Alexander Campbell's expensive and comprehensive survey of the sights of Scotland, *A Journey from Edinburgh Through Parts of North Britain: containing remarks on Scotish [sic] Landscape; and Observations of Rural Economy, Natural History, Manufactures, Trade, and Commerce; interspersed with Anecdotes, Traditional, Literary, and Historical; together with Biographical Sketches, relating chiefly to civil and ecclesiastical affairs, from the twelfth century down to the present time . . . embellished with forty-four engravings, made on the spot, of the Lake, River, and Mountain Scenery of Scotland* (1802). Campbell describes the scenery in the technical terms of the picturesque, in terms of 'foregrounds', 'glimpses', 'prospects', 'side-wings', 'side-screens', directs the arm-chair tourist's eye to especially fine views, and earnestly recommends 'stations' for the would-be sketcher, remarking on the virtues of a boat on the lake for this purpose. However, unlike Murray, Campbell displays antiquarian urges as well as picturesque sensibilities, and his book, as advertised, includes a number of 'anecdotes' which would later serve as some of Scott's raw material for his historical romance. Campbell remarks, for example, on the use of the forest of Glenfinglas as a royal hunting ground, identifies 'Cori-nan-Uriskin' (Murray's 'Den of Ghosts') as 'the den of the wild-men or savages' from a band of marauding outlaws who had made their headquarters there, and identifies 'the former residence of the famous highland free-booter *Rob Roy*.'[56] He even provides his own poem evoking a battle between the Highlanders and the Romans, which animates what he calls 'this region of sublimity and historical incident'.[57]

Campbell's book was designed to appeal to the refined sensibilities of leisured persons of taste at liberty to travel to a landscape with the intention of viewing it as an object of vertu. By 1802, there were already enough such travellers to galvanise the local minister of Aberfoyle into producing his own little guidebook to the area at the urging of 'some travelling gentlemen', *Sketches descriptive of Picturesque Scenery, on the southern confines of Perthshire, including the Trosachs, Lochard & c.* The Revd Patrick Graham notes in his preface the increase of travellers 'of taste', by which he means genteel connoisseurs of the picturesque, remarking that 'from the beginning of May to the beginning of November, this scenery is crowded with visitors of distinction, from every corner of the kingdom. It is no unfrequent thing to see here six or seven carriages in one day.'[58] The number of visitors was increasing so fast that the accommodation of two wicker shelters provided by Lady

Perth and commented upon by both Murray and Campbell was no longer adequate; in between his conventional comments on the picturesque and his provision of the usual set of historical anecdotes, Graham lobbies energetically for some proper accommodation for tourists, suggesting the erection of a cottage there, with two bedrooms, a kitchen, an open shade for the horses, a stock of provisions for the season and a resident servant. It was Graham's little book that Dorothy Wordsworth was carrying on her tour of the Highlands in the company of her brother and their friend Coleridge in the summer of 1803.[59] With typical contrariness the party initially tackled Loch Katrine not by the standard tourist route described by Murray, Campbell and Graham alike, but from the other end of the loch, the western end. Their adventures were accordingly altogether less comfortably genteel than Graham would have wished; indeed, they met with incredulity at their errand in the cottage in which they took refuge as night fell: 'A Laugh was on every face when William said we were come to see the Trossachs William endeavoured to make it appear not so very foolish, by informing them it was a place much celebrated in England, though perhaps little thought of by them, and that we only differed from our countrymen in having come the wrong way'[60] They repaired their mistake some days later, revisiting the loch by the 'proper' route.

It was, therefore, on a well-defined tourist route and itinerary that Walter Scott travelled on holiday in the summer of 1809, and a well-rehearsed stock of historical and folk anecdote lay ready to his hand. But the poem that he began writing while still resident in those scenes would not only bring about a boom in the local tourist trade, but would dramatically shift the aesthetic and sensibility of tourist practice in the area. If Rousseau had sentimentalised the landscapes of Lac Leman, Scott did more; he enriched Loch Katrine with a glamour both sentimental and, crucially, historical. In so doing, he would instantly write himself out of the landscape that had been his inspiration. Whereas, as we have seen in the case of Melrose Abbey, the eidolon of Scott whether in person or in the shape of his surrogate Bower occupied the foreground of the picture in the Victorian imagination, courtesy of Scott's ability to transform the site by his imagination, he was definitely *de trop* within the landscapes of *The Lady of the Lake*, which were already visually stunning enough to need little enhancement. The nature of this poem as a historical romance proved also to write Scott out of the landscape; the story effectively pre-dated the author's very existence. (It is instructive to compare *The Lady of the Lake* in this respect to both *The Lay of the Last Minstrel* and *Marmion* which, by constructing frames

around the core of the story, produced Scott as 'the Minstrel of the North'.) The result was a landscape saturated with fiction, a fiction entirely unsecured and unmediated by the author.

It is possible to calibrate something of the change that the publication of *The Lady of the Lake* brought about by taking a glance at the fifth edition of Margaret Oswald's *A Sketch of the Most Remarkable Scenery, Near Callender of Monteath; particularly the Trossachs, at the East End of Loch Catherine, and the road by Lochearn-Head to Duneira*. This little book had come out first in 1800. By 1815 it had gone through six editions. In 1811, the fifth edition, sold by the vintner at Callander, advertised itself as 'improved' to the tune of some ten extra pages. The text is peppered with remarks about the recent improvement of visitor amenities which must have delighted Graham's heart: Callander had recently acquired a new hotel 'for the encouragement of the public' which boasted 'nine public rooms, sixteen bedrooms with dressing-closets (some double-bedded), nine servants' apartments, stalls for thirty horses and accommodation for a further thirty, and pleasant walks in the garden and orchard.' A new Inn at Lochhearnhead is reviewed, and readers are assured that the road 'is much improved, so that carriages can travel with safety.'[61] The new stream of tourists needed a guide: one 'James Stuart of Ardkenknochan', according to Oswald, 'has engaged to attend strangers, to provide them with a boat, to explore both sides of Loch Catherine, to point out the most remarkable places and tell their names, to recount the traditions, current in the country of the circumstances that happened, and to gratify the inquisitive with every necessary information' (17–18). Much more of the additional space is taken up with quotations from *The Lady of the Lake*, sometimes rather crudely dropped in (cf. 16), sometimes more elaborately situated in relation to an actual location. The process of making the Trossachs into Scott country was not as yet complete in 1811 – Oswald refers to the little wooded island at the foot of the lake as the 'Rough Island', one of the last times in the nineteenth century that it would go by any other name than 'Ellen's Isle'. But by 1816 *The New Picture of Edinburgh for 1816* had added a special appendix on the Trossachs which recommended that 'The traveller should have with him Scott's poem of *The Lady of the Lake*, in which our Scottish bard, with so much beauty, describes many of the interesting scenes at this place,' including 'the Goblins' Cave, Ellen's Isle, and the Beach of Interview,' places to which they could expect to be able to hire a guide.[62] By the 1840s, with the coming of the railway and the introduction of steamers after 1843, hotels were springing up to cope with the increased tourist traffic. At 'Ardchreanochronachan' 'James Stewart'

had first converted his cottage into a 'public', then seen the public swell into the dignity of an Inn, until in the 1840s it was rebuilt as the Trossachs Hotel, finally breaking out into extension upon turreted Scottish baronial extension in 1852.[63]

'The traveller should have with him Scott's poem . . .' Despite the precedent set by enthusiasts for *La Nouvelle Héloïse* of taking the novel along on their sentimental investigations, it was still a novelty to suggest that travellers should use a fictional narrative as a guidebook in such a minute and extensive fashion. As in the case of Rousseau's novel, the explanation lies at least in part in the structure of the poem and the function of its protagonists in providing models for the tourist. Like so many of Scott's romances, the poem begins with the incursion of a stranger into a wild territory that is governed by rules, codes, alliances and emotions with which he is not familiar. Nominally set in the sixteenth century, the poem opens with a wild stag-hunt across the forest of Glenartney from dawn till dusk, when the leading huntsman Fitz-James finds himself alone, horseless and benighted deep in the wilderness surrounding Loch Katrine. In pursuit of the apparently tireless stag, he works his way from the Brig o' Turk through the Pass of the Trossachs, where his horse falls dead from being over-ridden, and then, in the absence of the eighteenth-century road later blasted through the rocks, clambers round the precipice projecting into the lake by means of a path of vertically strung ropes into the glen of Loch Katrine. He is rewarded not merely with wonderfully picturesque views, but, on sounding his horn for help, with a glimpse of the beautiful and hospitable 'lady of the lake', Ellen, framed by the 'scenery of a fairy dream',[64] who rows over to the 'silver strand' expecting to ferry her father to their romantic rustic retreat on the island. Fitz-James accepts hospitality from the mysteriously refined household hidden on the island, flirts with Ellen, and subsequently resumes his journey with some reluctance, giving in to temptation later to double back to visit her and her minstrel as they lie hidden in the all-but-inaccessible rocks of the 'Goblin's Cave'.

Fitz-James's adventure meticulously models and follows the standard route of the eighteenth-century tourist into this landscape, and he himself wilfully follows his pleasure as lightly, as whimsically as a tourist. Like a tourist too, Fitz-James has an imperfect and irresponsible sense of the topography, physical, political or emotional, of the place into which he has wandered. As it proves later in the poem, he is the king indulging himself in the pleasures of travelling incognito, pleasing himself with pretending to be a landless knight, a huntsman escaping to a land of

Spenserian romance. His touristic encounter with the Trossachs involves a sentimental susceptibility to the charms of the lady of the lake and her island retreat. Ellen presides over the perfect accommodation for such a visitor, embodying a sense that it is possible to escape everyday duties and responsibilities to somewhere secret, romantic, alternative and temporary, a holiday house in which one's normal social identity can be cast aside, without forfeiting one's class privileges. Although the poem points out that this absorption into a space of romance, indeed of fairyland, is simply a dangerous fantasy indulged by the king (who will be thereby exposed to the deadly enmity of the rebel Roderick Dhu), and that political responsibility and identity weigh as heavily on the lady as on the huntsman, it simultaneously makes that fantasy available and powerfully attractive to the reader. The poem as a whole brings about an alliance between the Highlands and the king in Stirling castle, made possible by the king's unfulfilled *tendresse* for Ellen (whose virtuous marriage to Malcolm Graeme he finally enables, rather than himself pursuing her to make her his mistress). The poem thus models the tourist's relation to the landscape – attraction, flirtation, followed by a wistfully regretful romantic distance; as such, it is a real holiday romance.

If the core of Scott's poem is romance, it is embedded within a discourse plundered and adapted from the genre of the guidebook; Coleridge, discussing *The Lady of the Lake* in a letter to Wordsworth in 1810, noted that Scott was clearly not only 'familiar with descriptive Poets and Tourists' but was 'himself a Picturesque Tourist'. Scott embroiders the narrative with a mass of antiquarian material drawn from Oswald, Campbell, Graham and others. The investment in traditionary anecdote common in different registers to both main text and notes had the effect of eliding the distinctions between the fictional and the actual and conferring equal reality on Romans, Rob Roy, Roderick Dhu and Highland customs as on fairies, Ellen Douglas and Malcolm Graeme. This effect is intensified by a trick typical of Scott's romances, which characteristically start off in an unspecified time in the romantic past, and sharpen up into historical focus; in *The Lady of the Lake* the dateless Fitz-James morphs into King James V to bring about the happy ending. Real historical personages and events thus occupy the same discursive territory and validity as fictional events and personages, and both become inextricably entwined. If narrative ambiguously fictional and historical is thus implanted by Scott into the picturesque scenery of the Trossachs, his footnotes also encouraged a practice of locating his fictional events upon a real map; he remarks, for example, of the route

of the sign for the clans to rise in support of the Douglas and Roderick Dhu, the Fiery Cross, that

> A glance at the provincial map of Perthshire, or at any large map of Scotland, will trace the progress of the signal The first stage of the Fiery Cross is to Duncraggan From thence it passes towards Callander, and then, turning to the left up the pass of Lennie, is consigned to Norman at the chapel of Saint Bride, . . . the alarm is then supposed to pass along the lake of Lubnaig, and through the various glens in the district of Balquidder, including the various tracts of Glenfinlas and Strathgartney.[65]

(Though the Fiery Cross itself is commemorated nowadays only as an emblem on the local war memorial and, more bathetically, as the sign of the local chicken barbeque, it is entirely possible to follow this route to this day with the aid of an Ordnance Survey map.) By 1813, the ever-opportunistic Ballantyne and Longman were advertising in the endpapers to *Rokeby* what must have been the first ever literary tourist map: described as 'a half-sheet map of the scenery of *The Lady of the Lake*', it was designed to slip into the pocket, and was accurate enough, the description suggests, for practical use, being 'taken from an actual survey and beautifully coloured'. The subsequent publishing history of the illustration of the poem also opportunistically magnified this original 'guidebook' effect. Although the two sets of illustrations by Westall and Cook commissioned soon after first publication are on the whole uninterested in topography, in 1830, when Scott and his publisher engaged J.M.W. Turner to illustrate the collected *Poetical Works* (1833), they decided on topographical subjects. This may well have been in response to the success of engravings of the locality made famous by Scott's poems, sets such as *Six Views of Loch Katrine* (1822), which had come captioned with Scott's verses. Turner eventually delivered a view of 'Loch Katrine' to act as a frontispiece to volume eight. Thus nearly thirty years after first appearing as a poet in print, Scott was effectively publishing his poems, including *The Lady of the Lake*, in a format designed to keep pace with the development of the very tourist sensibility that they had instigated. Illustrations to the poem would thereafter become ever more specifically topographical: Robert Herdman's *Six Engravings in Illustration of the Lady of the Lake* (1868), for example, included one showing Ellen 'with Ellen's Isle, Loch Katrine, and part of the slopes of Ben Venue behind her'.[66] This tendency towards mapping romance with documentary precision was only increased by the advent on the one

hand of the Ordnance Survey map, and on the other of photographic illustration, and is most strikingly exemplified by a 1904 edition of *The Lady of the Lake*. The first to use photographs by way of illustration, it was provided with 'A Topography of the Poem' by Sir George Biddell Airy, fifty full-page photographs, and a formidable map. It references the events of the poem to the six-inch Ordnance Survey map, aiming to make it possible for the reader accurately to retrace the author's reconstruction of the various journeys made by Fitz-James and Roderick Dhu:

> Fitzjames walked along the north shore of the lake . . . and passing the white-pebble beach, he came to a 'far-projecting precipice' . . . For the guidance of the tourist, I give the following accurate measures and directions. From the steamboat pier to the white-pebble beach . . . is four-fifths of a mile . . . On walking up this path, and turning a little to the left, the summit of the rock is gained, 120 feet (by aneroid) above the lake. The glorious view here obtained is described accurately by Scott.[67]

Measuring romance out by camera-lens, aneroid, and tape-measure is potentially a frustrated and frustrating endeavour: on the Goblin's Cave, Airy notes that 'The place whose character approaches nearest to [the Goblin's cave] is that (probably the same to which Scott refers) to which boatmen usually conduct strangers, situate in the lower of the sloping descents between the rocky swells; it is utterly unfit for the rest of even a single person' (147–8). But on the whole Airy takes an infectious delight in his literary detective work: 'In terminating the notes on this beautiful poem, I remark that the accuracy of Scott's topography gives a mental reality to the incidents, and the pleasure of examining them on the spot, such as I have never experienced in reference to any other literature' (154).

If Scott's poetic topography was thus progressively 'improved', so too was Loch Katrine, which was developed to match the poem, or rather, to match the expectations of visiting readers of the poem. The aristocratic proprietor of the land, Lord Willoughby D'Eresby, installed a summerhouse on 'Ellen's Isle', especially designed to correspond to Scott's description of Ellen's rustic bower:

> It was a lodge of ample size,
> But strange of structure and device;
> Of such materials, as around
> The workman's hand had readiest found.

> Lopp'd of their boughs, their hoar trunks bared,
> And by the hatchet rudely squared,
> To give the walls their destined height,
> The sturdy oak and ash unite;
> While moss and clay and leaves combined
> To fence each crevice from the wind . . .

> (Scott, *Lady of the Lake* I, stanza xxvi)

(Regrettably, this grotto, tantalizingly described as filled 'with many curious things' so as to correspond to Scott's description of its interior, was burned to the ground in the summer of 1837). Nor was D'Eresby the only one to engage in such grounding of Scott's story in actuality. Encouraged by the poem's guidebook mix of fiction and historical truth, local guides seem simply to have adopted Scott's imaginary story as traditionary truth, and retailed it along with older stories, flattening out the distinction between tradition and fiction. This practice was apparently well-established by the mid-century; according to *Menzies Guide* in 1854, 'the characters and incidents of the 'Lady of the Lake' have been adopted as realities by the Highland guides on the banks of Loch Katrine, who now point out to strangers the various scenes and localities mentioned in the poem, as if they formed part and portion of the ancient traditions of the district.'[68] *Black's Picturesque Guide* (1853) is more specific:

> Somewhere near the entrance of the defile Sir Walter Scott intended to lay the death-scene of Fitz-James' over-ridden horse. The guides show the exact spot with true Highland precision. Nay, farther, they will assert, as indeed they truly believe, that the event was no Saxon poet's dream, but that it happened, and happened there.[69]

As this 'improvement' of Loch Katrine would suggest, the tourists who crowded over the course of the century variously into the Trossachs Hotel and the less expensive hotels in Stirling, who took their tickets for the railway and the steamer round trip, used *The Lady of the Lake* as their guidebook, in much the same way as earlier visitors to Lac Leman had used *Julie*. John MacCulloch – a sophisticated, not to say a jaundiced, reader of his friend Scott – has much to say on the ways in which the landscape of Loch Katrine was being 'read' in the immediate aftermath of the poem's success. In his letters to Scott detailing his journeys across Scotland between 1811 and 1820 he complains fretfully about the

crowds newly infesting the Trossachs – 'barouches and gigs, cocknies and fishermen and poets, Glasgow weavers and travelling haberdashers' (194),[70] expressing especial annoyance at the cockney who arrives with a French horn so as to make the most of the echoes made famous by Fitz-James's horn-call. (This sort of thing may have become quite common, to judge from *Black's Picturesque Guide*, which rather coyly suggests that on visiting the pass in which Roderick Dhu dramatically whistles up his Highlanders to prove to the disguised king that he is entirely within his power 'there is no harm in the tourist trying his own whistling powers, and imagining the whole scene to himself').[71] Typical of this flush of tourists and their practices was the young actor William Charles Macready, who took a three week holiday after his play closed in Glasgow in the summer of 1818, walking to Loch Katrine, 'the object of my most ardent wishes', specifically for the pleasure of rowing 'merrily up the lake, visiting the island, the Goblin's Cave, and every spot that Scott's poetry has invested with a never-dying interest.'[72] MacCulloch speculates sourly on the nature of the 'never-dying interest' with which the poem inspired such tourists: 'Why the scenes of a fictitious tale should excite the same interest as those where the great drama of life has been acted in its various forms, I shall leave you to explain . . . but I am quite sure that many of the well-informed personages who come here to see, believe the whole thing.'[73] MacCulloch's lack of enthusiasm for this new way of seeing landscape informs his slightly vindictive pleasure in retailing the discomfiture of a too-credulous reader whom he had accompanied in a search for the Goblin's Cave, Ellen's second place of refuge: 'I had accompanied, on one occasion, a cockney friend whom I met here, and who, after scrambling among the rocks and bogs for an hour, expressed vast indignation when he had reached the Coir nan Uriskin. "Lord, sir," said the [guide], "there is no cave here but what Mr Scott made himself." "What the d—l, no cave?" "Na, Sir, but we go where the gentry chooses, and they always ask for the goblin cave first." '[74]

Although by 1825, if memory alone would not serve them, visitors could resort to carrying a special two-volume pocket edition of the poems, advertised as suitable for 'travellers and others visiting the scenes of the above celebrated Poems,'[75] Victorians seem to have been well up to recalling and reciting extracts from memory at the appropriate places. *Lumsden's Guide* confidently asserted in 1838 that 'the individual acquainted with the stanzas of the 'Lady of the Lake' will now recognise at every step, the scenes so graphically represented in that poem.'[76] In 1842 Queen Victoria herself was reciting passages of *The*

Lady of the Lake on site.[77] Theodor Fontane, travelling in 1860, reported that the breakfast tables of Stirling hotels were piled up with 'considerable quantities of gilt-edged copies of *The Lady of the Lake* in red and green bindings' and that as they drove out to the Trossachs his party of pleasure was alive with 'all manner of talk about *The Lady of the Lake*, talk to which everyone contributed from the storehouse of his memory as though the whole thing were a kind of conversational picnic' (110).[78] Although later guidebooks would relieve visitors of the necessity of re-reading the poem *in situ* by garnishing their suggested itinerary with the essential extracts, serving at once as guidebook and souvenir in the case of *Black's Picturesque Guide to the Trosachs* (1853), rather surprisingly guidebook and poem seem to have co-existed successfully for many years: the author of *Baedeker's Great Britain* (1887) remarked of Loch Katrine simply that 'The traveller need scarcely be reminded that Scott's poem renders all other guidebooks almost superfluous for this part of Scotland', and did not bother to exert himself in any further labour of description.[79]

The story of the rise of tourism associated with *The Lady of the Lake* is in miniature the second instalment of the story of a changing relationship of literary tourist to landscape. The eighteenth-century appreciation of the picturesque in scenery was overlaid by the pleasures of sentimental narrative hybridised with historical romance. Under Scott's influence, the Scottish landscape was newly saturated with poetic, traditionary and historic associations, associations which the highly tuned sentimental traveller would now be expected to have vibrating at his or her nerve-endings. Victorians now saw the landscape associatively, in terms of historical narrative, in a spirit of romantic documentary. Historical anecdote and folk tradition entwined seductively with enchanting creatures of imagination. Travel within such a landscape now promised an escape into the romance of the past, and with it the possibility of reinvigorating everyday modern existence. To step out of a carriage in the Trossachs was to breathe in a heady gasp of the air of the past. Breeches melted away mentally into kilts, muslins into charming plaids. For a whole century or more, despite reality – the mines, the lime-works, the marble quarry, the Chinese bridge in the grounds of the house at the west end of the lake, Duneira, and the 'sluice which is built across the river to keep up the level of the lake for the Glasgow waterworks'[80] which drowned the original quartz pebble beach on which the young Victoria picked up pebbles to have them made into a bracelet, despite even the depressingly efficient municipal iron railings that police the edge of the loch – it would be almost impossible and entirely

undesirable to see the region of Loch Katrine in any other way than as 'a country which [Scott's] genius has made classic.'[81]

III *Lorna Doone* (1869)

Scott's influence, though most powerfully felt in Scotland's subsequent fashionability and 'Balmoralisation', also affected other parts of the country. The governing narrative of *The Lady of the Lake* – of a transit from modernity to romance by way of a journey deep into a secret and forbidden landscape – also powerfully informed R.D. Blackmore's novel *Lorna Doone* (1869). Their structural similarities explicate the Victorian tourist rush which transformed Exmoor almost overnight into 'Lorna Doone country.' As early as 1879, a local guidebook, having referred to *The Lady of the Lake* as having done for Loch Katrine what Charles Kingsley had done for Westward Ho, went on to remark that 'There can be no better preparation for a tour in North Devon than the reading of Kingsley's *Westward Ho!* and Blackmore's "Lorna Doone", two books which have made North Devon known and famous wherever the English tongue has spread, and which abound in graphic touches descriptive of people and of places.'[82] The history of the transformation of Exmoor can tell us much about the ways in which late Victorian literary pilgrimage developed ever more strongly on the basis of documentary realism.

Now that *Lorna Doone* is no longer, as it was until the mid-twentieth century or thereabouts, a set text in schools and required teenage reading, 'Lorna Doone' country has faded in much the same fashion and for some of the same reasons as the territory of *The Lady of the Lake*. Following the example of Scott, Blackmore drew upon a fund of local legend, anecdote and historical titbit, collected by the Rev. Matthew Mundy in 1833, and already circulating in print in guidebooks to the locality, including *Cooper's Guide to Lynton*, by 1853. This material detailed the story of the seventeenth-century Doones, a clan of aristocrats who, outlawed and landless, took up residence in a remote Exmoor valley and terrorised and robbed the natives until they were eventually cleared out by government forces. Blackmore combined this material with the tradition of John Ridd, a giant among local men, with the story of a local highwayman, Tom Faggus, and with the tale of the Monmouth rebellion, and brought the whole to life with a landscape description that is almost pre-Raphaelite in the intensity of its foreground detailing, a brilliant particularity born of a boyhood spent with his grandfather and uncle on Exmoor. But although there is still a Lorna

Doone Hotel in Porlock, the girl behind the bar has very little idea of why it should be so named. The gift-shops may sell 'Lorna Doone' biscuits, thimbles and coasters, but there is hardly an edition of the book itself to be had. The very strategy that made both *The Lady of the Lake* and *Lorna Doone* importable into the landscape and detachable from the signature of the author – their plundering of historical bits and pieces to weld together within the fabric of a romance – has proven to be the undoing of both texts as they have decayed back into history in popular memory. The Glasgow Waterworks signs at Loch Katrine nowadays cite Scott's landscape descriptions and Graham's historical snippets separately, so unravelling all Scott's magic amalgam of picturesque and history that so entranced the Victorians. The captions in the Exmoor Visitor Centre perform a similar trick, providing information on the tradition of the Doones well-barricaded by a health and safety notice designed to police the unwary literary tourist: 'FACT: Did you know that Lorna Doone is a fictional character?' Spoilsports.

Yet for the literary enthusiast today, the charm of visiting Doone country, as Loch Katrine, is in many ways enhanced by this spectacular popular forgetting of the book that made the dreary wilds of Exmoor palatable to the tourist in the first place; nowadays there is remarkably little competition to take the classic literary walk, following in the footsteps of the young John Ridd up Badgeworthy Water, past the stone monument to Blackmore, and up the 'water-slide' into the Doone Valley. Imagination is needed to squint past the realities of the farm campsite, it is true, but once past it, if you cannot imagine the figure of John Ridd, you may just be able to catch a sight of Edwardian riding-habits trailing from small shaggy ponies up the path ahead. This excursion up Badgeworthy Water is the defining episode of *Lorna Doone*, the one that sticks in the imagination. Thirteen-year-old John Ridd goes fishing, and explores up the river into the dangerous heart of Doone country, eventually penetrating the outlaws' secret valley. Ridd's first-person account of his adventure is the very core and motive-power of the book and of the subsequent touristic desire to retrace his footsteps; like Fitz-James, he opens a way into the dark heart of romance, and is seduced by it. The way in, as in *The Lady of the Lake*, is improbable, secret, narrow, perilous and deathly, an all but impassable waterfall:

> I stood at the foot of a long pale slide of water, coming smoothly to me, without any break or hindrance, for a hundred yards or more, and fenced on either side with cliff, sheer, and straight, and shining.

The water neither ran nor fell, nor leaped with any spouting, but made one even slope of it, as if it had been combed or planed, and looking like a plank of deal laid down a deep staircase. However, there was no side-rail, nor any place to walk upon, only the channel a fathom wide, and the perpendicular walls of crags shutting out the evening.[83]

After a prolonged and dramatic struggle up the waterfall, John reaches the top, collapses, and is revived by the young Lorna, an aristocratic child who had been abducted by the Doones as an infant. Rescued subsequently by John from the outlaws, the young Lorna takes to life on the Ridd's Exmoor farm. Reclaimed by her family in London, she nonetheless eventually returns to marry her lover in Oare Church, where she is shot at the altar by John's arch-rival for her favours, Carver Doone. The two men fight to the death, with victory to the virtuous artisan John, Lorna miraculously survives, and the lovers live happily ever after.

Lorna Doone represented Exmoor as a place of historical romance, wildly picturesque scenery and simple healthiness, as exemplified by the lovingly detailed life of an Exmoor farm and its virtuous inhabitants. It therefore potentially combined the tourist allure of scenery with Scott-like romance and the emerging notion of the farm holiday. But the development of 'Lorna Doone country' was not altogether a straightforward matter. This was principally because Blackmore, in putting together what he called his 'romance', had underestimated the era's desire for documentary realism, ever more insistent by the 1860s as my history of tourism associated with *The Lady of the Lake* has already suggested. Almost from the first, the novel generated a strong desire to see the landscapes which it described, indirectly attested to by a guidebook of 1879 which extensively excerpts Blackmore's descriptions of Dunkery Beacon, Exmoor upland and Badgeworthy Water, remarking 'so was it seen by Master John Ridd, and so may it be seen now'.[84] As early as 1876 Ursula Halliday, the local aristocrat and would-be salonnière, was suggesting to Blackmore that an edition illustrating the locality would sell well, a project that eventually came to fruition in 1882. By 1889, Doone Valley was marked as such on Ordnance Survey maps of Exmoor, presumably for the convenience of tourists rather than locals.[85]

Unfortunately, the Exmoor scenery, and particularly Badgeworthy Water and the Doone Valley, were not (and are not) anything like as wildly picturesque as Blackmore, and his first illustrator, Armstrong, had

made them out to be. Blackmore himself felt that the artist had over-stated the scenery:

> Unluckily, it is not to be denied that Mr Armstrong has indulged in fiction almost as freely as I have In several of the . . . views, he has put into italics, if I may so express it, the plain English of Exmoor. I never saw such *gorges* as he has cleft for us, nor such a spectroscope of colours. From the first, my mind misgave me about the wrong impression that must ensue, but when I spoke of it, I was told, 'Why, the work is a romance, and the pictures must be romantic'.[86]

This tension between romance and topographic accuracy reached a head when the writer of the British *Baedeker*, James Muirhead, visited Badgeworthy Water, and, disappointed, wrote to Blackmore in 1887 demanding an explanation of the discrepancy between place and book. Blackmore's reply illuminates the way in which *Lorna Doone's* detailed descriptions had fed the Victorian reader's expectation of hyper-realism:

> If I had dreamed that *Lorna Doone* ever would be more than a book of the moment, the descriptions of scenery . . . would have been kept nearer their fact. I romanced therein, not to mislead any other, but solely for the uses of my story. Disappointed tourists have reproached me, and therefore I am glad that the truth should be told as distinctly as it is in the passage submitted so kindly to my scrutiny . . .[87]

Baedeker's Guide of 1887 accordingly warned tourists that they were liable to disappointment when they had identified the water-slide, so far short did it fall from the sort of expectations generated by the book:

> Readers of 'Lorna Doone' may, however, be told once for all that they will be disappointed if they expect to find a close resemblance between the descriptions of the book and the actual facts of nature. The 'Waterslide' – if this be indeed the 'Waterslide' – is a very mild edition of the one up which little John Ridd struggled so painfully; and the Doone Valley itself, instead of being defended by a 'fence of sheer rock' and approached by 'three rough arches, jagged, black, and terrible,' is enclosed by rounded though somewhat bleak moorland hills, and could not easily be defended without the aid of elaborate artificial fortifications.[88]

Baedeker's very unusual loquacity here reflects a more general feeling that Blackmore, in making the scenery more romantic than it actually was, was guilty of cheating.

Despite Baedeker, Blackmore's extraordinary writing of intensely observed topographical detail, together with the inclusion of many actual mappable places, promoted a perfect industry in identifying Blackmore's locations, whether real, thinly fictionalised, or altogether and frustratingly fictional. The burial place of Lorna's mother, for example, was for a while pointed out by the vicar of Watchet;[89] there was a spirited argument over the rival claims of Hoccombe and Lank Combe as the original for the Doone Valley, settled only by the interposition of the Ordnance Survey in 1968 and clinched by a plaque; and although there is in fact no bog called the Wizard's Slough or anything else where Carver Doone is sucked down into its depths, that did not prevent minute enquiry after it. Oare Church, at the altar of which Lorna is shot, has been the cause of similar controversy. A tradition has grown up, reinforced by screen adaptations of the novel, that Lorna was shot through the window of the church, a claim which does not stand up on investigation of the site for it is plainly physically impossible; to resolve this problem, guidebooks have been regularly obliged to produce explanations ('The fact is that the present chancel is a later addition, so that the altar has been moved since those days'),[90] although in fact the text itself makes no mention of where the shot might have been fired from.

The experience of visiting 'Lorna Doone Country' in the late nineteenth century and early twentieth century was therefore rather different to the experience of visiting Scott's Highlands: though Exmoor satisfied the desire for topographical verification in the cases of Oare Church, Oare Farm, Badgeworthy Water and other locations such as the Valley of Rocks, Dunkery Beacon and so on, it radically disappointed by with-holding the romantic centre of the novel, the Doone valley. While it was perfectly possible to publish and sell maps, detailed descriptions of the Doone Valley walk, editions extensively illustrated with photographs of the localities such as the Doone-Land edition of 1908, and full-length studies such as F.J. Snell's *The Blackmore Country* (1906), which came complete with no fewer than fifty photographs, the core of the romance remained as nearly inaccessible as it is supposed to be in the fiction.

This experience of touristic frustration is reminiscent of previous failures to find Julie at Meillerie or to locate Ellen's refuge in the Goblin's Cave. The American traveller who wrote up his visit in 1893 for *The*

Atlantic Monthly is forced as a result to pay tribute to 'the might and majesty of genius':

> For, lovely as this enchanting valley is when seen in its length and breadth, it yet needed the power of a creative imagination to describe so vividly and circumstantially the scenes of a tale of 200 years ago that they seem to have historical and topographical reality.[91]

What is *not* there – and after all, historical romance never has been there, even for the author – is in this account recuperated as just as important to the literary visitor as what is there. The power of fiction is actually confirmed by the tourist's disappointment, which drives the reader back to memories of the text in preference to the real. Descending the path down from the Doone fastness, following the stream of Badgeworthy Water the writer recommends the cream tea (still to be had) at the farm at the bottom of the valley as a fitting accompaniment to the consolation of fiction. Clearly Lorna Doone, surviving into domesticity beside this anticlimactic English brook, offers an altogether more comforting version of the discrepancy between fiction and geography than had all those poignant quests for the dead Julie along the shores of Lac Leman:

> So powerful is this faculty [the writer's creative imagination] that when you come finally to drink your tea and spread your bread with clotted cream, at the tiny hostelry, Lorna and John, their friends and foes, their joys and sorrow, will seem for the moment more real than the actual facts of life.[92]

5
Literary Geographies

I Literary countries

La Nouvelle Héloïse, *The Lady of the Lake* and *Lorna Doone* were all seminal in the nineteenth-century development of the notion of literary 'countries'. This notion reached a height of popularity between about the late 1880s and the 1920s, although it finds its inception much earlier with Scott, and is still alive and well today. Those particular forty years brought to birth a slew of publications with titles such as *About England with Dickens* (1883), *Glimpses of the Land of Scott* (1888), *A Week's Tramp in Dickens Land* (1892), *Weekends in Dickens Land* (1901), *The Thackeray Country* (1905), *The Blackmore Country* (1906), and *The Charm of the Scott Country* (1927), suggesting a healthy market for this species of parcelling-up different areas of the British Isles via the collected works of different popular authors. In parallel, there was a brisk trade in articles about literary tourism for the periodicals; some books began life as such articles, notably William Sharp's *Literary Geography* (1904). Sharp's contents list usefully suggests the range of other literary countries that had recently been precipitated: 'The country of George Meredith', 'The Country of Stevenson', 'The Country of George Eliot', 'Thackeray-land', 'The Brontë Country' and so on. In their purest form, the form that interests me here, literary countries and the genres associated with them typically tie verifiable topography, whether rural or urban, primarily to an author's works, rather than to authorial biography, and they are almost invariably associated with novelists. Their formation is driven in the first instance by the impulse to naturalise individual texts to particular places, a phenomenon we have already seen in the previous chapter, but their eventual scope is more ambitious than anything we have so far examined. The literary country represents a diffusion of characters and events

drawn from the author's entire *oeuvre* across the whole range of realist settings that the author has exploited. This wholesale geographical naturalisation of fiction designedly dramatises the nation both to itself and to outsiders, by setting up affective relations within whole quarters of the map of Great Britain. Tourism associated with literary countries, necessarily rather strenuous because of the sheer size of the tracts of country an author could describe over the course of a whole career, was most frequently pursued from the comfort of the arm-chair, as readers imaginatively followed more energetic travel writers as they wandered, rambled, sauntered, sketched and photographed these localities.

The first and for a while the most influential of these literary countries was undoubtedly 'Scott country', which was the effect not so much of the verse-romances we have already considered as of the series of twenty-six novels by 'The Author of Waverley'. From very early on tourists were engaged in visiting far-flung sites associated with Scott's individual novels – there was particular interest, for example, in the sites associated with *Rob Roy* (1817), which meant that the Trossachs *Lady of the Lake* itinerary could be charmingly extended to take in Loch Lomond and Loch Ard. In 1818 Macready had supplemented his tour of Loch Katrine with a jaunt to Rob Roy's cave; and William Howitt recalled being guided around Rob Roy locations, including the Falls of Ledard, by the Rev. Graham himself.[1] But as the series of novels built up, there developed a sense that Scott had not merely invented 'a new edition of human nature' but had produced a new edition of the nation, a sort of illustrated atlas of British and especially Scottish history.[2] This sense informed the design and situation of what is still the largest monument to any author in the world, the Scott monument – sixty-one metres high, with 227 steps – set in the heart of Scotland's ancient capital city, Edinburgh. Conceived as a tribute to Scott's romancing of the past, something 'Gothic' seemed indicated, as 'consistent to and in harmony with the author's mind and works intended to be commemorated',[3] and the design finally chosen was George Meikle Kemp's Gothic spire – inspired by Melrose Abbey and ornamented with no fewer than sixty-four statues of Scott's characters to act as a précis of his opus. Work began in 1838 and was completed in the autumn of 1844, although further modifications were made subsequently in 1870 and 1881.

Perhaps it is by chance rather than by design that climbing the Scott monument evokes the feeling of reading an abstract of all the Waverley novels, but so it does. You start at the bottom under something imposing and monumental; you summon up some simulacrum of Victorian reverence, and plunge up the first flight of stairs in a mood to 'do' the

monument before getting on with doing something more authentic. But as the stairs narrow and wind more tightly, the sense of the constrictions of romance press upon you. You move inexorably from that spacious modern neo-classical regularity and near-tedium, that civil blandness with which all Scott's novels are liable to start ('It was early in a fine summer's day, near the end of the eighteenth century, when a young man, of genteel appearance . . . provided himself with a ticket in one of those public carriages which travel between Edinburgh and the Queensferry . . .') and into the claustrophobic windings punctuated by giddiness as you glance down from successive balconies that feels so characteristic of Scott's climaxes, with his fevered hero shut up in a confined space at the mercy of dangerous strangers. At every few turns of the stairs another statue pounces out at you; familiar or menacing, all the characters are here, and they rise upon the view much as they typically do upon the protagonists – here is Ellen, with eyes downcast, gliding in to the silver strand on her boat, there is Rob Roy with his hand on his dirk, here stands Bonnie Prince Charlie and there Mary, Queen of Scots. The contrast between the constricted stair and the ever-increasing city panorama visible from successive landings is extreme, and provides much the same sensations as when Edward Waverley finds himself uncomfortably transported from modernity into a grandly panoramic moment of national history, the Jacobite rebellion of 1745.

The monument imagines the Magnum Opus as the heart of Scotland; east, west, north and south, Scott's characters, whether drawn from history or purely from his imagination, gaze out over a Scotland which for the Victorians was thus interfused throughout with new life, with a new 'romantic interest', as Lady Frances Shelley put it in a letter to Scott in 1819.[4] It is poignant to chat to the custodian and find that he has read almost nothing of Scott on the grounds that he read a little at school and found it boring, and to reflect that not so far below his small ticket booth, in the monument's foundations, is buried a plaque that bears upon it a proud and lengthy inscription anticipating a very different cultural future. Imagining a moment aeons ahead when the plaque might be unearthed by archaeologists of another civilisation because 'all the surrounding structures are crumbled to dust / By the decay of Time, or by Human or Elemental violence', this artefact is designed to testify to a distant posterity

> that / His Countrymen began on that day [15 August 1840] / To raise an Effigy and Architectural Monument / TO THE MEMORY OF SIR WALTER SCOTT, BART. / Whose admirable Writings were then allowed

to have given more delight and suggested better feeling / To a larger class of readers, in every rank of society, / Than those of any other Author, / With the exception of Shakespeare alone; / And which were therefore thought likely to be remembered / Long after this act of Gratitude / On the part of this first generation of his Admirers / Should be forgotten[5]

It would have seemed inconceivable in 1840 that the monument should outlast Britain's popular reading pleasure in Scott, and become merely a blackened viewing platform (wrongly supposed by most tourists to be copied from its imitator, the Albert Memorial in London, just as Abbotsford reminds them of its imitator Balmoral), offering convenient views of Holyrood, Arthur's Seat, the Castle and, beyond the New Town, the Firth of Forth; an incongruous Victorian pinnacle overlooking an Edinburgh no longer and forever Scott's 'ain town', the centre of a country no longer 'Scott country'. The reasons for this decay I have already touched upon briefly in the previous chapter; the diffusion of Scott's characters across the landscape and their naturalisation within it was rendered possible in the first instance by their historical or quasi-historical status as escapees from historical fiction, but this meant in the end that Scott no longer held authorial copyright over them. As they became received school 'history', Scott's authorial labour of imagination progressively vanished. Not even the later installation of John Steel's marble statue of Scott and his hound Maida beneath the Gothic buttresses of the monument, making it appear as though he was dreaming his characters in a fashion reminiscent of the contemporaneous engraving of Burns at Lincluden Abbey, could secure characters to author.

If it was possible in this first instance to invent 'Scott country' because the Author of Waverley had installed fictional and historical characters side by side within still existing landscapes and cityscapes, my second example of a literary country demonstrates that it was possible to interpolate a range of wholly fictional characters, derived from discrete novels, within a common realist setting and inspire similarly dedicated national and international tourism. Charles Dickens's novels produced a comprehensive fictional extension to an already existing 'literary London', 'Dickens's London.' Although there are other forms of tourism associated with Dickens, some of which (focussed around Gad's Hill, Rochester, Cooling and that locality) is essentially biographical in impulse, and some of which is associated purely with a single conveniently rambling text, *The Pickwick Papers* (1836–7), 'Dickens's London' is of relevance here because it is almost purely fictional in interest.

As early as 1876, T. Edgar Pemberton was remarking upon the joys of fic-
tive tourism as superior to the more conventional sights of London:

> He has dwelt fondly upon a series of sights which he has invented for
> himself, and which may be summed up, in short, as the London
> streets and houses which the, to him, almost magic pen of Charles
> Dickens has made immortal. He here confesses that he has revisited
> the neighbourhood of the Monument, in order to fix in his own
> mind the home of Mrs Todgers; the Tower, that he might picture to
> himself the exact house on Tower Hill inhabited by Daniel Quilp . . .[6]

Remarking that 'the writer cannot believe that his sources of pleas-
ure are altogether peculiar,' Pemberton goes on to sketch out the
London locations associated with each novel in turn, a piece of literary
scholarship that founded future tourist itineraries, including those
designed by Robert Allbutt in his *London Rambles 'En ZigZag' with
Charles Dickens* (1886) as a 'practical guide for those who may desire to
visit the haunts and homes of these old friends', by whom he means
Dickens's characters.[7]

Perhaps inevitably, this form of fictive literary tourism was dogged
with anxiety, an anxiety reminiscent of MacCulloch's strictures on
tourists' supposedly uncritical belief in the narrative of *The Lady of
the Lake*. Tourist-writers typically expend a fair amount of energy dis-
tancing themselves from the naivety of unproblematically conflating
fictional character and real setting; as we have already noted in the case
of Irving and Bower, this often entails setting up a lower-class native to
enact belief, while the writer both indulges this pleasure and distances
himself from it, offering to his readers the complicated *frisson* of pleas-
ure that comes from simultaneously collating and dissevering real place
and fictional event. Such is the policeman who is conjured up by the
American writer Elbert Hubbard to act as his guide on a bravura tour
through the night-time underworld of London animated by 'the wild
phantoms of Dickens's brain':[8]

> To him all these bodiless beings of Dickens' brain were living crea-
> tures. An anachronism was nothing to Hawkins. Charley Bates was
> still at large, Quilph [sic] was just around the corner and Gaffer
> Hexam's boat was moored in the muddy river below.[9]

If Hawkins is initially Hubbard's creation, he becomes ever more like
one of Dickens's creations, until finally he turns Hubbard himself into

Dickens, introducing him in one pub as 'the man who wrote *Martin Chuzzlewit'*.[10] As both Hubbard's transformation into Dickens and Allbutt's title 'with Charles Dickens' suggest, there is a tendency in this sort of writing to secure fictional character to settings by invoking the author's 'footsteps', coping with the precariousness of immersion in a fictive experience by constructing a personal relationship with the author. Christian Tearle's tourist Mr Fairchild speaks the anxiety simmering within many guidebook and pilgrimage texts concerning Dickens's London – and other literary countries – in his explanation for his excitement in successfully identifying the site where Oliver Twist was brought to face the magistrate in 54, Hatton Garden, which, after all, as his companion teases him, was a wholly fictitious scene:

> 'It isn't so much because Dickens has described these places that I take an interest in them,' he said . . . 'It's not so much because Dickens used them as a stage for his characters that I like to hunt them out. It's because I know he went over every inch of the ground himself. And that being so, when I see these places, they seem to bring me near *him*.'[11]

My third example of a literary country is 'Hardy's Wessex', and it is a consideration of the formation of this country that occupies me for the remainder of this chapter. The crystallisation of 'Hardy's Wessex' is of especial interest to any study of the development of literary tourism, because Hardy country as it developed at the turn of the century is both exemplary and extraordinary in its resolute and thoroughgoing fictiveness. Whereas Scott's geography is fundamentally determined by national history – that is to say, topography is sooner or later animated by events of national import or reference – Hardy's geography is essentially animated by imaginary personal histories, and Hardy's Wessex depends principally for its existence upon a readerly knowledge of the fates of Hardy's fictional characters in relation to local topography. In this sense, it could be said that 'Hardy country' was like Brontë country. Yet Wessex, unlike Haworth and its environs, did not require a strong admixture of the biographical to frame, define, anchor and coalesce it. Although over the late twentieth century Hardy's poems have become integrated much more substantially within a modern sense of Wessex, bringing with them an injection of the autobiographical, 'Hardy country' as an ideological formation has from the beginning always had an unusually wary relationship with the biographical actuality of Thomas Hardy. The unease which visitors have typically experienced when faced with Max

Gate, the house Hardy designed for himself and in which he wrote much of his fiction, is a useful measure of this. A modern, pleasant and comfortable red-brick house, it has an undeserved reputation for ugliness and discomfort born in large part of a sense that it does not fulfil expectations roused by the novels. This dubiousness as to the relevance of Hardyan biography to Wessex was much in evidence during the argument over what sort of monument should be erected to Hardy in Dorchester; Augustus John strongly deprecated the depressingly municipal and thoroughly respectable statue of Hardy as effectively the literary Mayor of Casterbridge erected by the town council, having advocated instead a much more radical monument – a huge statue of Tess striding across Egdon Heath.[12] Odd though this notion seems (and one feels grateful to have been spared this piece of civic sculpture), it does point to the way that 'Wessex' is not essentially affiliated to the genre of 'homes and haunts'; rather, it is more purely a textual function of interaction between the series of novels (as John's apparent conflation of *Tess of the d'Urbervilles* with *The Return of the Native* implies) than any preceding version of literary geography other than Dickens's London. Finally, unlike Dickens, who was obliged to divide his claim to fictive London with Thackeray, amongst others, Hardy succeeded in copyrighting his fictional territory to his exclusive use; out-competing the Scott-like pretensions of, for example, John Meade Falkner's novel *Moonfleet* (1898).

Hardy's Wessex is of further interest because its emergence coincides exactly with the cultural moment at which the notion of regional 'literary geography' emerges as an important way of understanding the map of the nation: roughly, between 1880 and 1920. If Scott may be said to have instituted literary geography as a mode, Hardy at the other end of the century consciously institutes and controls his own within a spectrum of other literary geographies being created at the same time. It is possible to trace the ways in which Hardy's novelistic practice, together with his subsequent editorial decisions, colluded with and developed this sensibility in conjunction and competition with readers and tourist-writers. Unlike either Scott or Dickens, Hardy succeeds in copyrighting his fictive region as a meta-text for his novels; where Scott can be folded back into Scotland, and Dickens's London is, after all, only a sub-set of literary London, 'Wessex' is never identical with Dorset and its neighbouring counties. The elusiveness of Wessex is traceable to a desire on the part of Hardy to frustrate the contemporary urge towards authenticating realist fiction by reference to topography; the key genres in this enterprise are variously the map and the photograph, and in what follows I consider the games Hardy plays with both.

II Hardy's Wessex

> From material that might have seemed at first sight unpromising, he
> has woven a series of great works of fiction he has painted Dorset
> with an incomparable art and a poet's soul, and revealed to us in its
> downs and heaths and woods, aye, and its towns and villages, its past
> and present, in a new and fascinating light. Just as Switzerland was
> first 'opened up' as a tourist ground by the pilgrims who reverently
> sought the scenes a great genius had depicted, just as the 'Wizard of
> the North' discovered Scotland to his own and succeeding genera-
> tions by his poems and his Waverley novels, so Mr Hardy has
> revealed Dorsetshire to a world which knew it not.[13]

In these words a little guidebook to Dorchester of 1905 offered up its
enthusiastic gratitude and homage to the writer who had put the county
town on the tourist map by the turn of the twentieth century, on equal
terms with the territories of Rousseau and Scott. Endearingly, even
whilst making these grand claims, the writers betrayed some residual
astonishment at the way 'material that might have seemed at first sight
unpromising' had been transformed into classic ground. After all, in the
second half of the nineteenth century Dorset was an agricultural back-
water. Its mostly understated landscape, with little claim to the pictur-
esque and none to the sublime, remote from the centres of power and
so almost entirely bypassed by the romance of history, had to date
attracted little tourist interest. Its watering-place, Weymouth, once a
favourite with George III, had since largely decayed, overtaken by the
rival attractions of Bournemouth further to the east. Dorchester itself,
once a Roman camp, and subsequently an important stop on the coach-
ing routes, had been bypassed by railways to the north, rendering the
main road that traced the course of the coast from east to west obsolete.
In the early years of the new century the town's main claim to fame and
importance would thus be as a centre out from which tourists made
eager excursions to identify and to view landscapes and locations that
they had hitherto only experienced in the form of words.

One marker of this tourist enthusiasm is to be found in the centre of
Dorchester, where the blandly eighteenth-century frontage of what is
now a branch of Barclay's bank boasts a plaque which reads:

This
house is reputed
to have been lived in

by the
MAYOR OF CASTERBRIDGE
in THOMAS HARDY's
story of that name
written in
1885

This type of plaque, designed to memorialise a fictional location within a real site, is exceedingly rare. Although it is more scrupulous in its wording than the brass plaque set into the floor of Jamaica Inn on Bodmin Moor, immortalised by Daphne DuMaurier, which baldly states that 'On this spot / Joss Merlyn / was murdered', it is noticeably less careful to distinguish between fact and fiction than the comparable stone plaque set into the wall of the old Marshalsea Prison which commemorates Dickens's Little Dorrit, or that set into the wall of Top Withens. ('Top Withens. / This farmhouse has been associated with / 'Wuthering Heights,' / the Earnshaw home in Emily Brontë's / novel. / The buildings, even when complete, bore / no resemblance to the house she / described, / but the situation may have been in her / mind when she wrote of the moorland / setting of the heights. / This plaque has been placed here in response to many enquiries. / Brontë Society / 1964'). In part, this is an effect of the wording and the typography – the peculiar evasiveness of 'reputed' hardly qualifies the insistence of the capital letters of 'THE MAYOR OF CASTERBRIDGE', which underscores the way the name is used as a personal name rather than as the title of a work of fiction. In part it is because this plaque is not any old plaque. This is a blue plaque, sharing the format conventionally used to memorialise the places where real people once really lived.

The exceptionality of this plaque provides a pointer to the central peculiarity of the ideological construction of 'Hardy's Wessex'. Consonant with Hardy's own fictional practice of rooting his fiction precisely in a verifiable topography and yet making that topography fictive by extensively renaming it, it overlays the physical reality of Dorchester with the parallel imagined physical reality of Casterbridge. Scott had rebuilt ruined castles and restored cities to earlier states of being, but he had for the most part retained the attachment of the real place-name to the real place. Dickens may have populated London with his grotesques, but his London remains, if only in part, written in plain in the A–Z. The Brontës had borrowed interiors and exteriors from real houses, but they had universally fictionalised them by hybridising, renaming and relocating them. Hardy, by contrast, typically took real places – roads, heaths, rivers,

valleys, hills, forts, castles, towns, villages and houses – and, leaving them pretty much in the same topographical situation, gave them plausible new names, often composite from other place-names in the district, sometimes aurally echoing and amplifying the meaning of the actual name, sometimes reverting to an archaic one. In so doing, he created a region in which the real, although still verifiably there, actually has rather less purchase upon the tourist's imagination than the overlay of the fictive. Hardy's hold upon the touristic imagination depended upon the partial integration of different fictions within an ambiguously fictive and actual territory held in common but exceeding any one novel. It was the gradual development of the idea of 'Wessex' as embracing all these places, as existing in actuality, and, eventually, as exceeding all the novels put together, that would put 'Hardy's Wessex' first onto a map of its own, and then onto the tourist map.

What Hardy called his 'part real, part dream country' in his General Preface to the collected edition of 1912 took time to develop. It began to emerge over the 1870s and 1880s, as Hardy constructed a series of novels which were highly specified to individual, often verifiable, topographies. The term 'Wessex' first appeared in his fourth published novel, *Far From the Madding Crowd* (serialised in 1873 and then published in book form in the following year), a reference which seems to mark the inception of the fictional territory the remainder of his fictions would traverse and people. Even so, at this stage this seems to have been a relatively unelaborated concept. Four years later, when Hardy published *The Return of the Native*, proposing as a 'desirable novelty' the use of a map of its locality on Egdon Heath as a frontispiece to the novel, the map he produced was entirely local, and entirely fictional.[14] It shifted the houses and villages to produce a more schematic effect, provided only fictional names, and offered no way of identifying the general area in which these places might exist. Most striking of all, the map was not conventionally orientated with north at the top, but had been rotated. Neither topographically accurate, localisable, nor orientated, it was exclusively particularised to the novel, and was not generalisable as a context for any other of Hardy's fictions. Hardy's next published novel, *The Trumpet-Major* (1880), being historical fiction, followed Scott's practice of adopting existing place-names instead of pursuing the Wessex scheme already partially in place. Arguably, therefore, it was only with *The Mayor of Casterbridge* (1886) that Wessex was for the first time, in Michael Millgate's words, 'perceived and projected [by Hardy] as distinct, integrated, and autonomous.'[15] But Hardy's full exploitation of the designation 'Wessex' as his own, as a completely

realised and fully explicit geographical framework for different fictions, would only come to completion in 1888, with the publication of his volume of short stories entitled *Wessex Tales*. In 1889, J.M. Barrie dubbed Hardy 'the historian of Wessex', the first such reference extant, and in 1890 in the *Athenaeum* Kipling referred to him as 'Lord of the Wessex Coast and of the lands thereby'.[16] *Tess of the d'Urbervilles*, published in uncensored book form three years later, was therefore Hardy's first full-length novel to be launched into a fully pre-existent fictional geography, which in part accounts for Hardy's first hand-drawn map of 'Tess's country' and his keeping of the Ordnance Survey map to hand during composition. Its powerfully topographical structure, combined with its usage of the language and aesthetic of the guidebook, accounts in part for its central position within tourist itineraries from the 1890s onwards.

Like Rousseau and Scott, Hardy deploys the well-developed language of the guidebook, constructing a readerly position analogous to the stance, vantage-point and aesthetic of a tourist, melding landscape prospects with antiquarian information and 'association' and geological or economic observations, architectural details and historical anecdote. Probably the most striking and developed instance of this is the description of the Vale of Blackmore in chapter two of *Tess of the d'Urbervilles*. It opens with an evocation of place from a tourist's – albeit a not-yet-arrived London tourist's – perspective. Rapidly modulating from the past tense that governs the narrative as a whole to a guidebook present, Hardy's lengthy description of the Vale opens by constructing a stranger's point of view, the perspective of a person with no previous 'acquaintance' with the vale who would need a local guide to explore it, and whose map-like prospect is annotated with urbane observations agricultural, geological, aesthetic and historical:[17]

The village of Marlott lay amid the north-eastern undulations of the beautiful Vale of Blakemore or Blackmoor aforesaid, an engirdled and secluded region, for the most part untrodden as yet by tourist or landscape-painter, though within a four hours' journey from London. It is a vale whose acquaintance is best made by viewing it from the summits of the hills that surround it – except perhaps during the droughts of summer. An unguided ramble into its recesses in bad weather is apt to engender dissatisfaction with its narrow, tortuous, and miry ways.

This fertile and sheltered tract of country, in which the fields are never brown and the springs never dry, is bounded on the south by

the bold chalk ridge that embraces the prominences of Hambledon Hill, Bulbarrow, Nettlecomb-tout, Dogbury, High Stoy, and Bubb Down. The traveller from the coast, who, after plodding northward for a score of miles over calcareous downs and corn-lands, suddenly reaches the verge of one of these escarpments, is surprised and delighted to behold, extended like a map beneath him, a country differing absolutely from that which he has passed through. Behind him the hills are open, the sun blazes down upon fields so large as to give an unenclosed character to the landscape, the lanes are white, the hedges low and plashed, the atmosphere colourless. Here, in the valley, the world seems to be constructed upon a smaller and more delicate scale; the fields are mere paddocks, so reduced that from this height their hedgerows appear a network of dark green threads overspreading the paler green of the grass. The atmosphere beneath is languorous, and is so tinged with azure that what artists call the middle distance partakes also of that hue, while the horizon beyond is of the deepest ultramarine. Arable lands are few and limited; with but slight exceptions the prospect is a broad rich mass of grass and trees, mantling minor halls and dales within the major. Such is the Vale of Blackmoor.

The district is of historic, no less than of topographical interest[18]

The tourists who do subsequently arrive to consume this pastoral panorama are Angel Clare and his two brothers, on a gentleman's walking tour. This passage is regularly excerpted in its entirety in guidebooks from the 1890s onwards, a practice that confirms Hardy's deliberate appropriation of the language and stance of the guidebook to mediate the region to the urban reader.[19] Indeed, *Tess of the d'Urbervilles* is notable throughout for its deployment of guidebook language and destinations: the scene of Tess's degradation and crime, fashionable Bournemouth (Sandbourne), is described in language reminiscent of the Baedeker *Guide to Great Britain* (1887);[20] Stonehenge serves as the site of Tess's arrest; while the view of Winchester that Angel and Liza-Lu see while waiting for the signal that marks Tess's execution is couched in the generalizing style of a guidebook prospect.[21]

The effect of Hardy's deployment of tourist sites in this way was to infuse and motivate already meaningful sites with modern emotional event and metaphorical significance, so adding another layer to the 'associations' of the place. One apparently minor example of this is Bindon Abbey. This is where, after Tess's confession of a previous

unmarried pregnancy by Alec d'Urberville, she is carried by her sleep-walking husband Angel Clare:

> . . . he went onward a few steps till they reached the ruined choir of the Abbey-church. Against the north wall was the empty stone coffin of an abbot, in which every tourist with a turn for grim humour was accustomed to stretch himself. In this Clare carefully laid Tess. (320).

By placing Tess within the coffin, Hardy re-energised and sexualised its pre-existent tourist meanings for a modern audience – and it subsequently became one of the most important tourist sites associated with *Tess*. Although Bindon Abbey is currently privately owned, they still receive the occasional caller in the tourist season 'asking to stretch out in the coffin'.[22]

To read Hardy's *Tess* in relation to the guidebook is to begin to explain how a canon of places of interest to the reader-tourist – churchyards, houses, roads, prehistoric and Roman remains and landscapes – emerged from these narratives. The affinity of Hardy's novels with the guidebook made possible the unravelling and refashioning of the novels into further guidebooks. If Hardy's novels first converted the area spanning Dorset and parts of Hampshire, Wiltshire, Somerset and Devon into 'Wessex', it was this cloud of inter-texts, produced from the 1890s onwards, which converted 'Wessex' into 'Hardy's Wessex', as Hardy, typically shrouding and projecting his own imaginative reclamation of the lost lands of his forebears, noted when he joked in 1904 that it was 'rather hard upon the landowners of this part of England that their property should be so-called by these tourist-writers'.[23]

The coming-of-age of Wessex as a literary idea in circulation beyond the confines of the novels themselves was marked by an article by Clive Holland in *The Bookman* of October 1891 associated with the publication of *A Group of Noble Dames*, the first to recommend the exploration of southwest England with Hardy's novels as guides. The seeds of all subsequent guidebooks to Hardy Country are found in Holland's assertion that 'To follow the fortunes of the people of his fancy through their native Wessex would be as good an itinerary as any need desire'.[24] Holland included a map of 'Thomas Hardy's Wessex', the first such map, in which real names are put in parenthesis under fictional names, fictional names appear side by side with proper names such as Bristol, Southampton and Andover, and the whole is fitted into the outline of south-western England complete with roads and scale. So familiar has the idea of a map

of Wessex become to modern readers of Hardy that it is worth pointing out how novel an idea it was in the 1890s to construct a map which purported to show the common setting for a number of novels. There is one precedent for a map of an ambiguously real and fictive place – the map of *The Lady of the Lake* – but this confines itself to one text.

It was probably Holland's article that brought a number of enthusiasts, mostly well-heeled American women, down to Dorset in the 1890s. The rich, cultivated and under-employed Rebekah Owen arrived in August 1892, and stayed for a month viewing sites associated with the novels, including Dorchester and the various places associated with *The Mayor of Casterbridge*, Bindon Abbey, Upwey (for *Under the Greenwood Tree*), Swanage (for *The Hand of Ethelberta*), Bathsheba's house in Puddletown, Weymouth (for *The Trumpet-Major*), Wyke Regis (for *A Pair of Blue Eyes*), Wareham (as it appeared in the short story 'The Withered Arm') and Salisbury (Melchester).[25] Other American visitors included Harriet Preston in July 1893, and, later, the writer Margaret Deland and her husband.[26] What was remarkable about all these three visitors was that their tourism was flatteringly aided and abetted by Hardy himself. Owen was squired around extensively by Hardy, Harriet Preston toured 'Egdon Heath' in his company, and, equally remarkably, when Deland wrote to enquire how to 'do Wessex', Hardy replied at length, enclosing a sketch-map showing how to reach 'Tess's Country' by the South-Western Railway, and drawing in not merely Dorchester, Bournemouth, Salisbury, Winchester, and the roads connecting them, but the Vale of Blackmoor, the Valley of the Frome and Flintcomb Ash. The year 1893 also brought a letter from another American, W.H. Rideing, who wrote offering to prepare and publish a Wessex map (a suggestion upon which Hardy poured cold water), and an exhibition of paintings of 'Wessex scenes' in April at the Royal Academy, one entitled 'In Hardy's Country, Egdon Heath'. The painter, Frederick Whitehead, would go on to specialise in such paintings over the next ten years, culminating in a show of some thirty-five paintings in Bond Street in 1904.[27]

Hardy attended this exhibition, commenting rather sourly: 'At Academy Private View. Find that there is a very good painting here of Woolbridge Manor-House under the (erroneous) title of "Tess of the d'Urbervilles' ancestral home".'[28] The anxiety regarding his control over his fictive territory which is suggested by that ambiguously mendacious 'erroneous' must have been fanned to full intensity by the publication in 1894 of Annie MacDonell's study, which contained not only a whole chapter devoted to Wessex but an efficient map, accompanied by a topographical key, together with practical suggestions for a tour

of 'the scenes of many of the stories', radiating out from 'Casterbridge' as a centre, and detailed instructions for following in the footsteps of Tess. MacDonell's chapter combines a first-person narrative of how she identified the scenes of Hardy's stories with instructions as to how to replicate her adventure. Its rhetorical structures were destined to be replicated in a subsequent generation of travel books, ranging from books designed for the armchair traveller to those marketed to those proposing more strenuous travel.

MacDonell's prose highlights the ways in which Hardy's novels solicit both tourism and tour-guides. On the one hand, she pitches the region as a tourist attraction very much in terms derived from Hardy's novels. Hardy's sense of the variety of the topography, particularly dramatised in *Tess of the d'Urbervilles* in relation to the vagaries of her fortunes, but also exploited as different types of metaphorically charged settings across the series of his novels, translates here into the general claim that the region 'is one of singular variety and beauty'. His habit of realising the landscape as an historical palimpsest transposes readily into guidebook generalisation: 'Its history is graven on its surface in wonderful characters. Everywhere springing up amid the new life are relics of a far back past, camps, barrows, giants' graves, stone circles, reminders of a forgotten worship, of a strenuous warfare' If this past is readily accessible, fossilised to the view of the enquiring tourist, it co-exists with a timeless rural present 'with no brand-new crudity', equally and charmingly available to the traveller via Hardy's novels with their portrayal of ancient country customs and within the regional culture itself which has 'a marvellous continuity, which may be partly accounted for by remoteness from the capital, by the agricultural and pastoral occupations, and partly by the essential character of the people.'[29] Her 'Wessex' is constructed entirely from excerpts from the novels, but reorganised by location: the result is to make, for example, Casterbridge a slightly indigestible compound of *Far From the Madding Crowd*, *The Mayor of Casterbridge* and 'The Withered Arm'. (She quotes successively Elizabeth-Jane's perception of the town on arrival, the descriptions of Maumbury Ring and Poundbury Camp, and locates Henchard at Ten Hatches, a 'stranger' in the Dorchester jail, Fanny Robin in the Casterbridge Union, Bathsheba Everdene at the Corn Exchange and Gabriel Oak at the hiring fair). This effect, though most pronounced in the case of Dorchester, obtains elsewhere too; as MacDonell remarks simply, 'The road between Weatherbury and Casterbridge echoes with the footsteps and wheels of Mr Hardy's folk.'[30] In line with Hardy's own fondness for providing prospects from high

vantage-points, she promises the reader the ability to re-experience the perceptions of Hardy's characters: of *The Trumpet-Major* she writes 'If you climb the downs above the mill [Osmington Mill] you may see, if your eyes and the atmosphere permit, what the Overcombe folks saw when they gathered there to watch for the king' (191). Most elaborately, she describes how to 'do' Wessex extensively and conveniently in terms of Hardy's latest novel: 'in following the footsteps of Tess, you pass over a good part of the country' (200). MacDonell provides, too, a justification for the practice of topographical sight-seeing with regard to Hardy's fiction: 'if the mere identification of localities be but of minor interest, in the course of it there is abundant illustration of the part that scene and landscape play in Mr Hardy's dramas, a part of much consequence to the characters, and often hardly subordinate to them.' (206) Finally, she also implicitly justifies the relevance of future guidebooks, complete with the apparatus of maps, to readers of Hardy's fiction by identifying (politely) the shortcomings of the novels viewed as guides:

> With regard to the identifications of the scenes of Mr Hardy's stories, I should say that they have mostly been made by means of maps and personal recognition on the spot, and, as such, are fallible. Besides, Mr Hardy is an artist, not a photographer: and he does not write guide-books. His accuracy in detail . . . is marvellous; but every place that has served him as model or suggestion he has described by the light of imaginative insight more than of memory. (179)

MacDonell's study may well have prompted and inflected Hardy's editorial decisions with regard to the projected collected edition of the 'Wessex Novels' with Osgood McIlvaine, which came out between 1895 and 1897. Certainly it seems clear that there was growing interest generally in identifying the topography of his novels, although this was still the province of a few dedicated enthusiasts; neither *Black's* nor *Worth's* guides to the area of 1894 mention Hardy. The collected edition would change all that.

In preparing the Osgood-McIlvaine edition, Hardy was concerned to strengthen the coherence of the concept of 'Wessex'. This was effected by a variety of strategies. For the first time the novels were collected under the series title 'Wessex Novels'. Textual revisions to the earlier novels were for the most part designed to bring them more explicitly, coherently and consistently into the fictive territory of Wessex. This involved, for example, converting the real place-names in *The Trumpet-Major* to 'Wessex' names to match the other novels, harmonizing place-names in

earlier novels such as *Desperate Remedies*, and providing Wessex place-names for places or features that had earlier been described in general terms.[31] If Wessex became more coherent in this way, it also became more readily identifiable with real topography. As W.J. Keith notes, Hardy's changes to place-names in *The Hand of Ethelberta* were designed to make the locations sound significantly more West Country, and indeed to be closer to the original, prompting the conclusion that Hardy's revisions were designed to make it easier 'for his readers to identify his fictional places with their existing counterparts'.[32] These revisions were amplified by new editorial apparatus; prefaces provided topographical information about the 'real' locations of Egdon Heath, Casterbridge and elsewhere, and, in the case of *Tess of the d'Urbervilles*, a selective but quite lengthy list of place-equivalents for towns and natural features; topographical illustrations of subjects chosen by Hardy and drawn from life.[33] Finally, Hardy provided a sketch-map of 'Wessex' by way of frontispiece to each novel in the collected edition.

Hardy's 1895 map of Wessex can best be understood in relation to the other maps that were by then in circulation, maps of Wessex as well as tourist-maps of the area. As Keith, Kay-Robinson, Millgate, Widdowson and Pite have variously argued, to some extent Hardy's hand was forced with regard to the need to copyright Wessex by competitor publications designed to satisfy a hunger for topographical detail that his novels – and others – had induced in the reading public.[34] In this light, the 1895 map of 'The Wessex of the Novels' can seem the result of prudent defensiveness. It can also seem more profoundly defensive. Because it is selective, excluding places other than those mentioned in the novels, it does not comprehensively orientate or integrate Wessex with the real. This conscious impracticality extends to omitting features common to current guidebook maps – most especially road and rail routes. The 1895 map seems both to promise and to withhold topographical minutiae. In fact, it can be construed as an elaborate epistemological joke; while an ordinary map is designed to refer in the abstract to a verifiable reality, a map of fictional locations is verifiable not by reference to the physical locations themselves but only by reference back to the novels.[35]

A closer look at the preface to *Far From the Madding Crowd* in which Hardy provided a pedigree for his fictive territory clarifies this double gesture of promise and reservation. Noting that it was in this novel in 1874 that he 'first ventured to adopt the word "Wessex" from the pages of early English history, and give it a fictitious significance' and claiming that this was prompted by the projection of a series of novels 'of the kind called local' and which therefore 'seemed to require a territorial

definition of some sort to lend unity to their scene', Hardy went on to assert that his 'Wessex' existed only within the confines of the text. Observing that the term first arrived in general usage as early as 1876 (although simply in general reference to the region, rather than specified to Hardy's fiction), he wrote:

> Since then the appellation which I had thought to reserve to the horizons and landscapes of a partly real, partly dream country, has become more and more popular as a practical provincial definition and the dream-country has, by degrees, solidified into a utilitarian region which people can go to, take a house in, and write to the papers from. But I ask all good and idealistic readers to forget this and to refuse steadfastly to believe that there are any inhabitants of Victorian Wessex outside these volumes in which their lives and conversations are detailed.

Characteristically, however, the preface goes on to tease the reader – the locations were there, but no longer exist, or, if they still exist, they are in the wrong place. How many would-be tourists and tourist-writers must have been both encouraged and frustrated by Hardy's remark that 'The heroine's fine old Jacobean house would be found in the story to have taken a witch-ride of a mile or more from its actual position; though with this difference its features are described as they still show themselves to the sun and moonlight'?[36]

If it was Hardy's intention to choke off topographical detectives, it would not be gratified. The coyness of the collected edition merely stimulated further guidebooks, the characteristic premise of which was, stated baldly, that 'to all intents and purposes Mr Hardy's Wessex of romance is the Dorset of reality'.[37] Within that phrase 'to all intents and purposes' lurks the practicality of the tourist planning an itinerary. By 1897, the fourteenth edition of the reading-man's guidebook, *Black's Guide to Dorset*, 'thoroughly revised', was acknowledging Hardy's novels as having 'given many strangers a new interest in this part of England. Most of the scenes in these novels are presented under a very thin guise of pseudonymity In the hope that many of Mr Hardy's readers may become ours, we are able to serve them with the following list of identifications . . .'[38] Hardy himself is credited in the preface as providing 'valuable advice and assistance' in this effort of identification.[39] For the next fifteen years or so, Hardy would find himself variously colluding with and resisting the production of 'Wessex' as it played out in texts beyond the confines of his fiction. There sprang up a minor industry

dedicated to and parasitic upon the meta-fiction of Wessex, ranging from guidebooks, through armchair travel accounts of personal pilgrimages, to detailed walking-itineraries, picture-books, paintings and gazetteers.

Yet the question of what would constitute a functional guidebook description and itinerary of Hardy's Wessex was by no means settled by the late 1890s. One difficulty was what relative weight to give to loco-description, sociological anecdote and incidents drawn from the novels. The first two would allow for extensive quotation from the novels, the third demanded paraphrase. Another was what proportion of a book about 'Wessex' should be tied to Hardy, and what proportion might be allowed to be more generally Hardyesque, offering a more extended tour of the region than that available in the novels themselves. To what extent would an itinerary be determined by journeys (indeed by modes of travel) featured within the fiction, or by the modern practicalities of road and rail (rather than cart, foot, or, even, donkey)? Some of these difficulties are evidenced in one of the earliest attempts for the general reader, *Black's Guide* of 1897, whose coverage of Hardy's fiction is peculiarly patchy and uneven. It is tempting to assume that this patchiness is partly because its internal organisation is dictated by the practicalities of guiding travellers around Dorset: 'we conduct them round the county, following the chief railway lines that almost girdle it, but here and there making lateral diversions by the branch lines or chief roads, so as to leave no place of importance unvisited' (v). However, the principle of selection seems at first glance obscure: Portland is mentioned as the site of *The Well-Beloved*, Egdon Heath is glossed with a quotation from *The Return of the Native*, Woodbury Hill Fair is identified with that in *Far from the Madding Crowd*, Hardy's description of Maiden Castle is extracted in full, Dorchester is identified as Casterbridge. Some clue is provided by one startling omission – the memorials of the d'Urberville family at Kings Bere are remarked upon but are not connected with *Tess*. On the whole, connections are made with Hardy in terms of pure landscape description and in terms of sociological detail. Story and character are, on the other hand, pointedly omitted. The one exception to this rule is the intensely uneasy comment upon Stonehenge. Quoting Hardy's description, the writer continues:

This stupendous ruin is seen with most imposing effect at sunset, or by 'pale moonlight.' Strangers will naturally not make their visit in the dark, like poor Tess of the d'Urbervilles, for, as the poet reminds us,

> It's a very sad thing to be caught in the rain,
> When night's coming upon Salisbury Plain.[40]

The story of Tess 'caught', is politely squeezed almost to extinction between the quotation from Scott's *Lay of the Last Minstrel*, which provides a safer, well-tried template for tourist experience, and the bathetic facetiousness of a couplet quoted from *The Ingoldsby Legends*.

By 1907, although this piece of singularly clumsy writing had been cut, *Black's* was evincing slightly less nervousness about the events of *Tess*, noting the possibility of a walking tour to Tess's birthplace and writing about Woolbridge House as the site of Tess's aborted honeymoon. This reduced coyness may have been the result of a flurry of publications in 1902: Bertram Windle's *The Wessex of Thomas Hardy* upon which Hardy collaborated, Wilkinson Sherren's (explicitly unauthorised) *The Wessex of Romance* and Charles G. Harper's *The Hardy Country: Literary Landmarks of the Wessex Novels*. These three books between them developed further ways of exploiting Hardy's fiction. Windle seems to have begun work on his book some ten years before. His book was organised as a set of expeditions out from Dorchester, illustrated by extensive (mostly loco-descriptive) quotation from the novels, a large number of line-drawings by Edmund New, and a map. Perhaps uneasy at the effect that this has of dismembering Hardy's narratives, he also provided a final chapter which reviewed each novel in turn 'with the intention of giving a topographical scheme of each', singling out *Tess* as 'having the most complex and at the same time the most faithful topographical indications'.[41] Despite this final chapter, Windle's book effectively continued the process, begun by Holland and MacDonell, of distributing Hardy's descriptive text across the countryside and in exiling it from the novels proper. Reviewing Windle in November 1901, Sir George Douglas remarked uneasily that it had thrown open the door of Wessex to 'the undiscriminating sight-seer' but with some relief noted 'that their book is final – no further work on the subject is conceivable'.[42]

He may have been right in the first contention, but he was certainly wrong in the second. 1902 saw the publication of two more rival works on the subject. Wilkinson Sherren's *The Wessex of Romance* developed a rather different strategy to Windle's, which nonetheless equally had the effect of dispersing the internal coherence of the individual novels. Sherren set out to provide full annotation, exegesis and extension to Hardy's novels: 'Wessex is the central theme, and every available fact which would tend to illuminate Mr Hardy's treatment of it has been incorporated.'[43] Providing 'character studies of the people', 'authentic' anecdotes, 'parallel instances of superstition', 'vignettes of several Wessex towns, their corporate history, and a summary of the fictitious incidents which link them to Mr Hardy's books', 'a Glossary of the

dialect' and a map, Sherren tried to provide, as he put it, 'a rough sketch of the author's "material"'. (v–vi). The large number of consciously documentary photographs which accompany the text also flatten the fiction out into its own pre-existence. The captions to the photographs display a happy lack of discrimination between the fictional and the actual names of places and their relative registers of reality: 'Egdon Heath' sits with 'The Turberville Aisle and Tombs', 'At the Gate of "Sylvania Castle"' with 'Thomas Hardy's Birthplace', for example. The effect is not so much to illustrate the novels as to improve the thick reality of actual place: this is especially marked when Sherren layers up characters out of the different novels into physical simultaneity, flattening out not merely the boundaries between texts but those between fiction and history:

> Well known to all the countryside was the royal watering-place in those days, and especially to the villagers of Sutton, the Overcombe of *The Trumpet-Major*. Bob Loveday knew its harbour, the gallant John Loveday its barracks, and Anne Garland its fashions. Fess Derriman cut 'a fine figure of a soldier' on the esplanade A reminiscence of the soldiery who were encamped on the Dorset Heights is also found in the churchyard of the tiny hamlet of Bincombe, where lies the body of a dragoon who accidentally fell from the cliffs. (124–5)

By detaching characters from their stories and attaching them to location, Sherren denaturalises them from narrative sequence and time and yet naturalises them to place. The result is to make them into ghosts – no wonder that under this rhetorical treatment 'the phantoms of Mr Hardy's creations seem to haunt the streets' (126). He brings off this effect of random 'haunting' with an especial flourish in regard to Dorchester:

> Dorchester is the arterial centre of the Wessex novels. Each notable building suggests a personality; Boldwood and Manston are wedded by memory to the county jail, Bathsheba diffidently entered the Corn Exchange, and poor Fanny Robin tottered to the door of the Union. Hither came Bob Loveday in haste to be married Sergeant Troy was educated at the grammar school. (141)

So powerful is this effect of saturating the built environment with momentarily glimpsed figures that Sherren can claim seductively, in a

manner reminiscent of Elbert Hubbard's exercise in this strain, that it would be possible for the tourist to return the favour and come to haunt the narrative: 'So suggestive are Dorchester streets of Mr Hardy's works that the romantic wayfarer feels he is taking an expurgated part in *The Mayor of Casterbridge*' (140).

Sherren's habit of anecdotalising narrative – that is to say, of chopping it up and attaching it, like a tour-guide, to place – has the peculiar effect of turning it into history for the tourist. Whereas *Black's* had simply quoted those descriptive passages of Hardy's that have the closest affinity to the guidebook, Sherren does something much more sophisticated, if equally Hardyesque, in turning place into the repository of past incident and emotion. A rival publication, Charles Harper's *The Hardy Country*, also an armchair travel book, particularly develops this sense of emotional history, combining once again the narrative of personal travel with Hardy's narrative as a way of providing 'the Londoner' with 'a thoroughgoing exploration of this storied land' (9). Paraphrase provides place with a 'history' (its fictional status acknowledged and elided in the word 'or' that connects the two place-names) and yet rethinks that 'history' as a form of immediately available readerly experience via a delicate use of the present tense:

> This church of Piddletown, or 'Weatherbury', is the scene of Sergeant Troy's belated remorse and the acute misery of that incident where, coming by the light of a lantern and planting flowers on Fanny Robin's grave, he sleeps in the porch while the rain-storm breaks and the storm-water from the gargoyles of the tower spouts furiously over the spot. (56)

Passages such as these naturalise novel-derived emotion to real place via the reader's memory. Other passages investigate the possibility of finding on the spot a bonus of the same sort of emotion with which Hardy's writing has already invested the place. This hope is frustrated in the case of Mellstock: 'The school-house is that of the young mistress, Fancy Day in the story; and suggests romance; but the sentimental pilgrim might be excused for being of opinion that it is all in the book, with perhaps nothing left over for real life' (150). But if Mellstock disappoints, Shaftesbury, as the setting for part of *Jude the Obscure*, gives satisfaction: 'Close by are the schools. Looking upon them the more than usually sentimental pilgrim, with, it may be, some ancient tender passages of his own, stored up in the inviolate strong-box of his memory, to be unlocked and drawn forth at odd times, may think he identifies that

window whence Sue . . . spoke with Jude' (296). Here, Harper speculates that the combination of real place and reader may activate other categories of remembered emotion. Indeed, he goes so far as to begin to suggest that 'Hardy country' is a place that 'naturally' and spontaneously generates emotional histories, a reservoir of romance still waiting to be activated, whether by Hardy or by the traveller; he writes of Woolbridge Manor that 'the air of bodeful tragedy that naturally enwraps the place and has made many a passenger in the passing trains exclaim at the sight of it, 'What a fitting home for a story!' has at last been justified in its selection by the novelist as the scene of Tess's confession to her husband' (123). In a similar vein, both Windle and Harper note sites which 'ought' to have been included in a Hardy novel; Harper advocating Eastbury house, and Windle Woodsford Castle 'which is waiting to be introduced into some future Wessex novel' (Windle, 131). By embedding a discourse about Hardy within a much more general treatment of the history, geography and antiquities of the region, Harper both produces the region as Hardyesque, and invents Hardy as *produit de terroir*. The three authors between them, with their different if overlapping practical and rhetorical solutions to locating fiction within the region, eventually succeed in constructing the whole region as 'Hardyesque'.

One result of this is to make 'Hardy' stand for the first time for a vanishing old English past for which the modern is homesick. It is curious to watch Harper working this alchemy on the ground of Egdon Heath, which *The Return of the Native* generally describes as inimical to all but a very few of its protagonists, condemned to the reclusive life here so glowingly described:

> Here, if anywhere in this poor old England of ours, generally over-populated and sorted over, rated about, and turned inside-out, there is quiet and solitude. No recent manifestations of the way the world wags, no advertisement hoardings, no gasometers or mean suburbs intrude upon the inviolable heath A railway skirts it, 'tis true, but only on the way otherwhere Elsewhere trim hedges or fences of barbed-wire restrain the explorer, but here he is free to roam
>
> It is a land totally antithetic from the bubbling superficial feelings of cities . . . A town-bred man . . . wearied with the weariful reek of the streets, the jostling of the pavements, and the intolerable numbers of his kind, might come to a spell of recluse life in a farm on Egdon, and there rid himself of the supersaturation of humanity (165–6)

This promise that the urban traveller could find the old England of a hundred years ago, 'the untroubled life of the past,' is made also by Sir Frederick Treves, in his classic *Highways and Byways in Dorset* (1906), by *Memorials of Old Dorset* (1907) and by Heath's *The Heart of Wessex* (1910).[44] In other words, over this first decade of the twentieth-century Hardy's fiction, with its complicated and tense relations with modernity and shockingly progressive views, was being rapidly smoothed out into a physical record of heart-warming and wholesome rural authenticity, still available to the sensitive traveller whether transported by bicycle or armchair.

In one sense, Hardy's revisions and apparatus to the collected edition of 1912 can be regarded as just one further inter-text to the novels amongst those I have already detailed. Something of Windle's, Sherren's, Harper's, Treves's and Holland's impulse to document and annotate the novels is certainly replicated in Hardy's project, and that project dates back as far as 1902 when Hardy first considered the possibility of an annotated edition on the lines of the Magnum Opus edition of Scott, with notes giving a trustworthy account of real places and scenery.[45] Part of Hardy's agenda in the General Preface to the collected edition of 1912 involved statements about his topography 'in response to inquiries from readers'. He remarks first that 'the description of these backgrounds has been done from the real – that is to say, has something real for its basis, however illusively treated' but continues with typical evasiveness to both proffer and avoid identification. A long list of identifications, for example, is preceded by this piece of distraction and indirection: 'Of places described under fictitious or ancient names in the novels – for reasons that seemed good at the time of writing them – . . . discerning people have affirmed in print that they clearly recognise the originals . . .' Hardy concludes slyly that 'I do not contradict these keen hunters for the real; I am satisfied with their statements as at least an indication of their interest in the scenes,' although he specifically reserves a 'wantonness' to himself.[46]

This teasing provision of information only partially to withdraw it is of a piece with Hardy's fundamentally double vision of topography as at once dream and real. Apparent 'improvements' to such topographical information as are provided in the 1895 prefaces, are generally designed only to frustrate the enthusiast. So Hardy writes with respect to *A Pair of Blue Eyes*: 'To add a word on the topography of the romance in answer to queries, unimportant as the point may be. The mansion called 'Endelstow House' is to a large degree really existent, though it has to be looked for at a spot several miles south of the supposed site.'

The Return of the Native is prefaced with the observation that 'To prevent disappointment to searchers for scenery it should be added that though the action of the narrative is supposed to proceed in the central and most secluded part of the heaths united into one whole . . . certain topographical features resembling those delineated really lie on the margin of the waste, several miles to the westward of the centre.' These are hardly adequate directions for the literary orienteer. Or again, he apologises for *A Laodicean*: 'its sites, mileages, and architectural details can hardly seem satisfactory to the investigating topographist, so appreciable a portion of these features being but the baseless fabric of a vision.' Hardy's desire to tease the reader with incompetent vagueness may have originated variously in his genuinely looser use of place in the earlier novels, his annoyance at the large correspondence with which he was afflicted concerning these queries, and in his desire to preserve one or two especially emotionally charged places free from prying eyes, but it served also to increase the tantalising effect of the muddle between the real and the imaginary that the edition as a whole exploited. Particularly fine as a tease is his comment apropos *The Woodlanders:*

> I have been honoured by so many inquiries for the true name and exact locality of the hamlet 'Little Hintock,'. . . that I may as well confess here once and for all that I do not know myself where that hamlet is more precisely than as explained above [in the 1895 preface] and in the pages of the narrative. To oblige readers I once spent several hours on a bicycle with a friend in a serious attempt to discover the real spot; but the search ended in failure; though tourists assure me positively that they have found it without trouble, and that it answers in every particular to the description given in this volume.

Hardy's suggestion that the tourist might 'find' a Wessex that he had either mislaid or simply made up both sticks pins into (rather than 'obliging') the reader and points to the possibility (already articulated by Charles Harper) that Wessex is larger than both author and novels, that there is an untapped and unauthorised residue of romance to be had for the touristic adventurer. It opens up the possibility that they might 'dream' Hardy country just as well as he.

This desire both to seduce and to baffle strongly informs the map that accompanies the 1912 edition, which, although it is based upon the earlier map of 1895, has increased its insistence upon its status as a map of a fictive domain. In particular, it deploys obsolete mapping conventions, such as the inclusion of miniature pictures of buildings and

obsolete decorative detailing such as pictures of eighteenth-century ships, a dolphin, a sea-serpent and a whale.[47] The handsome border, the scrolling round the title and the consciously arcane lettering for place-names both real and fictive insist that this place is not supposed to be entirely mappable onto the contemporary Ordnance Survey map. Its comprehensiveness, moreover, is that of the mythic imagination, not of modern practicability; it includes all the relevant place-names organised in relation to a recognisable national coast-line, but it does not translate those names that are fictional; nor does it provide roads or railways, although it does include rivers. This conscious frivolity, which arguably originates what we would now recognise as a modern style of tourist mapping, is combined with a certain refusal to distinguish between the fictive and the factual. A stranger to the area (and, after all, strangers necessarily made up the majority of Hardy's readers) without a detailed map to hand would have had no idea which places were being given their own names and which had been beglamoured with those of Hardy's coining. In that sense the map masquerades as something more practicable than it is. If we compare it to contemporary armchair travel-books, we can see that this map situates itself carefully in relation to these mapping conventions, coming closer to A.G. Bradley's *Round About Wiltshire* (1907) – which advertises its lack of purely practical intent by omitting roads, and enclosing the whole in an abstract border topped off with a decorative title – than, say, to Frederick Treves's *Highways and Byways in Dorset*, which provides a thoroughly up-to-date map complete with details of scale, railways, roads and high ground. Hardy's map appears deliberately impractical compared to the map produced by F.O. Saxelby the year before in his *A Hardy Dictionary* (1911). Although Saxelby's map is confined to 'The Heart of Wessex' and its styling is decorative, it is thoroughly pragmatic in its approach to the fictional, showing roads running between fictional places and locating some places such as 'Talbothays Dairy' which Hardy himself would resolutely refuse to identify with any one place. By comparison, Hardy's map at once promises the reader that they can 'find' Wessex as a real place, and makes it difficult to disentangle the fictional from the real, a process which is paradoxically a prerequisite for 'finding' Wessex on the ground.

One last element of the editorial apparatus contributes to this unstable complication of the documentary and the fictive. At Hardy's request and to his specifications, Hermann Lea produced a set of photographs to act as frontispiece illustrations to the novels. In this, the 1912 edition was and was not breaking new ground. Previous illustrations to the novels had been line-drawings whether of characters and dramatic

incidents or of settings. Using photographic illustration to the novels was therefore a new departure for Hardy himself. However, there were plenty of precedents for the illustration of fiction with topographical photographs, most particularly when it appeared as part of a uniform edition. Later editions of Scott's works, for example, replaced the earlier album-style engravings of Scott's locations with photographs, a practice that made especial sense as Scott's novels calcified into received school-boy history. Similarly, later collected editions of the Brontës' works boasted photographs of places identified as the originals for their settings – again, this made sense as they functioned as a documentary record of the discrepancy between romance and reality. As we have already noted, Sampson Low had brought out *Lorna Doone* in 1908 com-plete with an enormous quantity of topographical photographs; in this instance the edition was designed both to stimulate the Exmoor tourist industry, and capitalise upon it, functioning as a vastly expensive post-card pack. Photographs had been appearing as illustrations associated with Hardy's Wessex since 1901 when *The Bookman* provided a wide range of photographs including one captioned as 'Talbothays: A Typical Wessex Dairy Farm'. Sherren's *The Wessex of Romance* (1902) included photographs captioned both to real and to fictional names, including the 'mask' made famous by *The Mayor of Casterbridge* and Hermann Lea's *Handbook to the Wessex Country of Thomas Hardy's Novels and Poems* (1906) was exclusively illustrated with photographs, which included six which he enterprisingly issued as postcards. Hardy himself had had a long-standing interest in the possibility of photographing locations that he had exploited in his fictions. In 1892, during one of her tours of the locality with Hardy, Rebekah Owen conceived the fancy of photo-graphing the milestone that Fanny Robin passed on her way to Casterbridge; Hardy chalked onto the stone the words DORCHESTER 1 MILE for her, but, in the eventuality, as she wrote in her diary, 'The shadows were too heavy for an instantaneous picture. Mr Hardy was much interested and wanted one, if good.'[48] The story is intriguing, not least because of the necessity imposed upon Hardy to inscribe the stone with either the name 'Dorchester' or 'Casterbridge'. It suggests that more than ten years before he helped his new young friend Hermann Lea to compile his *Handbook* (1906), he was playing with the idea of the photographic as another vexed modality around which the real and the fictional might edgily co-exist.

This sense of the edgy relation between real and fictional topography may have informed the editorial decisions of many books on Wessex in favour of artistic illustration over photography to illustrate Hardy. The

Heath brothers' guidebook to *Dorchester (Dorset) and its Surroundings* (1905–6), for example, which came complete with a preface by Hardy and a chapter by his friend Henry Moule on local country walks, boasted both photographs and line drawings, but chose to illustrate locations associated with the novels (including 'The Mask, Glydepath Road' and 'The D'Urberville Window') exclusively with line drawings. This strategy effectively preserved Hardy's locations as having an admixture of the fictional, especially when counterposed with the more unproblematically documentary mode and subject matter of the photographs. This editorial choice is the more striking given that the authors had already explicitly bracketed the vulgarity and general dubiousness of interest in 'the particular spots where the more dramatic incidents of the great romances occurred' by attributing rational interest in Hardy's locations to his 'poetic' (for which read 'guidebook-like') descriptions.[49] It is hard to avoid the conclusion that there is a sense in which these guidebooks were anxious to preserve the sense that Hardy had 'painted' the landscape 'in a new light' (to reiterate my epigraph), filling place with a sense of romantic pastness, amplified in a noticeably non-documentary style of drawing. Hardy's set-piece descriptions were persistently identified as 'poetic' or 'artistic', 'fine, soft, silver-point Wessex landscapes' as 'Lucas Malet' described them.[50] Hence the commissioning of seventy-five dreamy landscape watercolours from Walter Tyndale in 1906 to accompany Clive Holland's *Wessex* (1906), twenty-five of which were captioned explicitly to scenes in the novels; hence Treves's choice of stylised illustrations by Joseph Pennell in 1906, and hence the general success of the late impressionist Frederick Whitehead's paintings. Even these tasteful illustrations occasionally came in for criticism for their investment in topographical accuracy: Sir George Douglas remarked of Edmund New's line-drawings for Windle's book in 1902 that 'for our own particular taste we admit that they are too realistic. Places over which poetry had hitherto cast its glow are now seen in the crude light of prose . . . often without even the advantage of an artistic point of view.'[51] Yet there clearly remains a tension within these texts. Their ambition, after all, was not unaffiliated to Hardy's composition of a 'part real, part-dream country'; their project locked the poetic to the documented, casting the glamour of the poetic over the real, but also the romance of the real and the physical over the evanescing poetic. Holland's remarks as early as 1891 focus this stereoscopic vision:

> Wanderers through our south and south-western counties . . . will find few better guides than Mr Hardy. To follow the fortunes of the

people of his fancy through their native Wessex would be as good an itinerary as any need desire. And in the main, this is a feasible plan. For though Mr Hardy, as an artist, works with a free hand, and is not a mere photographer, yet in many instances his indications of localities, partially veiled by fictitious names, are clear enough to leave little room for doubt in their identification.[52]

The photographic frontispieces to the 1912 edition embed Hardy's collected work in quite a different aesthetic to that obtaining around the 1895–7 edition. For one thing, they gloss the 1912 preface's new insistence on 'environment' as one of the central preoccupations of the *oeuvre*. They at once assert the primacy of environment and call for the absent characters to animate it. Equally, they gloss the 1912 preface's insistence on the disappearance of the old even while apparently conserving it – their very modernity highlights the increasingly distant period of Hardy's settings (*The Mayor*, for example, is set sometime in the 1860s). They increase the sense of reality of place for Hardy's readers – if it could be photographed it certainly had been there, perhaps still was there. It was a repeatable experiment, it could be photographed again. On the other hand, the photographs are so blandly documentary, so limitedly black and white, that they solicit the reader to go to find the romance and colour that they seem so entirely to exclude and yet which the fiction assures them is there.

The 1912 frontispieces exist in inter-textual relationship not merely with the novels they preface and as placed within a series of such frontispieces but also in relation to Hermann Lea's *Thomas Hardy's Wessex* (1913, an expansion of his earlier *A Handbook to Wessex*), which was published as uniform with the 1912 edition. The culmination of some twenty years' enthusiasm and friendship with the author – Lea was the friend with whom Hardy had cycled around failing to find 'Little Hintock' – this was compiled with the co-operation of Hardy, thus appearing as the authorised topography to match the authorised map. With no fewer than 240 photographs, captioned with real rather than fictional names, highly specified rather than generalised (no 'typical Wessex Dairy farms' here), and keyed to the individual novels and volumes of poetry, it is a monumental work, testament to Lea's travels of 'more than 150,000 miles on a cycle, in a car, on foot.'[53] It claimed to correct the 'many inexactitudes or misstatements that have appeared in too many guidebooks to the Wessex country . . . [which] have very likely arisen through a desire on the part of the writer to make the fictitious places conform to the real in an absolute, dogmatic manner.'(xix–xx).

Despite this caveat, Lea's procedure was in many respects 'absolute and dogmatic', writing his descriptions 'on the actual spots visited' (xx). In selecting Lea as his photographer, Hardy seems to have chosen a friend on the whole unanxious about the problem of the relation between the poetic and the real. Those remarks that suggest a more delicate apprehension of the problem in Lea's introductions were drafted by Hardy himself: 'The realistic treatment which the setting of the stories receives creates rather a dangerous position for the topographer, since there is an undoubted tendency to fall into the error of confusing the ideal with the actual' but 'the descriptions given in the novels and poems must be regarded in their totality as those of imaginative places. The exact Wessex of the book exists nowhere outside them . . .' (xxii). In fact, in line with Hardy's reservations, despite the apparent comprehensiveness of this mapping of Wessex, there are some notable omissions. Amongst them are numbered two episodes in *Tess*: 'The lodging-house called 'The Herons', where Clare finds Tess, and where the great tragedy of the book is assumed to occur, it is impossible and undesirable to distinguish' and 'It is difficult to trace their flight – there being, of course, no tangible track of a pair "avoiding high-roads, and following obscure paths tending more or less northwards . . ."' (27). Subsequent scholars, testing Lea's supposed comprehensiveness, have discovered errors: in 1972 Denys Kay-Robinson remarked that 'the closer one studies Lea *in the field*, the deeper grows the suspicion that during the two men's strenuous journeys Hardy's concentration sometimes wavered, leaving the questioning topographer to take for assent a silence that was merely a quiet failure to disagree.'[54] So characteristic does this sound of Hardy's evasiveness in relation to the real that it is hard not to wonder whether Lea was not being deliberately misled. But, arguably, it is these absences and inaccuracies, apparently so anomalous, so aggravatingly not on the Ordnance Survey map, that whet the appetite, whether of scholar, reader or tourist, to fill them in by research 'in the field'.

The edition of 1912 brings to full maturity the idea of 'Wessex'. It is not simply (if this is simple) an ambiguously real and fictional territory acting as a comprehensive meta-fiction for the entire series of Hardy's novels and poems. Rather, by simultaneously soliciting and blocking topographical identifications between the fictional and the factual, it produces a clash between two types of collective understanding – fictive realism and topographical truth. As a concept, therefore, it marks the full extension and the limits of realism in the period. The acts of tourism that came to maturity with this edition would also mark out the limits of realism, and even, it could be argued, of naturalism. Readerly ambition to

experience the text within the landscape – an ambition that can be documented in Rebekah Owen, whose reading-practice involved re-reading the novels *in situ*, taking photographs, and lying in Tess's stone coffin at the feet of Hardy – may be said to be an effort to naturalise the text in the landscape. Tourists were thus driven not so much to distinguish the real from the fictional as to perfect the identification of one with the other that Hardy had instigated. The determined Edwardian referred the novels to the Ordnance Survey map, took a train ticket, packed *Tess of the d'Urbervilles* and set about finding Hardy's 'dream-country' within the parameters of 'the prosaic map'.[55] The more energetic packed their boots as well, and set about walking 'Tess country' in an effort to come closer to the land and the people. One or two adventurers even claimed to have been rewarded with a meeting with the originals or doubles of Tess herself. It is testimony to the power of naturalism that hardly a twinge of doubt seems to have assailed such travellers that 'finding' the text in the landscape in this way might be impossible.

And anyway, if it proved impossible to find 'Hardy's Wessex', this was not because, as Hardy was himself keenly aware, it had been made up. At stake in a literary pilgrimage to the southwest was something new that would grow in importance as the century wore on. As early as 1912 Hardy had remarked in his General Preface that he had been concerned to 'preserve . . . a fairly true record of a vanishing life', [56] and Lea's introduction to *Thomas Hardy's Wessex* (drafted by Hardy) had attributed possible disappointment on the part of visitors 'on account of any want of similarity between these and the book descriptions' to the passage of time: 'most of the stories were written many years ago, and . . . Time and the hand of man have been responsible for many alterations, and have brought about actual obliterations of what were close originals at the date of portrayal.'[57] Thereafter, writers on Wessex would increasingly celebrate Hardy's preservation of an otherwise-vanished world, overpowered by modernity and its alienations, a celebration given urgency and poignancy by the outbreak of war two years later. By 1924, post-war anxiety over change had elevated this obsolescence that Hardy describes as having overtaken the realistic ambitions of his novels to an 'indescribable charm':

> It is as if the wizard hand of the Wessex novelist had cast once and for all a bewitching spell and transformed this country into an enchanted land . . . and not all the changes of later years can disturb its enduring romance, wrapped in a calm unbroken sleep, or rid it of its irresistible and fascinating appeal.[58]

That residual but enduring romance was identifiable as nothing less than 'Englishness', made available in this collective dream-geography-cum-history to an ever-larger proportion of the ever more mobile, self-improving population. Ever since, the more Hardy's Wessex has 'disappeared', the more powerful it has become as a dream of Englishness, and the more sedulously it is searched for, to preserve it as part of an imaginary map of the heritage of England. Hanging across one entire wall in the Dorset County Museum is one finally elaborated variant of the map of Wessex (Figure 5.1). Brilliantly coloured, annotated with the titles of novels and stories, flanked with the heraldic shields of local municipalities, bordered at the bottom with Hardy's biography in brief, and headed with a line that personalises the map simultaneously to writer and to viewer – 'I walked in loamy Wessex lanes afar' – it crystallises this conservationist Hardy:

> It is in preserving these venerable laws, customs, rites and beliefs through the medium of local character and institutions that the Wessex novels hold the position they do in our literature and history.[59]

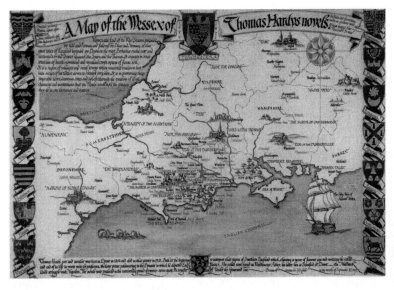

Figure 5.1 J.H. Field, 'A Map of the Wessex of Thomas Hardy's Novels' (1935). Dorset County Museum, Dorchester. © The Dorset Natural History and Archaeological Society.

Hardy's Wessex map given new meaning and poignancy as a lost place in the inter-war years.

Epilogue: Enchanted Places & Never Lands

The readerly impulse to locate author and text within real places may have been born out of the extended nineteenth century's love-affair with biography and with realist fiction, but it is still very much with us a century later. It finds its most extreme form today in the recent expansion of tourism to sites associated with fantasy literature. The absolute 'otherwhereness' of fantasy locations would seem designed to baffle the tourist impulse to seek out and verify fictional settings. Yet the power of the desire to map the imaginary onto the actual has meant that even the 'nonsense' of *Alice in Wonderland* (1865) could eventually come to be mapped within Oxford. By way of conclusion to my investigations into literary tourism, I want to discuss this tourism of the fantastic as the limit-case of the sentimental habits and strategies associated with nineteenth-century realism which I have been exploring. I have arranged this brief epilogue therefore as a recapitulation in miniature of the structure of the book as a whole, considering three writers' houses construed and displayed as 'enchanted' sites of entry into the fantastic, before looking at the ways in which three fantasy locations or 'never–never lands' are secured to real places and how these forms of organisation may themselves license and organise literary tourism.

There are three writer's houses currently on show within England which are associated primarily with the literature of fantasy. Bateman's in Sussex, the home of Rudyard Kipling from 1902 until his death in 1936, is where he wrote *Puck of Pook's Hill* (1906) and its sequel *Rewards and Fairies* (1910), stories in which his children meet Puck and are introduced by him successively to figures from the past, who provide a guided tour of the history of the locality reminiscent of a miniaturised set of Waverley Novels. Hill Top Farm at Near Sawrey was the home of Beatrix Potter from 1905 to 1913, where she wrote and illustrated the majority

of the series of children's tales which had begun with *The Tale of Peter Rabbit* (1901). The Manor, Hemingford Grey, was the home of Lucy M. Boston from 1935 until her death in 1990, and was the setting for the series of children's books initiated by *The Children of Green Knowe* (1954). Bateman's is essentially a writer's house along the lines of Abbotsford, where a middle-aged author sought to enchant and mythologize his immediate environs through fiction, but the National Trust's current display of the building is more concerned with Kipling's biography than with his imaginings. The climax of the visit to Bateman's is presented as being Kipling's highly professionalised study, rather than the settings for his children's fiction – within the house no indications are provided, for example, as to how to find 'The Theatre' in the meadow by the river where the children accidentally conjure Puck by reciting from *A Midsummer Night's Dream*, nor 'Pook's Hill', nor 'Far Wood' (with its huge tree 'Volaterrae') where they meet the Roman centurion, nor 'Weland's Ford' (on the map as Willingford Bridge) where they meet the Saxon smith Weland.[1] By contrast, both Hill Top and the Manor are displayed as something more unusual, less writer's houses than enchanted place-texts that pre-exist or even elide the labour of writing. In these two houses the author all but vanishes, becoming at best a textual effect: these two women writers are represented as absorbed or even displaced by their houses in ways reminiscent of Haworth.

It is the peculiarly deadpan relationship between solemn documentary realism and whimsical fantasy developed in Beatrix Potter's illustrated texts – their straight-faced hybridisation of modern bourgeois verisimilitude with the ancient literary form of the beast-fable – which produces and determines the tourist experience of Hill Top. Tellingly, unlike the illustrations to Kipling's books, Potter's settings are specified in almost every detail to particular place, a specificity which is critical to the effect of her books, including the six of her tales which are set in Near Sawrey or the house itself. From very early on, although rendered anxious and angry by day-trippers, Potter received properly introduced admiring visitors at Hill Top and was at pains to show them the house as it had already appeared in the books; they would see, disposed suggestively around the house, the rooms and artefacts featured as backdrop in her illustrations. In 1912 Beatrix and her father Rupert Potter were taking a series of photos apparently designed to feed this interest in documenting the fantastic; Rupert's photograph of the dresser at Hill Top, for example, is clearly taken quite deliberately from a rat's vantage point.[2] Potter left Hill Top Farm as a legacy to the National Trust on her death in 1943 on condition that nothing in it was moved or altered and

that it was never lived in again, so that it would give the impression to visitors 'as though I've just gone out' but it had already been consciously fossilised by her on her removal to Castle Cottage on her marriage to William Heelis some thirty years before in 1913.[3] Although she produced little work – and that not of her best – after her marriage, she kept on Hill Top as a study, studio and shrine to some ten years of a domesticity animated by fantasy. Since 1943 the National Trust has performed its ever-extraordinary trick of conferring perpetual life-in-death upon the house despite some 70,000 visitors a year – replacing wallpaper, re-weaving the landing-rug so that it matches the illustrations to *The Tale of Samuel Whiskers*, and conscientiously displaying artefacts next to the relevant illustrations. In that sense the Trust has busily and continually made Hill Top into a companion text for readers of the *Tales*. Yet though perhaps this impulse is generally congenial to the Trust's ethos, it originated in this instance with Potter.

The visitor to Hill Top today is invited to engage in reading the house as a text rather than as a writer's or illustrator's workshop. Potter's mediation of the house into text, whether as writer, illustrator or householder, is virtually erased, so eager is the house to produce itself as a simulacrum of the *oeuvre*. The enterprise of making the house mirror the text is naturally much eased by the importance of illustration to the *Tales*. There is the porch, the garden-path, the garden-wall and the garden-gate so familiar from pictures in *The Tale of Tom Kitten*, the dresser, the chairs, the range and the landing that appear in *The Tale of Samuel Whiskers*, the teapot from *The Tale of the Pie and the Pattypan*, the dolls and the doll's house food from *The Tale of Two Bad Mice*. Nowadays if you visit, you are also shown Anna Maria's rat-hole, the chest-of-drawers from which Tom Kitten's 'elegant and uncomfortable clothes' are plucked, and, artfully disposed around the garden, if you are sharp-eyed enough, you can spot the spade, watering-can, riddle and garden door familiar from *Peter Rabbit*, or Jemima Puddleduck's abandoned eggs, and congratulate yourself on your acuity, even as you notice the mendacity of back-dating the house and its garden in such a wholesale fashion. This experience of viewing Hill Top combines recognition and mis-recognition, satisfaction and frustration. Objects familiar from the texts seem obscurely unfamiliar, slightly out of scale and proportion. It takes a while before you realise that to make them look more familiar you would need to shrink your viewpoint to cat or rat or goose level. And then, the cats, rats, mice, rabbits, geese and ducks are nowhere in evidence, let alone packed up in uncomfortable clothes, except, that is, in the shapes of some painted souvenir china and the odd figurine once

owned by Potter herself. The reader-tourist is offered the opportunity to occupy the identical domestic space of the *Tales*, but the sheer battiness of the vantage point of the Peter Rabbit books remains as inaccessible as the view from the gable to which Potter climbed to paint the view that Tom Kitten saw when he poked his head out of the chimney. Text, house and landscape march in parallel; but the relationship between them remains non-hierarchical, obscure and un-narrated. The house does not succeed in presenting itself as the origin of the books, or even as their meta-text, but rather, merely, as one of a series of possible illustrations to them: not founding, but supplementary. It is not clear whether the house provides an entry-point into the texts or whether it is the other way around, and this effect is traceable to the near total elision of authorial presence, whether inside or outside the books.

A house of more recent literary fame does succeed in presenting itself as the entry-point to a fictive place. Like Hill Top Farm, the Manor at Hemingford Gray has been preserved in the state in which the elderly author left it at her death, although where Potter's house has been taste-fully embalmed at substantial cost, this property seems more subject to a process of uncanny self-imposed petrification. Owned and occupied by Diana Boston, Lucy Boston's daughter-in-law, since the writer's death in 1990, it is open to visitors by appointment only, welcoming only about 3500 a year, of whom perhaps 2000 have come principally to see the garden, celebrated for its collection of iris. For those who have come as literary tourists, however, the tour of the house works largely because it so efficiently replicates the structure of *The Children of Green Knowe*, repeating the introduction of the young protagonist into the house under the guidance of an authorial surrogate.

Hence a visit to the Manor House today replicates the arrival of the seven-year-old Toseland ('Tolly' for short) at the house of his great grandmother, Mrs Oldknow, described in the opening of *The Children of Green Knowe*. The text thus provides the tourist a way into the house, indeed overdetermines the tourist's arrival. Arriving by boat in the floods, Tolly, escorted by Mr Boggis, walks into the entrance hall:

> As they stepped in, a similar door opened at the far end of the house and another man and boy entered there. Then Toseland saw that it was only themselves in a big mirror There were three big old mirrors all reflecting each other so that at first Toseland was puzzled to find what was real, and which door one could go through straight, the way one wanted to, not sideways somewhere else. He almost wondered which was really himself.[4]

Tolly is made strange to himself, and multiplied between the real and the fictional. The effect is redoubled for the tourist, for the mirrors are all still there, and the mind's eye momentarily sees Tolly, and Mr Boggis, and one's own selves all jumbled together in the hall. Our guide said kindly to my children, 'you can pretend you're two little Tollies', and, just like the fictional Mrs Oldknow once did, took us up the same way that Tolly went to bed:

> She led him up winding stairs and through a high, arched room like a knight's hall, that she called the Music Room, and up more stairs to the very top of the house. Here there was a room under the roof, with a ceiling the shape of the roof and all the beams showing. It was a long room with a triangle of wall at each end and no walls at the sides, because the sloping ceiling came down to the floor, like a tent. There were windows on three sides, and a little, low wooden bed in the middle covered with a patchwork quilt There was a low table, a chest of drawers and lots of smooth, polished, empty floor. At one side there was a beautiful old rocking-horse – not a 'safety' rocking-horse hanging on iron swings from a centre shaft, but a horse whose legs were stretched to full gallop, fixed to long rockers so that it could, if you rode it violently, both rear and kick. On the other side was a doll's house. By the bed was a wooden box painted vermilion with bright patterns all over it A wicker bird-cage hung from one of the beams. On the only side that had no window there hung a big mirror reflecting all the rest – the rafters, the wicker cage, the rocking-horse, the doll's house, the painted box, the bed.
> 'In this house,' said Tolly, 'everything is twice!'[5]

Tolly's sense that 'everything is twice' prefigures and authorises the tourist's sense of replication – everything is indeed 'twice' – once in the text (and doubly described there by beautiful illustration), and once 'for real'. Feste, the rocking-horse, is there, and so is the linnet's cage. The chest of drawers still holds 'two curly white china dogs' and 'an old clock'. The girls knelt on the very window-seat from which Tolly looks out over the flood-waters and looked out towards the river.

The doubleness of the house is not just a matter of mirrors for Tolly; the attic room also contains a doll's house replica of Green Knowe:

> 'Why, it's this house!' he said. 'Look, here's the Knight's Hall, and here's the stairs, and here's my room! Here's the rocking-horse and here's the red box, and here's the tiny bird-cage! But it's got four beds in it. Are there sometimes other children here?'[6]

Reiterated in miniature, the house also turns out to reiterate its past in the shape of three ghostly Restoration children, Toby, Linnet and Alexander, who become Tolly's companions and surrogate brothers and sisters. The entry-points to this expanded and magical emotional world are two-fold: the hole in the floorboards in which Tolly finds the key to the toy-chest and Toby's 'Japanese mouse'. Both are still there in the house, and still shown; child-visitors are offered the chance to turn the key in the chest and find Toby's sword, Linnet's doll, Alexander's flute, the marbles and dominoes, and other items that call up the children's stories. Sitting on the chest of drawers is Toby's ebony Japanese mouse, the mouse that Tolly feels grow warm and live as he slips his hand for it under his pillow, the mouse that sometimes squeaks: only it's there twice too – once for real, and once in replica for visitors to hold. As a special treat my children were allowed to hold the real one as well, and they decided that they preferred the real mouse over the resin replica – colder, hairier and its eyes glistened more, they said. The mouse's part aliveness and part not-aliveness, its realness and not-realness, makes it the perfect figure for the visitor's ambiguous relation with the fiction and the house as they mesh imperfectly together through the mechanics of make-believe. As a talisman promising imaginative access to the book's fantasy, the resin replica is, fittingly, one of the few souvenirs that the house provides.

The haunting of the house provides a powerful model for the sense of the written story, absent yet present, that the documentary reality of the house throws into relief for the visitor. The explicit investment of the text in the idea of simultaneous realities inhabiting the house pre-models visitor experience. The Manor thematises the shifting and sometimes impossible relation between the real and the fantastic; as Mrs Oldknow says at one point to a disconsolate Tolly, 'it's been one of those afternoons where nothing will come alive'.[7]

Although on the dining-table there lies an exercise book containing the manuscript of *The Children of Green Knowe*, a chair pushed carelessly back, for all the world as though the author had just walked into the kitchen for a cup of tea, the Manor is not presented primarily as a writer's workshop. Rather, the house works as a physical counterpart to the texts because it expresses the same sensibility, compounded of a peculiar native quality of distress, nostalgia for the past and a precariously achieved consolation. Because it is realised so intensively in the books both in description and in the many illustrations, the Manor tacitly claims to pre-exist both the author and her fictional surrogate, Mrs Oldknow, chatelaine of Green Knowe and loving curator of its ghosts. It

is not the writer who provides the keys to the world of fantasy, but the place itself, enfolded around Toby's precious mouse. The overall effect of Hemingford Grey is as unsettling as a Haworth in which the Brontë sisters really had written solely and in obsessive detail about the Parsonage: hyper-realism and Gothic fantasy inhabit the same text and the same house simultaneously.

Hill Top and the Manor, however fantastically fossilised in mode, are at least real places. The same cannot be said of Wonderland, or so you might have thought. Neither Dodgson's text nor Tenniel's illustrations locate the fantastic events of *Alice in Wonderland* (1865) topographically. In fact, Carroll's epigraph specifies that its events happen somewhere only metaphorically topographical and almost inaccessible even to its inferred reader and apparent dedicatee:

> Alice! A childish story take,
> And with a gentle hand
> Lay it where Childhood's dreams are twined
> In Memory's mystic band,
> Like pilgrim's withered wreath of flowers
> Pluck'd in a far-off land.[8]

Yet Wonderland, alive and well and flourishing in and around Oxford, is testimony to a still vital realist desire to locate text within place, however fantastic the book, indeed, perhaps especially if it is fantastic. No-one has ever located that famous rabbit-hole (except on Carroll's memorial in Westminster Abbey, surely an unintentional black joke even if this is not actually his grave), or indeed interviewed the white rabbit, but the bank on which Alice became bored and fidgety has been identified up near Godstow, the treacle well has been rediscovered at Binsey, the little door into the garden which Alice has such difficulty negotiating is verifiably set into a wall in the Dean's garden at Christ Church, and Alice's serpent-like neck is supposed to have been suggested by a pair of fire-irons now pointed out to visitors in the hall at Christ Church.[9] The Dodo sits, stuffed and faintly smug, in the University Museum of Natural History. The Sheep Shop opposite Christ Church, model for the mirror-image that Tenniel drew for the sequel to *Alice in Wonderland* for *Through the Looking-glass* (1871), is now identified as such, and with a fantastical, post-modern commercial canniness sells postcards of itself as 'a Wonderland in the heart of Oxford'. (Figure 5.2). Carroll's imaginary but entirely Victorian literary souvenir of a 'withered wreath of flowers' has been replaced by souvenir figurines of Alice,

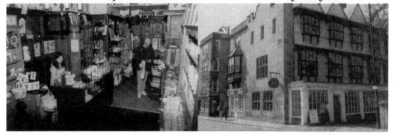

Figure 5.2 'Alice's Shop – a Wonderland in the heart of Oxford', postcard, c. 2002. Alice's Shop, Oxford.
An example of the commercial advantages of making it possible for tourists to visit Alice's Wonderland within modern Oxford.

the White Rabbit, the Mad Hatter and the Queen of Hearts in every conceivable medium from cloth to ceramic.

Alice has been successfully located in this fashion largely by sourcing its locations and characters to the author's biography, to his 'haunts', much as *Wuthering Heights* has been tied down, however tenuously, to Top Withens and Ponden Kirk. This is equally true of another classic quartet of children's books that have become rather improbably attached to real place, *When We Were Very Young* (1924), *Winnie-the-Pooh* (1926), *Now We Are Six* (1927) and *The House at Pooh Corner* (1928). Although little in these texts instigates or calls upon a sense of communal and verifiable topography, a topography has been invented, secured by reference to the biography of A.A. Milne and the autobiography of his son Christopher Robin, checked against E.H. Shepard's illustrations, and supplemented by consumer practicality. Between East Grinstead and Tunbridge Wells, apparently, at the Sussex village of Hartfield, can be found 'the home of all the "Animals of the Forest"'. Frank Barrett and John Woodcock have even provided 'The Winnie-the-Pooh map' to guide visitors to their homeland: on it is shown Cotchford Farm (Milne's weekend retreat),

Poohsticks Bridge, 'The Enchanted Place' (at which there is a memorial to Milne and Shepard), 'The North Pole', 'Pooh's car park' and, presumably for smaller cars, 'Piglet's car park'. Although the whole point of Milne's stories could be said to be the transformative power of a young child's imagination, transformation is not left up to the visitor's imagination: the Poohsticks bridge is 'carefully preserved to look just as E.H. Shepard drew it, with the wooden rails on which Christopher Robin is illustrated, standing and leaning over to drop his stick in the water.' If you look downstream, you will see that the water is choked with a thick tangle of ex-pooh sticks, testimony to how many have come to check up that the enchanted places are, really and truly, there.[10]

Milne and his son can hardly be accused of collusion with this particular touristic practice – Cotchford Farm itself remains as resolutely private as his son sought to be – but the readerly impulse actually to visit fictitious dream-worlds, or at least the specific sites where they are not, has been elegantly and revealingly toyed with by a more recent best-selling children's author, Philip Pullman. The alternative worlds promulgated by Pullman, however, are secured not by authorial biography – no tours are as yet available of the shed in which his major works were written, and nor does it feature in them itself – but by a rich and many-layered set of games with the already fantasied and fantastical topography of Oxford. Pullman's trilogy *His Dark Materials* (1995–2000), together with the opportunistic publication of a tailpiece, postscript and supplement called *Lyra's Oxford* (2003), constructs a topography of a parallel Oxford available only through the opening of 'windows' or 'doorways' between worlds culturally distinct but geographically equivalent. Pullman sets up equivalences and discrepancies between an Oxford which we as readers recognise and an Oxford which we only partially recognise; between Will's Oxford and Lyra's Oxford. Will effectively acts as tourist 'guide' and cicerone to Lyra in his world, Lyra to Will in hers. The trilogy finishes with the deliberate and principled closing down of such windows, and the consequent parting of the now-lovers, Will and Lyra. This conceit explicitly describes the relation that fiction-reading (and indeed writing) might have to the tradition of novelistic high realism. Even while the fictional world is being given the high gloss of the illusion of the real via the compendiousness of documentary detail, it turns out that this is the documentation of a world that never was, though it might have been, and is, in the sense that it exists for writer and readers.

With the windows between alternative worlds closed down, Will is offered one consolation; the possibility of partial transfer between worlds, described in the final moments of *The Amber Spyglass* in terms

of a practice of 'double-seeing' – an ability to see both worlds at once, as in an optical picture. It is described, too, as available through a process of imagination: 'But that does not mean *making things up*. It is a form of seeing.'[11] Such 'seeing' is consonant with the learned process of reading the alethiometer (the 'golden compass' of the American title of the first in the trilogy), which entails reading symbols down through many accreted possible layers of meaning. In thus suggesting both that Will's Oxford and Lyra's Oxford are consonant, and that they are still available to a practice of 'double-seeing', Pullman not only describes his own fictional aesthetic but licenses literary tourism. By 2003, with the publication of *Lyra's Oxford*, a super-short book dealing with an adventure of Lyra's supposed to post-date *The Amber Spyglass*, he was already playing literary games with this idea. In order to promote the book at the Oxford Literary Festival in spring 2004, Pullman was involved in the design of a literary walk for which I bought a ticket. A remarkable experience, the walk began in Exeter College (the location and part-original with Christ Church for Lyra's Jordan College) and wound its way via on-site readings down to the district of Jericho – already prominent on other fictional maps as the area of 'Christminster' where all those children are hanged in Hardy's *Jude the Obscure* – where the story reaches its climax, coming to rest in the little half-derelict St Sepulchre's cemetery. The walk was punctuated by the regular and rather unnerving apparition (given that it was a Saturday shopping day in Oxford) of a masked young man in vast black wings intermittently rushing across our field of vision playing the witch's daemon. It was indeed an experience of 'double-seeing'. This conscious exploitation and initiation of tourist activity was previewed and organised by *Lyra's Oxford* itself, which contains not merely a full map of 'Lyra's Oxford' (strongly reminiscent in its mix of the real and the fictive of the maps of Hardy's Wessex), but a cod souvenir postcard, divided into four pictures, one showing the street-name sign 'Norham Gardens' where the scientist Mary Malone is supposed to live, one the hornbeam trees in Sunderland Avenue where Will finds his first window into another world, one the Science Buildings, and one the seat in the Edenic Botanic Gardens where Lyra and Will promise to keep tryst every Midsummer's Day at midday: 'Will, I used to come here in *my* Oxford and sit on this exact same bench whenever I wanted to be alone What I thought was that if you – maybe just once a year – if we could come here at the same time, just for an hour or something, then we could pretend we were close again – because we *would* be close, if you sat here and I sat just *here* in my world ...'[12]

The way to find this pictured bench had already been carefully specified in *The Amber Spyglass*:

> She led him past a pool with a fountain under a wide-spreading tree, and then struck off to the left between beds of plants towards a huge many-trunked pine. There was a massive stone wall with a doorway in it, and in the further part of the garden the trees were younger and the planting less formal. Lyra led him almost to the end of the garden, over a little bridge, to a wooden seat under a spreading low-branched tree.[13]

When I took my children with me in an attempt to follow this itinerary and find a corresponding real bench in the summer of 2004, I discovered that the actual bench was unverifiable, partly because you can go over that little bridge in two directions, of course. A hot argument ensued, because the bench on one side of the bridge corresponded with Pullman's postcard and map, but the bench on the other corresponded with that which had appeared in the National Theatre's spectacular dramatisation of the trilogy that winter. The children won the argument, but if you go to the Botanic Gardens these days, likely as not you will find a little bunch of flowers laid on the other bench, or someone with an otherwise obscurely and inexplicably satisfied look photographing it. They have come for a type of sentimental experience dating all the way back to Rousseau; but nowadays, instead of searching for the lost Julie, they have come in search of the forever-inaccessible Lyra. So powerful is the desire to find the secret window into another, fictional, world for real, so powerful is the sense that this window is not simply the writer's desk. (The location of this bench has itself a Pullmanesque history; when Pullman took the photograph the bench had just been moved to a temporary location pending restoration of that part of the garden. However, there was such an outcry when it was returned to its proper place, that the authorities bowed to pressure and restored it again to the position in which Pullman's text had located it.)[14]

'Lyra's bench', then, returns the tourist to the text. It is, paradoxically, hard evidence of the absence of physical reality at the heart of the experience of reading. This dialectic between presence and absence constitutes at once the charm and the embarrassment of literary tourism's implication in make-believe. Not content with the airy worlds of fiction, it seeks to found it upon biography, and upon real estate. It tries to reanimate the hours of reading in the sunlit expanses of the Bodleian Library beyond the bounds of both library and book, welding literary

memory into physical, bodily memory, and embodying it variously as relic and as souvenir. Its emotional charge comes from the simultaneous policing of and trespassing across the ill-defined borders between the real and the fictive, between the present and the past, between past protocols of sentiment and the registers of emotion available to the modern. It involves enacting the art of reading as the art of make-believe, the subtlest of knives that cuts windows from this through into other worlds. It involves a willed waking dream that converts the fictive to the real and back again, a potent mix of scepticism and belief, a divided apprehension like that which Alice's daydreaming elder sister wills into being on the banks of the river in Victorian Oxford:

> . . . still as she listened, or seemed to listen, the whole place around her became alive with the strange creatures of her little sister's dream.
>
> The long grass rustled at her feet as the White Rabbit hurried by – the frightened Mouse splashed his way through the neighbouring pool – she could hear the rattle of the tea-cups as the March Hare and his friends shared their never-ending meal, and the shrill voice of the Queen ordering off her unfortunate guests to execution – once more the pig-baby was sneezing on the Duchess's knee, while plates and dishes crashed around it – once more the shriek of the Gryphon, the squeaking of the Lizard's slate-pencil, and the choking of the suppressed guinea-pigs, filled the air, mixed up with the distant sobs of the miserable Mock Turtle.
>
> So she sat on, with closed eyes, and half believed herself in Wonderland, though she knew she had but to open them again, and all would change to dull reality – the grass would only be rustling in the wind, and the pool rippling to the waving of the reeds – the rattling teacups would change to tinkling sheepbells, and the Queen's shrill cries to the voice of the shepherd boy – and the sneeze of the baby, the shriek of the Gryphon, and all the other queer noises, would change (she knew) to the confused clamour of the busy farm-yard – while the lowing of the cattle in the distance would take the place of the Mock Turtle's heavy sobs.[15]

Notes

Introduction

1. Norton Juster, *The Phantom Tollbooth* (London, 1962).
2. John Masefield, *The Box of Delights* (London, 1935).
3. Rudyard Kipling, *Puck of Pook's Hill* (London, 1906), 12–13.
4. Ian Ousby – in *The Englishman's England: Taste, Travel and the Rise of Tourism* (Cambridge, 1990) – reckons there are about 40 writers' houses currently open to the public, attracting between them some two million visits a year (22); if anything, this is a conservative estimate – at the 'Tourism and Literature Conference' in Harrogate in 2004, Karen Smith calculated that there were some 54 writers' homes currently open.
5. Tourist leaflet 'Arthur Ransome's Swallows and Amazons in the Lake District', The (Arthur Ransome Society, 2003).
6. Arthur Ransome, *Secret Water* (London, 1939).
7. On du Maurier and tourism, and especially on how the Brontë-like structures of *Rebecca* solicit a certain gothic form of literary pilgrimage, see Nicola J. Watson, '*Rebecca*', *The Popular and the Canonical: Debating Twentieth-Century Literature, 1940–2000*, ed. David Johnson (London and New York, 2005), 13–56, especially 51–4.
8. See Chapter 8, so titled, in William Sharp, *Literary Geography* (London, 1904). For the curious, it is improbably located simultaneously in Wales and East Anglia, and reflects the popularity of Walter Theodore Watts-Dutton's novel *Aylwin* (1898).
9. To date there have been a number of important studies to do with tourism and the development of heritage museums more generally; see especially James Buzard, *The Beaten Track* (Oxford, 1993); H. Berghoff, Barbara Korte, Ralf Schneider, and Christopher Harvie, *The Making of Modern Tourism: The Cultural History of the British Experience, 1600–2000* (Basingstoke, 2002); Barbara Kirschenblatt-Gimblett, *Destination Culture: Tourism, Museums, and Heritage* (Berkeley, 1998); and John Urry, *Consuming Places* (London, 1995). The phenomenon of literary tourism has been dealt with in part in two chapters on Shakespeare and Wordsworth, respectively, in Ian Ousby's *The Englishman's England*. There have been a few academic studies of individual authors in relation to tourism; notably chapters on Shakespeare in Péter Dávidházi's *The Romantic Cult of Shakespeare* (Basingstoke, 1998) and Douglas Lanier's *Shakespeare and Modern Popular Culture* (Oxford, 2002); the opening of Stephen Gill's *Wordsworth and the Victorians* (Oxford, 2001); a chapter on the Brontës in Patsy Stoneman's *Brontë Transformations* (Hemel Hempstead, 1996); a chapter on Dickens in *Literature and Its Cults*, eds, Péter Dávidházi and Karafiáth,(Budapest, 1994) and my own 'Shakespeare on the tourist trail' in *The Cambridge Companion to Shakespeare in Popular Culture*, ed. Robert Shaughnessy (Cambridge, 2007).

10. Barbara Johnson, 'Translator's Introduction', in Jacques Derrida, *Disseminations*, tr. Barbara Johnson (Chicago, 1981), xiii–xiv.
11. Ousby, 21.
12. Susan Coolidge, *What Katy Did Next* (1886; Hertfordshire, 1995), 76–7.
13. R.D. Blackmore, *Lorna Doone* (1869; Doone-Land Edition, 1908), preface.
14. Kate Marsh, ed., *Writers and their Houses: A Guide to the Writers' Houses of England, Scotland, Wales and Ireland. Essays by Modern Writers* (London, 1993), xi. For another excellent recent contribution to this genre, see Christina Hardyment, *Literary Trails: British Writers in their Landscapes* (London, 2000).
15. Parts of Chapter 4 of this study were first presented at this conference as 'Doing Rousseau', which was published on the *Tourism and Literature: Travel, Imagination and Myth* CD-Rom, eds, Mike Robinson and David Picard (Sheffield, 2004).

Chapter 1 An anthology of corpses

1. For a reading of the iconography of this memorial, see Philip Connell, 'Death and the author: Westminster Abbey and the meanings of the literary monument', *Eighteenth-Century Studies*, vol. 38 (2005) no. 4, 557–586.
2. [David Henry], *A Historical Description of Westminster Abbey, its Monuments and Curiosities . . . Designed Chiefly as a Guide to Strangers* (1753: London [1778]), iv.
3. See Connell, however, who argues that the symbolic heart of Poets' Corner shifted from Chaucer to Shakespeare, from the east aisle to the west aisle, around the early 1760s, as demonstrated by the choice of location for the monument to James Thomson. Connell, 577ff.
4. Nathaniel Hawthorne, *The English Notebooks*, ed. Randall Stewart (1941: New York, 1962).
5. *The Spectator*, ed. Donald F. Bond (5 vols, Oxford, 1965), I, 110.
6. See especially Michael Dobson, *The Making of the National Poet: Shakespeare, adaptation, and authorship, 1660–1769* (Oxford, 1992), 135–46.
7. For a full and convenient list distinguishing those buried in Poets' Corner from those commemorated there, and those buried elsewhere in the Abbey, see Christine Reynolds, *Poets' Corner, Westminster Abbey* (London, 2005), front and endpapers.
8. 'Upon the Poets Corner in Westminster Abbey', *Poems on Several Occasions* (1733), cited in Christine Reynolds, op. cit., 3.
9. Oliver Goldsmith, *The Citizen of the World* (1760–1761), in *Collected Works*, ed. Arthur Friedman (5 vols, Oxford, 1966), II, 56–60. On Poets' Corner in relation to the creation of a national literature, especially in relation to private patronage, see Connell, *passim*.
10. See, e.g., Péter Dávidházi, *The Romantic Cult of Shakespeare: Literary Reception in Anthropological Perspective* (Houndmills, 1998), 63–88.
11. See e.g., Connell, 570.
12. John Dart, *Westmonasterium. Or, The History and Antiquities of the Abbey Church of St Peter's, Westminster* (2 vols, London, 1723), I, xl.
13. Rev. Thomas Maurice, *Westminster Abbey: An Elegiac Poem* (London, 1784), 3; cited in Connell, 564.

14. D.M., *Ancient Rome and Modern Britain Compared. A Dialogue, in Westminster Abbey, between Horace and Mr Pope* (London, 1793), 23–4. Cited in Connell, 564.
15. J. Heneage Jesse, *Literary and Historical Memorials of London* (2 vols, London, 1850), I, 422.
16. Arthur Penrhyn Stanley, *Historical Memorials of Westminster Abbey* (London, 1868), 330.
17. Stanley, 269. For a more recent account of Shakespeare's likely participation at Spenser's funeral, and the legend of Spenser's fellow-poets burying their pens with his coffin, see James Shapiro, *1599: A Year in the Life of William Shakespeare* (London, 2005), 'Burial at Westminster', 67–83.
18. Stanley, 332.
19. Samantha Matthews, *Poetical Remains: Poets' Graves, Bodies, and Books in the Nineteenth Century* (Oxford, 2004); see especially Chapter 7.
20. See John Jowett, William Montgomery, Gary Taylor and Stanley Wells, eds, *The Oxford Shakespeare: The Complete Works* (1986; 2nd edn, Oxford: Clarendon Press, 2005), lxx.
21. Jonson, 'To the memory of my beloved, / The AUTHOR MASTER WILLIAM SHAKESPEARE AND WHAT HE HATH LEFT US', in Jowett et al., op. cit., lxxi.
22. Washington Irving, *The Sketch Book* (1820; Leipzig, 1847), 309.
23. Cited in Ian Ousby, *The Englishman's England; Taste, Travel, and the Rise of Tourism* (Cambridge, 1990), 28–9.
24. T.P. Grinsted, *Last Homes of Departed Genius: with biographical sketches of Poets, Painters, and Players* (London, 1867), vi.
25. For a discussion of necro-tourism which instances Wordsworth's poem 'The Brothers', see Tobias Döring, 'Travelling in Transience: The Semiotics of Necro-Tourism' in Berghoff et al., *The Making of Modern Tourism*, 249–66. For the standard connections between religious and secular pilgrimage see Ousby, op. cit., 22–3.
26. See Péter Dávidházi, op. cit.
27. See Michael Dobson, op. cit.
28. For a fuller account of tourism to the Shakespeare monument and other places associated with the Bard, see Nicola J. Watson, 'Shakespeare on the Tourist Trail' in *The Cambridge Companion to Shakespeare in Popular Culture*, ed. Robert Shaughnessy (Cambridge, 2007).
29. Christian Deelman, *The Great Shakespeare Jubilee* (London, 1964), 35.
30. On the Stratford monument and its fortunes, see Tarnya Cooper, Marcia Pointon, James Shapiro and Stanley Wells, *Searching for Shakespeare* (National Portrait Gallery catalogue, London, 2006).
31. *An Excursion to Stratford-upon-Avon* (Leamington, 1824), n.p.
32. On exhumation and poets' bodies, see Matthews, op. cit.
33. William Godwin, *Essay on Sepulchres: or, A Proposal for Erecting Some Memorial of the Illustrious Dead in all Ages on the Spot where their Remains have been interred* (1809), in *Political and Philosophical Writings of William Godwin*, ed. Mark Philp (7 vols, 1993), VI, 6.
34. Godwin, 20.
35. Ibid, 12.
36. Ibid, 22, 24.
37. See Mark Philp's preface to Godwin, I, 3.

38. Godwin, 30.
39. Washington Irving, *The Sketch Book* (1820; Leipzig, 1843), 206–7.
40. Ibid, 309.
41. Godwin, 23.
42. Ibid, 29–30.
43. For a discussion of the romantic author's anxiety of audience, see Andrew Bennett, *Romantic Poets and the Culture of Posterity* (Cambridge, 1999), Introduction.
44. Thomas Hardy, in *The Hand of Ethelberta* (1876), ed. Tim Dolin (Harmondsworth, 1997), 200.
45. H.W. Starr and J.R. Hendrickson, eds, *The Complete Poems of Thomas Gray* (Oxford, 1966), 37–43.
46. T. Warton, the Younger, in *The Poetical Works of the late Thomas Warton*, ed. Richard Mant (2 vols, 5th edn, Oxford, 1802), I, 156.
47. *An Irregular Ode, occasioned by the Death of Mr Gray* (London, 1772), 9–10.
48. T. J. Mathias, *Observations on the Writings and Character of Mr Gray* (London, 1815), 9.
49. William Howitt, *Homes and Haunts of the Most Eminent British Poets* (2 vols, London, 1847), I, 284; Mrs S.C. Hall, *Pilgrimages to English Shrines* (First Series. London, 1850), 104.
50. Theodore F. Wolfe, *A Literary Pilgrimage Among the Haunts of Famous British Authors* (2nd edn, Philadelphia, 1895), 40–1.
51. Robert Montgomery, 'The Tomb of Gray' (1836), in *The Poetical Works of Robert Montgomery* (London, 1854), 622.
52. Howitt, I, 278, 284.
53. Grinsted, 221.
54. Wolfe, 42.
55. Stephen Springall, *Thomas Gray, Stoke Poges, and 'Elegy Written in a Country Churchyard.' An Enquiry* (Uxbridge, [1923]), 13.
56. Wolfe, 41–2.
57. Stanley, 331.
58. Henry C. Shelley, *Literary Bypaths in Old England* (1906; London, 1909), 119.
59. Ibid, 101.
60. Ibid.
61. Matthews, 113. Matthews also notes that in 1850s and 1860s both Keats and Shelley became popular subjects for tribute poems, 148.
62. Emma Blyton, *Poetical Tributes to the Memories of British Bards, and Other Poems* (London, 1858), 22.
63. Susan Coolidge, 135.
64. See Monkton Milnes, *Life, Letters, and Literary Remains of John Keats* (London, 1848) and Joseph Severn, 'On the Vicissitudes of Keats's Fame' (*Atlantic Monthly*, XI, 1863) on the grave as place of pilgrimage. As a counter-example, however, one might consider William Miller's account of a long tour on the continent for his sick wife's health, *Wintering in the Riviera, with notes of Travel in Italy and France, and Practical Hints to Travellers* (London, 1879). Although of a literary turn – citing de Staël, Hawthorne and George Eliot, and visiting Juliet's reputed tomb in Verona, and although they actually stay in the Piazza di Spagna and consult the same doctor who treated Keats, Miller makes no mention of either Keats or Shelley. I could have provided many other examples. For the installation of the wall-plaque, complete with illustration, see *The Century* for 1867.

65. Anna Jameson, *Diary of an Ennuyée* (Philadelphia, 1826), 141; Mrs [Frances] Trollope, *A Visit to Italy* (2 vols, London, 1842), II, 328–9; Charles Dickens, *Pictures from Italy*, ed. Leonée Ormond (1846; London, 1997), 428.

66. For a pioneering reading of the relation between *Adonais* and the death of Keats, see Susan Wolfson, 'Keats enters history: autopsy, *Adonais*, and the fame of Keats', in *Keats and History*, ed. Nicholas Roe (Cambridge, 2005); for a really thorough discussion of the ways in which the friends and relations of both Keats and Shelley managed and memorialised the poets' deaths, including in relation to *Adonais*, see Matthews, op. cit. My own interest here is more particularly in the ways in which readers beyond the immediate circle read and experienced these sites of poetic death.

67. Matthews, op. cit., 146–7.

68. Charles Dickens, *Pictures from Italy*, 428. Marion Harland, *Where Ghosts Walk: The Haunts of Familiar Characters in History and Literature* (New York, London, 1898), 178.

69. Howitt, I, 466.

70. Cited in Matthews, 131.

71. For the installation of the plaque in the Piazza di Spagna see *The Century* (1895); Harland, 176, 177.

72. Ibid, 177.

Chapter 2 Cradles of genius

1. See John Keats, letter to John Hamilton Reynolds, 13 July 1818; John Keats, *The Letters of John Keats 1814–1821*, ed. Hyden Edward Rollins (2 vols, Cambridge, 1958), I, 176.

2. See the poem 'On the annual meeting of some Gentlemen to celebrate SHAKESPEARE'S BIRTHDAY', *London Magazine*, 24 (1755), 244.

3. Robert Bell Wheler, *History and Antiquities of Stratford-upon-Avon . . .* (Stratford-upon-Avon, 1806), ii. Possibly a quotation from the Reverend Joseph Greene's party-piece at an evening designed to raise money for the whitewashing of Shakespeare's bust in 1793.

4. Samuel Henry Ireland, *Picturesque Views on the Upper or Warwickshire Avon* (London, 1795), 186–7.

5. For a detailed reading of Stratford as a present-day tourist site, concentrating on 'tours, individual site displays, artefacts, descriptive materials and catalogues, souvenirs and trinkets' in a way which space here prohibits, see Barbara Hodgdon, *The Shakespeare Trade: Performances and Appropriations* (Philadelphia, 1998), Chapter 6, 'Stratford's Empire of Shakespeare; or, Fantasies of Origin, Authorship, and Authenticity: The Museum and the Souvenir', 191–240. The displays have changed in one crucial way, however, since Hodgdon published her study, in that they now extensively gesture towards the specific histories of each property, and indeed towards the history of Shakespeare tourism.

6. On the Jubilee, see especially Deelman, *passim*; Dobson, 214–227.

7. Included in Garrick's own part-satirical dramatisation of the whole festival, *The Jubilee* (1769); see *The Plays of David Garrick*, eds, Harry William Pedicord and Fredrick Lois Bergmann (6 vols, Carbondale, 1981), II, 108.

8. Ibid, 120. See also Ivor Brown and George Fearon, *Amazing Monument: A Short History of the Shakespeare Industry* (London, 1939), 81.

9. Nicholas Fogg, *Stratford-upon-Avon: Portrait of a Town* (London, 1986), 104.

10. David Garrick, *An ode, upon dedicating a building, and erecting a statue, to Shakespeare, at Stratford-upon-Avon* (London, 1769), 3.

11. Edward Daniel Clarke, *A Tour through the South of England, Wales and Part of Ireland, made during the summer of 1791* (London, 1793), 379.

12. William Dodd, *Poems* (London, 1767), 'On Seeing a Single Swan on the Banks of the Avon', l.5–6. See also John Huckell, *Avon: A Poem in Three Parts* (Birmingham, 1758) and Thomas Warton, 'Monody, written near Stratford upon Avon' (1777), *The Poetical Works of the late Thomas Warton . . .* (Oxford, 1802). Ireland quotes from Warton elsewhere in the text.

13. On the changed sense of location in the nineteenth century see Roger Sale, *Closer to Home: Writers and Places in England, 1780–1830* (Cambridge, MA, 1986); 2. On Kemble's production, see Jane Martineau et al., *Shakespeare in Art* (London, 2003), 152. Playbill in the author's own collection.

14. Christian Tearle, *Rambles with an American* (London, 1910), 77–78, 80, 94.

15. James Grant Wilson, ed., *The Poetical Writings of Fitz-Greene Halleck . . .* (New York, 1882), 29. The poem itself is of far earlier date, probably 1820s.

16. Richard Gall, *Poems and Songs, by the late Richard Gall, with a Memoir of the Author* (Edinburgh, 1819).

17. *Ayr Advertiser*, 25 January 1804. See James M'Bain, *Burns' Cottage: The Story of the Birthplace of Robert Burns, from . . . 1756 until the present day, with numerous illustrations, plans and sketches* (Glasgow, 1905), 69. The first recorded celebration of Burns's birthday was, however, in Greenock, 1802.

18. M'Bain, 72.

19. See Howitt, I, 355. There is a surviving example of this in the portrait of Burns on wood held by the Burns Cottage.

20. *The Land of Burns: A Series of Landscapes and Portraits, illustrative of the Life and Writings of the Scottish Poet. The Landscapes from paintings made expressly for the work by D.O. Hill esq. R.S.A. The Literary Department by Professor Wilson . . . and Robert Chambers esq.* (Glasgow, Edinburgh and London, 1840), I, 99.

21. 'Propertius', *Notes of a Trip to the Haunts of Tannahill and the land of Burns* (Dunfermline, 1876; originally published as a series of magazine articles), 42.

22. 'Propertius', 41. For a selection of these souvenirs, see the Burns Cottage museum holdings; for those being produced in Mauchline as early as the 1860s, see the holdings of the Writers' Museum in Edinburgh.

23. Newspaper report for 6 June 1815, displayed in the Burns House, Dumfries.

24. Howitt, I, 391.

25. See Keats to Thomas Keats, diary letter, entry dated 1 July 1818; Keats, *Letters*, I, 163.

26. Dorothy Wordsworth, 'Recollections of a Tour Made in Scotland A.D. 1802', *Journals of Dorothy Wordsworth*, ed. E. de Selincourt (New York, 1941), I, 198–202. William Wordsworth, 'At the Grave of Burns' composed in part in 1803, published in *Poems, Chiefly of Early and Late Years* (London, 1842).

27. Thomas Campbell, 'Ode to the Memory of Burns', c. 1820.

28. Nathaniel Hawthorne, *The English Notebooks*, ed. Randall Stewart (New York, 1941), 500; Theodore F. Wolfe, *A Literary Pilgrimage among the Haunts of Famous British Authors* (2nd edn, Philadelphia, 1895), 164.

29. William Currie, *The Works of Robert Burns; with an Account of his life, and a criticism on his writings. To which are prefixed, some observations on the character and condition of the Scottish peasantry* (4 vols, Liverpool, 1800), I, 31, 58.
30. Keats to John Hamilton Reynolds, 11 July 1818; *Letters* I, 174–5.
31. Gall, op. cit.
32. Currie, I, 58.
33. For a typical expression of this sentiment, see 'Propertius', 42.
34. See *The Burns Cottage*; see also Hew Ainslie, *A Pilgrimage to the Land of Burns; containing Anecdotes of the Bard, and of the Characters he immortalized, with numerous Pieces of Poetry, original and collected* (Deptford, 1822), 87; these locations were still being shown in 1848, although by then it was necessary to gain admittance to the grounds of a private villa, Roselle: Thomas and Edward Gilks, *Sylvan's Pictorial Handbook to Coila or the Land o' Burns* (London, 1848), 10.
35. John Keats to John Hamilton Reynolds, 13 July 1818; Keats, *Letters* I, 176.
36. Ainslie, 86.
37. Ibid, 92.
38. Ainslie, 92.
39. Ibid, 111–2. The Burns Cottage Museum holds a necklace made from the wood dated to 1822, so the travellers only missed their souvenirs by a few months.
40. 'Propertius', 54.
41. For a full account, see M'Bain, 75.
42. Howitt, I, 358.
43. Henry C. Shelley, *The Ayrshire Homes and Haunts of Burns* (New York and London, 1897), 7.
44. M'Bain, 97.
45. John Fisher Murray, 'Land of Burns', *Dublin University Magazine* (1842), quoted in 'Propertius', 67.
46. In 1799, knowledge of Burns's poetry was largely confined to the two editions of his *Poems, Chiefly in the Scottish Dialect*; other poems were collected up in 1800 and thereafter by Currie and R.H. Cromek (1808).
47. Currie, I, 267.
48. Ibid, 267, 31.
49. Ibid, 328. Wordsworth in 1816, while deprecating what was widely regarded as Currie's 'revolting account of a man of exquisite genius, and confessedly of many high moral qualities, sunk into the lowest depths of vice and misery', agreed with Currie that the biographical was appropriate to the study of Burns because he belonged to 'that class of poets, the principal charm of whose writings depends upon the familiar knowledge which they convey of the personal feelings of their authors Neither the subjects of [Burns's] poems, nor his manner of handling them, allow us long to forget their author. On the basis of his human character he has reared a poetic one.' William Wordsworth, *A Letter to a Friend of Robert Burns; occasioned by an intended republication of the Account of the Life of Burns by Dr Currie; and of the selection made by him from his letters* (London, 1816), 8–9, 19.
50. Currie, 327, 329.

51. Ainslie, 3, 4.
52. Ibid, 105–6.
53. Howitt, I, 351.
54. *The Land of Burns* . . ., 58. Issued originally in twenty-three parts starting in 1837. Used in 1843 to illustrate a new edition of Currie's *Works*. It was still authoritative enough to be reissued in 1891 as a set of separate prints.
55. One example currently hangs at 'Burns's Howff', the Globe Inn at Dumfries.
56. See Wordsworth's sonnet on the occasion: "There,' said a stripling, pointing with much pride / Towards a low roof, with green trees half-concealed, / 'Is Mossgiel Farm, and that's the very field / Where Burns ploughed up the Daisy.' . . . *Poetical Works of Wordsworth*, eds, E. de Selincourt and Helen Darbishire (5 vols, Oxford, 1940), IV, 408. See also *The Land of Burns*, I, 100.
57. Hawthorne, op. cit., 505.
58. Shelley, 304.
59. *The Land of Burns*, I, 12.
60. Howitt, I, 365.
61. *Ward and Lock's Illustrated Guide to, and Popular History of the Land of Burns* . . . (London, [1882]), 25.
62. Hawthorne, 502.
63. *Ward and Lock's Illustrated Guide*, 23. See also A.M. Boyle, *The Ayrshire Book of Burns-Lore* (Darvel, 1985), 20.
64. See Peter J. Westwood, *The Deltiology of Robert Burns: The Story of the Life and Works of Robert Burns illustrated with over 420 different postcards* (Dumfries, 1994).
65. Howitt, I, 263.
66. *The Land of Burns*, I, 103.
67. Ibid, 104.
68. Ibid, 105.
69. Ibid, 104, 105.
70. For a full description of how the figure of Queen Elizabeth is used to legitimise and nationalise Shakespeare see Michael Dobson and Nicola J. Watson, *England's Elizabeth: An After-life in Fame and Fantasy* (Oxford, 2002), Chapter 4. On how Scott's *Kenilworth* added Kenilworth to the Bardolatrous tourist's Warwickshire itinerary, see especially 138–46.
71. *The Land of Burns*, I, 105.
72. Emma Severn, *Anne Hathaway, or, Shakespeare in Love* (3 vols, London, 1845), III, 81.
73. *A Guide to Stratford-upon-Avon* . . . *with a description of the historic memorials and relics of Shakspeare* (Manchester [c. 1890s]), 22.
74. William Winter, *Shakespeare's England* (Edinburgh, 1886), 83.
75. Ibid, 84.
76. Tearle, 81.
77. Winter, 79.
78. Quoted in Shelley, 8.
79. Nathaniel Hawthorne, *Our Old Home: A Series of English Sketches* (Boston, 1863), 112, 115.
80. Tearle, 78.

Chapter 3 Homes and haunts

1. Wilkinson Sherren, *The Wessex of Romance* (London, 1902), 46, 48.
2. See Stephen Gill, *Wordsworth and the Victorians* (Oxford, 1998), 11, for a discussion of how Rydal Mount became 'a place of general pilgrimage while its saintly incumbent was still alive'.
3. Abbotsford was not the first writer's workshop to attract interest, only the first in Britain. English travellers had variously visited Voltaire's chateau at Ferney in the early and mid-eighteenth century, Rousseau's cottages at Môtiers and the Ile St Pierre, Gibbon's summer-house in Lausanne where he completed *The Decline and Fall of the Roman Empire*, and Coppet, kept briefly open after the death of Madame de Staël. Lady Frances Shelley visited Voltaire's chateau at Ferney in 1816 (seeing 'two rooms . . . in the same state in which they were during Voltaire's lifetime') and again in 1853 (when she was shown 'two rooms quite destitute of furniture'). In 1816 she also viewed Rousseau's houses in Môtiers and the Ile St Pierre. *The Diary of Frances, Lady Shelley 1787–1817*, ed. Richard Edgcumbe (2 vols, London, 1912), I, 219, 222, 234; II, 334. Others visited Petrarch's house in Arquà which was in 1818 (and probably much earlier) already showing the poet's desk, chair and inkstand, and the embalmed body of his white cat. See George Gordon, Lord Byron's *Childe Harold* canto IV (1819), stanzas 30–2; *Macready's Reminiscences, and Selections from his Diaries and Letters*, ed. Sir Frederick Pollock (2 vols, London, 1875), I, 239; *The Diary of Frances, Lady Shelley* for 1834, II, 238–9; Frances Trollope, *A Visit to Italy* (2 vols, 1842), 52ff.
4. John C. Schetky, *Illustrations of Walter Scott's Lay of the last Minstrel: consisting of twelve views on the rivers Bothwick, Ettrick, Yarrow, Tiviot, and Tweed . . . with Anecdotes and Descriptions* (London, 1808), 23.
5. The phrase is Washington Irving's. Washington Irving, *Abbotsford and Newstead Abbey* (Paris, 1835), 53.
6. J.G. Lockhart, *Peter's Letters to His Kinsfolk* (1819; London, 1952) 209.
7. *The Diary of Frances, Lady Shelley* II, 46.
8. Irving, 1.
9. Ibid, 4.
10. Ibid, 17.
11. Ibid.
12. Shelley, II, 43.
13. Irving, 5.
14. Ibid, 6.
15. Ibid, 6.
16. Ibid, 9.
17. Ibid, 6. Although Bower survived Scott, Scott had already, at his request, written his obituary and it was duly published.
18. David Hannay, *Glimpses of the Land of Scott*, illustrated by John MacWhirter (London, 1888).
19. H.V. Morton, *In Search of Scotland* (1929; London, 1946), 15.
20. Irving, 42. On *The Antiquary* and Abbotsford, see also Scott, *The Antiquary*, ed. Nicola J. Watson (Oxford, 2002), 'Introduction', vii–xxvii.
21. Ibid, 25.
22. Shelley, I, 47.

23. William Howitt, *Homes and Haunts*, II, 154.

24. Howitt, I, 200.

25. Thomas Frognall Dibdin, *A Bibliographical, Antiquarian, and Picturesque Tour in the Northern Counties of England and in Scotland* (2 vols, 1838), II, 1012.

26. Nathaniel Hawthorne, *The English Notebooks 1856–60*, vol XXII of *The Centenary Edition of the Works of Nathaniel Hawthorne*, eds, Thomas Wodson and Bill Ellis (Ohio, 1997), 22.

27. Ibid, 21.

28. John Marius Wilson, *The Land of Scott; or, Tourist's Guide to Abbotsford, the Country of the Tweed and its tributaries, and St Mary's Loch* (1858; London, 1859), 18.

29. Theodore Fontane, *Across the Tweed: A Tour of Mid-Victorian Scotland*, trans. Sir James Ferguson (London, 1965), 195.

30. Ibid, 203–4.

31. Ibid, 204.

32. H.V. Morton, *In Search of Scotland*, 16.

33. Elizabeth Grant, *Memoirs of a Highland Lady* (1898), ed. with intro. Andrew Tod (2 vols, Edinburgh, 1992), vol 2, 73; *Macready's Reminiscences, and Selections from his Diaries and Letters*, ed. Sir Frederick Pollock (2 vols, London, 1875), II, 275.

34. Macready, II, 275.

35. Dibdin, II, 1003–4, 1007, 1015.

36. Ibid, 1004.

37. Ibid, 1012.

38. Hawthorne, 24.

39. Ibid, 26.

40. Howitt, II, 158.

41. Ibid, 160.

42. Ibid, 195.

43. Captain Basil Hall, *Patchwork* (3 vols, London, 1841), II, 288.

44. Howitt, II, 146.

45. The Parsonage Museum changes the objects it displays annually; this account refers to the summer of 2004.

46. For the probable site of Emily's death, see Juliet V. Barker, *The Brontës* (London, 1994), 576.

47. On the plaque installed at Top Withens in 1964, see Chapter 5.

48. See C. Cory, 'Excursion to Brussels 19–23 April 1993,' *Brontë Society Gazette* (1995) 9, 12.

49. *Daily News*, April 1855, *The Brontës: The Critical Heritage*, ed. Miriam Farris Allott (1974; London, 1995), 303–4.

50. Matthew Arnold, 'Haworth Churchyard', *Fraser's Magazine*, May 1855, Allott, 309. See Lucasta Miller, *The Brontë Myth* (London, 2002), 59ff. for a discussion of the history of this misprision, to which I am indebted in what follows.

51. R.W. Franklin, ed., *The Poems of Emily Dickinson* (Cambridge, Massachusetts and London, 1998) I, 146, 187–8.

52. W.H. Charlton. Printed as preface to T. Wemyss Reid, *Charlotte Brontë: A Monograph* (London, 1877).

53. Emily Brontë, *Wuthering Heights* (1847), ed. David Daiches (Harmondsworth, Middlesex, 1979), 205.

54. Quoted in Kathleen Tillotson, 'A Day with Charlotte Brontë in 1850', *Brontë Society Transactions* (vol. 16, 1975, pt 81) 22–30.
55. Elizabeth Gaskell, *The Life of Charlotte Brontë* (1857), ed. Angus Easson (Oxford, 1996), 333.
56. An ex-Sunday school pupil of Charlotte's made this assertion when interviewed in about 1905. How reliable her memory was is anybody's guess; what it does suggest is the pressure of attention. Whiteley Turner, *A Springtime Saunter Round and about Brontë-Land* (1913; Wakefield, 1969), 201.
57. See J.A.V. Chapple and Arthur Pollard, eds, *The Letters of Mrs Gaskell* (Manchester, 1966), 243.
58. [John Stores Smith], 'A Day with Charlotte Brontë in 1850', *The Free Lance* (7 and 14 March, 1868), reprinted in full in Clement Shorter, *Charlotte Brontë and Her Circle* (1908), and discussed in Tillotson. In addition to an account of his dinner invitation (24), Smith also describes the way in which two of his friends go to Haworth Church for the service to catch a glimpse of the authoress, and misidentify her.
59. Juliet V. Barker, *The Brontës* (London, 1994), 810–11.
60. Walter White, *A Month in Yorkshire* (London, 1858), discussed in J. Copley, 'An Early Visitor to Haworth', *Brontë Society Transactions* (1973, part 83), 219–221.
61. See Mrs Ellis H. Chadwick, *In the Footsteps of the Brontës* (London, 1914), 483.
62. Walter White, *A Month in Yorkshire*, 278.
63. The earliest comment that I have so far located is that of John Tomlinson; see John Tomlinson, *Some Interesting Yorkshire Scenes* (London, 1865), 139, where he describes being shown the chair in perhaps 1864. It was still being shown some thirty years later; see, for example, Theodore F. Wolfe, *A Literary Pilgrimage Among the Haunts of Famous British Authors* (London, 1895), 122.
64. Copley, op. cit., 220.
65. See Juliet V. Barker, *Sixty Treasures: The Brontë Parsonage Museum* (Haworth, 1988); see also The Council of the Brontë Society, *The Brontë Parsonage* (1962, rev. 1978 repr. and revised, Haworth, 1984), facing 29.
66. For the possible early offer of sale see Marion Harland, *Charlotte Brontë at Home* (New York, 1899), 291ff., in which she retails a conversation she had to this effect with the aged incumbent Wade on her visit in c. 1898. For general indignation, see for example, the comments of J.A. Erskine Stuart, *The Brontë Country: Its Topography, Antiquities, and History* (London, 1888), 82.
67. W.H. Cooke, 'A Winter's Day at Haworth', *St James' Magazine* vol XXI (December 1867–March 1868), 167.
68. Ibid.
69. Charles Hale, letter to his mother, 11 November 1861. *Early Visitors to Haworth*, ed. Charles Lemon (Haworth, 1996), 80.
70. G. Phillips Bevan, *Tourist's Guide to the West Riding of Yorkshire* (1877; 2nd edn, London, 1880).
71. J.A. Erskine Stuart, *The Brontë Country*, 79.
72. Exhibition of Brontëana in Haworth Parsonage Museum, summer 2004.
73. Charles Lemon, *A Centenary History of the Brontë Society 1893–1993*, supplement to *Brontë Society Transactions*, vol 20, The Brontë Society, 1993, 13.
74. For a photograph of the interior of the museum as it looked when it opened, see F.C. Galloway, *Catalogue of the Brontë Museum* (Bradford, 1896), 20.

75. See Lemon, *A Centenary History*, 48, 53–4.
76. For a full history of the Brontë Society and the associated museum, see Lemon, *A Centenary History*.
77. Gaskell, 11.
78. Ibid.
79. Ibid, 12.
80. Ibid.
81. Ibid, 13.
82. Ibid, 43.
83. Virginia Woolf, 'Haworth' (1904), *The Essays of Virginia Woolf*, ed. Andrew McNeillie (3 vols, London, 1986), I (1904–1912), 5.
84. Woolf, 6.
85. Ibid.
86. Ibid, 7.
87. Gaskell, 337. Gaskell actually associates this experience with *Jane Eyre* in her next remarks: 'Some one conversing with her once objected, in my presence, to that part of "Jane Eyre" in which she hears Rochester's voice crying out to her in a great crisis of her life, he being many, many miles distant at the time. I do not know what incident was in Miss Brontë's recollection when she replied, in a low voice, drawing in her breath, "But it is a true thing; it really happened." ' However, given that the publication of *Jane Eyre* preceded the deaths in the family, this association seems mendacious.
88. Gaskell, 337.
89. Ibid, 316, quoting from *Shirley*; cf. Charlotte Brontë, *Shirley*, eds, Margaret Smith and Herbert Rosengarten (1847; Oxford, 1981), 442–3.
90. Gaskell, 192, (mis)quoting *Shirley*, 407.
91. *Shirley*, 399, 240.
92. Gaskell, 100.
93. Ibid, 337.
94. Ibid, 364.
95. Ibid, 312.
96. Ibid, 316.
97. Wolfe, *A Literary Pilgrimage*, 127–8.
98. Harriet Prescott Spofford, *In Titian's Garden and other Poems* (Boston, MA, 1897), 42.
99. Marion Harland, *Where Ghosts Walk: The Haunts of Familiar Characters in History and Literature* (New York, London, 1898), 280.
100. Harland, 289, 290, 293, 294.
101. Wolfe, 217–8.
102. Ibid, 219.
103. The claim of photographic accuracy surfaces as early as 1865 with John Tomlinson. J.A. Erskine Stuart, 152; Miriam Allott, ed., 331; Tomlinson, 139.
104. Lemon, *A Centenary History*, 20.
105. Elbert Hubbard, *Little Journeys to the Homes of Famous Women* (New York, London, 1897), 138, 141.
106. [John Stores Smith], 'A Day with Charlotte Brontë in 1850' *The Free Lance* (7 and 14 March, 1868), reprinted in full in Clement Shorter, *Charlotte Brontë and Her Circle* (1908), and discussed in Tillotson, 24, 26.

Chapter 4 Ladies and lakes

1. James Lumsden and son, publ., *Guide to the Romantic Scenery of Loch-Lomond, Loch-Kethurin, the Trosachs etc etc with a correct map of the adjacent country* (1831; 3rd edn, Glasgow, 1838).
2. For a full discussion of Rousseau's impact upon English readers and writers at the end of the century, see Nicola J. Watson, *Revolution and the Form of the British Novel, 1790–1825* (Oxford, 1994).
3. Rousseau, J.J., *The Confessions* (1782; tr. J.M. Cohen, Harmondsworth, 1953), 506; M. Cranston, *The Solitary Self: Jean Jacques Rousseau in Exile and Adversity* (London, 1997), 195.
4. Rousseau, *Confessions*, 506.
5. Rousseau, *La Nouvelle Hélöise* (1761; tr. William Kenrick as *Eloisa, or a series of original letters*, 2 vols, London, 1803 – *LNH* hereafter) I, xli–xlii.
6. Frederick A. Pottle, *James Boswell: The Earlier Years 1740–1769* (London, 1984), 164, 163.
7. Ibid, 174.
8. Simon Schama, *Landscape and Memory* (London, 1996), 481.
9. Rousseau, *Confessions*, 401.
10. Ibid, 149.
11. *LNH* II, 177.
12. Ibid, 214.
13. Ibid, 216–8.
14. Ibid, 219–220.
15. Ibid, 216.
16. Helen Maria Williams, *A Tour in Switzerland; or, A View of the Present State of the Governments and Manners of those Cantons: with comparative Sketches of the Present State of Paris* (2nd edn, 2 vols, London, 1798), II, 179–80. In spite of much research, I have regrettably been unable to locate the 'hundreds' of accounts to which Williams alludes.
17. J.R. Hale, *The Italian Journal of Samuel Rogers* (London, 1961) 143.
18. Percy Bysshe Shelley and Mary Shelley, *History of a Six Weeks' Tour through A Part of France, Switzerland, Germany, and Holland: with Letters Descriptive of a Sail round the lake of Geneva . . .* (1817), in *The Prose Works of Percy Bysshe Shelley*, ed. E.B. Murray (3 vols, Oxford, 1993), I, 215.
19. George Gordon, Lord Byron, *Childe Harold's Pilgrimage, Canto III* (1816) in *Lord Byron: Selected Poems*, eds, S.J. Wolfson and P.J.Manning (London, 1996) 415–55; fn to stanza 50, 449.
20. Ibid.
21. P.R. Feldman and D. Scott–Kilvert, eds, *The Journals of Mary Shelley 1814–1844* (2 vols, Oxford, 1987), I, 110.
22. Ibid, 110–111.
23. Percy Bysshe Shelley and Mary Shelley, *History of a Six Weeks' Tour . . .* , I, 218.
24. Ibid, 219.
25. Ibid, 212.
26. Ibid, 215.
27. Ibid, 217.
28. Leslie Marchand, ed., *Byron's Letters and Journals* (11 vols, London, 1976), V, 81.
29. Ibid, 82.

30. Byron, *Childe Harold*, 449–450.
31. *Childe Harold*, 448–9.
32. Percy Bysshe Shelley and Mary Shelley, *History of a Six Weeks' Tour . . .* , I, 180.
33. Thomas Raffles, *Letters, during a Tour through Some Parts of France, Savoy, Switzerland, Germany, and the Netherlands, in the summer of 1817* (Liverpool, 1818), 252.
34. Charles Tennant, *A tour through parts of the Netherlands, Holland, Germany, Switzerland, Savoy, and France, in the year 1821–2. Including a description of the Rhine voyage in the middle of autumn, and the stupendous scenery of the Alps in the depth of winter. Also containing, in an appendix, fac-simile copies of eight letters in the hand-writing of Napoleon Bonaparte to his wife Josephine.* (London, 1824), 263, 267.
35. Marchand, V, 98.
36. Tennant, 267.
37. Anna Jameson, *Diary of an Ennuyée* (Philadelphia, 1826), 42.
38. John Murray, publ., *A Handbook for Travellers in Switzerland, and the Alps of Savoy and Piedmont* (London, 1838), 144.
39. Ibid, 141.
40. Thomas Roscoe, *The Continental Tourist. Views of Cities and Scenery in Italy, France and Switzerland* (3 vols, London, 1850), I, 73.
41. Murray, *A Handbook . . .* , 146.
42. Ibid, 147.
43. Ibid.
44. Simmons, Jack, ed., *Murray's Handbook for Travellers in Switzerland, 1838* (Leicester, 1970), 28.
45. E.F. Carritt, ed., *Letters of Courtship between John Torr and Maria Jackson 1838–43* (London, 1933), 176.
46. John Ruskin, *Praeterita and Dilecta* (1885–9), in *The Works of John Ruskin*, eds, E.T. Cook and A. Wedderburn (39 vols, 1908), XXXV, 518, 150.
47. Ibid, 151.
48. William Sharp, *Literary Geography* (London, 1904), 212.
49. Ibid, 242–3.
50. Ibid, 247.
51. See William B. Todd and Anne Bowden, *Sir Walter Scott: A bibliographical history, 1796–1832* (New Castle, DE, 1998), 178.
52. Nineteenth-century publications sometimes credit the 'discovery' of the Trossachs to Dr James Robertson, Minster of Callender, who in 1794 and 1799 published *A General View of the Agriculture on the County of Perth. The Statistical Account* is also sometimes mentioned. However, Murray's account is the first I have discovered that extends the genre of the tour to the area. For an extensive bibliography of eighteenth-century Tours of Scotland, see David Fleeman's edition of Samuel Johnson's *Journey to the Western Isles*.
53. Sarah (Aust) Murray, *A Companion, and Useful Guide to the Beauties of Scotland, to the lakes of Westmoreland, Cumberland, and Lancashire; and to the Curiosities in the District of Craven, in the West Riding of Yorkshire. To which is added, a more particular description of Scotland, especially that part of it, called the Highlands* (London, 1799), x–xi.
54. Ibid, 52.

55. *The Traveller's Guide; or, a Topographical Description of Scotland, and of the Islands belonging to it* (Edinburgh, 1798), 169–70.
56. Alexander Campbell, *A Journey from Edinburgh Through Parts of North Britain* . . . (2 vols, London, 1802), I, 122.
57. Ibid, 132.
58. Patrick Graham, *Sketches descriptive of Picturesque Scenery, on the southern confines of Perthshire, including the Trosachs, Lochard &c.* (Aberfoyle, 1802), 28.
59. Dorothy Wordsworth, *Recollections of a Tour Made in Scotland in 1803*, ed. Carol Kyros Walker (New Haven, 1997), 104.
60. Ibid, 97.
61. Margaret Oswald, *A Sketch of the Most Remarkable Scenery, Near Callender of Monteath* (1800; 5th edn, Stirling, 1811), 5, 10.
62. *The New Picture of Edinburgh for 1816* . . . *To which are added, A Description of Leith, and the Trosachs* (Edinburgh [1816]), 293.
63. *Menzies' Pocket Guide to the Principal Scottish Lakes* . . . (Edinburgh, 1854), 46. Southey had drily commented on the origins of this establishment's prosperity in 1819 when it had just become an inn: 'if the owner of this house has a proper sense of his obligations, he will set up the sign of Walter Scott's head.' Robert Southey, *Journal of a Tour in Scotland in 1819*, ed. C.H. Herford (London, 1929), 30.
64. Walter Scott, *The Lady of the Lake. A Poem by Walter Scott Esq. Illustrated with engravings from paintings by Richard Cook/with engravings from the designs of Richard Westall* (Edinburgh and London, 1811), Canto I, stanza xii.
65. Scott, *Lady of the Lake*, Canto III, Note X, p. lxiii.
66. There would be many later representations of Loch Katrine which had at their heart *The Lady of the Lake*, such as Horatio McCulloch's 'Loch Katrine' (1866). For a discussion of this painting as a representation of 'a landscape that is central to the history of Scottish tourism', marking it as a hidden, romantic world, see John Glendenning, *The High Road: Romantic Tourism, Scotland, and Literature 1720–1820* (Basingstoke, 1997), 234. See also James Holloway, *The Discovery of Scotland: the appreciation of Scottish scenery through two centuries of painting* ([Edinburgh], 1978).
67. Sir Walter Scott, *The Lady of the Lake with Topography of the Poem by the Late Sir George Biddell Airy and Notes by Andrew Lang* . . . (London, 1904), 140.
68. *Menzies Pocket Guide to the Principal Scottish Lakes, the Trosachs, and Surrounding Mountain Scenery, with map and illustrations* (Edinburgh, 1854), 51.
69. *Black's Picturesque and Pictorial Guide to the Trosachs* . . . (Edinburgh, 1853), 117.
70. John MacCulloch, *The Highlands and Western Islands of Scotland, Containing Descriptions of their Scenery and Antiquities* . . . *Founded as a series of Annual journeys between the years 1811 and 1821, and forming a universal guide to that country, in Letters to Sir Walter Scott, Bart.* (4 vols, London, 1824), I, 194.
71. *Black's Picturesque and Pictorial Guide*, 103, 75.
72. William Charles Macready, *Reminiscences, and Recollections from his Diaries and Letters*, ed. Sir Frederick Pottle (2 vols, London, 1875) I, 183, 187.
73. MacCulloch, I, 193.
74. Ibid, 165.
75. Todd and Bowden, 188.
76. Lumsden, 43.

77. Victoria, *Leaves from the Journal of our life in the Highlands*, ed. Arthur Helps (London, 1868), *passim*; J.A. Hammerton, *Memories of Books and Places* (London, 1928), 35.

78. Theodor Fontane, *Across the Tweed: A Tour of Mid-Victorian Scotland*, tr. Sir James Fergusson (London, 1965), 104.

79. Karl Baedeker, *Great Britain: Handbook for Travellers* (Leipzig and London, 1887), 484.

80. William Edward Franklin, *Franklin's Itinerary for the Trosachs* . . . (Edinburgh and Glasgow, [1877]), 14.

81. Lumsden, 22.

82. R.N. Worth, *Tourist's Guide to North Devon and the Exmoor District* (London, 1879), 3.

83. R.D. Blackmore, *Lorna Doone: A Romance of Exmoor* (1869; 'Doone-Land Edition. With introduction and notes by H. Snowden Ward and illustrations by Mrs Catharine Weed Ward', London, 1908), 43.

84. Worth, 16, 92, 94, 95.

85. Max Keith Sutton, *R.D. Blackmore* (Boston, 1979), 49.

86. Blackmore to Ursula Halliday, 23 November 1882; quoted in Waldo Hilary Dunn, *R.D. Blackmore* (London, 1956), 139.

87. Blackmore to James F. Muirhead, 10 March 1887; quoted in Dunn, 139.

88. Baedeker, 160–1.

89. A. Elliott-Cannon, *In Quest of the Doones* (Dulverton, 1981), 14.

90. Ibid, 45.

91. 'The Valley of the Doones' *The Atlantic Monthly* (April 1893), 573.

92. Ibid.

Chapter 5 Literary geographies

1. Howitt, I, 153.

2. Unsigned review of *Ivanhoe*. *Eclectic Review* XIII (2nd series)(June, 1820), 526–40. Quoted in *Scott: The Critical Heritage*, ed. John O.Hayden (London, 1970), 191–2.

3. John Britton, letter to John Meikle Kemp, quoted in N.M. Holmes and Lyn M. Stubbs, *The Scott Monument: A History and Architectural Guide* (Edinburgh, 1989), 9. See also *History of the Scott Monument, Edinburgh, to Which is prefixed a Biographical Sketch of Sir Walter Scott, Bart* (Edinburgh, 1881).

4. Frances, Lady Shelley to Sir Walter Scott, 16 August 1819; quoted in *The Diary of Frances Lady Shelley 1787–1817*, ed. Richard Edgcumbe (2 vols, London, 1912), II, 62.

5. A copy of this inscription is on display at the Writers' Museum, Edinburgh.

6. T. Edgar Pemberton, *Dickens' London; or, London in the Works of Charles Dickens* (London, 1876), 3–4.

7. Pemberton, 5; Robert Allbutt, *London Rambles 'En ZigZag' with Charles Dickens* (London, 1886) iv.

8. Elbert Hubbard, *Little Journeys to the Homes of Good Men and Great* (New York and London, n.d.), 287.

9. Ibid, 274.

10. Ibid, 279.
11. Tearle, 13.
12. Augustus John, *Chiaroscuro*, quoted in Hugh Brasnett, *Thomas Hardy: A Pictorial Guide* (Wimborne, 1990), as caption to frontispiece.
13. F.R. and Sidney Heath, *Dorchester (Dorset) with its Surroundings* (Dorchester and London, 1905–6), 12.
14. F.E. Hardy, *The Life of Thomas Hardy 1840–1928* (London, 1962), 122.
15. Michael Millgate, *Thomas Hardy, A Biography* (Oxford, 1982), 248.
16. J.M. Barrie, 'Thomas Hardy: The Historian of Wessex,' *Contemporary Review* LVI (July, 1889), 57–66; Rudyard Kipling, *The Athenaeum* (6 December 1890).
17. I am indebted to Jeff Nunokawa's essay for drawing my attention to the importance of tense in such passages of description. Jeff Nunokawa, 'Tess, tourism, and the spectacle of the woman' in *Rewriting the Victorians: Theory, History, and the Politics of Gender*, ed. Linda M. Shires (New York and London, 1992), 70–86.
18. Thomas Hardy, *Tess of the D'Urbervilles*, ed. David Skilton (1891; Harmondsworth, 1978), 48–9.
19. Other popular descriptive excerpts included the evocation of Egdon Heath, the extensive description of Casterbridge and the nearby Roman amphitheatre at the opening of chapter 11 of *The Mayor of Casterbridge*, the description of Swanage and the view from Nine Barrow Down towards Corfe in *The Hand of Ethelberta*, and the description of the white horse cut into the downs at Osmington in *The Trumpet-Major*.
20. On the generic guidebook language of the descriptions of Sandbourne and Winchester, see Nunokawa, 75–6 and 79.
21. For an account of the use of tourist sites in *Tess* and their affinity with the Baedeker guide of 1887, see Nunokawa, *passim*.
22. Brasnett, 86.
23. Quoted in Millgate, 422. Hardy's remark was made apropos of the publication of Charles G. Harper's *The Hardy Country: Literary Landmarks of the Wessex Novels* (London, 1904).
24. Clive Holland, 'Thomas Hardy's Wessex,' *The Bookman* I (October, 1891), 26.
25. For a full account of Owen's stay in Dorset and of her curious and pathetic relationship with Hardy see Carl J. Weber, *Hardy and the Lady from Madison Square* (Waterville, Maine, 1952).
26. Weber, 126, 130.
27. Clive Holland, 'The Work of Frederick Whitehead, A Painter of Hardy's Wessex', *Studio* XXXII (15 July 1904), 110; Keith, 83.
28. See Carl J. Weber, *The Letters of Thomas Hardy* (Waterville, Maine, 1954), 38; F.E. Hardy, *The Life of Thomas Hardy 1840–1928* (London, 1962). I am indebted generally here to W.J. Keith's survey of 1890s interest in Hardy topography, 'Thomas Hardy and the Literary Pilgrims', *Nineteenth-Century Fiction* 24 (June, 1969), 80–92.
29. Annie MacDonell, *Thomas Hardy* (London, 1894), 176.
30. Ibid, 185.
31. For fuller details of these textual revisions see Keith.
32. Keith, 86.
33. Hardy took the artist Macbeth-Raeburn around some of the sites he had in mind in May 1895. Millgate, 363.

34. These critics' emphases differ as to how much Hardy colluded with this process, and how much he resisted it; my own sense is that both collusion and resistance contribute to the peculiar formation that is Hardy Country. See W.J. Keith, *Regions of the Imagination: The Development of British Rural Fiction* (Toronto, 1988), 81; Denys Kay-Robinson, *Hardy's Wessex ReAppraised* (Newton Abbot, 1972); Millgate; Peter Widdowson, *Hardy In History* (London, 1989); Ralph Pite, *Hardy's Geography: Wessex and the Regional Novel* (Basingstoke, 2002).

35. I am indebted here to Hillis Miller's suggestive comments on the referentiality of fictional maps in J. Hillis Miller, *Topographies* (Stanford, 1995).

36. Thomas Hardy, *Far From the Madding Crowd*, eds, John Bayley and Christine Winfield (1874; London, 1974), 38.

37. Sidney Heath, *The Heart of Wessex* (London, 1910), 8.

38. *Black's Guide to Dorset*, ed. A.R. Hope Moncrieff (London, 1897), 6.

39. Ibid, vi.

40. Ibid, 18.

41. Bertram Windle, *The Wessex of Thomas Hardy* (London, 1902), 276, 312.

42. Sir George Douglas, 'An Itinerary of Wessex', *The Bookman* I, (November, 1901), 59.

43. Wilkinson Sherren, *The Wessex of Romance* (London, 1902), v–vi.

44. Sir Frederick Treves, *Highways and Byways of Dorset* (London, 1906), viii; *Memorials of Old Dorset*, eds, Thomas Perkins and Herbert Pentin (London, 1907); Heath.

45. See Millgate, 421.

46. 'General Preface to the Wessex Edition' (1912), reprinted in Hardy, *Far From the Madding Crowd*, 443–7.

47. For a comprehensive and suggestive reading of this map, see Pite.

48. Weber, 66.

49. F.R. & Sidney Heath, 64.

50. Quoted in ibid, 64.

51. Douglas, 59.

52. Clive Holland, 'Thomas Hardy's Wessex', *The Bookman* I (October, 1891), 26.

53. Hermann Lea, *Thomas Hardy's Wessex* (London, 1913), xix.

54. Kay-Robinson, 258.

55. Sherren, 182.

56. Thomas Hardy, 'General Preface to the Wessex Edition', 445.

57. Lea, xxii.

58. W.M. Parker, *On the Track of the Wessex Novels: A Guide to the Hardy Country* (Poole, 1924), 45.

59. J.H. Field, 'A Map of the Wessex of Thomas Hardy's Novels', (1935) The Dorset County Museum.

Epilogue

1. This omission is partly supplied in the guidebook; see Adam Nicolson, *Bateman's, East Sussex* (London, 1996), 42.

2. Judy Taylor, *Beatrix Potter and Hill Top* (London, 1989), 9.

3. Conversation with the guide at Hill Top, October, 2004.

4. Lucy M. Boston, *The Children of Green Knowe,* illustrated by Peter Boston (1954; London, 2000), 6.
5. Ibid, 10.
6. Ibid, 11.
7. Ibid, 34.
8. Lewis Carroll [Charles Dodgson], *Alice in Wonderland* (1865; London, 1994),10.
9. Ibid, 11.
10. Frank Barrett, *Where was Wonderland? A Traveller's Guide to the Settings of Classic Children's Books* (London, 1997), 139–140. (Maps drawn by John Woodcock.)
11. Philip Pullman, *The Amber Spyglass* (London, 2000), 523.
12. Ibid, 537.
13. Pullman, 537.
14. Conversation with a trustee of the Botanic Gardens, October, 2005.
15. *Alice in Wonderland*, 148.

Index